2003
CyberArts

Hannes Leopoldseder – Christine Schöpf

PRIXARS ELECTRONICA
2003 CyberArts

International Compendium Prix Ars Electronica – Net Vision / Net Excellence, Interactive Art,
Computer Animation / Visual Effects, Digital Musics, cybergeneration – u19 freestyle computing

CONTENTS

CONTENTS

010 Hannes Leopoldseder: Orwell's Children Are Growing Up
016 Christine Schöpf: Editorial

NET VISION / NET EXCELLENCE

020 Galvanizing the Engagement of Society – Statement of the Net Vision / Net Excellence Jury
028 Yury Gitman / Carlos J. Gomez de Llarena – Golden Nica (Net Vision)
034 Sulake Labs Oy – Golden Nica (Net Excellence)
040 David Crawford
042 Golan Levin
046 Lia
050 James Tindall
052 Antoni Abad
054 Christophe Bruno
056 Amit Pitaru / James Paterson
058 Agathe Jacquillat / Tomi Vollauschek / FL@33
060 Jared Tarbell / Lola Brine
062 Axel Heide / onesandzeros / Philip Pocock / Gregor Stehle
064 Wiggle / Han Hoogerbrugge
066 LAN
068 LAN
070 Last.Team
072 LeCielEstBleu
074 ubermorgen
076 Shinya Yamamoto
078 OSDN

INTERACTIVE ART

082 Interaction—New Modes and Moods / Statement of the Interactive Art Jury
088 Blast Theory in collaboration with Mixed Reality Lab, University of Nottingham – Golden Nica
092 Margarete Jahrmann / Max Moswitzer
096 Maywa Denki
100 Ross Cooper & Jussi Ängeslevä
102 dECOi
104 Sibylle Hauert / Daniel Reichmuth / Volker Böhm
106 Haruo Ishii
108 George Legrady
110 Justin Manor
112 Agnes Meyer-Brandis
114 Iori Nakai
116 Henry Newton-Dunn / Hiroaki Nakano / James Gibson / Ryota Kuwakubo
118 Marcel.lí Antúnez Roca
120 Marie Sester
122 Scott Snibbe

COMPUTER ANIMATION / VISUAL EFFECTS

126 Art as Experiment? / Statement of the Computer Animation / Visual Effects Jury
134 Romain Segaud / Christel Pougeoise – Golden Nica
138 Carlos Saldanha / Blue Sky Studios, 20th Century Fox
142 Koji Yamamura
146 Christoph Ammann
148 Eric Armstrong /Sony Pictures Imageworks
150 Jérôme Decock / Olivier Lanerès / Mélina Milcent / Cécile Detez de la Dreve
152 Roger Gould / Pete Docter / Pixar
154 Thorsten Fleisch
156 Luc Froehlicher / La Maison
158 H5 / Ludovic Houplain / Hervé de Crécy
160 Wayne Lytle / Animusic
162 Siri Melchior
164 Jordi Moragues
166 Tippett Studio
168 Satoshi Tomioka

DIGITIAL MUSICS

172 A new Ambiguity: Human and digital / Statement of the Digital Musics Jury
182 Ami Yoshida, Sachiko M, Utah Kawasaki – Golden Nica
184 Florian Hecker
186 Maja Solveig Kjelstrup Ratkje
188 Oren Ambarchi
189 Whitehouse
190 Kevin Drumm
191 Rudolf Eb.er
192 Phill Niblock
193 Yuko Nexus 6
194 Gert-Jan Prins
195 Rechenzentrum
196 Tujiko Noriko
197 Toshiya Tsunoda
198 Aaron Funk (Venetian Snares) & Rachael Kozak (Hecate)
199 Mark Wastell / Toshimaru Nakamura / Taku Sugimoto / Tetuzi Akiyama

CYBERGENERATION – U19 FREESTYLE COMPUTING

202 u19 Freestyle Computing – Statement of the u19 Jury
206 Georg Sochurek – Golden Nica
208 Martin Leonhartsberger / Sigrun Astrid Fugger
210 Armin Ronacher / Nikolaus Mikschofsky
212 Dominik Dorn
213 Georg Gruber
214 Manuel Fallmann
215 David Hackl
216 Thomas Hainscho
217 Hauptschule Steinerkirchen / Traun
218 Alexandra Voglreiter / Katharina Krummel / Anna Obermeier
219 Projektgruppe der HBLA für künstlerische Gestaltung, Garnisonstraße / Linz
220 Franz Wengler / Christof Haidinger
221 7a des BORG 3 Wien
222 Tobias Schererbauer / Matthäus König / Sebastian Schreiner

226 Prix Ars Electronica 2003 Jury
234 Prix Ars Electronica 2003 Participants
267 Impressum

PRIX ARS ELECTRONICA 2003

Orwell's Children Are Growing Up
Orwells Kinder werden erwachsen

Hannes Leopoldseder

Ein Festival, das sich seit mehr als zwei Jahrzehnten mit Zukunftsthemen befasst, kann 2003 an einem Namen nicht vorbeigehen: an George Orwell, der vor 100 Jahren in Motihari in Indien geboren wurde. George Orwell hat bekanntlich knapp vor seinem Tod im Jahr 1950 den wohl meist zitierten Zukunftsroman *1984* geschrieben, in dem er das Negativbild eines totalitären Überwachungsstaates zeichnet.

Als das reale Jahr 1984 kam, war es für Ars Electronica naheliegend, an dieses Zukunftsszenario anzuknüpfen. Angesichts der Vielzahl von Veranstaltungen und Projekten, die sich in diesem Orwell-Jahr mit den Schreckensszenarien befassten, wählte Ars Electronica ebenfalls einen Sprung in die Zukunft, und zwar in das Jahr 2019. Die Wahl dieses Jahres hatte zwei Gründe: Erstens, so war unsere Überlegung, werden die Kinder, die im Orwell-Jahr 1984 zur Welt kommen, im Jahr 2019 35 Jahre alt sein, also in verantwortlichen Positionen in Politik und Wirtschaft stehen; zweitens waren seit dem Tod von George Orwell im Jahr 1950 34 Jahre vergangen, also kamen wir ebenfalls der Zahl 35 nahe.

Soweit zur Geschichte. Ars Electronica, mit ihrer Gründung im Jahr 1979 wohl das traditionsreichste Medienfestival der Welt, kann im Jahr 2003 bereits wiederum an das historische Jahr 1984 anknüpfen: denn die Kinder, die im Orwell-Jahr 1984 geboren wurden, werden 2003, also in diesem Jahr, 19 Jahre alt. Orwells Kinder werden erwachsen. Wie sieht also jene Generation aus, die 1984 geboren worden ist?

Es ist hier nicht der Ort, ein Gesamtszenario der Welt von heute zu entwerfen. Zu gewaltig sind die Veränderungen, die in den letzten Jahrzehnten, vor allem auch um die Jahrtausendwende, ihre Spuren legen. Bei diesem Vierteljahrhundert handelt es sich politisch, wirtschaftlich und technologisch um eine Zeit des radikalen Wandels, den sich kaum jemand vorzustellen wagte. Es ist die Periode der „Fünften Kondratieff -Welle", die als Basisinnovation die Informationstechnologie hervorbringt, die verändert, was wir tun, und die Biotechnologie, die verändert, wer wir sind. Aus dieser verknappten Formulierung wird deutlich, dass wir mitten in einer der tief greifendsten Phasen in

A festival which has devoted itself to topics related to the future for more than two decades cannot get around one name in 2003: George Orwell, who was born 100 years ago in Motihari, India. Shortly before his death in 1950, George Orwell wrote, as we all know, 1984, the most frequently cited novel on the future. In it he paints a negative picture of a totalitarian state under constant surveillance.

So when the year 1984 actually came round, the most obvious thing for Ars Electronica to do was to take up this scenario of the future. In view of the many projects and events dealing with horrifying scenarios in that Orwellian year, Ars Electronica chose to take a leap into the future, to the year 2019. And there were two reasons why we picked exactly that year: first of all, we reflected, children born in the Orwellian year of 1984 would be 35 years old in 2019, putting them in political and financial positions of responsibility; and, secondly, 34 years had gone by since George Orwell's death in 1950, again giving us a number approaching 35.

So much for the past. In 2003, Ars Electronica, which was founded in 1979 and is without a doubt the media festival with the richest tradition in the world, has again succeeded in taking up the historic year of 1984: for the children born in the Orwellian year of 1984 are turning nineteen this year. Orwell's children are growing up. So what is this generation, born in 1984, like?

This is not the place to draft a complete scenario of the world today. The changes which have affected the past decades, especially those at the turn of this century, are too enormous. The past 25 years have been an era of drastic political, economic and technological upheaval, such as no one had even dared imagine. The time of the "fifth Kondratieff cycle" has brought forth, as basic innovation, information technology, which alters what we do, and biotechnology, which alters who we are.

Hannes Leopoldseder

This abbreviated formulation reveals quite clearly how we are in the midst of one of the most profound stages in the development of mankind. Ars Electronica's position as a festival for "art, technology and society", as laid out in 1979, is today no longer one held just by the festival in Linz, but in the meantime has come to serve as a model for a large number of events. This triad of topics has made it possible for Ars Electronica to select its central annual theme according to a certain relevancy of events and an immediacy within this spectrum of topics. By doing so it has attained a certain lead function within the festival world. For those responsible for the festival, the actuality of the themes ensures this lead and makes the media's recurring question as to what Ars Electronica really is—an art festival or a technology festival—, or the question of what a socio-political subject has to do with an art festival, recede into the background. For in fact it was this basic concept which gave Ars Electronica not only its special status from the start but has been in part responsible for the festival's continuity over a quarter of a century.

"The future", Alvin Toffler writes, "always comes too fast and in the wrong order". This is especially true for the development of information technology. Yet the symbol of the 90s, the "net", which was to change everything, has not lost reality. The fascination of the Internet's potential as a new medium has, however, made many forget that, like humans, every medium requires time to go through the essential stages of development. Silicon Valley is having its worst recession since the 60s. Every sixth job has been lost. For as Alvin Toffler said with reason, technological breakthroughs are rarely predictable, especially not in terms of time.

Ten years ago, in 1993, and two years after Berners-Lee went online in August 1991 with the software for the WWW and made it accessible to the public, Andreessen and his team went online with "Mosaic" . Hence in 1993, ten years ago, the triumphal advance of the WWW began, years before Orwell's children were to grow up and be raised with the global world of the Internet which would make knowledge and communication possible, but also Orwell's world of control.

If we take a look at this period, we see that the Internet is now, after ten years, in a state similar to colour television in the late 50s or early 60s. "Internet will change our lives." This declaration is not the objective of one decade but a task for several decades. In many fields, be it commerce, music, travel, financial services, education, media, it has become almost impossible to imagine a

der Entwicklungsgeschichte der Menschheit leben. Die Positionierung von Ars Electronica als Festival für „Kunst, Technologie und Gesellschaft", die 1979 grundgelegt wurde, gilt heute nicht nur für das Festival in Linz, sondern ist in der Zwischenzeit für eine Vielzahl von Veranstaltungsreihen zum Modell geworden.

Dieser Dreiklang der Thematik ermöglichte es Ars Electronica, je nach Ereignishaftigkeit und Zeitbezogenheit im Themenspektrum das jährliche Festivalthema zeitnah zu wählen und dadurch eine bestimmte Lead-Funktion im Festivalgeschehen zu erreichen. Diese Themenaktualität sichert für die Festivalverantwortlichen den Vorsprung und lässt die immer wieder insbesondere von Medien aufgeworfene Frage, was denn Ars Electronica eigentlich sei – ein Kunstfestival, ein Technologiefestival – oder die Frage, was ein gesellschaftspolitisches Thema bei einem Kunstfestival zu tun habe, in den Hintergrund treten. Faktum ist: Dieses Grundkonzept hat Ars Electronica von Beginn an nicht nur eine besondere Position verliehen, sondern ist auch mitverantwortlich für die Kontinuität des Festivals über ein Vierteljahrhundert.

„The future", schreibt Alvin Toffler, „always comes too fast and in the wrong order". Dies gilt insbesondere auch für die Entwicklung in der Informationstechnologie. Das Symbol der 90er Jahre, das „Netz", das alles verändern würde, hat allerdings nichts an Realität verloren. Die Faszination des Potenzials des neuen Mediums Internet ließ allerdings viele vergessen, dass jedes Medium seine Zeit braucht, um die entsprechenden Entwicklungsstufen zu durchlaufen, genauso wie der Mensch. Silicon Valley durchläuft derzeit die tiefste Rezession seit den 60er Jahren. Jeder sechste Arbeitsplatz ist verloren gegangen. Technologische Durchbrüche lassen sich selten prognostizieren, insbesondere nicht in der zeitlichen Dimension, wie Alvin Toffler zurecht schreibt. Vor zehn Jahren, 1993, stellten Andreessen und sein Team „Mosaic" ins Netz, nachdem Tim Berners-Lee im August 1991 die WWW-Software im Internet veröffentlicht und für jeden zugänglich gemacht hat. Damit beginnt 1993, vor zehn Jahren, der Siegeszug des WWW, zehn Jahre, bevor Orwells Kinder erwachsen werden und mit der globalen Welt des Internet aufwachsen, das Wissen und Kommunikation, aber auch Orwells Welt der Kontrolle ermöglicht.

Wenn wir diese Zeitspanne betrachten, so befindet sich das Internet heute nach zehn Jahren in einem ähnlichen Zustand wie das Farbfernsehen Ende der 50er / Anfang der 60er Jahre. Das Internet wird unser Leben verändern. Diese Ansage ist nicht das Ziel eines Jahrzehnts, sondern Aufgabe von Jahrzehnten. In vielen Bereichen, seien es Handel, Musik, Reisen, Finanzdienstleistungen, Bildung, Erziehung, Medien, ist eine Zeit ohne Internet kaum mehr vorstellbar. Ebenso nicht im Kunstbereich, in allen Bereichen der Interaktivität.

Wenn wir diese Entwicklung an den „Orwell-Kindern" überprüfen, um zum Beginn zurückzukommen, so bestätigt die Orwell-Generation dieses Bild. Nicht zufällig spricht eine Studie über das Leben im Informationszeitalter (Forschungsinstitut der British American Tabacco) von „Generation @". Die 13. Shell-Jugendstudie sieht die Welt der heutigen Kinder und Jugendlichen gekennzeichnet durch einen zunehmend rascher werdenden Wandel der Familienformen, durch kleinere Familien, geringe Verbindung zwischen der Welt der Kinder und der Arbeitswelt der Eltern, vor allem aber durch eine Allgegenwart den Medien. Die Kinder sind von einer umfassenden Medienwelt umgeben. Die Imagination der Medienwelt tritt in Konkurrenz zur Realwelt.

Orwells Kinder leben heute weniger in der Familien-Szene, sondern in selbst geschaffenen Szenen, wie in der Musikszene, in der Sportszene, in der Subkultur, in der Neuen-Medien-Szene und sich ständig neue generierenden Szenen. Nach einer Untersuchung des Wiener Institutes für Jugendkulturforschung und Kulturvermittlung zählen quer durch die Szenen Spaß, Vertrauen, Verlässlichkeit. Darüber hinaus sind Freundschaft, Partnerschaft, Familienleben und Eigenverantwortung vorrangig. Im Technologiebereich steht nach wie vor Fernsehen an erster Stelle, allerdings eingebettet in Hi-Fi, PC, Handy, Internet, Sampling, Networking. Die Orwell-Kinder sind zu einer Netz-Generation geworden.

Das Kennzeichen Globalität ermöglicht durch den Tod der Entfernung die zunehmend punktgenau Erreichbarkeit jedes Punktes auf dem Globus der industrialisierten Welt. Im Gegenzug wird immer stärker das Auseinanderklaffen greifbar, das durch die Zugangsmöglichkeit bzw. durch den Nicht-Zugang zu den weltweiten Netzen entsteht. Es geht heute nicht mehr um das Netz als Verbindung von Computer zu Computer, sondern um die Kommunikation von jedem zu jedem, ob Mensch oder Gegenstand, sowie um die Kommunikation von überall zu überall, wireless und nochmals wireless. Nicht die Technologie steht im Vordergrund, sondern die Beziehung zwischen Person und Person ist entscheidend.

„Life goes mobile", das Evangelium von Nokias Pekka Ala-Pietila, ist nicht nur richtungsweisend, sondern in der Zwischenzeit eine Selbstverständlichkeit. Für die Künstler, insbesondere jene, deren Arbeiten interaktiv ausgerichtet sind, erstehen neue Gestaltungsmöglichkeiten.

Über die Naturwissenschaft hinaus, ob in der Technik, in der Medizin oder in anderen Disziplinen, steht eine Neuorientierung der Werte bevor, die Herausforderung, eine „bessere Welt" zu bauen. Gemessen an dieser Forderung, die immer wieder und von jeder Generation mit Recht neu gestellt wird, sind die Fortschritte, selbst die der letzten Jahrzehnte, noch in keiner Weise zufriedenstellend, sondern angesichts der unendlichen Not in weiten Regionen der Erde erschreckend. Der Prix Ars Electronica spiegelt auch dieses Bild, von einzelnen Künstler gezeichnet, in ihren Werken wider.

time without the Internet. The same is true for the arts and all fields involving interactivity.

To return to my original thoughts, if we examine this development in terms of "Orwell's children", we find this picture substantiated by them. It is not a coincidence that a study on life in the information age (by the research institute of British-American Tobacco) talks about the "generation @". The 13th Shell Youth Study sees the world of today's children and young people as being marked by ever more rapidly changing family constellations, by smaller families, and frailer ties between the worlds of children and the working lives of parents, but above all by the ubiquity of the media. Children are surrounded by an all-encompassing media world. And the imagination of this media world has entered into competition with the real world.

Today it is no longer common for Orwell's children to live within a family scene, but within scenes created by them, such as a music scene, sports scene, subculture, new media scene, or new scenes that are constantly being generated. According to a study by the Vienna Institute for Youth Culture Research and Cultural Mediation, throughout these scenes it is fun, trust and reliability that count. Other priorities are friendship, partnership, family life and taking responsibility for oneself and one's actions. With regards to technology, television still comes first, though in combination with a hi-fi, PC, mobile phone, the Internet, sampling and networking. Orwell's children have become a net generation.

By eliminating distances, globality makes it possible to reach every point on the globe of the industrial world with ever more precision. Conversely, the gap between those able to access worldwide networks and those not able to access them is becoming ever more glaring. It is no longer a matter of the net as a link from one computer to another, but of communication from each of us to the other, whether person or object, as well as communication from any one location to another, wireless there and wireless back. It is not technology that has top priority but the relationship between one person to another person that is all-important.

"Life goes mobile", Nokia's president Pekka Ala-Pietila's guiding principle, is no longer just an indication of the direction things are taking but has become their natural course. For the artist, especially for those whose works are directed towards interactivity, new design options are emerging.

Beyond the natural sciences, whether in engineering, medicine or in other disciplines, a reorientation of values is imminent, the challenge to build a

Hannes Leopoldseder

"better world". Measured in terms of this task, justifiably set by every generation over and over again, progress, even of the last decades, is by no means satisfactory but, in face of the immense need to be found across vast areas of the earth, horrifying. The Prix Ars Electronica also reflects this situation, as illustrated by individual artists in their works.

Today "Orwell's children" make up a considerable number of the Prix Ars Electronica's entrants. The participants of the category "cybergeneration – u19 freestyle computing", on the other hand, all belong to this generation. This category was quite exciting again this year, because as its leitmotif "freestyle" expresses: everything goes. There is no subdividing into specific categories here, so any form of creativity accomplished with digital media can be submitted.

With the aid of the Internet, the Prix Ars Electronica has established a worldwide network of artists who work with digital media—be it in music, interactive art, animation or using the Internet itself as the medium of their projects.

Ars Electronica's worldwide network has become one of the festival's major pillars. And the sheer numbers in this network clearly demonstrate the Prix Ars Electronica's positive balance since 1987. For over the years the Prix Ars Electronica has involved:

- 21,000 works,
- 16,000 artists,
- participants from 87 nations,
- 204 Golden Nicas, Awards of Distinction
- 1,750,000 euro in cash prizes.

As founder of the Prix Ars Electronica, and on behalf of the more than 15,000 participants since the first competition, I would like to express my thanks: first to the sponsors who have donated all the cash prizes since 1987 and above all contributed substantially to the competition's implementation. Special acknowledgment also goes to these sponsors for not investing in established fields of art, but supporting what was new and hence in its very essence still on shaky ground.

„Orwells Kinder" stellen heute bereits eine beträchtliche Anzahl von Teilnehmern beim Prix Ars Electronica, und alle Teilnehmer der Kategorie „cybergeneration – u19 freestyle computing" gehören dieser Generation an. Auch in diesem Jahr war diese Kategorie besonders spannend, denn nach dem Leitmotiv „freestyle" ist dort alles möglich – es gibt noch keine Aufgliederung in Detailkategorien. Alles kann eingereicht werden, was an Kreativität durch digitale Medien geschaffen wird.

Über das Internet hat der Prix Ars Electronica ein weltweites Netzwerk von Künstlern und Künstlerinnen geschaffen, die mit digitalen Medien arbeiten – sei es in der Musik, in der interaktiven Kunst, in der Animation oder im Internet selbst als Medium ihrer Projekte. Dieses weltweite Netzwerk der Ars Electronica ist zu einer tragenden Säule des Festivals geworden. Die Bilanz des Prix Ars Electronica seit 1987 weist dieses Netzwerk in klaren Ziffern aus. Der Prix Ars Electronica bedeutet:

- 21.000 Werke
- 16.000 KünstlerInnen
- TeilnehmerInnen aus 87 Ländern
- 204 Goldene Nicas und Auszeichnungen
- 1.750.000 Euro an Preisgeldern

An dieser Stelle möchte ich als Gründer des Prix Ars Electronica, aber auch im Namen der über 15.000 TeilnehmerInnen seit dem ersten Prix im Jahr 1987 einen Dank aussprechen: einen Dank an die Sponsoren, die seit 1987 nicht nur die gesamten Geldpreise gestiftet haben, sondern darüber hinaus zur Durchführung des Wettbewerbes wesentlich beigetragen haben. Es verdient eine besondere Anerkennung, dass Sponsoren nicht in den etablierten Kunstbereich investieren, sondern in das Neue, das sich seinem Wesen gemäß auf noch ungesichertem Boden bewegt.

In den Dank sind vor allem auch die Mitglieder der Jurys mit einzubeziehen. Von Beginn an war der Prix Ars Electronica darauf bedacht – und darauf ist Dr. Christine Schöpf als Verantwortliche für das ausgezeichnete Prix-Ars-Electronica-Team des ORF mit Recht stolz –, für die Jurys der jeweiligen Kategorien hoch qualifizierte Fachleute zu gewinnen. Denn es geht dabei nicht nur darum, aus den Einreichungen die Besten auszuwählen, sondern vor der Preisentscheidung steht die Findung und Definition der Kriterien. Aber gerade dadurch trägt der Prix Ars Electronica wesentlich zur Trendsetzung bei.

Nicht zuletzt gilt der Dank allen beteiligten Mitarbeitern des ORF, des O. K Centrum für Gegenwartskunst sowie des Ars Electronica Center, letztlich allen, die von der Ausschreibung bis zu den Publikationen und der Ausstellung befasst sind.

Die erstklassige Arbeit des gesamten Teams des Prix Ars Electronica schafft mit diesem Projekt ein einzigartiges weltweites Netzwerk, das insgesamt zur weltweiten Verankerung des Festivals einen entscheidenden Beitrag leistet.

Es ist für ein Festival eine besondere Auszeichnung, dass so viele Künstler und Künstlerinnnen über viele Jahre mit dem Festival verbunden bleiben. Ars Electronica wird auch in Zukunft seiner unterschiedlichen Schwerpunktbildung aus den Bereichen Kunst, Technologie und Gesellschaft nachkommen, entsprechend der Relevanz, die sich zur jeweiligen Zeit im jeweiligen Gebiet abzeichnet. Der Prix Ars Electronica, der sich seit 1987 immer mehr zum Mittelpunkt des weltweiten Ars-Electronica-Netzwerkes entwickelt hat, wird in Zukunft noch stärker als bisher in das Festival integriert werden. Gerade in den kommenden Jahren, in denen neben den neuen Medien immer stärker Biotechnologie und Nanotechnologie in den Vordergrund rücken, wird es für Ars Electronica eine besondere Herausforderung sein, die richtige Balance in der zeit-und themengemäßen Auseinandersetzung und Festivalprogrammierung zu finden, um der geforderten Zukunftskompetenz gerecht zu werden.

Der Prix Ars Electronica bleibt dabei die ständige und zentrale Einladung an die KünstlerInnen, mit kreativen Spürsinn die Themen unserer in höchstem Maße heterogenen Zeit in künstlerische Projekte umzusetzen und zu präsentieren.

I would also like to include the jury members in these words of gratitude. From the start, the Prix Ars Electronica—and Dr. Christine Schöpf as the person responsible for the excellent Prix Ars Electronica team from the Austrian Broadcasting Corporation (ORF) can indeed be proud of this—was intent on obtaining highly qualified experts for the juries of the respective categories. For it is not only a question of picking the best works from those submitted, but of finding and defining the criteria for evaluating them. And this is exactly why the Prix Ars Electronica has been able to contribute so greatly to setting trends. Last but not least, our thanks go to the entire ORF staff involved in the Prix, the O. K Center for Contemporary Art, as well as the Ars Electronica Center, i.e. everyone involved in the whole process, from the call to entry to the publications and exhibition. With this project, the outstanding efforts of the entire Prix Ars Electronica team have created a unique global network, and thus contributed decisively to establishing the festival internationally. For a festival it is a particular distinction when so many artists maintain ties with it over so many years. In the future, Ars Electronica will continue to address central topics from the fields of art, technology and society in accordance with what is relevant at a particular time in a particular field. The Prix Ars Electronica, which since 1987 has increasingly become a main focus of the global Ars Electronica network, will be integrated even more greatly into the festival in the future. Especially in the coming years when, alongside new media, biotechnology and nanotechnology come more to the fore, it will be a special challenge for Ars Electronica to find the right balance for exploring and programming topics in a manner appropriate to both the times and its themes, so as to achieve the competence required for the future.

In this process, the Prix Ars Electronica remains a constant and central invitation to artists to realize and present with creative intuition the themes pertinent to our extremely heterogeneous age in artistic projects.

Hannes Leopoldseder

Editorial
Christine Schöpf

The tools of the information nomads of the 21st century are wireless, mobile and ubiquitous. Enormous data packets are transported by ever more intricate data networks and with ever smaller and user-friendlier hardware and software. The development predicted by the vanguard in the hype of the 90s appears to be progressing unhindered.

In contrast to this are the disastrous worldwide downward trends affecting what were until recently booming model enterprises, as well as cautious investors and success stories that have fizzled out into nothing. Is the optimistic spirit of "going digital" becoming a "going-nowhere" mindset, full of resignation?

More than 20 years ago, that is, at a time when everything seemed possible in the world of digital media, Joseph Weizenbaum, one of the most celebrated visionaries and sceptics, commented that we must first know our desires if we are to develop the tools which we need to fulfil them. Any other course would inevitably wind up in a dead end.

Could it be that this is exactly where we have landed? Conceivably, yes, but not quite! For worldwide, entirely removed from the industrial mainstream, artists, scientists and experts from the most diverse branches are developing, exploring and designing. Adopting alternative positions, they question the medium itself and direct the current debate away from how it is, towards how it can and should be.

And since 1987 it is exactly for such individuals that the Prix Ars Electronica has been an annual invitation to present themselves and their works to audiences outside laboratories and studios. 2,500 media activists from 85 countries around the globe have responded to the invitation by submitting 2,714 entries in 2003—the 17th year of this cyberarts competition. They include professionals as well as children and young adults under the age of 19, the first generation to grow up with digital media on a broad scale.

From these entries, five juries of international experts have selected 79 works which display particular expertise and visionary force. As such they are being presented at the Ars Electronica Festival 2003 and, beyond this immediate event, in the documentary media available (book, DVD, CD).

Die Werkzeuge der Informationsnomaden des 21. Jahrhunderts sind wireless, mobil und allgegenwärtig. Über immer komplexere Datennetze werden mittels zunehmend kleinerer und benutzerfreundlicherer Hard- wie auch Software massive Datenpakete transportiert. Die im Hype der 90er-Jahre von Vordenkern prognostizierte Entwicklung geht scheinbar ungebremst weiter.

Dem gegenüber stehen weltweit ruinöse Talfahrten von noch vor kurzem boomenden Paradeunternehmungen, zurückhaltende Investoren und sich im Sand verlaufende Erfolgsstories. Wird aus dem opimistischen „Going Digital" eine resignative „Going Nowhere"-Haltung?

Vor mehr als 20 Jahren, also zu einer Zeit, in der in der Welt der digitalen Medien alles möglich schien, meinte einer der profiliertesten Visionäre und gleichzeitig Skeptiker Joseph Weizenbaum sinngemäß, dass wir erst unsere Wünsche kennen müssten, um jene Tools zu entwickeln, mit Hilfe derer wir diese verwirklichen können. Alles andere würde unweigerlich nur in Sackgassen führen.

Könnte es also sein, dass wir genau in einer solchen gelandet sind? Möglicherweise doch nicht ganz! Denn weltweit entwickeln, forschen und gestalten Künstler, Wissenschafter und Experten verschiedenster Branchen abseits vom industriellen Mainstream; sie nehmen alternative Positionen ein, hinterfragen das Medium an sich und leiten den aktuellen Diskurs von der Ist- auf eine Kann- und Soll-Ebene.

Und genau für Letztere ist der Prix Ars Elctronica seit 1987 die jährliche Einladung, sich mit ihren Arbeiten einer über Ateliers und Labors hinausgehenden Öffentlichkeit zu präsentieren.

2.500 Medienaktivisten aus 85 Ländern weltweit sind mit 2.714 Einreichungen 2003 – also im 17. Jahr des Bestehens dieses Wettbewerbs für Cyberarts – der Einladung gefolgt: Professionisten ebenso wie Kinder und Jugendliche unter 19, also jene Generation, die als erste flächendeckend mit den digitalen Medien aufgewachsen ist.

Fünf internationale Fachjurys haben aus diesen Einreichungen jene 79 ausgewählt, die sich durch besondere Expertise und Visionskraft auszeichnen und als solche beim Festival Ars Electronica 2003 sowie über den aktuellen Anlass hinaus in den vorliegenden Dokumentationsmedien (Buch, DVD, CD) präsentiert werden.

Insgesamt ist der Prix Ars Electronica in seiner Kontinuität seit 1987 und durch seine Einbettung in das Festival Ars Electronica zu einem dauerhaften Seismografen künstlerischer wie wissenschaftlicher Formulierungen innerhalb der stürmischen Entwicklung der digitalen Medien geworden und hat damit auch seinen kulturpolitischen Stellenwert etabliert.

Der Prix Ars Electronica 2003 in Zahlen und Fakten

Der Prix Ars Electronica wird vom Österreichischen Rundfunk (ORF-Oberösterreich) innerhalb des Festivals Ars Electronica in den Wettbewerbskategorien Interaktive Kunst, Digital Musics, Computeranimation / Visual Effects, NetVision / NetExcellence vergeben und fokussiert damit auf die Hauptbereiche gegenwärtiger digitaler Mediengestaltung.

Ergänzung dazu ist der Jugendwettbewerb „cybergeneration – u19 freestyle computing" als offene Plattform für junge Menschen unter 19.

Pro Wettbewerbskategorie werden eine Goldene Nica und zwei Auszeichnungen als Geldpreise vergeben sowie bis zu zwölf Anerkennungen ausgesprochen. Die Geldpreise im Prix Ars Electronica sind mit insgesamt Euro 100.000 dotiert (das sind fünf Mal Euro 10.000, zehn Mal Euro 5.000), die Preise des Jugendwettbewerbes „u19 freestyle computing" betragen insgesamt Euro 9.900 (ein Mal Euro 5.500, zwei Mal 2.200).

Förderung durch Wirtschaft und öffentliche Hand

Ermöglicht wird die Durchführung des Prix Ars Electronica mit Unterstützung von Sponsoren aus der Wirtschaft und Förderungen seitens der öffentlichen Hand. Stifter des Prix Ars Electronica ist die Telekom Austria, weiterer Sponsor ist die voestalpine AG.

Der Jugendbewerb u19 wird von der Österreichischen Postsparkasse unterstützt. Förderer der öffentlichen Hand sind die Stadt Linz und das Land Oberösterreich. Weitere Förderer sind Sony DADC, Casinos Austria, Pöstlingberg Schlössl, Gericom, Austrian Airlines, Lufthansa und Courtyard by Marriott.

Through its continuity since 1987 and its integration into the Ars Electronica Festival, the Prix Ars Electronica has become a continuous seismograph of artistic and scientific formulations in the turbulent developments of digital media. As a consequence it has come to enjoy great political and cultural standing.

Some facts and figures about the Prix Ars Electronica 2003

The Prix Ars Electronica is awarded by the Austrian Broadcasting Corporation (ORF-Upper Austria) within the scope of the Ars Electronica Festival in the following competition categories: Interactive Art, Digital Musics, Computer Animation/Visual Effects, NetVision and NetExcellence. Hence its focuses on the main fields of contemporary digital media art and design.

These categories are complemented by "cybergeneration – u19 freestyle computing", a competition with an open platform for young people under the age of 19.

In each category one Golden Nica und two Awards of Distinction are honoured with cash prizes; up to twelve Honorary Mentions are also awarded. The Prix Ars Electronica's cash prizes total 100,000 euro (five at 10,000 euro each, ten at 5,000 euro each); the cash prizes in the u19 freestyle computing competition for young people amount to 9,900 euro (one at 5,500 euro, two at 2,200 euro each).

Sponsored by commercial enterprises and public authorities

The Prix Ars Electronica has been made possible by support from commercial sponsors and subsidies from the government.

The main sponsors of the Prix Ars Electronica are Telekom Austria and voestalpine.

The u19 competition for young people has been supported by the Österreichischen Postsparkasse. Public funds are provided by the city of Linz and the federal province of Upper Austria.

Additional supporters include Sony DADC, Casinos Austria, Pöstlingberg Schlössl, Gericom, Austrian Airlines, Lufthansa and Courtyard by Marriott.

Christine Schöpf

Galvanizing the Engagement of Society
Communities und Social Software

Steve Rogers

It was fascinating to be on a jury with such breadth as the Net Vision / Net Excellence jury this year—with renowned digital artists, academics and highly regarded professionals from the commercial world. It was clear from the level of debate on the jury that our profession is maturing and growing, having left behind the baggage of the 2000 fall-out. We all had war stories and scars to compare but like our industry have moved on. This was reflected in the way that we tackled one of the hardest tasks we faced, the distinction and clarification of the two categories, Net Vision and Net Excellence.

We determined that for a project to win a Golden Nica in net excellence then it had to excel in every aspect. Visual and technical excellence were a pre-requisite of course, but also the concept behind it had to have been truly followed through, and it must clearly be the absolute best example of its field. We determined that a project did not have to be new this year as long as it continued to grow and change to maintain its relevance to its user group.

"Net Vision" is altogether different, this category is not necessarily about perfect execution, this category is about challenging the way we view the Net in order to move our thinking forward. In the very best cases, such as our Nica winner and two distinctions for this year, they move our thinking forward, not only within the network but they also challenge our thinking and perspective outside the Net.

Much of our discussion centred on the appropriateness of use of the medium; whether, for instance, it was right that the Net be used simply as a publishing medium, or whether to be worthy of inclusion it should make use of some of the other intrinsic qualities of the Net. Of course one of those intrinsic qualities is the opportunity to publish that it offers to everyone. Publishing on the Net enables the artist to enter into a direct

Es war faszinierend, Mitglied einer derart breit gefächerten Jury zu sein, wie sie die Kategorie Net Vision / Net Excellence des diesjährigen Prix Ars Electronica zu bieten hatte – mit renommierten digitalen Künstlern, Forschern und hoch angesehenen Profis aus der Wirtschaftswelt. Schon das Niveau der Diskussion in der Jury machte klar, dass unser Beruf reift und wächst und den Ballast der Jahrtausendwende abgeworfen hat. Wir hatten alle Geschichten von Kämpfen zu erzählen und ein paar Narben zu vergleichen, aber wie unser Fachbereich haben auch wir uns weiterentwickelt. Und dies spiegelte sich auch in der Art und Weise wider, in der wir eine unserer schwierigsten Aufgaben angingen – die Unterscheidung und Abgrenzung der beiden Kategorien „Net Vision" und „Net Excellence".

Wenn ein Projekt für die Goldene Nica der Kategorie „Net Excellence" in Frage kommen sollte, so musste es – nach den von uns festgelegten Kriterien – in jedem Aspekt herausragend sein. Natürlich waren visuelle und technische Brillanz eine Voraussetzung, aber auch das dahinterstehende Konzept musste vor allem konsequent durchgehalten sein, und das Werk sollte das absolut beste Beispiel seiner Art sein. Auch wurde festgelegt, dass ein Werk nicht unbedingt aus diesem Jahr stammen musste, wenn es sich nur offensichtlich weiterentwickelt und seine Bedeutung für die entsprechende Usergruppe ausgebaut hat.

„Net Vision" hingegen ist eine ganz andere Sache – hier ging es nicht notwendigerweise um perfekte Umsetzung, diese Kategorie beschäftigt sich damit, wie wir das Netz erfahren, um unser Denken voranzubringen. In den allerbesten Fällen – etwa beim diesjährigen Nica-Preisträger und den beiden Auszeichnungen – bedeutete das, unsere Denkweise zu verändern, und zwar nicht nur innerhalb des Netzwerks, sondern als Herausforderung auch an unser Denken und unsere Perspektiven außerhalb des Netzes.

Ein erheblicher Teil unserer Diskussionen drehte sich um Fragen der Angemessenheit des Mediums, etwa darum, ob es ausreicht, das Netz als Publikationsmedium zu verwenden, oder ob für eine Anerkennung

eine weitergehende Einbindung der anderen intrinsischen Qualitäten des Netzes erforderlich ist. Natürlich ist auch die jedem dargebotene Möglichkeit, im Netz etwas zu publizieren, eine der netztypischen Eigenschaften. Die Veröffentlichung im Netz erlaubt es dem Künstler, in einen direkten Dialog einzutreten und anderen die Möglichkeit zu bieten, zum Werk etwas beizutragen, es zu adaptieren und zu erweitern, oder alternativ jedem eine einzigartige und vergängliche Erfahrung zur Verfügung zu stellen. Wir haben ausgiebig über User-generierte Inhalte und über das generelle Wachstum von Social Software und Communities gesprochen. Communities und Social Software waren tatsächlich eines unserer diesjährigen Hauptthemen, und die Möglichkeit, das Netz sozusagen zur Galvanisierung eines gesellschaftlichen Engagements einzusetzen, wird von beiden Goldenen Nicas dieses Jahr reflektiert. Echte Social Software erlaubt den Schöpfern, eine gleichberechtigte Beziehung mit ihren Beiträgern einzugehen, sodass die Grenzen zwischen diesen beiden Gruppen immer mehr verblassen. Dies verleiht den entstehenden Gemeinschaften sowohl Lebendigkeit wie Langlebigkeit und erlaubt ihnen auch, eine Relevanz in der physischen Welt zu erlangen. Letztlich haben wir auch die wachsende Bedeutung berücksichtigt, die die Open-Source-Bewegung für unser aller Leben erlangt. Viele der dieses Jahr eingereichten Arbeiten beschäftigen sich mit der Demokratisierung des Entwicklungsprozesses und der Neuformulierung der Frage nach geistigem Eigentum.

Goldene Nica / Net Vision
Carlos J. Gomez de Llarena / Yury Gitman: Noderunner
www.noderunner.com
Unser Preisträger der Goldenen Nica in „Net Vision" vereint viele der oben angesprochenen Gedankenfäden. Dank einer starken Community, die mithilft, die Art unserer Kommunikation mit dem Netz zu verändern, verschmilzt dieses Projekt den physischen Raum mit dem Netz. Die Site selbst dokumentiert ein Ereignis,

dialogue and to offer others the chance to adapt, contribute to and grow the work, alternatively to offer everyone a unique and transitory experience. We talked at length about the use of user generated content and the growth in general of social software and communities. Communities and social software were key themes for us this year and the possibility to use the Net to galvanise the engagement of society is seen in both of the Golden Nicas. True social software allows the creators to enter a peer relationship with their contributors so that the boundaries between them fade. This gives communities both vibrancy and longevity; it also allows these communities to have relevance in the physical world. Finally we looked at the increasing importance of the Open Source movements to all our lives. The democratisation of the development process and the reinvention of the issue of intellectual property is being explored and celebrated by many entrants this year.

Golden Nica / Net Vision
Carlos J. Gomez de Llarena / Yury Gitman: Noderunner
www.noderunner.com
Our selection for a Golden Nica in Net Vision brings many of the threads outlined above together. It melds physical and Net space through a strong community who are helping to change the way we interact with the network. The site itself documents an event in NYC in a style that parodies TV game shows and reflects on early computer games. The reason that we gave this project a Golden Nica however, is that it represents a movement to re-democratise the Internet, and does it in a way that is accessible. Through Noderunner the team has demonstrated a way of working and interacting that is first possible due to the proliferation of WiFi networks in cities such as New York.

Distinction / Net Vision
David Crawford: Stop Motion Studies
www.lightofspeed.com
We were all enthralled by *Stop Motion Studies*: this project uses the power of the network to allow users to create wonderful juxtapositions of people on subways, which enable us to see just how much we all express as we go about our daily lives. It turns the limitations of bandwidth into an advantage by looping a number of still images to capture a moment rather than attempting to stream video. Through this the essence of each expression is captured and displayed. As a user you can either browse through the subways of the world almost hypnotically or bring four together to create your own story with limitless variation.

Distinction / Net Vision
Golan Levin: The Secret Lives of Numbers
www.turbulence.org/works/nums/
Through *The Secret Lives of Numbers*, Levin Golan encourages us to re-examine the relationship of primacy between words and numbers; in almost every aspect of life we use words to describe, locate, and classify things. Here we look at the world purely through the language of numbers, now possible because of the vast amount of data available to the Net. Previously the use of numbers was limited to distinct fields; postcodes, telephone numbers, or grid references, whereas words were used to define the fields or domains of knowledge and therefore allowed them to be used together. Here we see how our world looks once we start to see things through this different axis. The way that the information is presented is truly excellent, with the possibility to focus in on vast fields of data to see the significance of individual integers in a way that is fascinating and accessible to everyone.

Golden Nica / Net Excellence
Sulake Labs: Habbo Hotel
www.habbohotel.com
There are very few projects which have maintained their relevance in the way that *Habbo Hotel* has done. It has become such a strong part of the lives of its members that the community of Habbo starts to blur with the real community. This project more than any other showed us why it is starting to become necessary to see projects with a longer perspective. Both technically and visually *Habbo Hotel* continues to excel and grow as an environment which is both safe and cool for children to enjoy.

das in New York stattgefunden hat, in einem Stil, der durchaus TV-Game-Shows parodiert und Erinnerungen an frühe Computerspiele wachruft. Der Hauptgrund für die Zuerkennung der Goldenen Nica an dieses Projekt ist jedoch, dass es eine Bewegung zur Re-Demokratisierung des Internet darstellt, und dies auf eine sehr eingängliche Weise. Mit *Noder Runner* hat das Team um Carlos J. Gomez und Yury Gitman einen Arbeits- und Interaktionsweg aufgezeigt, der erst durch die stark anwachsende Verbreitung von WiFi-Networks in Städten wie New York möglich wird.

Auszeichnung / Net Vision
David Crawford: Stop Motion Studies
www.lightofspeed.com
Stop Motion Studies hat uns in seinen Bann geschlagen. Dieses Projekt verwendet die Leistungsfähigkeit des Netzwerks, um den Anwendern zu ermöglichen, wunderbare Gegenüberstellungen von Menschen in U-Bahnen zu schaffen, die uns vor Augen führen, wie viel wir alle bei unseren alltäglichen Handlungen von unserem Inneren zum Ausdruck bringen. Crawford verwandelt auch die Bandbreiten-Beschränkungen in einen Vorzug: Er verwendet eine gewisse Anzahl von geloopten Standbildern, um einen Augenblick wiederzugeben, anstatt einen Video-Stream zu versuchen. So wird die Essenz eines jeden Ausdrucks eingefangen und dargestellt. Als User kann man entweder fast hypnotisch durch die U-Bahnen der Welt browsen oder jeweils vier Aufnahmen kombinieren, um damit eine eigene Geschichte mit grenzenlosen Variationen zu erstellen.

Auszeichnung / Net Vision
Golan Levin: The Secret Lives of Numbers
www.turbulence.org/works/nums/
In *The Secret Lives of Numbers* lädt uns Golan Levin ein, die Frage nach dem Primat von Zahl und Wort neu zu untersuchen. In fast allen Aspekten des Lebens verwenden wir Wörter, um Dinge zu beschreiben, zu lokalisieren und zu klassifizieren. Hier aber betrachten wir die Welt durch die Sprache der Zahlen, was nur durch die enorme Menge von Daten im Netz möglich wird. Früher war der Einsatz von Zahlen auf ganz bestimmte Bereiche begrenzt – Postleitzahlen, Telefonnummern, geografische Koordinaten –, während Worte die Felder oder Bereiche des Wissens definierten und so erlaubten, diese gemeinsam zu verwenden. Hier sehen wir, wie unsere Welt aussieht, wenn wir die Dinge entlang dieser anderen Achse ansehen. Wie die Information präsentiert wird, ist wirklich hervorragend und bietet die Möglichkeit, enorme Datenfelder fokussiert zu betrachten, um die Signifikanz einzelner ganzer Zahlen zu erfassen, und das auf eine Weise, die für jedermann zugänglich und faszinierend ist.

Goldene Nica / Net Excellence
Sulake Labs: Habbo Hotel
www.habbohotel.com

Es gibt wenige Projekte, die ihre Relevanz auf solche Weise aufrecht erhalten haben wie *Habbo Hotel*. Es ist zu einem derart bestimmenden Teil des Lebens seiner Mitglieder geworden, dass die Habbo-Community langsam mit der wirklichen Gemeinschaft zu verwachsen und verschmelzen beginnt. Mehr als irgendein anderes Projekt hat uns *Habbo Hotel* vor Augen geführt, warum es inzwischen wichtig ist, Projekte unter einer längerfristigen Perspektive zu betrachten. Technisch wie visuell ist *Habbo Hotel* weiterhin herausragend und wächst als ein Environment weiter, das für Kinder ebenso sicher wie erlebnisreich und cool ist.

Vor allem das ständige Wachstum und die Weiterentwicklung ist Grund für die diesjährige Auszeichnung, und hier sind wieder zwei Aspekte besonders relevant: Die Einführung des „Yellow Bus" für die Community, der dem System der Gelben Busse nachempfunden ist, die vor den Schulen parken und Kindern erlauben, bei Beratern Unterstützung in Sachen Drogen oder Sex zu holen. Bei *Habbo Hotel* parkt ein gelber Bus mit einem Team von echten Beratern vor dem Hotel, und schnell bildet sich eine ordentliche Warteschlange von Kindern, die von dem Angebot, in einer sicheren, anonymen Umgebung Rat zu holen, Gebrauch machen. Außerdem wollten wir damit anerkennen, dass das Projekt in der Lage ist, sich an neue Umgebungen und Kulturen anzupassen: Dieses Jahr ist es z. B. in Japan mit anhaltendem Erfolg eingeführt worden.

Auszeichnung / Net Excellence
James Tindall: Boards of Canada Website
www.boardsofcanada.com

Wunderbar, hier gibt es ein Irgendwo, das man durchwandern und in dem man sich verlaufen kann – oder wo man sich auch nur zurücklehnen und betrachten kann. Die Arbeit von James Tindall kombiniert ein großartiges 3D-Environment mit der Musik von Boards of Canada. Dank der speziellen Navigation durch das Environment kann jeder mit der Musik interagieren, was bedeutet, dass jede Reise eines jeden Besuchers einzigartig ist. Besonders erfrischend ist, dass zwei doch prominente Musikkünstler es dem Publikum anheimstellen, was und wie man es zu hören bekommt, und nicht die Hörerfahrung selbst steuert. Hier funktioniert der Einsatz des Netzwerks als Publikationsumgebung hervorragend und bietet den Künstlern die Möglichkeit, auf einen Schlag eine unendliche Anzahl von Darbietungen zu veröffentlichen.

Its continued growth and development is what we are recognising this year, particularly two aspects thereof. Firstly the introduction of "the yellow bus" to the community, which echoes the real life yellow bus scheme, where a bus parks outside schools to allow children to visit councillors to discuss their worries over topics such as drugs or sex. In Habbo a yellow bus parks outside the hotel with a real team of councillors. When there, an orderly line forms for the children to take advantage of the opportunity in safety and relative anonymity. Secondly we recognise that it is able to adapt to new environments and cultures, having opened this year in Japan with ongoing success.

Distinction / Net Excellence
James Tindall: Boards of Canada Website
www.boardsofcanada.com

Wonderful, here is somewhere that you can both wander and become lost or sit back and spectate. The work of James Tindall combines a fabulous 3D environment with the music of *Boards of Canada*. The way you navigate through the environment allows you to interact with music meaning that each journey for each user is unique. What is really refreshing is the way that two major recording artists are enabling each user to change the way they are heard rather than the artists controlling the experience. Here the use of the network as a publishing medium works magnificently, allowing the artist to publish once to an infinite number of executions.

Distinction / Net Excellence
Lia: re:move
www.re-move.org

Many artists have explored the world of shockwave to create exciting and intoxicating images. Lia, through *re:move*, has presented us with the most compelling and professional of these. Each of the ten works presented through *re:move* is worthy of note in itself but the bringing together of this body of work is truly impressive. What sets this apart, however, is that not only does Lia present us with the tools to create stunning works, but she also shows us her vision for the work and her achievements through the portfolio which accompanies every part of the site. This is truly the very best example of this field of exploration.

As a jury we decided not to distinguish between Net Excellence and Net Vision for those projects we chose to give an honourable mention. We were impressed by the high standard of all entries but the following projects merit particular mention.

Christophe Bruno: The Google Adwords Happening

www.iterature.com/adwords

Christophe Bruno used the advent of commercially available keywords on Google to create a poetry event. Although it was unfortunately short-lived as Google decided to close the project, it was a truly inspired project: it brought poetry by serendipity to at least 12,000 people.

ubermorgen: Injunction Generator

www.ipnic.com

The *Injunction Generator* demonstrates the international nature of the network and exposes the difficulty of one nation trying to regulate it. This project allows anyone to create an injunction document that has no more or less validity than one from a foreign nation. Impressive is both the simplicity and extremely convincing nature of the result.

LAN: SuPerVillainizer—Conspiracy Client

www.supervillainizer.ch

This project shows the difficulty in attempting to watch and control email traffic, akin to trying to tap all telephone conversations continually. *SuPerVillainizer* introduces "noise" into the system by allowing software agents to create dialogues and conspiracies between fictitious characters. It also allows you to watch the conspiracies that ensue with often very comical results.

Agathe Jacquillat / Tomi Vollauschek: Bzzzpeek.com

www.bzzzpeek.com

Agathe Jacquillat has created a project which is both fascinating and engaging whilst being educational. It makes use of the international nature of the Internet, the ease of introducing user-generated content and the commonality of sounds. It compares in a charming and inviting way the differences in children's sounds between cultures for a number of everyday things.

Amit Pitaru / James Paterson: InsertSilence

www.insertsilence.com

This work produces a beautiful fluid animation born out of the technique of creation during real time. This approach allows the artist to play the visual media in the same way that a musician plays music. The result is a stunning combination of the two where both are created simultaneously.

Auszeichnung / Net Excellence
Lia: re:move

www.re-move.org

Viele Künstler haben die Welt von Shockwave erforscht, um aufregende und berauschende Bilder zu schaffen. Lia hat uns mit *re:move* die fesselndste und professionellste davon geschenkt. Jedes der in *re:move* präsentierten zehn Werke wäre schon allein bemerkenswert, aber die Kombination dieses Gesamtwerks ist wahrhaft beeindruckend. Was dieses Gesamtwerk aber vor allem auszeichnet, ist, dass uns Lia nicht nur die Werkzeuge bietet, mit denen man selbst faszinierende Arbeiten erstellen kann, sondern auch ihre Vision hinter den Arbeiten zeigt und ihre Erfahrungen in einem Portfolio präsentiert, das jeden Teil der Site begleitet. Dies ist ohne Zweifel das allerbeste Beispiel dieses künstlerischen Untersuchungsbereiches.

Bei der Vergabe von Anerkennungen haben wir beschlossen, nicht zwischen „Net Excellence" und „Net Vision" zu unterscheiden. Wir waren vom hohen Standard aller Werke beeindruckt, aber die folgenden verdienen besondere Anerkennung:

Christophe Bruno: The Google Adwords Happening

www.iterature.com/adwords

Christophe Bruno hat die von der Suchmaschine Google bereitgestellten kommerziell nutzbaren Schlüsselbegriffe verwendet, um ein Poesie-Event zu schaffen. Auch wenn das Projekt leider sehr kurzlebig war, weil Google es schnell abgestellt hat, war es wirklich genial – immerhin brachte es durch Zufälligkeit generierte Poesie an mindestens 12.000 Leute …

ubermorgen: Injunction Generator

www.ipnic.com

Injunction Generator zeigt die Internationalität des Netzwerks auf und damit auch die Schwierigkeiten, die sich ergeben, wenn eine Nation versucht, es zu regulieren. Das Projekt erlaubt jedermann, eine Einstweilige Verfügung zu erzeugen, die genauso viel oder wenig rechtliche Wirksamkeit hat wie eine solche eines ausländischen Gerichts. Beeindruckend ist vor allem die Einfachheit und die extrem überzeugende Form des Ergebnisses.

LAN: SuPerVillainizer – Conspiracy Client

www.supervillainizer.ch

Dieses Projekt zeigt, welche Schwierigkeiten beim Versuch auftreten, den E-Mail-Verkehr analog zu einer ständigen Überwachung aller Telephongespräche zu überwachen und zu steuern. *SuPerVillainizer* führt „Nebengeräusche" in das System ein, indem es Software-Agents erlaubt, Dialoge und Verschwörungen zwischen fiktiven Charakteren zu generieren. Auch ermöglicht es, die Verschwörungen weiter zu beobachten, was häufig zu äußerst komischen Ergebnissen führt.

Agathe Jacquillat / Tomi Vollauschek: Bzzzpeek.com

www.bzzzpeek.com

Agathe Jacquillats und Tomi Vollauscheks Projekt ist sowohl faszinierend als auch unterhaltend – und nebenbei auch noch informativ. Es setzt die Internationalität des Internet ein und macht sich die Tatsache zu Nutze, dass User sehr einfach selbst generierten Inhalt ins Netz stellen können, und macht die Ubiquität von Klängen bewusst. Es vergleicht auf charmante und einladende Weise die in unterschiedlichen Kulturen unterschiedlichen Kindergeräusche für eine Anzahl von Dingen des Alltags.

Amit Pitaru / James Paterson: InsertSilence

www.insertsilence.com

Diese Arbeit produziert dank einer Echtzeit-Technik eine wunderbar fließende Animation. Der Ansatz erlaubt es den Künstlern, das visuelle Medium ähnlich zu „spielen", wie ein Musiker eben Musik spielt. Das Ergebnis: Eine fesselnde Kombination aus beidem – und noch dazu gleichzeitig erzeugt.

Axel Heide, onesandzeros, Philip Pocock, Gregor Stehle: Unmovie

www.unmovie.net

Das *Unmovie* Team bietet sowohl einen Kontext als auch ein Motiv, sich mit Poesie zu beschäftigen. Die User betreten sozusagen einen Fluss aus Gedichten, die teilweise von den Mitwirkenden, teilweise von Bots erzeugt werden, die ständig den Raum bewohnen. Das Ergebnis ist großartig – es nimmt das Konzept von Chat und Community als Kommunikation auf und bildet damit den Kontext, innerhalb dessen ein gemeinschaftliches Werk geschaffen werden kann.

Antoni Abad: Z

http://zexe.net

Antoni Abad geht von der menschlichen Eigenschaft aus, sich um ein „Haustier" anzunehmen, und baut daraus ein extrem ungewöhnliches und organisches Netzwerk auf. Dass als Symbol und Verkörperung des Netzwerks eine Fliege verwendet wird, macht das Projekt nur noch interessanter. Es liefert eine sehr originelle Gedankenstruktur, die durch hervorragende Umsetzung unterstützt wird. Besonders bemerkenswert ist, dass man auch die Gesamtaktivität des Netzwerks beobachten kann, die sehr deutlich – wenn auch nicht ausschließlich – dem Tageslicht um die Welt folgt.

Wiggle / Han Hoogerbrugge: Flow

www.unsound.com/flow

Flow ist eine hypnotische Erfahrung, die oberflächlich extrem simpel erscheint, aber dennoch mitreißt und fasziniert. Han Hoogerbrugge und Wiggle haben eine Animationsform geschaffen, die einen simplen

Axel Heide, onesandzeros, Philip Pocock, Gregor Stehle: Unmovie

www.unmovie.net

The *Unmovie* team provides context and motive to engage in poetry. Users enter into the stream of poetry, which is created partly by the participants and partly by the bots that permanently inhabit the space: the result is splendid. It takes the concept of chat and community as communication and effectively allows it to become the context for creating a joint work of art.

Antoni Abad: Z

http://zexe.net

Antoni Abad builds on human nature to care for a "pet" to create an extremely unusual and organic network. That the instantiation of the network is a fly makes it intriguing. It shows a very original train of thought that is supported by excellent execution. Of particular note is the possibility to see the global level of activity of the network, clearly although not exclusively following daytime around the world.

Wiggle / Han Hoogerbrugge: Flow

www.unsound.com/flow

Flow is a hypnotic experience which although it is superficially extremely simple, it engages and intrigues. Wiggle and Han Hoogerbrugge have created a form of animation which has a simple mode of interaction for a very rich experience. The image of a man in an infinite elevator is compelling and disturbing in equal measure

LeCielestbleu: PuppetTool

www.lecielestbleu.com/puppettool

The very best projects are often those which do one thing extremely well; such is the case here. *Puppet Tool* does not attempt to create faultless models, but to create faultless motion for its simple models; the result is fluid, and fascinating. Being able to see the work of other users as well helps to build the value and community of the site.

Jared Tarbell / Lola Brine: Levitated

www.levitated.net

Jared Tarbell has created an excellent open source graphic work that has incredible breadth. The project clearly shows the wealth of work done which is then offered as a rich open source palette to work from. The quality of the experience and interaction is as high as the quality of the work making for a very complete and fulfilling work.

Last.fm: The Last Online Music Station
http://Last.fm
Both the rise of communities on the Net as well as the growth of music sharing have been dominant forces in the industry for some time. *Last.fm* brings both of these together in an extremely compelling well-executed work. It uses the context of music and musical taste to create vibrant communities.

LAN: TraceNoizer
www.tracenoizer.org
We have all put our names into Google to see what exists about us on the network. We don't always want to be so easy to find, so *TraceNoizer* allows us to create an alter ego, which although resembling us will be completely fictitious. The result is a site which can then be hosted and which combines much of the real information found about us with real information found out about people with similar names to ourselves. What makes this so compelling is the quality and credibility of the resulting site.

OSDN: SourceForge.net
http://sourceforge.net
Open Source is changing the way that the economy works: it demands that we rethink the way intellectual capital is handled. *SourceForge* is the pre-eminent company in the domain. As a company they have embraced and enabled the Open Source movement, which puts them into a peer relationship with their customers. This, more than any other recent event, changes the way we all work and develop our products.

Shinya Yamamoto: Sinplex Show
www.sinplex.com
Shinya Yamamoto explores the world of silent imagery in a stark but exquisite work. Through choosing to exclude sound the impact of the visual is even stronger. The intriguing manner of interaction through "catching falling droplets" encourages repeated exploration and experience.

Interaktionsmodus für ein reichhaltiges Erlebnis bereitstellt. Das Bild eines Mannes in einem unendlich hohen Aufzug ist zugleich fesselnd und beunruhigend.

LeCielestbleu: PuppetTool
www.lecielestbleu.com/puppettool
Die allerbesten Projekte sind jene, die nur eine Sache extrem gut umsetzen, und genau das ist hier der Fall. *PuppetTool* versucht nicht, fehlerfreie Modelle zu produzieren, wohl aber seinen simplen Modellen fehlerfreie Bewegung zu geben – und das Produkt ist flüssig und faszinierend. Dass man die Arbeit anderer User ebenfalls sehen kann, hilft, den Wert und die Gemeinschaft der Site aufzubauen.

Jared Tarbell / Lola Brine: Levitated
www.levitated.net
Jared Tarbell hat eine hervorragende Open-Source-Grafikarbeit geschaffen, die eine schier unglaubliche Bandbreite aufweist. Das Projekt umfasst eine Fülle an bereits abgeschlossenen Arbeiten, die hier als reichhaltige Open-Source-Palette zur Weiterbe- und -verarbeitung angeboten werden. Die Qualität der Erfahrung und Interaktion ist ebenso hoch wie die Qualität der Arbeit, was insgesamt ein sehr komplettes und erfüllendes Werk schafft.

Last.fm: The Last Online Music Station
http://Last.fm
Die Entstehung von Communities und das Anwachsen des Musiksharings waren dominante Faktoren für die Industrie der letzten Jahre. Last.fm bringt beide Faktoren in einem extrem fesselnden und gut ausgeführten Projekt zusammen. Es verwendet den Kontext von Musik und Musikgeschmack, um höchst lebendige Communities zu schaffen.

LAN: TraceNoizer
www.tracenoizer.org
Wir haben alle unsere Namen durch Google gejagt, um herauszufinden, was über uns im Netz so alles existiert. Aber wir wollen auch nicht immer so leicht aufzufinden sein, deswegen erlaubt uns *TraceNoizer*, ein Alter Ego

zu schaffen, das uns zwar ähnelt, aber völlig fiktiv ist. Das Ergebnis ist eine Site, die dann gehostet werden kann und viel von der realen Information über uns mit realer Information über Menschen mit ähnlichem Namen wie dem unseren kombiniert. Was diese Site so bestechend macht, ist die Qualität und die Glaubhaftigkeit des Ergebnisses.

OSDN: SourceForge.net

http://sourceforge.net

Open Source verändert die Funktionsweise der Wirtschaft – diese Bewegung verlangt, dass wir die Art und Weise, in der intellektuelles Kapital behandelt wird, überdenken, und SourceForge ist die in diesem Bereich führende Organisation. Als Unternehmen hat sich Sourceforge der Open-Source-Bewegung verschrieben, was es mit seiner Kundschaft auf eine gleichberechtigte Ebene stellt. Dies wird mehr als jedes andere Ereignis unsere Arbeitsweise und die Entwicklung unserer Produkte verändern.

Shinya Yamamoto: Sinplex Show

www.sinplex.com

Shinya Yamamoto erforscht die Welt der stillen Bilder in einer etwas schlichten, aber dennoch exquisiten Arbeit. Durch den bewussten Verzicht auf Sound wird der Eindruck der Bildwelt sogar noch verstärkt. Die faszinierende Interaktionsweise durch das „Einfangen fallender Droplets" lädt zu wiederholter Erforschung und Erfahrung ein.

Noderunner

Yury Gitman / Carlos J. Gomez de Llarena

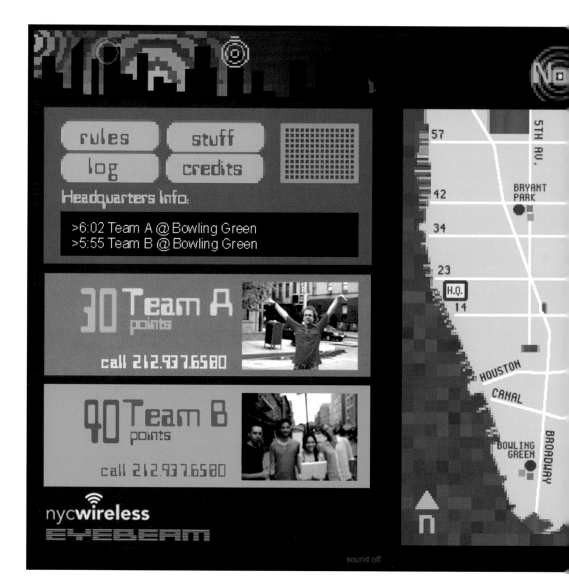

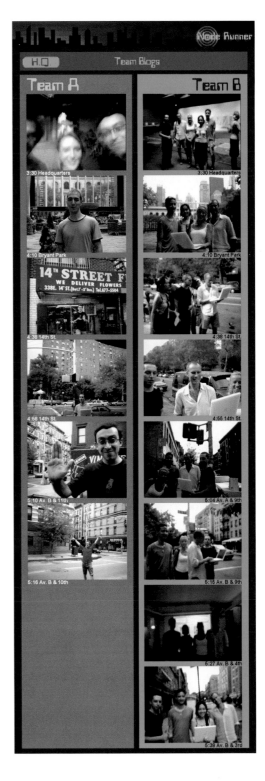

Noderunner is a game that transforms a city into a playing field. Two teams race against time to access as many wireless Internet nodes as possible. To prove that they have successfully connected to an open node, each team must submit photographic proof to the Noderunner weblog. During game play, the weblog becomes a busy scoreboard tracking the competing teams in real time. After the game, the photos provide visual documentation of the path taken by each team and public spaces that have free wireless connectivity.

Each four-person team was given a WiFi-enabled laptop, a digital camera, taxi fare, and two hours to get from Bryant Park in midtown to Bowling Green in Lower Manhattan, both free wireless parks. Teams earned points by taking their portraits in the exact spots where they were able to connect to wireless access points. They also earned points by using scanning software to sniff all the nodes along the way, even those that were password protected or too weak to transfer pictures. The teams collected logs recording hundreds of closed or weak nodes, but scored more points when they were actually able to use a node to upload a picture.

The simple rule set forced players to develop strategies for planning the most rewarding routes within the city. For example, the East Village was a popular route destination because it offered a large number of open nodes. Participants also needed technical savvy to troubleshoot connection problems and upload pictures despite fragile signal. Spending too much time on a weak node could have been the difference between winning and losing, so teams moved quickly through the city with a combination of running on foot and riding by taxi. An additional link was established between the teams and a central 'headquarters' location where the progress of the competitors was plotted on an 80-foot map of Manhattan and where photographs taken by the teams were projected on a large screen. Urban photography gave spectators a new appreciation of the city's open nodes, and the winning team popped champagne in celebration.

Noderunner's playing field is the available WiFi spillover in a densely populated area. The density of this spillover is so great that it can be used as a legitimate wireless network. For example, in

Noderunner ist ein Spiel, das eine Stadt in ein Spielfeld verwandelt. Im Kampf gegen die Uhr bemühen sich zwei Teams, Zugang zu möglichst vielen Knotenpunkten kabelloser Netzwerke zu bekommen. Als Nachweis für eine erfolgreiche Verbindung mit einem offenen Knoten muss jedes Team einen fotografischen Beweis an das Noderunner-Weblog übermitteln. Bei laufendem Spiel wird das Weblog zu einer lebendigen Anzeigetafel, die die Fortschritte der miteinander wetteifernden Mannschaften in Echtzeit verfolgt. Nach dem Spiel stellen die Fotos eine visuelle Dokumentation der von den Teams gewählten Routen sowie der öffentlichen Räume dar, in denen es offene Wireless-Verbindungen gibt.

Jedes Team aus vier Personen erhielt einen mit WiFi ausgestatteten Laptop, eine Digitalkamera, Geld für Taxispesen und zwei Stunden Zeit, um von Bryant Park im Stadtzentrum nach Bowling Green in Manhattan – beides freie Wireless-Parks – zu gelangen. Punkte bekamen die Teams für jedes Selbstportrait, das sie dort aufnehmen, wo ihnen der Zugriff auf einen Hot Spot in ein kabelloses Netzwerk gelungen ist. Weitere Punkte gab es, wenn die Teams Scan-Software einsetzten, um alle Knoten auf ihrem Weg aufzuspüren, auch wenn diese durch Passwörter geschützt oder zu schwach waren, um Fotos zu übertragen. Die Logs der Teams zeichneten Hunderte von geschützten oder schwachen Knoten auf, aber mehr Punkte wurden erzielt, wenn es tatsächlich gelang, so einen Knoten für den Upload von Bildern zu benutzen.

Die an sich einfachen Regeln zwangen die Spieler, Strategien zur Planung der einträglichsten Routen durch die Stadt zu entwickeln. So war zum Beispiel East Village ein beliebtes Zwischenziel, weil dort eine Vielzahl offener Knoten zu finden ist. Die Mitspieler benötigten auch technische Kenntnisse, um Verbindungsprobleme zu lösen und Bilder trotz schlechter Signalqualität der Verbindungen zu senden. Zu viel Zeit mit einem schwachen Knoten zu verschwenden konnte bedeuten, das Spiel zu verlieren, deshalb bewegten sich die Teams möglichst schnell zu Fuß oder per Taxi durch die Stadt. Ein zusätzlicher Link bestand zwischen den Teams und dem „Hauptquartier", wo der Fortschritt der Spieler auf einem 80 Fuß großen Plan von Manhattan nachgezeichnet und die geschossenen Fotos auf eine Großleinwand projiziert wurden. Diese Stadtfotografie vermittelte den Besuchern einen Eindruck von den offenen Netz-Knoten der Stadt, und das Siegerteam feierte ausgiebig mit Champagner.

Das Spielfeld von Noderunner ist das Spill-Over der kabellosen Netzwerke in einem dicht bevölkerten Gebiet.

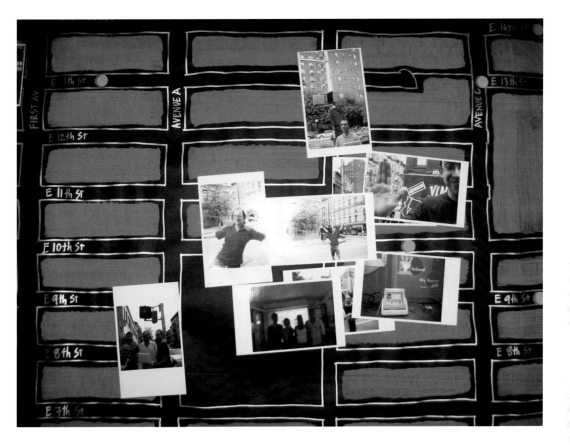

Die Dichte dieses Spill-Over ist so groß, dass er sich selbst als kabelloses Netzwerk gebrauchen lässt. In New York etwa ist es inzwischen einfacher, einen offenen, kostenlosen 802.11-Hotspot zu finden als ein öffentliches WC. New Yorker, die über einen mit WiFi ausgestatteten Laptop verfügen, gewöhnen sich schon daran, über offene Zugangspunkte zu stolpern, die von ihren Nachbarn, von öffentlichen Parks, Cafés oder Bars und nicht nur von ihren Arbeitsplätzen zur Verfügung gestellt werden. Nie zuvor haben diese vielbesuchten kulturellen Brennpunkte eine derart unmittelbare Anbindung ans Internet erlebt, und genauso war das Internet bisher noch nie so nahtlos in die tatsächliche Architektur und Sozialstruktur der Stadt eingebunden.

Noderunner-Sessions machen die Überschneidungen zwischen Information und städtischer Umwelt sichtbar und fördern die Verwendung von öffentlichen Orten für kreative Zwecke. In dem Maße, in dem kabellose

New York City it is now easier to find an open and free 802.11 hotspot than it is to find a public restroom. New Yorkers with WiFi enabled laptops are becoming accustomed to stumbling on open access points made available by their neighbors, pubic parks, cafes, bars, and not just their work places. These well-traveled cultural spots have never before experienced Internet connectivity, nor has the Internet ever enjoyed such seamless integration into a city's actual architecture and social fabric.

Noderunner sessions highlight overlaps between information and the urban environment, encouraging the use of public spaces for creative endeavors. As wireless access becomes more prevalent in our cities, this paradigm offers new opportunities for applications that treat public space as an interface. This work draws on spatially

based games like tag, scavenger hunts, and hide-and-go-seek, as well as graffiti art, skateboarding, and urban bicycling that characterize cities like New York. Recently, new technologies have expanded the scope of these activities, spawning a diverse community of artists, entrepreneurs and activists developing location-based models for social movements, advertising, urban services and pervasive gaming. Instead of making our video games look more realistic, we now have the ability to turn our reality into a video game, a city's infrastructure into a play space. Our cities are becoming game engines and software, as citizens collectively program, code, and update the place where they live.

This diverse collective action means that even in the same city, like New York, *Noderunner*'s playing field is in constant flux as WiFi continues to proliferate. At first glance this would appear to make *Noderunner* easier but as WiFi spreads, new legislation, use patterns, and technologies emerge. Will new security measures limit open access despite an increase in nodes and improvements in transmission distance? Played over time, *Noderunner* games help answer these questions by providing empirical data about our culture's adoption of wireless technology. *Noderunner* is in itself an exemplar of an emerging culture. A culture where smart and wireless environments are as much an object of play as a grass field or an open lake.

The open wireless movement is being built by the end-users, one node at a time. Drawing on the original spirit of the Internet, WiFi enthusiasts embrace open standards, peer-to-peer dynamics, and user-centered innovation. As artists, we combined game design with the existing culture of the open wireless movement. Instead of creating an artificial game environment, we tapped into the revolution that was already happening around us. Our goal was not just to contribute to a new genre of public art, but also to actively engage the general public in a vital cultural and technological transformation. *Noderunner* is continually reinvented by the citizens who build the network and run the streets. The game is an entrance point to the political and social movements behind wireless. We offer *Noderunner* as celebration of free and open wireless connectivity and as a symbol of the city's cultural flexibility and potency.

Netzwerk-Zugänge in unseren Städten häufiger werden, bietet dieses Paradigma neue Möglichkeiten für Anwendungen, die den öffentlichen Raum als Interface behandeln. *Noderunner* selbst hat natürlich seine Wurzeln in raumbezogenen Spiele wie Schnitzeljagden und Versteckspielen, aber auch in der Graffitikunst, im Skateboardfahren und im Radfahren, das für Städte wie New York charakteristisch ist. In jüngster Zeit haben die neuen Technologien die Bandbreite solcher Aktivitäten wesentlich erweitert und schließen so unterschiedliche Akteure wie Künstler, Unternehmer und Aktivisten in eine Community zusammen, die ortsbezogene Modelle für soziale Bewegungen, Werbung, städtische Dienstleistungen und umfassende Spiele entwickelt. Anstatt unsere Videospiele realistischer aussehen zu lassen, haben wir jetzt die Möglichkeit, unsere Wirklichkeit in ein Videospiel und die Infrastruktur einer Stadt in ein Spielfeld zu verwandeln. Unsere Städte werden dadurch kollektiv, dass die Stadtbewohner den Ort, an dem sie leben, kollektiv programmieren, codieren und updaten.

Diese so breitgefächerte kollektive Aktion bedeutet, dass auch in ein und derselben Stadt – etwa in New York – das Spielfeld von *Noderunner* in stetem Fluss ist, während sich WiFi weiter ausbreitet. Auf den ersten Blick scheint es, als würde dies *Noderunner* einfacher machen, aber mit der Verbreitung kabelloser Netze verändern sich auch Gesetzgebung, Anwendungsmuster und Technologie. Werden neue Sicherheitsmaßnahmen trotz der ständig wachsenden Zahl von Knoten und der Verbesserung der Übertragungsreichweite den freien Zugang einschränken? Über längere Zeiträume durchgeführt, helfen *Noderunner*-Spiele bei der Beantwortung dieser Fragen, da sie empirische Daten über die Akzeptanz der kabellosen Technologien in unserer Gesellschaft liefern. *Noderunner* selbst ist ein Beispiel für eine entstehende Kultur, eine Kultur, in der intelligente kabellosen Environments ebenso ein Spielobjekt sind wie eine Wiese oder ein frei zugänglicher See.

Die Open-Wireless-Bewegung wird Knoten um Knoten von den Endanwendern selbst aufgebaut. Ganz im ursprünglichen Geist des Internet, greifen WiFi-Enthusiasten nach offenen Standards, nach Peer-to-Peer-Dynamik und nach User-bezogener Innovation. Als Künstler haben wir Game-Design mit der Kultur der Open-Wireless-Bewegung kombiniert. Anstatt eine künstliche Spielumgebung zu erschaffen, haben wir uns in jene Revolution eingeklinkt, die bereits rund um uns stattfindet. Unser Ziel war nicht nur, einen Beitrag zu einem neuen Genre öffentlicher Kunst zu leisten,

sondern auch, die breite Öffentlichkeit in eine lebhafte kulturelle und technologische Transformation einzubinden. *Noderunner* wird kontinuierlich von jenen Mitbürgern neu erfunden, die das Netzwerk aufbauen und durch die Straßen gehen. Das Spiel ist ein Einstiegspunkt in die politischen und sozialen Bewegungen, die hinter Wireless stehen. Wir bieten *Noderunner* als etwas an, das freie und offene kabellose Konnektivität zelebriert und gleichzeitig ein Symbol ist für die kulturelle Flexibilität und Potenz der Stadt.

Noderunner wurde von Yury Gitman und Carlos J. Gomez de Llarena für eine Ausstellung unter dem Titel „We Love NY: Mapping Manhattan with Artists and Activists" (*http://www.eyebeam.org/ny*) geschaffen. Die Ausstellung wurde von Eyebeam, einer neuen Medienkunst-Organisation, produziert und von Jonah Peretti und Cat Mazza kuratiert. Wie andere Forschungs- und Entwicklungsprojekte von Eyebeam ist *Noderunner* sowohl eine Form empirischer Forschung und politischen Engagements als auch ein Kunstprojekt. *Noderunner* entstand in Kooperation mit New York City Wireless (*http://www.nycwireless.net*), einer vom New York State Council of the Arts durch ein Stipendium unterstützten Non-Profit-Organisation zur Förderungen des freien kabellosen Internets. Carlos und Yury haben die Entwicklung von *Noderunner* innerhalb des Artist-in-Residence-Programms von Eyebeam fortgesetzt. Zu den Plänen für die Zukunft gehört die Entwicklung einer Plattform, die Spiele in Städten auf der ganzen Welt unterstützte.

Noderunner was created by Yury Gitman and Carlos J. Gomez de Llarena for an exhibition called We Love NY: Mapping Manhattan with Artists and Activists (*http://www.eyebeam.org/ny*). The exhibition was produced by Eyebeam, a new media arts organization, and curated by Jonah Peretti and Cat Mazza. Like other Eyebeam R&D projects, *Noderunner* is a form of empirical research and political engagement as well as an art project. *Noderunner* was developed in collaboration with New York City Wireless (*http://www.nycwireless.net*), a non-profit organization dedicated to providing free wireless Internet, and supported by a grant from the New York State Council of the Arts. Carlos and Yury continued the development of *Noderunner* in the Eyebeam artists-in-residence program. Future plans for *Noderunner* include the development of a platform to support games in cities around the world.

Yury Gitman and Carlos Gomez, edited by Jonah Peretti

Yury Gitman und Carlos Gomez, bearbeitet von Jonah Peretti.

Yury Gitman (USA) uses WiFi, the web, hardware hacks, and cultural forces to create expressive art pieces and initiate public interventions. He has exhibited work at Eyebeam, The New Museum, and elsewhere. Currently he teaches graduate students at the Parsons School of Design. Additionally, he is the director of the Arts group at NYCWireless. He received a Masters and Bachlors degree from New York University and the Georgia Institute of Technology. **Carlos J. Gomez de Llarena (VEN)**, is engaged in exploring the ways in which digital media influences social and spatial relationships. He works with a diverse palette of tools including architecture, space, video, sound, networks and programming. His work has been shown in the Museum of Contemporary Art of Caracas, Ars Electronica, ZKM, ResFest, The BitScreen, galleries and raves. His background is in Architecture and Telecommunications. He currently lives in New York, where he works as an Interaction Designer and performs as a VJ. **Yury Gitman (USA)** nutzt Wireless-Technologie, das Web, Hardware-hacks und kulturelle Kräfte, um Interventionen im öffentlichen Raum zu entwickeln. Seine Arbeiten wurden u. a. bei Eyebeam und im New Museum gezeigt. Er lehrt zurzeit an der Parsons School of Design. Außerdem ist er Leiter der Arts Group bei NYCWireless. Er hat einen MA und BA der New York University und des Georgia Institute of Technology. **Carlos J. Gomez de Llarena (VEN)** erforscht, wie digitale Medien soziale und räumliche Beziehungen beeinflussen. Er arbeitet mit den unterschiedlichsten Tools, mit Architektur, Raum, Video, Sound, Netzwerken und Programmierung. Seine Arbeiten wurden u. a. im Museum of Contemporary Art of Caracas, bei Ars Electronica, im ZKM, bei ResFest oder The BitScreen gezeigt. Er hat eine Ausbildung in Architektur und Telekommunikation und lebt zurzeit in New York als Interaction Designer und performt als VJ.

Habbo Hotel
Sulake Labs Oy

Habbo Hotel is an online gaming environment for teenagers. It's a place where teens can meet up to play games and develop their self expression. *Habbo Hotel* provides a safe, rich and positive gaming environment but it's the teens themselves who write the script. As 'Habbos' they create their own character and virtual world by interacting and playing with others.

Social entertainment

Habbos can talk, shout, walk, dance and even furnish their room with items from the online catalogue. The key to Habbo Hotel is social interactivity: meeting other Habbos and having fun together. Each player has a Habbo Console, which lets them keep in contact with their friends through instant messaging, email and SMS without ever sharing personal details.

Safe meeting place

Habbo Hotel is patrolled 24 hours a day by volunteer moderators called Hobbas. Hobbas can alert, kick and ban players who break the rules and they're backed up by professional paid moderators.
Every conversation and written comment in the hotel passes through the Bobba Filter before it appears on the screen. This filters out swearing, racist and sexist terms, and other words unsuitable for children. The filter also covers the players' names, room names, and descriptions. The filters are updated on a daily basis and contain many hundreds of words and terms.

Going universal

Sulake has now launched *Habbo Hotel* in four countries (Finland, UK, Switzerland and Japan) and is looking to open up to three more within Europe during 2003. Worldwide, there are over seven million registered Habbo characters, and over 700,000 unique players visit the hotels each month. Eighty percent of Habbo players are between the ages of 10 and 18, with an equal divide between the sexes (source: Habbo Statistics Tool 20th June, 2003).

Habbo Hotel ist ein Online-Gaming-Environment für Teenager. Es ist ein Ort, an dem sich Teens treffen können, um Spiele zu spielen und ihre Ausdrucksfähigkeit zu verbessern. *Habbo Hotel* bietet eine sichere, reichhaltige und positive Spielumgebung, aber die Teens selbst schreiben die Scripts. Als „Habbos" schaffen sie ihre eigenen Gestalten und virtuellen Welten, indem sie mit anderen interagieren und spielen.

Soziales Entertainment

Habbos können sprechen, schreien, gehen, tanzen und sogar ihr Zimmer mit Objekten aus dem Online-Katalog einrichten. Der Schlüssel zum *Habbo Hotel* ist soziale Interaktivität: Man trifft andere Habbos und hat Spaß mit ihnen. Jeder Spieler hat eine Habbo-Konsole, durch die er mit seinen Freunden in Kontakt bleiben kann – über Instant-Messages, E-Mails und SMS – ohne dass er jemals persönliche Details bekannt geben müsste.

Sicherer Treffpunkt

Das *Habbo Hotel* wird rund um die Uhr von freiwilligen Moderatoren bewacht, die Hobbas genannt werden. Hobbas können Spieler, die gegen die Regeln verstoßen, verwarnen, hinauswerfen und dauerhaft aussperren, und werden von professionellen bezahlten Moderatoren dabei unterstützt.
Jede Konversation und jeder geschriebene Kommentar im Hotel geht durch den Bobba-Filter, bevor er am Bildschirm erscheint. Dabei werden Flüche, rassistische und sexistische Begriffe sowie andere für Kinder ungeeignete Wörter ausgefiltert. Der Filter überwacht auch die Namen der Spieler, ihre Zimmer und ihre Beschreibungen. Diese Filter werden täglich aktualisiert und enthalten viele hundert Worte und Begriffe.

Going Universal

Sulake hat *Habbo Hotel* derzeit in vier Ländern in Betrieb (Finnland, United Kingdom, Schweiz, Japan) und wird im Laufe des Jahres 2003 noch in drei weiteren europäischen Ländern aktiv werden. Insgesamt gibt es weltweit über sieben Millionen registrierter Habbo-Charaktere, pro Monat besuchen über 700.000 Spieler die Hotels. Achtzig Prozent der Habbo-Spieler sind zwischen zehn und 18 Jahre alt, die Geschlechterverteilung ist ausgewogen (Quelle: Habbo Statistics Tool, 20.6.2003).

Habbo Credits

Habbo Credits are the game's currency—they're used to pay for enhanced services such as virtual furniture, game tickets and mobile phone functions. Virtual furniture in particular is an important factor in most "Habbos'" lives within the hotel, allowing them to express themselves through the creation of themed rooms, game rooms and places to chill out in. Players can pay using reverse SMS billing, IVR telephone lines, credit cards, and prepay cards.

Unique style and technology

"Habbo pixel style" pays homage to the early computer games, but its axonometric 2D environment, unique design and fresh colour palette makes Habbo pixel style stand out from other international multiplayer online games.
Habbo Hotel is built on Java-based FUSE technology, which has been developed by Sulake specifically to support multi-user online environments. The hotel client itself is programmed by lingo experts and can be viewed with standard web browsers enriched with Macromedia's Shockwave Director plug-in.

Fan culture and community

Thousands of simultaneous players meet each other daily in *Habbo Hotel*, playing and chatting together, and making new friends. Habbos hang out together in "posses" and run police departments and hospitals, often paying their "workers" with virtual furniture. They tend to treat Habbo staff members and Hobbas (moderators) as celebrities, often creating rooms in their honour and sending them gifts at Christmas and Easter. This fan culture extends beyond the boundaries of the hotel, with hundreds of fan sites worldwide reporting on hotel news and rumours.

Habbo Credits

Habbo Credits sind die Währung des Spiels – man verwendet sie, um zusätzliche Leistungen wie virtuelle Möbel, Spieltickets und erweiterte Handy-Funktionen zu kaufen. Besonders die virtuellen Möbel sind ein wichtiger Faktor im Leben der meisten Habbos im Hotel, da sie Individualität durch themenbezogene Räume, Spielräume und Ruheorte ausdrücken. Die Spieler können zwischen Bezahlung über SMS, Telefon-Mehrwertrechnung, Kreditkarte oder Prepaid-Karte wählen.

Einzigartiger Stil und Technologie

Der „Habbo Pixel Style" kann durchaus als Hommage an die frühen Computerspiele angesehen werden, aber das axonometrische 2D-Environemt, das einzigartige Design und die frische Farbplaette heben den Habbo-Pixelstil doch von anderen internationalen Multiplayer-Online-Games ab.
Habbo Hotel baut auf Java-basierter FUSE-Technologie auf, die von Sulake speziell dafür entwickelt wurde, Multi-User-Online-Spielumgebungen zu schaffen. Der Hotel-Client selbst wurde von Lingo-Experten programmiert und kann mit allen Standard-Webbrowsern betrachtet werden, die mit Macromedias Shockwave-Director-Plug-in ausgestattet sind.

Fankultur und Gemeinschaft

Tausende von simultanen Spielern treffen sich täglich zu Spiel, Chat und freundschaftlichen Begegnungen im *Habbo Hotel* . Die Habbos verbringen ihre Zeit gemeinsam in „Posen" und leiten Polizeistationen ebenso wie Spitäler, wobei ihre „Mitarbeiter" häufig mittels virtuellen Möbeln bezahlt werden. Sie neigen dazu, die Mitglieder der Habbo-Belegschaft und die Hobbas (Moderatoren) als Prominenz zu betrachten und schaffen manchmal sogar eigene Gedenkräume für sie oder senden ihnen Weihnachts- und Ostergeschenke. Diese Fankultur reicht weit über die Grenzen des Hotels hinaus und umfasst Hunderte von Fan-Sites auf der ganzen Welt, die Neuigkeiten und Gerüchte aus dem Hotel austauschen.

Sulake Labs Oy (SF) is a Finnish company specialising in the development of multiplayer games and communities. Its products, such as *Habbo Hotel* and *Coke Studios*, are community-driven, readily accessible and great fun to play—factors which form the core of all Sulake games. Sulake has currently 40 employees in three countries: Finland, the United Kingdom and Switzerland. **Sulake Labs Oy (SF)** ist ein finnisches Unternehmen, das sich auf die Entwicklung von Multiplayer-Games und -Environments spezialisiert hat. Seine Produkte, darunter *Habbo Hotel* und *Coke Studios*, werden von der Community selbst betrieben, sind leicht zugänglich und bieten Spielspaß – alles Faktoren, die sämtlichen Spielen von Sulake zugrunde liegen. Derzeit hat Sulake 40 Angestellte in Finnland, Großbritannien und der Schweiz.

Stop Motion Studies
David Crawford

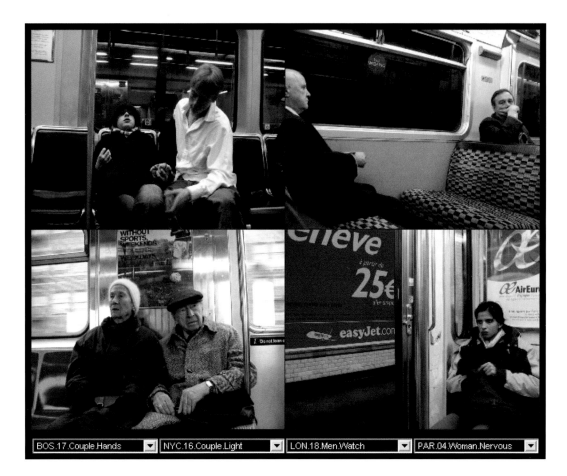

BOS.17.Couple.Hands NYC.16.Couple.Light LON.18.Men.Watch PAR.04.Woman.Nervous

The *Stop Motion Studies* extend my long-standing interest in narrative and, in particular, look at the subway as a stage upon which social dynamics and individual behavior are increasingly mediated by digital technology. As one of the most vibrant and egalitarian networks in our cities, the subway brings people from a wide range of social and cultural backgrounds into close contact with each other. This process plays a significant role in shaping both the character of a city as well as our individual identities.

It is said that 90 per cent of human communication is non-verbal. In these photographs, the body language of the subjects becomes the basic syntax for a series of Web-based animations exploring movement, gesture, and algorithmic montage. Many sequences document a person's reaction

Stop Motion Studies sind eine Weiterführung meiner Beschäftigung mit dem Erzählerischen. Ich betrachte darin vor allem die Untergrundbahn als Bühne, in der durch digitale Technologie mediatisiert wird. Als eines der lebendigsten und egalitärsten Netzwerke unserer Städte bringt die U-Bahn Menschen mit unterschiedlichstem sozialem und kulturellem Hintergrund in engen Kontakt miteinander. Dieser Prozess spielt eine bedeutende Rolle in der Formung sowohl des Charakters einer Stadt wie unserer eigenen Identität.

Man sagt, daß 90 Prozent der menschlichen Kommunikation nonverbal abläuft. In den Fotos der *Stop Motion Studies* wird die Körpersprache der Abgebildeten zur Grundsyntax einer Serie Web-gestützer Animationen, die Bewegung, Gestik und Fragen der algorithmischen Montage erforschen. Viele Sequenzen dokumentieren, wie die Betroffenen darauf reagieren, wenn sie von einem

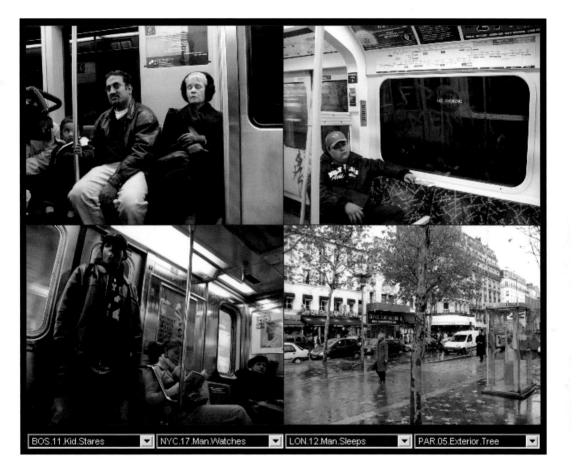

BOS.11.Kid.Stares | NYC.17.Man.Watches | LON.12.Man.Sleeps | PAR.05.Exterior.Tree

Fremden fotografiert werden: Manche lächeln, andere verziehen das Gesicht, wieder andere schauspielern, und einige tun so, als hätten sie nichts bemerkt. Hinter all diesen Reaktionen stehen Annahmen und Unbekannte, die für jede Situation spezifisch sind.

to being photographed by a stranger. Some smile, others snarl, still others perform. Some pretend not to notice. Underneath all of this are assumptions and unknowns unique to each situation.

David Crawford (USA/S) is an internationally recognized artist as well as a designer and teacher. As an artist, he has received numerous grants and honors. As a designer, Crawford has held posts at some of the most preeminent organizations in the world. As a teacher, he has pioneered programs at the School of the Museum of Fine Arts and Pratt Institute. He is currently a faculty member at both schools and is actively engaged in curricular development. He studied at the Massachusetts College of Art with filmmaker Mark Lapore and video artist Julia Scher. **David Crawford (USA/S)** ist international anerkannter Künstler, Gestalter und Lehrer. Als Künstler ist er Träger zahlreicher Preise und Stipendien, als Gestalter war er bei einigen der hervorragendsten Institutionen dieser Welt beschäftigt. Als Lehrer war er ein Pionier neuer Studiengänge an der Schule des Museum of Fine Arts und am Pratt Institute. Derzeit ist er Fakultätsmitglied beider Institutionen und beschäftigt sich aktiv mit der Entwicklung von Curricula. David Crawford hat am Massachusetts College of Art beim Filmemacher Mark Lapore und bei der Videokünstlerin Julia Scher studiert.

The Secret Lives of Numbers
Das geheime Leben der Zahlen

Golan Levin

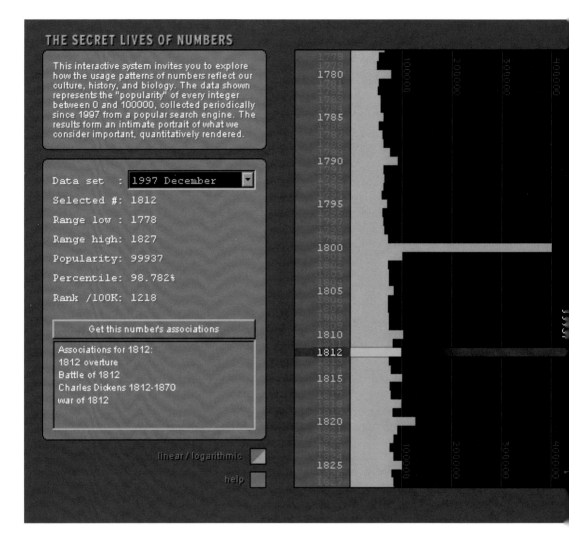

When we choose to say there are "a lot" of gorillas or "17" gorillas or "around 20," we are making a choice based on our interests and abilities. Those interests and abilities are systematically expressed in the numbers we choose to send out into the world. The Internet provides us with a large and diverse database of the stuff people have sent out into the world, and it naturally includes large numbers of numbers. Since 1997, we have collected at intervals a novel set of data on the popularity of numbers: by performing a

Wenn wir sagen, es gibt „viele" Gorillas oder „17" Gorillas oder „knapp 20" Gorillas, so treffen wir eine auf unseren Interessen und Fähigkeiten basierende Entscheidung. Diese Interessen und Fähigkeiten drücken sich systematisch in den Zahlen aus, die wir auf die Welt loszulassen belieben. Das Internet bietet uns eine umfassende und sehr diversifizierte Datenbank all jener Dinge, die Menschen in die Welt hinaus gesandt haben, und dazu gehört natürlich auch eine große Anzahl von Zahlen. Seit 1997 haben wir in gewissen Intervallen ein neuartiges Dataset über die Popularität von Zahlen zusammengetragen:

Indem wir eine umfangreiche automatisierte Internet-Suche nach ganzen Zahlen zwischen 0 und 1.000.000 durchführten und all jene Seiten zählten, auf denen diese Zahlen jeweils vorkommen, haben wir ein Abbild der numerischen Vorlieben und Neigungen der Internet-Community erhalten. Die interaktive Visualisierung des Ergebnisses dieser Suche will einige der auffälligsten Trends sichtbar machen. Unsere Daten können punktweise erforscht oder in größeren Sets betrachtet werden und führen zu einem Einblick in die kognitive Struktur von Rechenkenntnis, Kultur und Gedächtnis.

massive automated Internet search on each of the integers from 0 to 1,000,000 and counting the number of pages which contained each, we have obtained a picture of the Internet community's numeric interests and inclinations. The interactive visualization which accompanies this statement attempts to make some of the more striking trends visible. Our data can be explored point by point or viewed in larger sets and may lend some insight into the cognitive structure of numeracy, culture, and memory.

888 : 488650

Bestimmte Muster werden im Daten-Browser sofort sichtbar, etwa die Vorliebe der Leute für Vielfache von 10 oder für Zahlen mit Verdopplung von Zifferngruppen (1010, 1111, 1212 usw.). Während amerikanische Postleitzahlen kein solch zusammenhängendes visuelles Muster ergeben, sind sie dennoch recht prominent vertreten, und anders als bei der Betrachtung von Städten aus dem Weltraum, wo nur die größeren sichtbar werden, leuchten hier die größeren und die interessanteren hell heraus. Weitere Highlights in den Daten zeigen eher verschwommenere Spiegelungen unserer Aktivitäten: Helle Flecke wie für 80486 und 68040 belegen nicht nur unser Interesse für Technologie, sondern sagen auch etwas über den Status der Technologie zur jeweiligen Zeit aus. Und die Popkultur lässt natürlich auch ihre Anwesenheit spüren, wenn auch etwas weniger als erwartet.

Sprachwissenschaftler haben festgestellt, dass das Idealkonstrukt einer „Sprache" stark von ihren Gebrauchsformen abweicht, was nahelegt, dass das linguistische „Ideal" eine blasse Abstraktion einer viel stärker nuancierten und texturierten Praxis ist. Auch wenn wir Zahlen gerne als objektiv und losgelöst von unserem eigentlichen Leben betrachten, so scheint es doch, als zeigten sie Elemente einer „Praxis". Die „Bewohner" der Zahlenreihe sind nicht die reinen Automaten oder Gruppenwerkzeuge, als die wir sie gerne ansehen: Jeder hat Persönlichkeit, Talente, Gemeinsamkeiten – und manchmal auch das gewisse Etwas. Sie spiegeln uns wider. Und diese ungewöhnliche Widerspiegelung steht im Mittelpunkt unseres Projekts.

Certain patterns are made readily visible in the data browser, such as people's preference for multiples of 10 or reduplicative numbers such as 1010, 1111, 1212, etc. While American zip codes do not present a similarly coherent visual pattern, they can nevertheless be quite prominent—and unlike viewing cities from space, where only the larger cities are visible, here both the larger and the more interesting places are brighter. Further highlights in the data reveal more fleeting reflections of our activities: bright spots such as those for 80486 and 68040 reveal our interest not only in technology, but tell us about the state of that technology at the time. Other points indicate our interest, or lack of interest, in history. And popular culture inevitably makes its presence felt, but perhaps less than we might expect.

Linguists have noted that the ideal construct of proper "language" diverges considerably from its actual use, suggesting that the linguistic "ideal" may be a pale abstraction of a far more nuanced and textured practice. Although we like to think of the use of numbers as objective and removed from our personal lives, it appears they also display elements of "practice." The denizens of the number line are not the mere automatons or corporate tools we have made them out to be: each has a personality, talents, communities, and sometimes a little *je ne sais quoi*. They reflect us. This unusual reflection is the focus of this project.

Golan Levin (USA), born 1972, is an artist, composer, performer and engineer interested in developing artifacts and events which explore supple new modes of reactive expression. His work focuses on the design of systems for the creation, manipulation and performance of simultaneous image and sound as part of a more general inquiry into the formal language of interactivity, and of non-verbal communications protocols in cybernetic systems. **Golan Levin (USA)**, geb. 1972, ist Künstler, Komponist, Performer und Techniker und interessiert sich vor allem für die Entwicklung von Artefakten und Events, die neue Formen des reaktiven Ausdrucks erforschen. Seine Arbeit konzentriert sich auf das Design von Systemen zur Schaffung, Manipulation und zur simultanen Aufführung von Bild und Ton und beschäftigt sich ganz allgemein mit der formalen Sprache von Interaktivität und nonverbalen Kommunikationsprotokollen in kybernetischen Systemen.

The Secret Lives of Numbers

Lia's pieces in the *re:move* series have been refining much of her earlier outputs in more focused pieces in the project *Turux*. It's all, of course, about mathematics and geometry; it's all about motion, time, and simplicity. It's about creating complex interaction and generative audiovisual experiences, where the pieces are open to the inputs of the user: it's about creating systems in which the control over the events is shared between the author and the user.

Some pieces have already been described as "drawing machines" in the sense that they provide the user with fundamental tools for graphical manipulation, but this classification is over-simplistic, as all the pieces indeed provide the tools and the framework for elaborating the compositions but simultaneously do not allow

In den Arbeiten aus der Serie *re:move* hat Lia einen Teil ihrer früheren Produktion bei *Turux* in Form fokussierterer Werke weiter ausgearbeitet. Natürlich dreht sich alles um Mathematik und Geometrie, um Bewegung und Zeit und um Einfachheit: Es geht um die Schaffung komplexer Interaktion und generativer audiovisueller Erfahrungen, bei denen die Stücke offen sind für den Input der User; es geht um die Schaffung von Systemen, bei denen die Steuerung der Ereignisse zwischen Autor und Benutzer geteilt wird.

Manche der Stücke wurden bereits als „Zeichenmaschinen" bezeichnet, weil sie dem Anwender fundamentale Werkzeuge zur grafischen Manipulation in die Hand geben. Aber diese Klassifikation ist allzu vereinfachend, da alle Arbeiten zwar tatsächlich Werkzeug und Rahmenbedingungen für die Schaffung der Komposition bereitstellen, aber gleichzeitig keine volle Kontrolle über den

Output erlauben, da ihre dynamische Natur sie sich entwickeln und wandeln lässt. Zudem ist ihre Präsentation frei von irgendwelchen Betriebsanleitungen, was den User zum Experimentieren vor Ort zwingt.

In der Interaktion mit den Arbeiten werden menschliche Interferenzen zum System hinzugefügt, indem einige der Steuerungsvariablen selektiv verändert und die allgemeine Komplexität des audiovisuellen Outputs gesteigert werden, sodass überraschend unvorhersehbare Kompositionen entstehen.

(Miguel Carvalhais, Dezember 2002)

for full control of the output since their dynamic nature makes them evolve and mutate and their presentation is void of operating instructions of any sort, leading the user to hands-on experimentation. By interacting with the pieces, human interference is added to the system: by selectively changing some of the variables that govern it and increasing the overall complexity of the audiovisual outputs generated to the point where surprising unpredictable compositions arise.

(Miguel Carvalhais, Dec. 2002)

Lia (A) defines herself as a "graphical programmer". Some people define her as a digital artist and she's also frequently called a designer. All of these are true, as they define what she does or, in her words, how she does it. Born in Graz, Lia studied at music high school and later moved to Vienna to study fashion design. In 1995 she started using the computer as her main artistic tool, developing a very close relationship to it and to the media she works with. In 1997 she co-founded the online project *Turux* and in 1999 she premiered her personal *re:move* project. Both have been awarded the Josef Binder award in the "Vision" category in 1998 and 2000. Since 2000 she has been regularly performing live generated visuals with the music project @c+lia (*www.at-c.org*), developing design projects in cooperation with revdesign.pt and working in the project *wofbot.org*. In 2003 she has become a founding member of the Crónica media label (*www.cronicaelectronica.org*), which aims to release new music and art. *[Miguel Carvalhais, April 2003]* **Lia (A)** definiert sich selbst als „graphikprogrammiererin". Manche Leute bezeichnen sie als digitale Künstlerin, und häufig wird sie auch Designerin genannt. All diese Bezeichnungen sind richtig, da sie definieren, was sie tut, oder – mit ihren Worten – wie sie es tut. In Graz geboren, hat sie ein Musikgymnasium besucht und ist später zum Studium des Modedesigns nach Wien übersiedelt. Ab 1995 begann sie, den Computer als ihr hauptsächlichstes kreatives Werkzeug einzusetzen, wobei sie eine enge Beziehung zum Werkzeug und zu den Medien entwickelte, mit denen sie arbeitet. 1997 war sie Mitbegründerin des Online-Projekts *Turux*, und 1999 stellte sie erstmals ihr persönliches Projekt *re:move* vor. Beide wurden mit dem Josef-Binder-Preis 1997 bzw. 2000 ausgezeichnet. Seit 2000 zeigt sie regelmäßig live generierte Visuals gemeinsam mit dem Musikprojekt @c+lia (*www.at-c.org*), weiters entwickelt sie Designprojekte in Zusammenarbeit mit *revdesign.pt* und arbeitet am Projekt *wofbot.org* mit. 2003 wurde sie Gründungsmitglied des Medienlabels Crònica (*www.cronicaelectronica.org*), das Neue Musik und Kunst herausbringen wird. *[Miguel Carvalhais, April 2003]*

"Boards of Canada" Website
James Tindall

The "Boards of Canada" website was a dream project. It was immediately apparent that the band and I shared an interest in synaesthetic relationships between audio and visuals and this was to inform the direction of the site. Mike and Marcus approached me in the winter of 2001 with a need for a site to accompany the release of their 3rd album and a completely open brief.

Around that time I was becoming increasingly obsessed with *Crystal Voyager* (an early 70's surf movie by George Greenough). After half an hour or so the movie plunges into a 30 minute sequence entirely shot from inside breaking waves. The amorphous, pulsating turbulence of the waves and the saturated colours of the 70's film stock combine to create a breathtaking aesthetic tinged with the same nostalgic flavour so richly present in the music of Boards of Canada. Upon discussing the film with the band I discovered that it was, coincidentally, also their favourite film and that they had even composed music about it.

The site is an attempt to combine the mood and tone of Crystal Voyager with the synaesthetic imagery created in my head while listening to boc's music.

For me boc's music is always meteorological. Each track suggests a weather condition as well as a location. Rich with meticulously considered textural juxtapositions and colour harmonies, the music also provokes more abstract visual sensations that inspired the kaleidoscopic scenes on the site.

My intention was to provide as immersive an experience as possible with today's bandwidth. Each scene is between 80 and 150k. The file size is kept low because most of the visuals are created algorithmically. For example, the Island scenes have no image assets at all as the landscape and clouds are all created on the fly by using custom made perlin noise functions. Upon entering an island scene, a new, completely

Die Website der Band „Boards of Canada" war ein Traumprojekt. Es war von Anfang an offensichtlich, dass die Band und ich die gleichen Ansichten über synästhetische Beziehungen zwischen Audio und Video hatten, und dies sollte die Richtung der Site wesentlich beeinflussen. Mike und Marcus traten im Winter 2001 an mich mit einem völlig offenen Konzept heran und ersuchten mich, eine Site zu ihrem vor der Veröffentlichung stehenden dritten Album zu erstellen.

Um diese Zeit hatte ich mich gerade für *Crystal Voyager* zu interessieren begonnen, ein Surf-Movie von George Greenough aus den frühen 70er Jahren. Nach etwa einer halben Stunde versinkt der Film in eine 30-minütige Sequenz, die zur Gänze inmitten von brechenden Wellen gedreht wurde. Die amorphen, pulsierenden Turbulenzen der Wellen und die gesättigten Farben des Filmmaterials der 70er Jahre verbinden sich zu einer atemberaubenden Ästhetik, die stark an jenen nostalgischen Unterton erinnert, der in der Musik von Boards of Canada so präsent ist. Als ich der Band von dem Film erzählte, stellte sich heraus, dass er zufällig auch der Lieblingsfilm der beiden war und dass sie sogar Musik dazu komponiert hatten.

Die Site ist der Versuch, Stimmung und Tonfall von *Crystal Voyager* mit der synästhetischen Bildwelt zu verbinden, die in meinem Kopf beim Anhören der Musik von BOC entstand.

Für mich hat die Musik von BOC immer einen meteorologischen Inhalt – jeder Track suggeriert eine Wetterlage ebenso wie eine Gegend. Die Musik, reich an sorgfältig berechneten texturalen Gegenüberstellungen und Farbharmonien, provoziert auch eher abstrakte visuelle Empfindungen, die die kaleidoskopischen Szenen auf der Site inspiriert haben.

Meine Absicht war, eine so immersive Erfahrung anzubieten, wie sie mit der heutigen Bandbreite eben möglich ist. Jede Szene umfasst zwischen 80 und 150k; die Dateigröße wird deswegen so klein gehalten, weil die meisten Bilder algorithmisch erstellt werden. So haben etwa die Inselszenen überhaupt keine Basisbilder, da die Landschaft und die Wolken mit Hilfe von eigens geschriebenen Perslin-Noise-Funktionen in Echtzeit generiert

werden. Beim Eintreten in eine Inselszene werden jedesmal eine neue, einzigartige Insel und Wolkenformationen erzeugt. Eine völlig andere Insel kann erreicht werden, wenn man kurz aufs Meer hinausfliegt.

Rund um die Inseln sind Punktquellen für Sound-Samples positioniert. Während man auf der Insel herumfliegt, wird der Insel-Song neu gemixt, da Lautstärke und Panning eines jedes Samples von der relativen Entfernung des Besuchers zur Punktquelle und von der Entfernung der Punktquellen zueinander abhängt. Da die Topologie jeder Insel variiert, variieren auch die möglichen Mixes des Insel-Songs.

Ich habe mich bemüht, die Bedienung der Site für Anwender so einfach wie möglich zu machen. Die Steuerung jeder Szene erfolgt durch die Maus und nur einige wenige Tasten. Der User kann im 3D-Raum herumschauen, indem er einfach mit der Maus irgendwohin zeigt. In den Inselszenen habe ich versucht, ein Maximum an Bewegungsfreiheit mit einem Minimum an Klicks zu ermöglichen. Der Mauszeiger steuert die horizontale Richtung, das Halten der linken Maustaste beschleunigt, ihr Auslassen bremst durch Reibung. Durch Drücken von „q" steigt man empor, beim Auslassen fällt man mit der Schwerkraft. Wer schweben will, drückt „a".

Damit man die Site ebenso passiv wie aktiv erleben kann, gibt es eine Auto-Navigationsfuktion, die den User durch die Site führt. Diese Funktion kann der Anwender jederzeit schalten und manuell zu irgendeiner Szene navigieren, indem er im Menu auf die gewünschte Szene klickt.

unique island and clouds are created. Another unique island can be reached by flying out to sea. Placed around the islands are sound sample point sources. As you fly around the islands the island song is remixed as the volume and panning of each sound sample is dependant upon your proximity to the point sources and their proximity to each other. As the topology of each island varies the possible mix of the island song also varies.

I have attempted to make the user control of the site as simple as possible. The control of each scene is achieved with the mouse and just a couple of keys. In the island scenes I have attempted to provide the user with the maximum degrees of freedom of movement with as few buttons as possible. Pointing the mouse controls the horizontal direction and holding down the left mouse button increases the speed of movement; letting go you will slow with friction. Pressing "q" will lift you upwards and letting go you will fall with gravity. You can hover by pressing "a". In an attempt to allow the site to be experienced passively as well as actively there is an auto navigation function that takes the user through the site. The user can turn this function off and navigate manually to any scene by clicking the particular scene in the menu.

James Tindall (USA) published his first personal website www.thesquarerootof-1.com (now at *www.atomless.com/sqrt-1*) in the Autumn of 1998. Since the summer of 2000 he has been working freelance in roles varying from senior art director to lead programmer. In January 2001 he published *www.modifyme.com* and shortly after contributed a piece titled *Algaerhythms* to *singlecell.org*. He continues to explore responsive audio visual possibilities in his personal work and in work for clients such as the Boards of Canada. He is also planning to venture beyond the browser in some new artwork and collaborations with the art collective Greyworld. **James Tindall (USA)** publizierte seine erste Website *www.thesquarerootof-1.com* im Herbst 1998 (jetzt unter *www.atomless.com/sqrt-1*). Seit Sommer 2000 arbeitet er freiberuflich in verschiedenen Funktionen, die vom Senior Art Director bis hin zum Lead Programmer reichen. Im Jänner 2001 publizierte er *www.modifyme.com*, kurz danach steuerte er eine Arbeit namens *Algaerhythms* zu *singlecell.org* bei. In seiner persönlichen Arbeit, aber auch in der Arbeit für Auftraggeber wie Boards of Canada erforscht er responsive audiovisuelle Möglichkeiten. Er plant auch, einen Ausflug in neue künstlerische Arbeiten jenseits des Browsers zu unternehmen und eine Zusammenarbeit mit dem Kunstkollektiv Greyworld.

Z
Antoni Abad

POPULATION

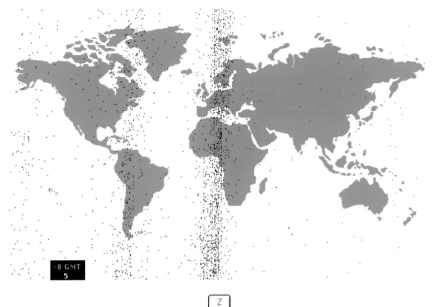

Z is a freeware fly with variable behaviour patterns. Each fly is genetically unique and only lives when the PC it inhabits is on-line. Conceived as a virtual swarm, the flies are intended to multiply throughout the Internet by free exchange between users.

Z ist eine Freeware-Fliege mit variablen Verhaltensmustern. Jede Fliege ist genetisch einmalig und lebt nur, wenn und solange sie von einem PC online belebt wird. Als virtueller Schwarm konzipiert, sollen sich die Fliegen über das Internet im freien Austausch unter den Benutzern vermehren.

Z.txt

Z ist eine **Fliege** mit variablen Verhaltensmodellen. Jede Fliege ist genetisch einmalig und lebt, wenn der Computer, den sie bewohnt, on-line ist. Geschaffen als Mitglied eines virtuellen Schwarmes hat Z vor, sich im Internet mittels eines freien Austausches unter den Benutzern zu verbreiten. Die Mitglieder kommunizieren über den Kanal Z nach verschiedenen Kriterien: Zeitzone, on-line-Fliegen, grafische Darstellung der Gemeinschaftsevolution, genetischer Baum des Schwarmes, die Sprache usw. Die Benutzer von Z können das Verhalten und die Morphologie ihrer Fliegen im genetischen Labor (Z.lab) manipulieren. Die entstandenen Mutanten können über den Kanal Z ausgetauscht werden. Das Ziel von Z ist eine **Netzbildung** für eine Kommunikation, unabhängig von jeglichem Zentralserver. Jede Fliege wird so gleichzeitig zum Kunden und zum Server. Demnächst werden die Benutzer von Z ihr eigenes Netzwerk aufbauen können. Die gemeinschaftliche Evolution und andere gemeinschaftliche Phänomene können in http://zexe.net und im **Kanal Z** erfragt werden. Um Z entwickeln zu können, brauchen wir deine Hilfe. Bitte lade Z runter und installiere es in deinem Computer, indem du die untere Z-Taste betätigst. Danke für deine Mitarbeit!

Individuals can communicate through canal Z interface according to different criteria: time zone, on-line flies, community evolution graph, swarm genealogical tree, language, etc.
Z users can manipulate the behaviour and morphology of individual flies at Z.lab, the genetic laboratory. The resulting mutants can then be exchanged through canal Z.
The aim of Z is to create a distributed communication network that is independent of any central server. Each fly will become both server and client simultaneously. Soon Z users will be able to create their own networks.

Über das „Kanal-Z-Interface" können Individuen nach unterschiedlichen Kriterien miteinander kommunizieren: Zeitzone, Online-Fliegen, ein Graph der Entwicklung der Community, Stammbaum des Fliegenschwarms, Sprache etc. Z-User können das Verhalten und die Morphologie individueller Fliegen im Z.lab, dem genetischen Labor, manipulieren und die so entstehenden Mutanten wiederum über Kanal-Z austauschen.
Das Ziel von Z ist es, ein verteiltes Kommunikationsnetzwerk zu schaffen, das unabhängig von einem zentralen Server ist. Jede Fliege wird gleichzeitig zum Server und zum Client, und bald schon können Z-User ihre eigenen Netzwerke bauen.

Z

Z ist ein langfristig angelegtes Projekt, das sich seit Februar 2001 in Entwicklung befindet. Die erste Beta-Version der Fliege wurde am 13. März 2001 per E-Mail an die ersten 50 User versandt. Von diesen frühen *Z*-Usern wurden die Fliegen an andere Anwender weitergegeben, bis im September 2002 die Zahl von 1120 Individuen erreicht war. Updates der Software wurden regelmäßig an Beta-Tester weitergegeben, bis die Version 2.0 von *Z* am 16. September 2002 im Museu d'Art Contemporani in Barcelona und in Le Fresnoy offiziell vorgestellt wurde.
Evolution und Phänomene von *Z* sind online unter *http://zexe.net* und auf Canal Z abrufbar.

Z is a long term project that has been in development since February 2001. The first betaversion of the fly was sent by email to 50 people on 13th March 2001. Flies were re-distributed by those early *Z*.users to new users, to reach a number of 1,120 individuals in September 2002. Updates of the software were periodically distributed to betatesters till the launching of *Z* 2.0 edition on 16th September 2002.
Z 2.0 was presented on 16th September 2002 at the Museu d'Art Contemporani de Barcelona and at Le Fresnoy.
Z evolution and phenomena are online at *http://zexe.net* and at canal Z.

Antoni Abad (E). After a residency at The Banff Centre for the Arts in 1993 / 94, his work has developed in different media: video installations, software projections and Internet projects. Group exhibitions and events include the Biennale di Venezia, ZKM Karlsruhe, 2a Bienallberioamericana or Big Sur, Hamburger Bahnhof, Berlin. Solo venues include: Centro de Arte Reina Sofia (Madrid 1997), Museo de Arte Moderno (Buenos Aires 1999), Media Lounge, New Museum of Contemporary Art (New York 2001) and the Museu d'Art Contemporani de Barcelona (2002). Internet projects are: *Sisyphus* (1996) and *1.000.000* (1999). He is currently developing the version 3.0 of *Z*. **Antoni Abad (E)**. Nach einem Studienaufenthalt am Banff Centre for the Arts 1993/94 haben sich seine Arbeiten auf verschiedene Medien ausgedehnt – Video-Installationen, Software-Projektionen und Internet-Projekte. Gruppenausstellungen und Events fanden u.a. statt bei der Biennale von Venedig, am ZKM Karlruhe, bei der 2a Bienallberoamericana oder Big Sur, am Hamburger Bahnhof und in Berlin. Einzelausstellungen u.a. in: Centro de Arte Reina Sofia (Madrid 1997), Museo de Arte Moderno (Buenos Aires 1999), Media Lounge, New Museum of Contemporary Art (New York 2001) und im Museu d'Art Contemporani de Barcelona (2002). Internet-Projekte: *Sisyphus* (1996) und *1.000.000* (1999). Derzeit entwickelt er Version 3.0 von *Z*.

The Google AdWords Happening
Christophe Bruno

At the beginning of April, a debate took place on rhizome.org mailing list about how to earn money with net art. It suggested to me an answer to an easier problem: how to spend money with my art (if you understand everything about how to spend money, you should in principle understand also how to earn money, because of conservation laws...). I decided to launch a happening on the web, consisting of a poetry advertisement campaign on Google AdWords. I opened an account for $5 and began to buy some keywords. For each keyword you can write a little ad. and, instead of the usual ad., I decided to write little "poems", non-sensical or funny or a bit provocative. I began with the keyword "symptom". The first ad. I wrote was:

Words aren't free anymore
bicornuate-bicervical uterus
one-eyed hemi-vagina
www.unbehagen.com

As soon as the campaign was launched, I was able to see the results. Every time somebody was looking for the word "symptom" in Google, they could see my ad in the top right corner of the page. My first satisfaction occured when somebody who had typed "hemorroid symptom" on Google arrived on my website, after having clicked on my ad. I decided to explore this new world and to launch several campaigns. Each of them was to be a targeted poetic happening of a new kind.

Anfang April fand auf *rhizome.org* eine Debatte darüber statt, wie man mit Netz-Kunst Geld verdienen kann. Diese brachte mir eine Antwort auf die viel einfachere Frage, wie ich mit meiner Kunst Geld ausgeben kann (wer alles über das Geldausgeben weiß, sollte damit im Prinzip auch alles über das Geldverdienen wissen, schließlich gilt ja das Gesetz von der Erhaltung ...). Ich beschloss, ein Happening im Web zu veranstalten, das aus einer Anzeigenkampagne mit Poesie auf *Google AdWords* bestand. Ich eröffnete also für fünf Dollar ein Konto und kaufte einige Schlüsselbegriffe. Für jedes dieser Schlüsselwörter kann man eine kleine Anzeige schreiben, wobei ich beschloss, statt der üblichen Anzeigen unsinnige oder witzige oder etwas provokative „Gedichtlein" einzusetzen. Ich begann mit dem Schlüsselbegriff „Symptom". Die erste von mir geschriebene Anzeige lautete:

Words aren't free anymore
bicornuate-bicervical uterus
one-eyed hemi-vagina
www.unbehagen.com

Nach dem Start der Kampagne konnte ich unmittelbar deren Ergebnisse sehen. Jedes Mal, wenn jemand das Suchwort „Symptom" in Google eingab, erschien meine Anzeige in der oberen rechten Ecke der Ergebnisseite. Mein erstes befriedigendes Ergebnis war, dass jemand, der „hemorroid symptom" in Google gesucht hatte, auf meiner Webseite landete, nachdem er die Anzeige angeklickt hatte. So beschloss ich, diese neue Welt zu erforschen und mehrere Kampagnen zu starten, die jeweils ein gezieltes poetisches Happening in einer neuen Form sein sollten.

Words aren't free anymore
bicornuate-bicervical uterus
one-eyed hemi-vagina
www.unbehagen.com

Keyword	Clicks	Impr.	CTR	Avg. CPC	Cost
symptom	16	5517	0.3%	$0.05	$0.8

Follow your dreams
Did I just urinate ?
Directly into the wind
www.unbehagen.com

Keyword	Clicks	Impr.	CTR	Avg. CPC	Cost
dream	14	2837	0.4%	$0.05	$0.70

mary !!!
I love you
come back
john

Keyword	Clicks	Impr.	CTR	Avg. CPC	Cost
mary	31	2682	1.1%	$0.06	$1.56

don't ever do that again
aaargh !
are you mad ?
ooops !!!

Keyword	Clicks	Impr.	CTR	Avg. CPC	Cost
money	5	837	0.5%	$0.05	$0.25

Wie 12.000 Leute meine „Gedichte" innerhalb 24 Stunden sahen und wie ich von Google zensiert wurde

Innerhalb von 24 Stunden startete ich die folgenden Kampagnen mit den Schlüsselbegriffen „symptom", „dream", „mary" und „money".

Während der vierten Kampagne erhielt ich folgende E-Mails von Google:
„Wir glauben, dass der Inhalt Ihrer Anzeige den Inhalt Ihrer Website nicht korrekt widerspiegelt. Wir schlagen vor, Sie überarbeiten den Anzeigentext so, dass er die Art der von Ihnen angebotenen Produkte präzise darstellt. Dies verhilft Ihrer Kampagne zu mehr Effizienz und erhöht Ihre Umsetzungsrate. Außerdem empfehlen wir, Ihre spezifischen Schlüsselbegriffe in die erste Zeile Ihrer Anzeige einzubinden, denn das würde die User eher auf Ihre Website locken."

Dann bekam ich eine automatisch erstellte Mail:

„Hallo. Ich bin der automatisierte Performance-Monitor von *Google AdWords Select*. Meine Aufgabe ist es, die durchschnittlichen Anklickraten so hoch wie möglich zu halten, damit die Benutzer sich darauf verlassen können, dass AdWords-Anzeigen ihnen helfen, Produkte und Dienstleistungen zu finden. Die letzten 1000 Page Impressions Ihrer Anzeige, die ich für Ihre Kampagne(n) eingeblendet habe, erhielten weniger als fünf Klicks. Wenn ich Ergebnisse wie dieses finde, reduziere ich die Einblendungsfrequenz für diese Anzeigen signifikant, damit Sie Änderungen zur Verbesserung der Leistung vornehmen können. Hochachtungsvoll, Ihr Google AdWords Automated Performance Monitor."

Zuletzt wurden meine Anzeigen abgelehnt und meine Kampagnen suspendiert.

How 12,000 people saw my "poems" in 24 hours and how I was censored by Google.

In 24 hours, I launched the following campaigns, with the keywords "symptom", "dream", "mary", "money".

During the fourth campaign, I kept receiving these emails from Google: "We believe that the content of your ad does not accurately reflect the content of your website. We suggest that you edit your ad text to precisely indicate the nature of the products you offer. This will help to create a more effective campaign and to increase your conversion rate. We also recommend that you insert your specific keywords into the first line of your ad, as this tends to attract viewers to your website."

Then I got a last email:

"Hello. I am the automated performance monitor for *Google AdWords Select*. My job is to keep average clickthrough rates at a high level, so that users can consistently count on AdWords ads to help them find products and services. The last 1,000 ad impressions I served to your campaign(s) received fewer than five clicks. When I see results like this, I significantly reduce the rate at which I show the ads so you can make changes to improve performance. Sincerely, The Google AdWords Automated Performance Monitor."

My ads were then disapproved and my campaigns were suspended.

Christophe Bruno (F) is an artist whose work is focussed on art happenings and poetics on the Internet. His works have been shown internationally at festivals and museums. He has established two websites: *http://unbehagen.com* and *http://iterature.com*. **Christophe Bruno (F)** ist ein Künstler, dessen Werk sich vor allem auf Kunsthappenings und Poesie im Internet konzentriert. Seine Arbeiten wurden international bei Festivals und in Museen gezeigt. Er betreibt zwei Websites, *http://unbehagen.com* und *http://iterature.com*.

InsertSilence
Amit Pitaru / James Paterson

For the past two years, Amit Pitaru and James Paterson have been collaborating under the name *InsertSilence*. During this time, they have developed a unique process to communicate with each other, extending beyond the traditional means in which a musician (Amit) and visual-artist (James) would usually collaborate. *Insertsilence.com* holds a variety of projects—snapshots that depict the evolution of this relationship.

InsertSilence have exhibited in London, NYC, San Francisco, Barcelona, Paris, Seoul, Amsterdam and Milan. Their work has been recognized by such magazines as *Zoo Quarterly*, *Surface*, *Dazed & Confused*, *Creative Review*, *Shift*, *Create Online*, *Impress Korea*, *PDN / PIX* and *Res* among others. They have also taken part in exhibitions at the Design Museum in London, and the Seoul Metropolitan Museum of Art.

Die letzten beiden Jahre lang haben Amit Pitaru und James Paterson unter dem Namen „InsertSilence" zusammengearbeitet. In dieser Zeit haben sie einen einzigartigen Prozess zur Kommunikation miteinander entwickelt, der weit über jene traditionellen Bereiche hinausgeht, in denen ein Musiker (Amit) und ein visueller Künstler (James) normalerweise zusammenarbeiten würden. *Insertsilence.com* enthält eine Vielzahl von Projekten – Schnappschüsse, die die Entwicklung dieser Beziehung darstellen.

InsertSilence haben in London, New York, San Francisco, Barcelona, Paris, Seoul, Amsterdam und Mailand ausgestellt. Über ihre Arbeiten wurden unter anderem in Zeitschriften wie *Zoo Quarterly*, *Surface*, *Dazed & Confused*, *Creative Review*, *Shift*, *Create Online*, *Impress Korea*, *PDN / PIX* und *Res* berichtet. Daneben haben die beiden auch an Ausstellungen am Design Museum in London und am Seoul Metropolitan Museum of Art teilgenommen.

Amit Pitaru (IL), born 1974, received training in composition and piano. In 1997 he moved to New York. Amit teaches at Pratt Institute as well as for New York University's Interactive Telecommunications Program. **James Paterson (GB)**, born 1980, moved to Canada in 1988. After studying drawing and printmaking for six years in Toronto and Halifax James left his BFA part way through to pursue a job in NYC as a design technologist. Aside from his involvement with *InsertSilence*, James exists online at *Presstube.com* and *Halfempty.com*. **Amit Pitaru (IL)**, geb. 1974, studierte Komposition und Klavier. 1997 übersiedelte er nach New York. Er unterrichtet am Pratt Institute sowie am Interactive Telecommunications Program der New York University. **James Paterson (UK)**, geb. 1980, brach sein Studium der Zeichnung und Drucktechnik in Toronto und Halifax ab und nahm in New York einen Job als Design Technologist an. Neben seiner Arbeit für InsertSilence existiert James online auch bei *Presstube.com* und *Halfempty.com*.

Bzzzpeek.com
Agathe Jacquillat / Tomi Vollauschek / FL@33

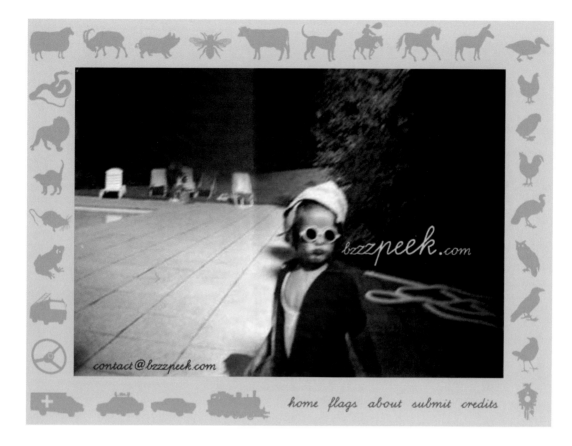

Bzzzpeek.com is presenting a collection of "onomatopoeia" from around the world using sound recordings from native speakers imitating the sounds of mainly animals and vehicles. This self-initiated project by London-based design studio *FL@33* focuses on the pronunciation and comparison of these sounds by presenting them side by side as each language expresses them differently. *Bzzzpeek.com* is an interactive experience inviting everybody to contribute. Submissions of additional recordings representing missing languages are more than welcome. Concept generation and design have been developed with a family experience in mind. The menu is easy to use and is based on a mainly visual approach to invite a truly international audience to interact. Our audience is mainly families, teachers / educational institutions, designers / artists and musicians / sound artists. Since its launch in September 2002 *bzzzpeek.com*

Bzzzpeek.com präsentiert eine Sammlung von Onomatopoeia aus der ganzen Welt und verwendet dafür Tonaufzeichnungen von Sprechern, die in ihrer Muttersprache Geräusche von Tieren und Fahrzeugen imitieren. Dieses vom Londoner Designstudio FL@33 initiierte Projekt konzentriert sich auf die Wiedergabe und den Vergleich dieser Klänge, indem es sie nebeneinander stellt, um deutlich zu machen, dass jede Sprache diese Geräusche unterschiedlich ausdrückt. *Bzzzpeek.com* ist eine interaktive Erfahrung, die alle zum Mitmachen einlädt. Die Zusendung weiterer Aufnahmen vor allem mit fehlenden Sprachen ist mehr als willkommen.
Konzept und Gestaltung wurden mit Hinblick auf Familienfreundlichkeit gestaltet. Das Menü ist einfach zu bedienen und vor allem grafisch aufgebaut, um ein internationales Publikum in die Interaktion einbinden zu können. Unser Publikum besteht vor allem aus Familien, Lehrern und Bildungseinrichtungen, Designern und Künstlern, Musikern und Klangkünstlern.

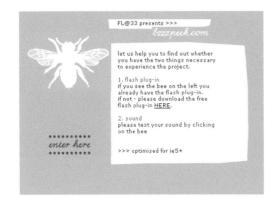

Seit seinem Start im September 2002 wurde *bzzzpeek.com* mit dem Distinctive Merit Award des Art Directors Club New York (ADCNY) ausgezeichnet und war in Hunderten von Publikationen und Websites wie *howdesign.com, yahoo.com, usatoday.com, TimeOut New York, Parisian Radio Nova* jeweils Website des Tages, der Woche oder des Monats.

has been awarded the Distinctive Merit Award by the Art Directors Club New York (ADCNY) and has been site of the day, week and/or month in hundreds of publications and websites such as *howdesign.com, yahoo.com, usatoday.com, Time-Out New York, Parisian Radio Nova*, amongst others.

FL@33 is a multidisciplinary design studio for visual communication founded in July 2001 by **Agathe Jacquillat (F)** and **Tomi Vollauschek (A)**. The multilingual and multi-specialised graphic design team is based in London. Concept Generation, Print, Screen-based Work, Motion Graphics, Exhibition Design and Publishing are keywords to describe the areas the studio is working in. The award-winning team met in 1999 while studying at the post-graduate Communication, Art and Design course at the Royal College of Art, London. **FL@33** ist ein im Juli 2001 von **Agathe Jacquillat (F)** und **Tomi Vollauschek (A)** gegründetes interdisziplinäres Design-studio für visuelle Kommunikation. Das mehrsprachige und vielseitige Designteam ist in London beheimatet. Konzeptentwicklung, Druck, Bildschirm-Arbeiten, Motion Graphics, Ausstellungsdesign und Publikationen sind die Schlüsselwörter, die das Tätigkeitsfeld des Studios beschreiben. Das preisgekrönte Team traf 1999 zusammen, als seine Mitglieder den Post-Graduate Communication Art and Design-Kurs am Londoner Royal College of Art in London besuchten.

Levitated.net
Jared Tarbell / Lola Brine

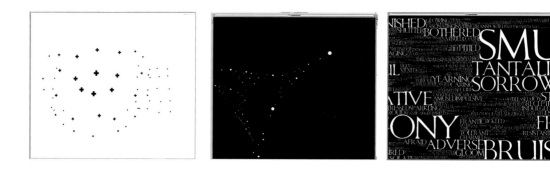

Levitated.net contains visual poetry and science fun narrated in an object oriented graphic environment. The sketches and applications generated as a byproduct of research are provided online as open source Flash modules.

Levitated.net actively engages in the installation of computational structures in and around Austin, TX. The purpose of these structures is to enlighten and inspire while also providing a stable income from which to continue research. In the studio, *Levitated.net* experiments with large, geodesic interfacing structures intended to bring the computational experience closer to the participant.

The webpages of *Levitated.net* are attempting to fasten a usable structure around a continually evolving computational ecology, so that it may be observed and enjoyed by participants of the network.

Levitated.net enthält visuelle Poesie und wissenschaftliche Scherze, die über ein objektorientiertes grafisches Environment transportiert werden. Die als Nebenprodukte der Forschung generierten Skizzen und Anwendungen werden als Open-Source-Flash-Module zur Verfügung gestellt.

Levitated.net engagiert sich aktiv in der Installation von Computerstrukturen in und um Austin, Texas. Diese Infrastruktur soll einerseits bildend und inspirierend sein, andererseits als solide Einkommensquelle dienen, um weitere Forschungen zu ermöglichen. Im Studio experimentiert *Levitated.net* mit großen geodäsischen Interface-Strukturen, die die Computererfahrung näher an den Anwender bringen sollen.

Die Webseiten von *Levitated.net* versuchen, eine nutzbare Struktur rund um eine sich ständig weiterentwickelnde Computer-Ökologie aufzubauen, sodass diese von den Mitwirkenden im Netzwerk betrachtet und genossen werden kann.

Jared Tarbell (USA) holds a Bachelor of Science in Computer Science from New Mexico State University. He participates in the growth of the digital arts community by sitting on the board of the Austin Museum of Digital Art. Jared most enjoys the surprisingly complex structures formed through generative construction techniques. Currently he is a computational artisan laying logical brickwork around trees and other organic surfaces in Austin, TX. **Lola Brine (USA)** constructs narrative and environmental spaces and is responsible for several algorithmic agitations on levitated.net. **Jared Tarbell (USA)** graduierte zum Bachelor of Science aus Informatik an der New Mexico State University. Als Vorstandsmitglied des Austin Museum of Digital Art ist er am Wachstum der Digital Arts Community beteiligt. Jared genießt besonders die überraschend komplexen Strukturen, die durch generative Konstruktionstechniken entstehen. Derzeit ist er als Computerhandwerker tätig, der logische Bausteine rund um Bäume und andere organische Oberflächen in Austin, Texas, legt. **Laura Brine (USA)** konstruiert narrative und Umwelträume und ist für einige Algorithmen von *levitated.net* verantwortlich.

Unmovie

Axel Heide / onesandzeros / Philip Pocock / Gregor Stehle

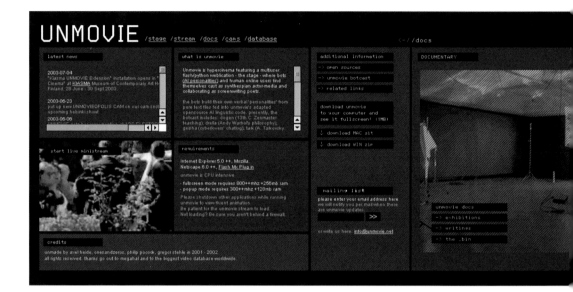

Unmovie is hypercinema featuring a multiuser flash / python weblication—the stage—where bots (AI personalities) and human online users find themselves cast as synthespian actor-media and collaborating as screenwriting poets.

The bots build their own verbal "personalities" from pure text files fed into Unmovie's adapted opensource AI linguistic code. Presently, the "botcast" includes: dogen (13th C. Zenmaster teaching), geisha (cyberlovers' chatlog), tark (A. Tarkovsky film theory), drella (A. Warhol philosophy) and zimi (Bob Dylan lyrics). Since bot "brains" are exchangable, new "actor-media" bots may arrive on stage for interaction with users soon. Stay tuned.

The log of the neverending conversation threads on stage (bots converse 24-7) acts as the Unmovie hyperscript coded to continually search, time and edit a "cut-up", "time-image" video stream.

Unmovie ist Hyperkino mit einer Multi-User Flash-/Python Weblication – die Bühne, auf der sich Bots (KI-Gestalten) und menschliche Online-User als synthespische Schauspieler-Medien wiederfinden und als Drehbuchpoeten zusammenarbeiten.

Die Bots bauen ihre eigenen verbalen „Persönlichkeiten" aus reinen Textfiles auf, die in Unmovies adaptierten linguistischen Open-Source-Code eingespeist werden. Derzeit umfasst die Besetzungliste der Bots: Dogen (die Lehren des Zen-Meisters aus dem 13. Jahrhundert), Geisha (Chat-log für Cyberliebhaber), Tark (Tarkowkysche Filmtheorie), Drella (Warholsche Philosophie) und Zimi (Texte von Bob Dylan). Da die „Gehirne" der Bots austauschbar sind, können auch bald neue „Medien-Schauspieler" (Bots) zur Interaktion mit den Unsern auftauchen. Bleiben Sie dran!

Das Log der unendlichen Konversations-Threads auf der Bühne (die Bots unterhalten sich rund um die Uhr, sieben Tage die Woche) dient als Hyperscript von Unmovie und

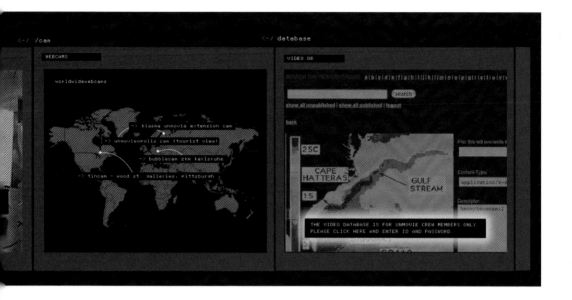

wird so kodiert, dass es ständig einen „aufgeschnittenen" „Zeit-Bild"-Videostream durchsucht, taktet und schneidet. Aus dem Log, der von Bots und Usern auf der Bühne produziert wird, kristallisieren sich beim Auftauchen von Themen „Szenen" heraus, die Schlüsselwörter aussenden, aus denen sofort Abfragen an die Video-Datenbank von *Unmovie* getätigt werden. Die Datenbank enthält „gefundene" Net-Videoclips samt assoziativer und konkreter Beschreibung, aus denen eine passende Playlist erstellt und gestreamt wird. Solange sich also auf der Bühne „was tut", liefert *Unmovie* endlose Videoströme. Nehmen Sie auf der Bühne teil und genießen Sie den Videostrom!

From the log produced by the bots and users on stage, "scenes" crystallize as topics emerge, sending keywords to instantly query and build fitting visual playlists and stream them from the *Unmovie* video database, where a growing collection of "found" net video clips have been associatively and concretely described. As long as there is "action" on stage, *Unmovie* streams endlessly. Participate on stage. Enjoy the stream.

Axel Heide (D), born 1972, datatect, based in Stuttgart. **onesandzeros (D)**: Thorsten Klöpfer, born 1974, is working in a design studio in Switzerland, Oliver Kauselmann, born 1976, is working as a freelancer for Fork Unstable Media Hamburg. **Philip Pocock (CDN / D)**, born 1954, artist, based in Karlsruhe. **Gregor Stehle (D)**, born 1973, artist, based in Alsace. **Axel Heide (D)**, geb. 1972, Datatect, arbeitet in Stuttgart. **onesandzeros (D)**: Thorsten Klöpfer, geb. 1974, arbeitet bei Designstudios in der Schweiz; Oliver Kauselmann, geb. 1976, arbeitet freiberuflich für Fork Unstable Media in Hamburg. **Philip Pocock (CDN / D)**, geb. 1954, Künstler, arbeitet in Karlsruhe. **Gregor Stehle (D)**, geb. 1973, Künstler, arbeitet im Elsass.

Flow
Wiggle / Han Hoogerbrugge

Flow is the first collaboration between Dutch artist Han Hoogerbrugge and Internet band Wiggle.

Designed to be an interactive music clip, the music and sound are both non-linear. The musical phrases and visuals change to the user's actions, making the music video conform to each and every user.

It includes guest vocals by Tatsuya Yoshida of Tokyo's legendary Prog-Punk duo, "The RUINS."

Flow is at: *www.unsound.com/flow/*, Hoogerbrugge is at *www.hoogerbrugge.com*, Wiggle is at *www.wiggle.info*.

Flow ist die erste Kooperation zwischen dem niederländischen Künstler Han Hoogerbrugge und der Internet-Band Wiggle.

Da das Werk als interaktiver Musik-Clip angelegt ist, sind Musik und Klang nicht-linear. Die musikalischen Phrasen und die Bildwelt verändern sich bei und mit den Aktionen der User und passen so das Musikvideo jedem einzelnen Nutzer an.

Gastvokalist ist Tasuya Yoshida von Tokios legendärem Prog-Punk-Duo „The RUINS".

Flow findet man unter *www.unsound.com/flow*, Hoogerbrugge unter *www.hoogerbrugge.com* und Wiggle unter *www.wiggle.info*.

Wiggle (J) is a Net collaboration between five musicians located in Tokyo, San Francisco, and Perth. Though they have a deal with a major record label, all the members have yet to meet in the flesh. **Han Hoogerbrugge (NL)**, born 1963 in Rotterdam, Netherlands has been a visual artist since 1983 and dedicated to (web)animation since 1997.

Wiggle (J) ist eine Net-Kollaboration zwischen fünf Musikern, die in Tokio, San Francisco und Perth beheimatet sind. Selbst wenn sie eine Vereinbarung mit einem größeren Plattenlabel haben, haben sich die Mitglieder noch niemals leibhaftig getroffen. **Han Hoogerbrugge (NL)**, geboren 1963 in Rotterdam, ist seit 1983 visueller Künstler und widmet sich seit 1997 der (Web-) Animation.

KNOCK OUT

Since and even well before the 11th of September, laws have been passed in the United States and in Europe that permit certain nations to keep all e-mail traffic under close surveillance. This has also happened in Switzerland. For more than a year now, Swiss providers have been required by law to retain telecommunications data for six months and, if required by a judge, to arrange the real-time interception of the email communication of their customers. It is the consequence of these advanced surveillance practices that the question is no longer: Who? Where? What? but: What not? Fears are being fueled and "enemy" profiles established.

SuPerVillainizer is an interactive web project aimed against the establishment of the enemy profiles that these data retention surveillance scenarios are based on. Through the generating of artificial villains, *SuPerVillainizer* is questioning the prevalent notion of "friend" and "enemy": *SuPerVillainizer* is about creating profiles of

Seit dem 11. September 2001 haben die USA und die Europäische Union Gesetze erlassen, mit deren Hilfe der E-Mail-Verkehr lückenlos überwacht werden kann. Das ist auch in der Schweiz passiert. Seit mehr als einem Jahr sind Schweizer Provider gesetzlich verpflichtet, E-Mail- und andere Verbindungsdaten für sechs Monate zu speichern und auf richterlichen Erlass Echtzeitüberwachungen des Email-Verkehrs ihrer Kunden durchzuführen. Es ist die Konsequenz dieses fortgeschrittenen Überwachungsstaates, dass nicht mehr gefragt wird: Wer? Was? Wo? Sondern: Was nicht? Ängste werden geschürt und Feindbilder geschaffen.

SuPerVillainizer ist ein interaktives Webprojekt, das sich gegen das Denken in Feindbildern richtet, wie sie diesen neuen Überwachungsszenarien zugrunde liegen. Durch das Generieren von künstlichen Bösewichten („Villains") stellt *SuPerVillainizer* die gängige Vorstellung von „Freund" und „Feind" in Frage: Bei *SuPerVillainizer* geht es darum, Profile von Bösewichten, Schurken und Sündenböcken anzulegen, diese mit echten E-Mail-Konten bei Schweizer Providern auszustatten, sie zu

„Verschwörungen" zu verschalten und dann zuzuschauen, wie die Schurken beginnen, sich mit dem von *SuPerVillainizer* generierten Verschwörungscontent zu bemailen. Der Inhalt der verschwörerischen Mails kann mitbeeinflusst, die Verschwörungssprache gewählt werden. So werden die sorgfältig geplanten Überwachungsdatenbanken mit verschwörerischen Beziehungen infiltriert, verwirrt und angefüllt.

Dadurch, dass echte E-Mail-Konten bei einem Schweizer Provider erzeugt und über verschiedene SMTP-Server echte Mails verschickt und von anderen ebenfalls echten E-Mail-Konten empfangen werden, findet das Spiel in der Realität statt. Das eröffnet natürlich auch die Möglichkeit realer Konsequenzen, sollten die Behörden auf den fiktiven Verschwörungscontent beziehungsweise die realen Verschwörungsbeziehungen hereinfallen.

Ziel des Projekts ist das Obsoletmachen von Feindbildern. Die Welt besteht nicht aus Gut und Böse, wie uns derzeit erfolgreich glaubhaft gemacht werden soll (Beispiel: „War on Terrorism"). Gegen diese unangemessene Personifizierung („Freund / Feind") richtet sich *SuPerVillainizer* und gegen das vorherrschende Schwarz-Weiß-Denken: Viele Feindbilder koexistieren in einem *SuPerVillainizer*-Environment: Alle können potenzielle Schurken werden: Bush kann mit Bin Laden zu einer Verschwörung zusammengeschaltet werden, Herr Müller von nebenan mit Saddam. Man kann auch sich selber zum „SuperVillain" deklarieren und schauen, was passiert. Hier wird das Überwachungssystem ad absurdum geführt, weil es ja gerade annimmt, dass jeder und jede potenziell verdächtig ist.

villains, rogues, bad guys, and scapegoats, equipping them with real email accounts at a Swiss provider, uniting them into conspiracies, and then watching as the villains start to automatically communicate with each other using *SuPerVillainizer*-generated conspiracy content, infiltrating the carefully planned surveillance system with more and more disinforming mails every day. This conspiracy mail content can be influenced, the conspiracy language chosen.

Because real email accounts at a real Swiss provider are being generated, and real mails are being sent using several SMTP-servers, the game is in reality taking place. This opens up the possibility of real consequences should the authorities fall for the fictional content or the real conspiratorial connections between the accounts. Moreover, this conspiratorial email traffic is not to be limited to Switzerland only: concerned email-users can "donate" the email accounts they do not want to use (anymore). The accounts are integrated into the conspiracies and should be set to "AutoReply" if possible, so that an automated dialogue between the conspiring villains and the donated account evolves.

It is the goal of the project to render the aforementioned enemy profiles obsolete. The world does not consist only of good and evil as some people would like us to believe (example: "War on Terrorism"). *SuPerVillainizer* calls concerned people to act against this inadequate personalization (friend / enemy) and against the predominant black-and-white-thinking: many "enemy"-profiles coexist in the *SuPerVillainizer* environment and everyone can potentially become a villain: Bush conspires with Osama Bin Laden, a member of the Swiss federal council plots to contaminate water supplies together with Saddam Hussein. Everyone can declare themselves "SuPerVillains" and join a conspiracy. Here, the surveillance-system is being rendered absurd because it actually assumes that everybody is a potential criminal.

LAN (CH). Students, designers, artists, and media workers are operating under this name in varying compositions. They have lived and worked in Zurich, Switzerland, since 2001. Unter dem Label **LAN (CH)** agieren in wechselnder Zusammensetzung junge GestalterInnen, KünstlerInnen, StudentInnen und MedienarbeiterInnen. Wir leben und arbeiten seit 2001 in Zürich.

TraceNoizer
LAN

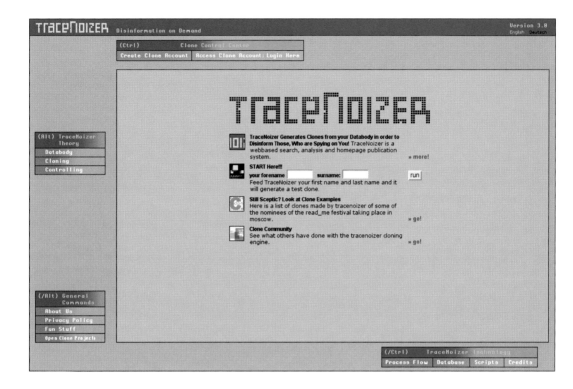

What is *TraceNoizer*?

TraceNoizer – Disinformation on Demand calls attention to the issue of electronic surveillance on the Internet and as a service offers a strategy to counter it. There is information about most people in the Internet. We call that the databody. Often, one cannot delete this information. To protect this data, one has to systematically falsify this information. *TraceNoizer* does exactly that: it offers the opportunity to clone the databody, disperse the clones throughout the Internet and therefore make relevant Information difficult to pinpoint: spreading disinformation as a disguise.

Was ist *TraceNoizer*?

TraceNoizer – Desinformation on Demand lenkt das Augenmerk auf Fragen der elektronischen Überwachung im Internet und bietet als Dienstleistung eine Strategie an, um dem entgegenzuwirken. Im Internet findet man Informationen über die meisten Menschen. Wir nennen das den „Datenkörper". Häufig kann man diese Information nicht löschen. Um die Daten zu schützen, muss man sie daher systematisch verfälschen, und *TraceNoizer* bietet genau das: eine Möglichkeit, den „Datenkörper zu klonen, die Klones übers Internet zu verteilen und es somit schwer zu machen, relevante Daten festzunageln – kurzum, Desinformation als Verkleidung zu verbreiten.

Wie verwendet man *TraceNoizer*?

Zunächst gibt man seinen Vor- und Zunamen in das Formular auf der *TraceNoizer*-Homepage ein, dann klickt man auf „Feed". *TraceNoizer* sucht nach Informationen, die mit dem eingegebenen Vor- und Zunamen im Internet verknüpft sind, und analysiert sie mit statistischen Verfahren. Zuletzt generiert *TraceNoizer* eine persönliche Homepage für den Anwender, die mit dem angegebenen Namen verbundene Texte und Bilder in thematischer Aufgliederung enthält.

Wenn man mit dieser Site einverstanden ist, gibt es die Möglichkeit, sie automatisch auf einen Webserver hochzuladen, der kostenlosen Webspace anbietet (etwa yahoo geocities, *www.geocities.com*). Gleichzeitig wird die URL dieser Homepage an die Indizierungs-Bots der diversen Suchmaschinen weitergegeben. Innerhalb weniger Wochen sollte dann die Klon-Site in den Ergebnissen auftauchen, wann immer jemand eine Suchmaschine mit Ihrem Namen füttert. Aber das ist noch nicht alles: Damit das Suchergebnis sich wirklich verändert, müssen weitere falsche Spuren gelegt werden. Deswegen wird *TraceNoizer* weitere Klonseiten generieren, die sich alle minimal voneinander unterscheiden. Auch diese werden automatisch auf freie Webserver geladen und ihre URLs an die Indizierungs-Bots weitergegeben. Durch die enge thematische Beziehung zwischen Information und Desinformation wird es unmöglich, zwischen den beiden zu unterscheiden, wodurch der Datenkörper erfolgreich verkleidet wird.

Wie steuert man seine Klonseiten? Kann man sie löschen?

Die Klonseiten werden über das Clone Control Center administriert. Bevor man seine Seite auf einen freien Webserver uploadet, muss man Usernamen, Passwort sowie E-Mail-Adresse angeben. Mit Hilfe des Usernamens und des Passworts man dann jederzeit in sein persönliches Clone Control Center einloggen. Es erlaubt einem, die strukturelle Komposition des eigenen Klons zu betrachten und bietet einen Link zur Klonseite ebenso an wie ein Instrument zur Löschung von Klons, die nicht den Erwartungen entsprechen. Die E-Mail-Adresse ist erforderlich, um dem User automatisch die Links zu den eigenen Klonseiten zusenden zu können.

How do I use *TraceNoizer*?

First, enter your first name and your last name into the form on the *TraceNoizer* homepage, then click on "Feed". *TraceNoizer* searches for information connected to your first name and surname on the Internet, then analyzes it using statistical means. Finally *TraceNoizer* generates a personal homepage for you. This homepage contains text and pictures connected to your name which are structured in a thematic manner.

If you agree with this page you have the option of automatically uploading it on a webserver offering free webspace(like yahoo geocities *http://www.geocities.com*). At the same time, the URL of this homepage will be passed on to search-engine indexing robots. Within a few weeks the clone-page should surface in the result if someone queries a search engine with your name. But this is not enough. So that the search-result really changes more false tracks need to be laid. Therefore *TraceNoizer* will generate more clone-pages, which all differ minimally. They are loaded automatically on servers offering free webspace, their URLs are passed on to the indexing robots. In this way the databody is continuously being adulterated with thematically related information and disinformation. Because of the close thematical relation between information and disinformation, one cannot distinguish one from the other and the databody is successfully disguised.

How do I control my clone-pages? Can I delete them?

You administer your clone-pages through the Clone Control Center. Before uploading your page on a free webserver, you are asked to enter a username and a password as well as an email address. Using the username and password you can log into your personal Clone Control Center at any time. It allows you to view the structural composition of your clone and also provides a link to the clone-page as well as an instrument to delete clones which do not fulfill your expectations. The email address is needed to automatically send you the links to your clone-pages.

LAN (CH). Students, designers, artists, and media workers are operating under this name in varying compositions. They have lived and worked in Zurich, Switzerland, since 2001. **LAN (CH).** Unter diesem Label arbeiten seit 2001 Studenten, Designer, Künstler und Medienarbeiter in unterschiedlicher Zusammensetzung. Wir leben und arbeiten in Zürich.

Seit 2002 hinterfrägt das Last.Team die Beziehung zwischen digitalem Inhalt und digitalem Kontext, wobei eine Vielzahl kontroversieller Techniken in einer künstlerischen Umgebung eingesetzt wird. Nach über einem Jahr entstand eine kollaborative Online-Musik-Sharing- und -Streaming-Station, die den individuellen Musikgeschmack des Users analysiert und in einen Kontext mit allen anderen Usern auf *Last.fm* stellt.

Besonders Fragen der Datensicherheit und des Copyrights werden aufgeworfen, da *Last.fm* hoch entwickelte Datensuchwerkzeuge bereitstellt, die auf einer Open-Data/Open-Source-Basis angeboten werden. *Last.fm* ist eine Online-Musik-Sharing- und Multicasting-Station, die ProfileNavigation einsetzt, eine innovative Musik-Navigationsmethode, die auf Technologien zu Erstellung von Profilen, kollaborativen Filtermethoden und Empfehlungen basiert. ProfileNavigation zeichnet die Musikvorlieben der User von *Last.fm* auf. *Last.fm* verbindet User mit ähnlichen Profilen zu Mikro-Gemeinschaften mit vergleichbarem Musikgeschmack. Darauf baut ein leistungsfähiges Musik-Navigationstool auf: Der jeweilige Benutzer kann die Beziehung des eigenen Musikgeschmacks zu jenem der anderen Anwender festlegen. ProfileNavigation erlaubt ein Profil-Surfen, das heißt das Hin- und Herspringen zwischen diesen Micro-Communities unterschiedlichen Musikgeschmacks.

Die Summe aller Profil-Cluster bildet die „MusicMap", die alle Musiktitel und alle User auf *Last.fm* verbindet und die Basis für die offene Datenbank darstellt. Jeder Benutzer von *Last.fm* hat sein eigenes Geschmacksprofil, das er mit der *Last.fm*-Community teilen kann. Kurzum – bei *Last.fm* geht es eher um den gemeinsamen Geschmack als um den Austausch von MP3s, *Last.fm* handelt vom Kontext der Musik und nicht von ihrem Inhalt.

Since 2002, the Last.Team has been questioning the relationship between digital content and digital context by utilizing a number of controversial technologies in an artistic environment. After more than one year, the result is a collaborative online music sharing and streaming station, which analyses a user's individual music taste and puts it into context with all other users on *Last.fm*.

Privacy and copyright issues are challenged in particular, because *Last.fm* provides sophisticated data mining tools and makes them available on an open data / open source basis. *Last.fm* is an online music sharing and multicasting station which is utilizing ProfileNavigation, an innovative music navigation method based on profiling, collaborative filtering and recommendation technologies. ProfileNavigation is profiling users' musical preferences on *Last.fm*. *Last.fm* connects users with similar profiles and clusters these users in micro communities with similar music-taste. This is the basis of a powerful music navigation tool: The user is able to determine the relationship between her / his individual taste and all other users' taste. ProfileNavigation (profile-surfing) enables the user to jump in between these music-taste micro communities.

The sum of all profile clusters results in the Music-Map, which connects all music titles and users on *Last.fm*. It is the source for Last.fm's open data.

Every user on *Last.fm* has her / his own individual taste profile. She / he can share it with the *Last.fm* community. *Last.fm* is about sharing taste instead of sharing mp3s. *Last.fm* is about the context of music rather than the content.

Michael Breidenbrücker (D) studied electronics and information technologies. He worked as a freelance designer, as Director of the London based Secretforces and as Senior Lecturer at the Ravensbourne College in London. **Felix Miller (D)** studied Electrical and Mechanical Engineering before changing to Computational Linguistics at Munich University. Since 2000, he has been (together with Martin Stiksel) founder and director of the London based Insine Ltd., which is dedicated to innovative online music promotion and distribution concepts. **Martin Stiksel (A)** studied linguistics and Digital Sound and Music. Since 2000 he has been director of NBAW Audiovisual Design Ltd. in London, England. In 2001, Martin started working for Ravensbourne College as a Lecturer where he is currently doing an MA in Interactive Digital Media. **Michael Breidenbrücker (D)** studierte Elektronik und Informationstechnologie. Er arbeitete als freiberuflicher Designer, als Direktor der Londoner Secretforces und als Senior Lecturer am Ravensbourne College in London. **Felix Miller (D)** studierte Ingenieurwesen, bevor er auf Informatik (Computersprachen) an der Uni München umstieg. Seit 2000 ist er gemeinsam mit Martin Stiksel Gründer und Leiter der in London beheimateten Insine Ltd., die sich innovativer Online-Musik-Promotion und -Distribution verschrieben hat. **Martin Stiksel (A)** studierte Sprachwissenschaften sowie Digital Sound and Music. Seit 2000 ist er Leiter von NBAW Audiovisual Design Ltd. in London. 2001 begann er als Lektor am Ravensbourne College zu arbeiten, wo er derzeit seinen Master of Arts aus Interaktiven Digitalen Medien erwirbt.

PuppetTool
LeCielEstBleu

PuppetTool ist ein experimentelles Animationswerkzeug, das es den Usern ermöglicht, hoch expressive Bewegungen ohne Einschränkung durch Schwerkraft oder Elastizität zu erzeugen. Die so entstehenden Animationen sind nicht linear, sondern zyklisch und generativ. Jeder User kann Ergebnisse erzielen, die vom beinahe Realistischen bis hin zum Absurden und Fantastischen reichen, und diese Kreationen dann einer Datenbank von User-Produkten hinzufügen. Der interaktive Zoo, eine Serie von sechs von uns selbst mit *PuppetTool* erzeugten interaktiven Filmen, bietet durch eine neuartige nichtlineare Erzählform, die immer vollkommen interaktiv bleibt, eine reiche narrative Erfahrung.

PuppetTool is an experimental animation tool that allows users to generate highly expressive movements unhindered by limits of gravity or elasticity. The animations created are not linear but rather cyclic and generative. Users can achieve personalized results ranging from the nearly realistic to the absurd and fantastic and then add their creations to an online database of user-generated creations. The interactive zoo, a series of our own six short interactive films produced with *PuppetTool*, offers a rich narrative experience through a new, non-linear kind of storytelling that remains totally interactive at every moment.

LeCielEstBleu (F) is a Paris-based laboratory of interactive art specialized in creating highly interactive interfaces. A civil engineer by training, Frederic Durieu (B) has been making multimedia and interactive art for over ten years. With a background in semiotics and photography, Kristine Maiden (USA) has been creating new media projects since graduating from the Interactive Telecommunications Program at NYU. Together with musician Jean-Jacques Birgs (F), they founded *LeCielEstBleu.com*, a site showcasing some of their more experimental work. **LeCielEstBleu (F)** ist ein in Paris beheimatetes Laboratorium für interaktive Kunst, das sich auf hoch interaktive Interfaces spezialisiert hat. Der gelernte Zivilingenieur Frederic Durieu (B) macht seit über einem Jahrzehnt interaktive und Multimediakunst. Kristine Maiden (USA) kommt von der Semiotik und Fotografie her und beschäftigt sich seit ihrem Studienabschluss beim Interactive Telecommuncations Program der New York University mit Projekten zu Neuen Medien. Gemeinsam mit dem Musiker Jean-Jacques Birgs (F) gründeten die beiden *LeCielEstBleu.com*, eine Site, die einige ihrer experimentelleren Arbeiten präsentiert.

Injunction Generator
ubermorgen

IP·NIC
Internet Partnership for No Internet Content

Universal Content and/or Domain Removal Form (UCDR)

Personal Data of Claimant

01	Email Address:	
02	Name of Person or Organization:	
03	Nationality:	United States

Involved Parties and Jurisdiction

04	Defendant - Target Website/Domain:	www_____ .com
05	Defendant: People and/or Organization:	
06	Plaintiff - Person(s) and/or Organization:	
07	Venue of Court, US State:	Select State
08	Venue of Court, US County:	<_____>
09	select kind of the Court Order:	⦿ temporary ○ preliminary
10	Legal Basis of Court Order:	State Rules
11	enter sections (plain numbers, best: 1-20):	12 , 9 , 18
12	enter subsections or articles (plain numbers, best: 101-785):	303 , 428 , 721 , 723

Crime and Misconduct Information

13	☑ defendants violate trade mark rights and/or copyrights by operating above-mentioned domain.	
14	☐ defendants violate the law by offering pornographic material to minors by operating above-mentioned domain.	
15	☑ defendants violate the law by making false promise to consumers by offering services they cannot deliver.	
16	☐ general criminal activity as defined by ICANN statutes.	
17	☐ other:	
18	timeframe: since when have crimes been comitted?	1 ▼ 1 ▼ 99 ▼
19	specific nature of crime:	○ pornography ○ slave/child labor ○ internet crimes ○ illegal MP3s ○ consumer fraud ○ trademarks and copyrights ○ corruption ○ child porn ○ hate crime ○ prostitution and slave trading ○ terrorist activity ○ biochemical warfare
20	Defendants have violated the law by .. :	
21	Defendants' use of the web site for the purpose of encouraging individuals to .. :	
22	.. and encouraging individuals to .. (FILL IN) constitutes a violation of US-laws:	
23	Defendants who will engage in .. (FILL IN) one duty for Plaintiffs not to violate the law.:	
24	Select which of these extras you also want to include (hint: use all):	☑ Plaintiffs possess certain and clearly demonstrated rights which need protection. ☑ Plaintiffs will suffer irreparable harm without protection of an injunction. ☑ There is no adequate remedy at law to compensate for Plaintiffs' injuries. ☑ In the absence of injunctive relief, the Plaintiffs would suffer greater harm without an injunction than Defendants will suffer if it is issued. ☑ Defendant have been notice of the Plaintiffs' Emergency Motion for a Temporary Restraining Order.

Judge's Order

Defendants and all acting in concert with them are enjoined from:

25	☑ Using or operating above-mentioned Internet website and domain.
26	☑ Using, operating, facilitating or accessing above-mentioned domain name and to remove such web site from the Internet completely or, in the alternative, to modify the above-mentioned Internet web site as so as to remove any illegal content.
27	☑ Allowing or continuing registration of above-mentioned Internet domain name or any other domain name offering substantially the same service as above-mentioned site.
28	☐ Using or operating any Internet web site by any name in any manner that would violate the prohibitions set forth in this document and/or violate the laws as stipulated above.
29	☐ other?
30	Defendants shall within [10] days report to the court on the measures they have taken to implement this order:

Publication and Handling:

31	send this Order to these Email Addresses:	
32	Handle my personal information:	○ share with journalists ○ share with police etc. ○ do not share
33	☐ I want to receive a printed and stamped copy of this Court Order (this involves costs, you can revoke this option anytime).	
34	Are there any Messages you want to send to IP·NIC or ubermorgen?	

[Send your injunction]

Notes to the UCDR

01	We use your Email Address to inform you of the status of your injunction.
02	We need this information for basic statistics.
04	Enter the Website you want to be taken down.
05	Enter the People or Company behind the site. If you do not know this information, leave this empty, we will fill it in for you.
06	(Kläger, Person suing) this can be anyone, you yourself, another company.
07	Make up a US-Court - Use something like Court of Cook County. Note: Use Google to locate a court in a specific US-State.
08	Something like "Division of Internet Crime" or "Department of Civil Law", etc.
09	Select your favorite order.
19	By selecting one of the proposed crimes, you get some default texts in the text areas below. Select the crime you feel most comfortable with, or the one that suits best for the site you are targeting.
20	You can either leave these texts the way they are, or you can adapt them in any way you want, but try to use proper english.
21	Same as above.
22	Same as above.
23	Same as above.

Eine Dienstleistung von ubermorgen.com via IPNIC.org

Gibt es eine Website, die Sie – mit Hilfe einer höchst subversiven Methode – gerne vom Netz nehmen lassen würden?
Auf unserem Server generieren Sie automatisch eine standardmäßige „gerichtliche Verfügung" (im PDF- oder RTF-Format), in der behauptet wird, die betroffene Website agiere auf illegaler Basis. Dieses Dokument wird anschließend an den zuständigen DNS-Registrar [DNS = Domain Name Service], den Eigner der Website sowie möglicherweise einige Journalisten zur weiteren Veranlassung übersandt. Alles, was Sie selbst zu tun haben, ist das Formular auszufüllen und abzusenden, was keine Viertelstunde in Anspruch nimmt. Sollte die Webseite tatsächlich vom Netz genommen werden, informieren wir Sie über E-Mail.
Diese äußerst nützliche Plattform [IPNIC] entwickelte sich aus unserem Projekt [V]ote-auction. Während der [V]ote-auction-Operation im Herbst 2001 erließ ein amerikanisches Gericht (Circuit Court von Cook County, Chicago) eine Einstweilige Verfügung gegen die „Individuen" (ubermorgen, James Baumgartner und andere) hinter [V]ote-auction. Diese Verfügung wurde dann per E-Mail an CORENIC, den DNS-Registrar in Genf (Schweiz), gesandt. Nach Erhalt der Verfügung beschloß CORENIC, alle DNS-Dienste betreffend die Domain vote-auction.com ohne Vorwarnung zu sperren. Nun gehört zwar die Schweiz eindeutig nicht in den Jurisdiktionsbereich eines amerikanischen Gerichts und es ist auch eine ordnungsgemäße Zustellung eines gerichtlichen Schriftstücks über E-Mail nicht möglich, aber dennoch waren wir offline ... Dank dieser kreativen Aktion und Reaktion wurden wir aber dazu inspiriert, diesen öffentlichen Webseiten-Schließungsdienst einzurichten.
Eine Dokumentation zu unserem [V]ote-auction „MEDIA HACK" finden Sie unter *http://vote-auction.net* oder in der Google-Datenbank.

A service brought to you by ubermorgen.com via IPNIC.org

Is there any web-site you wanna take off the web using a highly subversive method?
On our server, you auto-generate an "injunction" (.pdf /.rtf format), a standard court-order, claiming the target-website to operate on an illegal basis, this document will then be sent to the appropriate DNS-registrar [DNS = domain name service], to the owner of the web-site and possibly to some journalists for legal and public processing. All you have to do is to simply fill out a form and send it off: it will take you not more than 15 minutes; if the web-site is taken down we will inform you via email.
This very useful platform [ipnic] grew out of our project [V]ote-auction. During the [V]ote-auction operation in fall 2000, an American court [circuit court of Cook County, Chicago] issued a temporary injunction, against the "individuals" [ubermorgen, James Baumgartner, and others] behind [V]ote-auction. This injunction was then sent out per email to Corenic, the DNS-registrar in Geneva / Switzerland. After receiving this email, Corenic decided to shut down all DNS-services on the domain vote-auction.com without notice. The jurisdiction of an American court order does obviously not include Switzerland, the delivery of a court-order cannot be official via email; nevertheless we were offline but, thanks to this creative action and reaction, we were inspired to build a public shutdown-service.
You can find some documentation of our [V]ote-auction "MEDIA HACK" at *http://vote-auction.net* or check out the Google database.

E. Maria Haas aka lizvlx, studied Economy and Applied Arts in Vienna. In collaboration with Christoph Schlingensief she worked on projects for (among others) *micromusic.net* and *silverserver*, co-founder of ubermorgen. **Luzius A. Bernhard** aka hans_extrem aka etoy.HANS (CH / USA) studied Applied Arts in Vienna. He is (co-)founder of *[etoy.LABS]* and *etoy.TANKSYSTEM* (Golden Nica, Prix Ars Electronica). Both artists currently live in Vienna. **E. Maria Haas** alias lizvlx studierte Wirtschaft und Angewandte Kunst in Wien. Sie arbeitete mit Christoph Schlingensief, an Projekten für *micromusic.net* und *silverserver* (und andere) und ist Mitbegründerin von ubermorgen. **Luzius A. Bernhard** alias hans_extrem alias etoy.HANS (CH / USA) studierte Angewandte Kunst in Wien und ist Mitbegründer von [etoy.LABS] und etoy.TANKSYSTEM (Gewinner der Goldenen Nica, Prix Ars Electronica). Beide Künstler leben derzeit in Wien.

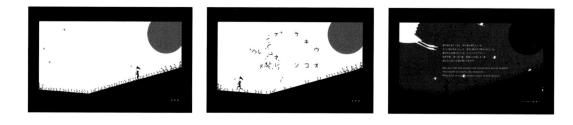

I once visited Japan's oldest private house with two other friends. We were sitting on a porch, doing nothing, when we saw water dropping from the straw-thatched roof. The image I had at the time made me want to create this work. In the beginning I put in sound, and it had color, so it was not monochrome. But after going through a number of processes, it became what it is like now. I dropped the sound and color in the course of assembling the concept. The Web has its unique way of stimulating the creation of works, one of which is that you can keep changing them to match the image you want to create. You can continue to add or subtract content indefinitely, instead of saying "OK, it's completed as is".

It may incorporate thousands of complex elements in the process stage, but the important thing is to simplify them in order to adequately express all the elements.

A work is not only there for people to look at; it is also there for me to have fun with. I want to show to other people something I myself enjoy making. This is the most important concept. It is totally meaningless to show to other people things that you find no fun looking at. By having many people look at my works, I can learn different ideas and ways of thinking.

Ich habe einmal gemeinsam mit zwei Freunden das älteste Haus Japans besichtigt. Wir saßen untätig auf dem Vorbau des Hauses und beobachteten das vom strohgedeckten Dach herabtropfende Wasser. Die Erinnerung an jenes Bild weckte in mir den Wunsch, *Sinplex* zu schaffen. Anfänglich war es in Farbe und mit Ton unterlegt, also keineswegs monochrom, aber nach ein paar Bearbeitungsschritten wurde es so, wie es sich jetzt präsentiert. Im Zuge der Umsetzung des Konzepts habe ich auf Sound und Farbe verzichtet. Das Web hat seine eigene Art, die Schaffung von Werken zu stimulieren, und dazu gehört die Möglichkeit, jederzeit die Arbeit verändern zu können, bis sie dem Bild entspricht, das einem vor Augen schwebt. Man kann unendlich lange Inhalt hinzufügen oder wegnehmen, ohne jemals an den Punkt zu geraten, an dem man sagen muss: Ok, das ist es jetzt. Es kann im Laufe des Prozesses Tausende komplexer Objekte enthalten, aber letztlich besteht der wichtigste Schritt darin, die Arbeit so weit zu vereinfachen, dass alle Elemente adäquat zum Ausdruck gelangen.

Ein Werk existiert nicht nur, damit andere es betrachten, sondern auch, damit ich selbst meinen Spaß daran habe. Ich möchte andern Leuten das zeigen, was mir zu schaffen Freude macht, und das ist das wichtigste Konzept. Es wäre völlig sinnlos, wollte man Dinge herzeigen, die einem selbst beim Betrachten keine Freude bereiten. Indem ich viele Leute meine Arbeit betrachten lasse, kann ich unterschiedliche Ideen und Denkweisen kennen lernen.

Shinya Yamamoto (J), born in 1978, lives in Kobe, Japan. Graduated from Kobe Art College in 2000. Left a printing company in 2000. In 2000 joined TGV Inc. in charge of graphics and Web design. Left the company in 2003. **Shinya Yamamoto (J)**, geb. 1978, lebt in Kobe, Japan. Studienabschluss am Kobe Art College 2000, Aufgabe der Beschäftigung bei einer Druckerei 2000 und Eintritt bei TGV Inc. im Bereich Grafik und Web Design. Er verließ das Unternehmen im Jahre 2003.

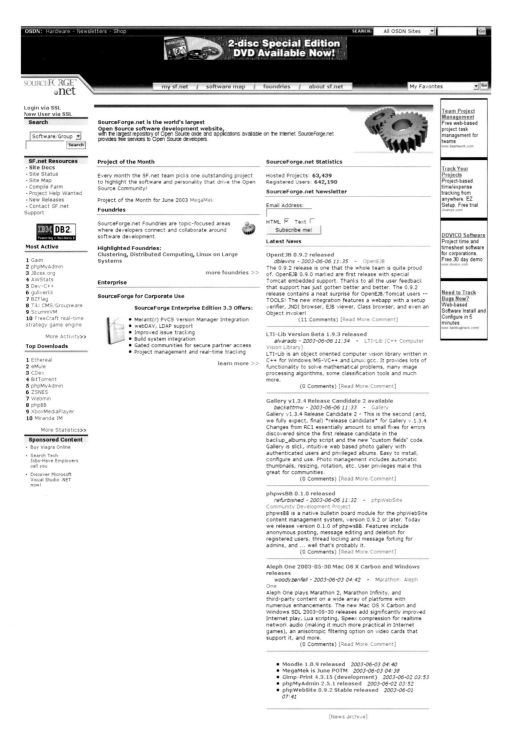

OSDN (Open Source Development Netowrk, Inc.) ist das dynamischste der Community-betriebenen Medien-netzwerke im Web. OSDN publiziert zwei weltberühmte Netzwerke von Websites: das OSDN Technology-Netzwerk und das MediaBuilder-Netwerk. OSDN liefert monatlich über 160 Millionen Pageviews und erreicht über neun Millionen Einzelbesucher per Monat.

Die technischen Sites von OSDN ziehen IT-Entschei-dungsträger aus allen Ebenen und technische Einkäufer von Projektmanagern bis hinunter zur C-Ebene an. Techniker, Unternehmensgestalter, Entwickler und Syste-madministratoren wenden sich an OSDN, um kreativ tätig zu sein, zu debattieren, IT-News auszutauschen und Informationen zu den neuesten Werkzeugen, Technolo-gien und Techniken zu erhalten. Zu den OSDN-Sites gehört die preisgekrönte Diskussionssite *Slashdot.com* sowie *SourceForge.net*, die weltweit größte Site für kollaborative Open-Source-Softwareentwicklung.

Weiters gehört auch die führende E-Commerce-Site *ThinkGee.com* zu OSDN, die innovative Produkte für die „intelligenten Massen" anbietet.

Das MediaBuilder-Netwerk erreicht Web- und Print-Designer sowie Konsumenten, die nach originellen Animationen, Präsentationswerkzeugen, Design-Tools, Online-Grüßen und anderen Medien suchen, um ihre Kommunikation wirkungsvoller zu gestalten. Besucher downloaden und verbreiten Bilder aus Animation Factory und anderen MediaBuilder-Sites über Handy, PDAs und E-Mail-Anwendungen über die ganze Welt.

OSDN ist das führende Netzwerk, um Technologie-Neuigkeiten online an Interessenten zu verbreiten, und das führende Netzwerk für Besucher, die innerhalb der letzten sechs Monate auf Composition basierende Software online gesucht oder gekauft haben.

OSDN (Open Source Development Network, Inc.) is the most dynamic community-driven media net-work on the Web. OSDN publishes two world-renowned networks of Web sites: the OSDN technology network, and the MediaBuilder net-work. OSDN delivers more than 160 million page views and reaches 9 million unique visitors per month.

OSDN technical sites attract all levels of IT deci-sion maker and technical buyer, from C-level to project managers. Technologists, enterprise architects, developers and system administrators all turn to OSDN to create, debate, and make or break IT news, and learn about the latest tools, technologies and techniques. OSDN sites include *Slashdot.org*, the award-winning news discussion site and *SourceForge.net*, the world's largest collaborative open source software development site. OSDN also owns *ThinkGeek.com*, the lead-ing e-commerce site featuring innovative products "for smart masses."

The MediaBuilder network reaches Web and print designers and consumers seeking original anima-tions, presentation tools, design tools, online greetings, and other media enabling them to ex-press themselves with powerful communications. Visitors download and share images from Anima-tion Factory and other MediaBuilder sites to share via their cellular phones, PDAs and e-mail applica-tions all over the world.

OSDN is the No. 1 network for delivering people who look for technology news online, and the No. 1 network for delivering visitors who have shopped for or purchased software online in the past 6 months, based on composition.

SourceForge.net is the world's largest Open Source software development web site, providing free hosting to tens of thousands of projects. The mission of *SourceForge.net* is to enrich the Open Source community by providing a centralized place for Open Source developers to control and manage Open Source software development. To fulfill this mission goal, we offer a variety of services to projects we host and to the Open Source community. *SourceForge.net* ist die weltweit größte Website für Open-Source-Softwareentwicklung und hostet kostenlos Zehntausende von Projekten. Aufgabe und Ziel von SourceForge.net ist es, der Open-Source-Community einen zentralisierten Ort anzubieten, wo Open-Source-Entwickler die Entwicklung von Open-Source-Software steuern und managen können. Dafür bieten wir eine Vielzahl von Dienstleistungen für die von uns gehosteten Projekte und die Open-Source-Community an.

Interaction–New Modes and Moods
Interaktion – neue Wege, neue Welten

Christiane Paul

Interactive art now has a decades-long history—not counting early artistic experiments that date back almost a century—and has recently become a more widely recognized field as art institutions worldwide have begun to pay increasing attention to this form of artistic practice. It comes as no surprise that the number of submissions to Ars Electronica's interactive art category has continuously been growing and exhibiting more diversity. Interactive art is by nature a hybrid field and this year's submissions covered a broad area, including interactive installations and immersive environments (with or without network components), screen-based work, music projects and performance, interface mechanisms that could be adopted for various purposes, as well as interactive systems for display of content in a museum or public setting.

The term "interactive" has now become almost meaningless due to its inflationary use for numerous levels of exchange. The models of interaction that form the basis of these exchanges differ widely in conceptual and technological sophistication and a competition such as Ars Electronica provides an ideal forum for taking a close look at the variety of approaches in this field. A huge portion of interactive art can be summed up under the label of reactive or responsive art where input such as the audience's movements and actions, changing light levels, temperature or sounds trigger responses from the environment. In many other works the interaction is based on enabling the audience to explore "databases" of preconfigured materials through seemingly infinite combinations. Yet another model is system interaction, where elements of software systems themselves interact with each other with varying degrees of audience input. The creation of technologized tools and "instruments" that are used and played by the audience is an area of inquiry that has consistently grown. The "re-engineering"

Selbst wenn man die frühen künstlerischen Experimente, die nun vor bald einem Jahrhundert stattgefunden haben, außer Acht lässt, blickt die interaktive Kunst nun schon auf eine Jahrzehnte lange Geschichte zurück. In dem Maße, in dem Kunstinstitutionen auf der ganzen Welt dieser Form künstlerischer Praxis mehr Aufmerksamkeit widmen, findet sie auch in weiteren Kreisen Anerkennung. Deswegen ist es auch nicht überraschend, dass die Anzahl der Einreichungen in der Kategorie Interaktive Kunst des Prix Ars Electronica ständig wächst und eine immer größere Vielfalt aufweist. Von Natur aus ist die interaktive Kunst ein hybrider Bereich, und so wiesen auch die heurigen Einreichungen eine große Bandbreite auf – von interaktiven Installationen und immersiven Environments mit und ohne Netzwerkkomponenten über Bildschirm-Arbeiten, Musik- und Performance-Projekten sowie Interface-Mechanismen, die für unterschiedlichste Zwecke adaptiert werden können, bis hin zu interaktiven Systemen zur Darstellung von Inhalten im musealen oder öffentlichen Bereich.

Der Begriff „interaktiv" ist dabei inzwischen schon beinahe bedeutungslos geworden, da er auf geradezu inflationäre Weise für Austausch auf den unterschiedlichsten Ebenen verwendet wird. Die Interaktionsmodelle, die diesen Austauschmechanismen zugrunde liegen, unterscheiden sich stark hinsichtlich ihres konzeptuellen und technischen Entwicklungsstandes, und ein Wettbewerb wie der Prix Ars Electronica bietet einen idealen Rahmen, um die Vielfalt der Ansätze auf diesem Gebiet näher zu betrachten. Ein erheblicher Teil der interaktiven Kunst ließe sich wohl auch als „reaktive" oder „responsive Kunst" bezeichnen, nämlich all jene Arbeiten, bei denen ein Input – wie etwa die Bewegungen und Handlungen des Publikums, sich ändernde Beleuchtungsverhältnisse, Temperaturen oder Klänge – eine Reaktion der Umgebung auslöst. Bei vielen anderen Werken wiederum basiert die Interaktion darauf, dass dem Publikum die Gelegenheit geboten wird, „Datenbanken" mit vorkonfiguriertem Material in scheinbar unendlich vielen Kombinationsmöglichkeiten zu erforschen. Ein weiteres Modell ist die „Systeminteraktion", bei der Elemente von Software-Systemen bei unterschiedlicher

Publikumsbeteiligung miteinander interagieren. Die Schaffung von technischen Werkzeugen und „Instrumenten", die vom Publikum benützt und gespielt werden, ist ein weiteres, stark wachsendes Anwendungsfeld. Auch das „Re-Engineering" existierender kommerzieller Systeme (wie etwa Game-Engines) und deren In- oder Subversion hat zugenommen, auch wenn man dieses Feld noch immer als zu wenig erforscht bezeichnen kann. Betrachtet man das Potenzial des digitalen Mediums, so gibt es noch immer relativ wenige Werke, die offene Systeme schaffen, indem sie den Benutzern erlauben, das System selbst auf ausgefeilte Weise neu zu konfigurieren oder umzuschreiben oder sich auf anspruchsvolle Weise auf Kommunikationsprozesse in Netzwerken einzulassen. Da akademische Institutionen ihr Angebot an Programmen zu den „Neuen Medien" ständig ausbauen, gibt es auch immer mehr Praktiker, die mit diesen Medien arbeiten und von denen einiges zu erwarten ist. Dazu kommt, dass Künstler nach wie vor die seit über einem Jahrzehnt bewährten Methoden der Interaktion anwenden, wobei sie sie aber nicht unbedingt weiterentwickeln. Das heißt nicht, dass neuartige Formen der Kommunikation mit dem Anwender nicht auch mit bestehenden Technologien und herkömmlicher Software möglich wären, aber wir mussten doch feststellen, dass es eine ganze Menge Redundanz in den Ansätzen gibt. Bei der Durchsicht von über 350 Einreichungen wurde uns auch deutlich vor Augen geführt, dass vielen mit Sensor- oder Motion-Tracking-Techniken arbeitenden Installationen leider noch einiges an Feinschliff und Sensibilität fehlt. Ein weiterer problematischer Aspekt bei zahlreichen Einreichungen war, dass die verwendete Technologie ganz offensichtlich nicht hinlänglich ausgereizt wurde – so gab es etwa einige CAVE-Anwendungen, die genauso gut als Projektion funktioniert hätten. Die Immersion wurde dabei eher als „netter Effekt" denn als notwendige Voraussetzung für die Erforschung neuer Interaktionsparadigmen behandelt.
Kriterien für die Beurteilung eines so hybriden Feldes wie jenes der interaktiven Kunst festzulegen, ist zweifellos eine große Herausforderung, ja, vielleicht ist es tatsächlich

of existing, commercial systems (such as game engines) or their inversion and subversion has also increased, although this territory arguably remains underexplored. Considering the potential of the digital medium, there are still relatively few works that create open systems by allowing users a sophisticated reconfiguration or rewriting of the system itself or by relying on networked communication processes in challenging ways.
As the number of new media programs in academic institutions multiplies, we are seeing a new wave of promising practitioners in the medium. At the same time, artists are still exploring tried-and-true methods of interaction which have been used for over a decade and aren't necessarily carried to new levels. This is not meant to say that novel ways of user interaction cannot be accomplished through existing software and technologies but we noticed a fair amount of redundancy in approaches. Going through over 350 submissions, one also becomes more aware of a certain lack of fine-tuning and sensitivity that characterizes many sensor-based or motion-tracking installations. A problematic aspect of several submissions proved to be technology that was underused. There were some CAVE projects, for example, that would have worked equally well as a projection. Immersion was treated as a "nice effect" rather than a necessity for exploring new paradigms of interaction.
Establishing criteria for judging a hybrid field such as interactive art is obviously challenging, if not impossible. In our selection process, we kept discussing and outlining certain "standards for excellence"—even if this a rather pretentious term—taking into consideration the models of interaction and issues outlined above. One of our main criteria was a strong artistic concept supported by and realized through technologies that communicate it in the most sophisticated, accomplished and appropriate way. At the same

time, we acknowledged new forms of interfaces that question familiar notions of interaction, expand concepts of functionality and reveal the technology's social influences. We felt that interaction should not be explored as a mere effect but as an intervention that expands the audience's agency—allowing them to create, change and intervene with events in a meaningful way—or reflects on the aesthetic and cultural impact of technologies. The originality of an artistic concept is obviously an important standard and does not rely on technological wizardry.

With hundreds of submissions, there are never enough prizes and honorary mentions to acknowledge everything one likes. Some very promising projects had to be disregarded because they were still under development and Ars Electronica requires projects to be fully realized at the time of their submission. In selecting the honorary mentions we tried to be as inclusive as possible, considering all the different submission categories mentioned above. Among the 12 honorary mentions are three music projects and "instruments" (*Block Jam*, *Hyperscratch* and *Instant City*) that—in very different ways—explore possibilities of non-linear composition and of expanding the dynamic structure of music in user interaction. We also acknowledged new forms of interfaces, such as the *Aegis Hyposurface* and Justin Manor's *Cinéma Fabriqué* (as artist-created DJing software). Marcel-lí Antúnez Roca's *POL* represents an original new model for theatrical performance; Agnes Meyer-Brandis' *Coral Reef* (with its extension *Earth Core Laboratory and Elf Scan*) puts a charming fantasy twist on low-tech augmented reality; and Iori Nakai's *Streetscape* condenses a site-specific experience (sounds of a city) into a minimalist, navigable map. Two of the selections address the concept of a mediated memory: while Scott Snibbe's *Deep Walls* creates a temporary memory of viewers' shadows, *Last* (by Ross Cooper & Jussi Ängeslevä) functions as a clock incorporating live video feed and constructing a record of its own history. The audience becomes the focus and subject of the artwork in Marie Sester's *Access*—which allows remote users to track people in public space with a robotic spotlight and acoustic beam—as well as George Legrady's *Pockets Full of Memories*, a cultural database and self-organizing map of the audience's personal belongings.

It didn't prove to be easy to identify the three winners among the final selection of work but after extended discussion we decided to give the awards to the following three projects:

unmöglich. Den ganzen Auswahlprozess hindurch diskutierten wir immer wieder, welchen Standards eine Arbeit entsprechen müsse, um als „herausragend" (auch wenn das ein bisschen prätentiös klingt) eingestuft werden zu können – wobei wir stets die oben erläuterten Interaktionsmodelle und Probleme im Auge behielten. Eines unserer Hauptkriterien war: ein starkes künstlerisches Konzept, das auf Technologien basiert und mit Technologien umgesetzt wird, die es in der angemessensten, bestmöglichen und ausgefeiltesten Weise vermitteln. Gleichzeitig aber haben wir auch neue Formen von Interfaces anerkannt, die die übliche Definition von Interaktion hinterfragen, das Konzept von Funktionalität erweitern und / oder den sozialen Einfluss der Technologie aufzeigen. Wir waren der Ansicht, dass Interaktion nicht als bloßer Effekt erforscht werden sollte, sondern als Intervention, die den Aktionsradius des Publikums erweitert – indem die Mitwirkenden Ereignisse auf relevante Weise auslösen, sie verändern oder beeinflussen können – oder die den ästhetischen und kulturellen Einfluss der Technologie widerspiegelt. Daneben ist natürlich auch die Originalität eines künstlerischen Konzepts ein wichtiges Kriterium, wozu keineswegs nur technische Zauberkünste notwendig sind.

Bei Hunderten von Einreichungen gibt es nie genug Geldpreise und Anerkennungen, um alles auszuzeichnen, was einem gefällt. Einige vielversprechende Projekte mussten unberücksichtigt bleiben, weil sie sich noch im Entwicklungsstadium befanden, der Prix Ars Electronica aber verlangt, dass sie zum Zeitpunkt der Einreichung schon vollständig umgesetzt sind. Bei der Auswahl der zwölf Anerkennungen haben wir uns bemüht, so umfassend wie möglich vorzugehen, das heißt, alle oben angeführten Kategorien zu berücksichtigen. Unter den Anerkennungen finden sich drei Musikprojekte und „Instrumente" (*Block Jam*, *Hyperscratch* und *Instant City*), die auf sehr unterschiedliche Weise die Möglichkeiten einer nicht-linearen Komposition und einer Ausweitung der dynamischen Struktur von Musik in der User-Interaktion untersuchen. Wir haben auch neue Formen von Interfaces ausgezeichnet, wie etwa *Aegis Hyposurface* und Justin Manors *Cinéma Fabriqué* (eine vom Künstler geschaffene DJing-Software). *POL* von Marcel-li Antúnez Roca stellt ein originelles Modell für eine Theater-Performance vor, Agnes Meyer-Brandis' *Coral Reef* (mit den Erweiterungen *Earth Core Laboratory and Elf Scan*) verleiht einer mit Low-Tech-Mitteln arbeitenden Augmented-Reality-Installation einen Fantasy-Touch, Iori Nakais *Streetscape* hingegen kondensiert eine ortsspezifische Erfahrung (die Klänge einer Stadt) in eine minimalistische, navigierbare Landkarte. Zwei der ausgewählten Werke gehen vom Konzept einer mediatisierten Erinnerung aus: Während Scott Snibbes *Deep Walls* die Bewegungen der Schatten der Besucher vorübergehend bewahrt, funktioniert *Last* (von Ross Cooper & Jussi Angeslevä) als eine Art Uhr, die mit

Live-Zuspielungen arbeitet und eine Aufzeichnung ihrer eigenen Geschichte darstellt. Bei *Access* von Marie Sester wird das Publikum zum Mittelpunkt und Subjekt der künstlerischen Arbeit, die es den Benutzern erlaubt, aus der Ferne Menschen im öffentlichen Raum mittels robotergesteuertem Scheinwerfer und akustischem Beamer zu verfolgen. Und George Legradys *Pockets Full of Memories* karte, die die persönliche Habe des Publikums abbildet. Es war keineswegs einfach, aus den in der letzten Entscheidungsrunde ausgewählten Arbeiten die Gewinner der drei Geldpreise zu bestimmen, aber nach ausgedehnten Diskussionen haben wir beschlossen, folgenden drei Projekten die Goldene Nica bzw. Auszeichnungen zu verleihen:

Blast Theory / Mixed Reality Lab
Can you see me now? Goldene Nica

Das mobile Spiel *Can you see me now?* mag zwar nur die ganz bescheidenen Anfänge dessen einfangen, was uns unsere vernetzte Zukunft bringen kann, aber es weist auf eine sehr originelle Weise in eine neue Ära der Interaktion, wobei es grundlegende Fragen nach Körperlichkeit und Verkörperung aufwirft. Das Spiel, das gleichzeitig in der physischen und in der virtuellen Welt stattfindet, ähnelt einer Jagd, bei der die Online-Spieler ihren Avatar anhand eines Plans durch die Straßen der Stadt dirigieren, um den „Läufern" zu entgehen, die ihm in den Straßen der physischen Stadt nachjagen. Die Läufer – ausgerüstet mit einem Hand-held-Computer samt GPS-Tracker, der ihre Position an die Online-Spieler via Wireless Network übermittelt – versuchen die Online-Spieler „einzufangen", deren Position ebenfalls per Netzwerk auf die Computer der Läufer übertragen wird. Die virtuellen Spieler können Nachrichten austauschen und bekommen Live-Ton von den Walkie-Talkies der Läufer zugespielt. Das Spiel ist zu Ende, wenn die Läufer ihre virtuellen Gegner „sichten" und von diesen ein Foto schießen (das klarerweise nur den leeren Raum einfängt). Auch wenn die Technologie etwas flüssiger und nahtloser eingebaut sein könnte – das Militär verwendet eine ausgereiftere Ausrüstung –, so erreicht das Spiel doch einen bemerkenswerten Grad an Verschmelzung zwischen virtuellem und realem Raum. Im Vergleich zu Vorgängern wie *Botfighters* – das mittels Handies SMS-Nachrichten ein Shooter-Game entwickelte, das in der realen und in der virtuellen Welt gespielt wurde – gelingt es *Can you see me now?* vor allem, die Frage nach der „Präsenz" auf wesentlich substanziellere und erfinderischere Weise zu untersuchen. Künstlerische Experimente mit der Telepräsenz haben sich vor allem auf die Verschmelzung virtueller Abbilder von remoten Orten mit neuen, ebenfalls virtuellen „Bild-Orten" beschäftigt oder mit Remote-Interventionen im physischen Raum vermittels Robotern.

Blast Theory / Mixed Reality Lab
Can you see me now? Golden Nica

The mobile game *Can you see me now?* may still capture only the humble beginnings of what our networked future will look like but it points to a new era of interaction in an inventive way that raises profound questions about embodiment. Unfolding both in the physical and virtual world, the game essentially takes the form of a chase where online players navigate their avatar through the streets of a city map in order to escape from "runners" in the physical city who are hunting them. The runners—equipped with a handheld computer-cum-GPS tracker that sends their position to online players via a wireless network—attempt to "catch" the online players whose position is in turn sent to the runners' computers. The virtual players can send text messages to each other and receive a live audio stream from the runners' walkie talkies. The game is over when the runners "sight" their virtual opponents and shoot a photo of them (which obviously just captures empty space). While the technologies could be implemented in a more fluid and seamless way (the military is using more advanced equipment), the game achieves a noteworthy level of merging and collapsing physical and virtual space.

Compared to predecessors such as *Botfighters*—which relied on mobile phones and SMS messaging to create a shooter game played in the virtual and physical world—*Can you see me now?* succeeds in exploring the issue of "presence" in a more substantial and inventive way. Artistic experiments in telepresence have mostly focused on the fusion of images from remote places in a new, virtual "image place" or on remote interventions in physical space through robotic devices.

Blast Theory's project operates on the boundaries of telepresence and -absence: through networking, absence creates a presence in its own right that is absurdly documented in the sightings photos. Photography, an established mode of technological representation, becomes obsolete in the face of a presence—consisting of virtual movements—that leaves no physical trace. As its title indicates, the project questions the very process of seeing itself, suggesting a form of perception independent of embodiment. At a time where GPS technology and "networked cells" are mostly associated with destructive or negative potential (surveillance, war machinery, terrorism), Blast Theory emphasizes the creative possibilities of the human and technological network.

Maywa Denki, *Tsukuba Series*
Award of Distinction

With their *Tsukuba Series*, the "art unit" Maywa Denki—led by "president" Nobumichi Tosa—has taken experiments with electro-mechanical musical instruments to new levels. The *Tsukuba Series* consists of approximately two dozen instruments or musical devices that are played mechanically or computer-controlled through motors and electromagnets. The highly original instruments are the result of a unique combination of invention and craft and include devices such as "electric mallets" as a base unit used in various configurations; a remote-controlled pedal organ (with a built-in 100V controller) that plays six guitars at the same time; a saxophone-shaped Yankee horn built from bikers' klaxons that produce sounds on 6 scales accompanied by lights blinking on each blow; or an electric "music saw" that is shaped and operated like a bow. The *Tsukuba Series* stands in the tradition of both George Antheil's *Ballet mécanique* (1924) – which was performed by traditional instruments in combination with 16 player pianos, electric bells, a siren and different-sized airplane propellers – and the work of Seattle-based sound sculptor and composer Trimpin who has been interfacing computers with traditional musical instruments. Maywa Denki have extended the concept of electro-mechanical instruments into wearable configurations and live performance and developed considerable talent at performing their instruments in contexts ranging from pop to avant-garde. They are at the crest of a developing trend to augment live performers with robots or robotic extensions in order to replace "preformatted" speaker systems. Maywa Denki succeeded in transforming what could essentially be considered "folk art" into a pop-cultural movement that treats creative work as "product" and encompasses anything from videos to nonsensical machines and toys.

Margarete Jahrmann / Max Moswitzer
nybble-engine-toolZ
Award of Distinction

Billing itself as a "radical meta-art system shooter" and "collaborative statement tool," Margarete Jahrmann's and Max Moswitzer's *nybble-engine-toolZ* explores very different forms of interaction to the other two winners. The project may be more of a deliberately abstruse experiment than a transparent implementation of a tool—it doesn't conceal its self-ironic attitude—but investigates

Das Projekt von Blast Theory ist im Grenzbereich zwischen Telepräsenz und -absenz angesiedelt: Durch die Vernetzung schafft die Absenz eine eigenständige Form von Präsenz, die auf absurde Weise in den „Sichtungs-Fotos" dokumentiert wird. Die Fotografie als etablierte Methode technologischer Darstellung wird angesichts einer Präsenz obsolet, die nur aus virtuellen Bewegungen besteht und keine Spuren hinterlässt. Wie der Titel schon besagt, hinterfragt das Projekt den Prozess des Sehens an sich, indem es eine Form der Wahrnehmung vorschlägt, die von der Körperlichkeit unabhängig ist. In einer Zeit, in der die GPS-Technologie und „vernetzte Zellen" überwiegend mit destruktivem oder negativem Potenzial verknüpft sind (Überwachung, Kriegsmaschinerie, Terrorismus), unterstreicht Blast Theory die kreativen Möglichkeiten des Mensch-Technologie-Netzwerks.

Maywa Denki, *Tsukuba Series*
Auszeichnung

Mit ihrer *Tsukuba Series* ist die „Kunsteinheit" Maywa Denki unter der Leitung ihres „Präsidenten" Nobumichi Tosa einen Schritt weiter in den Experimenten mit elektromechanischen Musikinstrumenten gegangen. *Tsukuba Series* besteht aus rund zwei Dutzend Instrumenten oder, besser gesagt, musikalischen Gerätschaften, die mechanisch oder computergesteuert über Motoren und Elektromagneten gespielt werden. Die höchst originellen Instrumente sind das Ergebnis einer einzigartigen Kombination aus Erfindungsgeist und handwerklichem Können und umfassen unter anderem Geräte wie „elektrische Schlägel" als Grundeinheit, die in zahlreichen Konfigurationen eingesetzt werden, eine ferngesteuerte Pedal-Orgel (samt eingebautem 100-Watt-Controller), die sechs Gitarren gleichzeitig spielt, ein saxophonförmiges Yankee-Horn aus Motorradhupen, das sechs Tonskalen spielen kann und bei dem jeder Ton von einem entsprechenden Lichtsignal begleitet wird, oder aber eine elektrische Singende Säge, die wie ein Bogen geformt ist und gespielt wird. Die *Tsukuba Series* steht gleichzeitig in der Tradition von George Antheils *Ballet mécanique* (1924) – das von traditionellen Instrumenten in Kombination mit 16 Pianolas, elektrischen Klingeln, einer Sirene und Flugzeugpropellern unterschiedlicher Größe ausgeführt wurde – und in jener des in Seattle beheimateten Klangbildhauers und Komponisten Trimpin, der Computer mit traditionellen Instrumenten verbunden hat. Maywa Denki haben das Konzept der elektromechanischen Instrumente hin zu wie Kleidungsstücken tragbaren Konfigurationen und Live-Auftritten ausgebaut und zeigen ein bemerkenswertes Talent beim Spielen dieser Instrumente, wobei sie sowohl im Pop als auch in der Avantgarde zu Hause sind. Sie stehen an der Spitze einer Bewegung, die Live-Performer mit Robotern oder robotischen Erweiterungen als Ersatz für die

„vor-formatierten" Lautsprechersysteme ausstattet. Maywa Denki hat etwas, was man als „Volkskunst" im weitesten Sinne bezeichnen könnte, erfolgreich in eine Popkultur-Bewegung integriert, die die kreative Arbeit als „Produkt" behandelt und so ziemlich alles vom Video bis zu unsinniger Maschinerie und Spielzeug umfasst.

Margarete Jahrmann / Max Moswitzer
nybble-engine-toolZ
Auszeichnung

nybble-engine-toolZ von Jahrmann / Moswitzer, das sich selbst als „radikalen Meta-Kunst-System-Schießstand" und „kollaboratives Werkzeug für Statements" definiert, erforscht Formen von Interaktion, die sich grundlegend von jenen der beiden anderen preisgekrönten Werke unterscheiden. Das Projekt mag zwar eher ein bewusst abstruses Experiment als eine transparente Implementierung eines Werkzeugs sein – seine selbstironische Haltung wird keineswegs versteckt –, aber es erforscht wichtige Aspekte von vernetzten offenen Systemen und Echtzeit-Programmierwerkzeugen. *nybble-engine-toolZ* – der Name bezieht sich auf „Nybble", die ein halbes Byte (also vier Bit) große Einheit, die die Basis für digitale Umwandlung und Software-Logik bildet – ist ein Peer-to-Peer-Servernetzwerk und eine Abwandlung der Unreal-Game-Engine, die das Spiel selbstreflektierend aus den Netzwerkprozessen generiert. Die Spieler können sich von verschiedenen Orten – auch aus der Installation, einem 180-Grad-Schirm – in die Engine einloggen und durch das Environment navigieren, andere Spieler und Bots treffen (in diesem Fall Darstellungen von Serverprozessen) und mit ihnen kommunizieren. In dieses Environment abgegebene Schüsse lösen Anti-Kriegs-Mails oder Friedensaufrufe an Regierungsserver aus; beim Drücken von Knöpfen auf dem Gamepad werden Ping-Befehle an Regierungsserver geschickt. Die vom Netzwerktraffic selbst produzierten Logfiles werden zusammen mit Daten auf der Festplatte (Text, Bilder, Klänge) zum Rohmaterial für 3D-„Filme", aus denen letztlich die Spielumgebung konstruiert ist. So besteht das Environment aus den Netzwerkaktivitäten in Echtzeit. Konzeptuell betrachtet, wirft *nybble-engine-toolZ* wichtige Fragen zu generativer Kunst und zu Möglichkeiten von Software und zu Engines als Werkzeugen auf. Spiel-Engines gehören zweifellos zu den wichtigsten (und viel zu wenig erforschten) Generatoren von Narration im weitesten Sinn. Das Projekt von Jahrmann / Moswitzer erschließt die Engine – sozusagen den Motor – als Werkzeug und als algorithmischen Rahmen für den Umgang mit der „Mechanik" des Spielens und lässt sie gleichzeitig den Prozess des Spielens als solchen reflektieren. *nybble-engine-toolZ* zeigt, dass das Spielen von Games auch darin bestehen kann, Code zu editieren und genau jenes Tool umzuschreiben, das das Spiel innerhalb eines offenen kollaborativen Systems erst hervorbringt.

important aspects of networked, open systems and real-time programming tools. Referring to the nybble (half a byte, or four bits) as a basis of digital conversion and software logic, *nybble-engine-toolZ* is a peer-to-peer server network and modification of the Unreal game engine that self-reflexively constructs the game itself out of network processes. Players may log on to the engine from various locations—including the installation, a 180 degree circular screen—to navigate the environment, meet other players and bots (in this case, representations of server processes) and communicate with them. Shots fired in the environment generate anti-war mails or calls for peace to a government server; pressing buttons on the gamepad sends ping commands to government servers. The log files produced by the network traffic itself and data on the hard disk (text, images and sound) become raw material for 3D "movies" out of which the game environment itself is constructed. The environment thus consists of real-time network activities. As a conceptual proposal, *nybble-engine-toolZ* raises important issues about generative art, the possibilities of software and engines as tools. Game engines are arguably one of the most important (and under-explored) generators of narrative in the broadest sense. Jahrmann / Moswitzer's project opens up the engine—as a tool and algorithmic framework for handling the "mechanics" of game playing—and makes it reflective of the process of playing itself. *nybble-engine-toolZ* points to the possibilities of game playing as editing of code and rewriting of the very tool that creates the game in an open collaborative system.

Can you see me now?

Blast Theory in collaboration
with Mixed Reality Lab, University of Nottingham

www.blasttheory.co.uk/work_cysmn.html

Can you see me now? has been presented at the Dutch Electronic Art Festival in association with V2 in Rotterdam, 2003 as a partnership with the Mixed Reality Lab, University of Nottingham, England. *Can you see me now?* draws upon the near ubiquity of handheld electronic devices in many developed countries. Blast Theory are fascinated by the penetration of the mobile phone into the hands of poorer users, rural users, teenagers and other demographics usually excluded from new technologies. Some research has suggested that there is a higher usage of mobile phones among the homeless than among the general population. The advent of 3G brings constant Internet access, location based services and massive bandwidth into this equation.

Can you see me now? is part of a sequence of works that attempt to establish a cultural space on these devices. A future version of the game might allow the public to play on the streets using their own devices, as well as online.

These social forces have dramatic repercussions for the city. As the previously discrete zones of private and public space (the home, the office etc.) have become blurred, it has become commonplace to hear intimate conversations on the bus, in the park, in the workplace. And these conversations are altered by the audience that accompanies them: we are conscious of being overheard and our private conversations become three-way: the speaker, the listener and the inadvertent audience. *Can you see me now?* takes the fabric of the city and makes our location within it central to the game play.

The piece uses the overlay of a real city and a virtual city to explore ideas of absence and presence. By sharing the same "space", the players online and runners on the street enter into a relationship that is adversarial, playful and ultimately, filled with pathos.

As soon as a player registers they must answer the question: "Is there someone you haven't seen for a long time that you still think of?" From that moment issues of presence and absence run through *Can you see me now?*. This person—absent in place and time—seems irrelevant to the subsequent game play; only at the point that the player is caught or "seen" by a runner do they hear the name mentioned again as part of the live audio feed from the streets of Rotterdam. The last words they hear are "Runner 1 has seen ...".

Can you see me now? wurde erstmals beim Dutch Electronic Art Festival 2003 in Rotterdam in Zusammenarbeit mit V2 und als Gemeinschaftsprojekt mit dem Mixed Reality Lab der University of Nottingham, England, vorgestellt.

Can you see me now? baut auf der fast uneingeschränkten Verfügbarkeit mobiler elektronischer Geräte in vielen entwickelten Ländern auf. Die Gruppe Blast Theory ist fasziniert davon, welchen Verbreitungsgrad das Handy auch bei ärmeren Usern – z. B. bei der Landbevölkerung, bei Teenagern und anderen gesellschaftlichen Gruppen – gefunden hat, die üblicherweise von den neuen Technologien eher abgekoppelt waren. Untersuchungen deuten darauf hin, dass der Nutzungsgrad von Mobiltelefonen etwa bei Obdachlosen höher ist als bei der Durchschnittsbevölkerung. Die Einführung des 3G-Standards bringt konstanten Internetzugang, ortsbezogene Dienste und eine große Bandbreite in diese Gleichung ein.

Can you see me now? ist Teil einer Serie von Arbeiten, die einen kulturellen Raum auf Basis dieser Geräte aufbauen wollen. In einer zukünftigen Version des Spiels werden die Mitspieler auf der Straße mit ihren eigenen Geräten ebenso wie online spielen können.

Diese sozialen Kräfte haben dramatische Auswirkungen auf die Stadt. In dem Maße, in dem die Grenzen zwischen den ehemals getrennten Bereichen von privatem und öffentlichem Raum (Zuhause, Büro usw.) verschwimmen, wurde es immer üblicher, private Kommunikation im Bus, im Park, am Arbeitsplatz mitzuhören. Und diese Privatgespräche verändern sich allein schon dadurch, dass jemand mithört: Wir sind uns bewusst, dass jemand mithorcht, und gestalten unsere Konversation zu einer Drei-Wege-Kommunikation um, mit Blickrichtung auf den Sprecher, den Konversationspartner und das zufällige Publikum. *Can you see me now?* bedient sich des Gewebes der Stadt und macht unsere Position innerhalb der Stadt zum zentralen Punkt des Spiels.

Ausgehend von der Überlagerung einer realen und einer virtuellen Stadt untersucht das Spiel die Problematik von An- und Abwesenheit. Da die Online-Spieler und die Läufer auf der Straße den gleichen „Raum" nutzen, treten sie in eine gegnerische Beziehung zueinander, die aber auch ihre spielerischen und letztendlich fast pathetischen Seiten hat.

Wenn sich ein Spieler zu *Can you see me now?* anmeldet, muss er folgende Frage beantworten: „Gibt es jemanden, den Sie schon lange nicht mehr gesehen haben, an den Sie aber noch denken?" Von diesem Augenblick zieht sich An- und Abwesenheit als Thema durch das ganze Spiel. Die – zeitlich und örtlich abwesende –

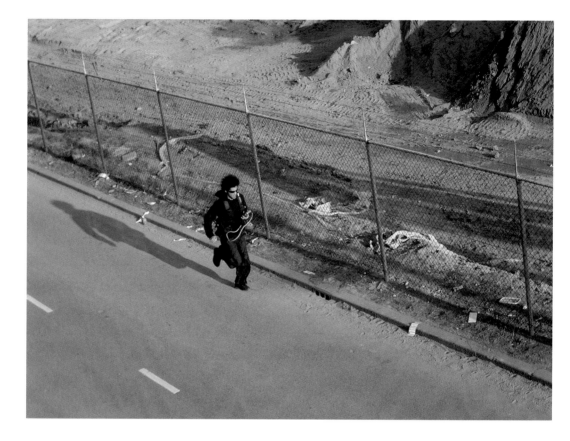

With the advent of virtual spaces and, more recently, hybrid spaces in which virtual and real worlds are overlapping, the emotional tenor of these worlds has become an important question. In what ways can we talk about intimacy in the electronic realm? In Britain the Internet is regularly characterised in the media as a space in which paedophiles "groom" unsuspecting children and teenagers. Against this backdrop we can establish a more subtle understanding of the nuances of online relationships. When two players who know one another place their avatars together and wait for the camera view to zoom down to head height so that the two players regard one another, what is going on? Is this mute tenderness manifest to anyone else and should it be? And alongside these small moments, there is a

Person scheint für das folgende Spiel zwar irrelevant zu sein; erst in dem Moment, in dem der Spieler von einem Läufer gefangen oder „gesehen" wird, hört man den Namen als Teil der Live-Audio-Zuspielung aus den Straßen von Rotterdam wieder. Die letzten Worte, die der Mitspieler hört, sind: „Läufer eins hat ... gesehen." Mit dem Auftauchen virtueller und neuerdings hybrider Räume, in denen sich virtuelle und reale Welt überlappen, ist der emotionale Tenor dieser Welten zu einer wichtigen Frage geworden. Auf welche Weise können wir im Reich der Elektronik über Privates, über Intimes sprechen? In Großbritannien wird das Internet in den Medien regelmäßig als ein Raum beschrieben, in dem Pädophile sich um nichtsahnende Kinder und Jugendliche „kümmern". Dem können wir ein etwas subtileres Verständnis der Nuancen von Online-Beziehungen entgegenstellen. Wenn zwei Spieler, die einander kennen, ihre Avatare zueinander

stellen und warten, bis die Kamera auf Kopfhöhe hinunter fährt, sodass die beiden Spieler sich anblicken – was geschieht da? Kann ein Dritter diese stumme Zärtlichkeit überhaupt wahrnehmen? Ja, sollte er sie überhaupt wahrnehmen?

Neben diesen kleinen Augenblicken gibt lautere und kraftvollere Interaktionen zwischen Läufern und Spielern, die auf Beschimpfungen, Necken, Anstacheln und Humor aufbauen. Diese öffentlichen Erklärungen scheinen friedlich mit den privaten Momenten zu koexistieren, die einem Zufallsbetrachter marginal erscheinen mögen. Und dennoch kann dieser sozusagen demokratische Diskurs auch überraschen: Das Verständnis der Online-Spieler dafür, dass die Läufer müde sind und frieren, dass sie mit der Umgebung auf der KopVanSuid zu kämpfen haben, kann zu einer kraftvollen Emotion werden. Eine Spieler aus Seattle schrieb: „Mir blieb beinahe das Herz stehen, als mich in meiner verzweifelten Bemühung, mich nicht fangen zu lassen, plötzlich die Panik befiel, der mich jagende Läufer könnte von einem reversierenden LKW überfahren worden sein – denn genau so hat sich das, was passiert war, angehört."

louder and more forceful set of interactions between runners and players based on insults, teasing, goading and humour. These public declarations seem to happily coexist with the private moments that appear marginal to the casual observer. Yet, this democratic discourse can also surprise: The online players understanding that the runners are tired, cold, struggling with the environment on the KopVanZuid can become a powerful emotion. A player from Seattle wrote: "I had a definite heart stopping moment when my concerns suddenly switched from desperately trying to escape, to desperately hoping that the runner chasing me had not been run over by a reversing truck (that's what it sounded like had happened)."

Can you see me now? is created by Blast Theory in collaboration with the Mixed Reality Lab at the University of Nottingham.
Group Members: Matt Adams, Ju Row Farr, Nicholas Tandavanitj
Company Manager: Helen Kirlew
Development Officer: Catherine Williams

People involved in *Can you see me now?* Rotterdam: Blast Theory: Matt Adams, Ju Row Farr and Nick Tandavanitj with additional performers Paul Dungworth and Sheila Ghelani. Mixed Reality Lab, University of Nottingham: Rob Anastasi, Steve Benford, Adam Drozd, Martin Flintham, Chris Greenhalgh. **Blast Theory (UK)** is one of the most adventurous artists' groups in Britain making interactive performances, installations, video and mixed reality projects. Combining rigorous research and development with leading edge technologies, their work confronts a media saturated world in which popular culture rules to ask questions about the ideologies present in the information that envelops us. **Mixed Reality Lab (UK)** is an interdisciplinary research initiative at the University of Nottingham. The MRL brings together leading researchers in Computer Science, Engineering and Psychology to research new technologies that merge the physical and digital worlds, focusing on playful, artistic and educational applications. Die an der Rotterdamer Version von *Can you see me now?* beteiligten Personen waren: Blast Theory: Matt Adams, Ju Row Farr und Nick Tandavanitj mit den zusätzlichen Teilnehmern Paul Dungworth und Sheila Ghelani. Mixed Reality Lab, University of Nottingham: Rob Anastasi, Steve Benford, Adam Drozd, Martin Flintham, Chris Greenhalgh. **Blast Theory (UK)** ist eine der abenteuerlustigsten Künstlergruppen in Großbritannien und produziert interaktive Performances, Installationen sowie Video- und Mixed-Reality-Projekte. In einer Kombination aus rigoroser Forschungs- und Entwicklungsarbeit mit den neuesten Technologien stellen sich ihre Werke einer mediengesättigte, von der Popkultur bestimmten Welt und fragen nach den in der auf uns einströmenden Information enthaltenen Ideologien. **Mixed Reality Lab (UK)** ist eine interdisziplinäre Forschungsinitiative an der Universität Nottingahm. Das MRL bringt führende Forscher aus Informatik, Ingenieurwesen und Psychologie zusammen, die neue Technologien zur Verschmelzung physikalischer und digitaler Welten untersuchen und dabei auf spielerische, künstlerische und erzieherische Anwendungen setzen.

nybble-engine-toolZ
A radical meta-art system shooter

Margarete Jahrmann / Max Moswitzer

nybble engine toolz is a re-engineering of an existing commercial system, a game engine sprinkled with network commands. A nybble is the unit of half a byte or four bits and thus the basis of every digital conversion.

nybble-engine-toolZ is a radical meta-art shooter, a self-ironic multi-player statement tool. Sensible from a cyber-ethical point of view, an anti-war email is commissioned with each shot made with the game pad in the installation and the online network. This email is displayed in real-time as both ASCII text and newly generated object. Out of this visually coded environment, text messages are sent. Commands can also be sent from the running engine to the network. With movements through the environment, trace routes are started from the game to a number of crucial government servers as are also inquiries to network connections. On the other hand, network activities outside the engine are displayed in the game environment in real-time as texts and 3-D objects. Emails can be sent into the environment and change it. By reversing the effects of a specific action, such as jump'n run or shoot, the rules of the game engine are turned round: the unreal tournament

nybble-engine-toolZ ist ein Re-Engineering eines existierenden kommerziellen Systems, einer Game-Engine, die mit Netzwerk-Kommandos durchsetzt wird. Ein Nybble als Einheit ist ein halbes Byte bzw. vier Bits und damit die Basis für jede digitale Konversion.

nybble-engine-toolZ ist ein radikaler Meta-Kunst-Shooter, ein selbstironisches Multiplayer-Werkzeug zur Meinungsäußerung. Kybern-ethisch sinnvoll wird bei jedem Schuss mit dem Gamepad in der Installation und im Online-Netzwerk eine Anti-War-Mail in Auftrag gegeben. Dies wird in Echtzeit als ASCII-Text und neu generiertes Objekt angezeigt. Aus dem visuell kodierten Environment heraus werden Text-Nachrichten gesendet. Auch Kommandos können aus der laufenden Engine ins Netzwerk gesandt werden. Mit Bewegungen durch die Umgebung werden Traceroutes auf eine Anzahl von wichtigen Government-Servern genauso vom Spiel aus gestartet wie Anfragen über Netzwerk-Connections. Auf der anderen Seite werden Netzwerkaktivitäten von außerhalb der Engine in Echtzeit im Game-Environment als Text und 3D-Objekt angezeigt. Mails können in die Umgebung gesandt werden und diese verändern. Durch die Umkehrung der Effekte eines bestimmten Handelns wie Jump'n run oder Shoot werden die Regeln des Game-Engines verdreht: Das Unreal Tournament Turnier wird zu einem

situationistischem Détournement, einer Umkehrung. Angriff ist Kollaboration, Schuss ist Kommunikation, Spielen wird zum Editieren von Code!

Die Installation, ein interaktives / interpassives Gruppen-Experiment

Im Raum selbst findet ein weiterer Medienwechsel statt. Die 3D-Form der virtuellen Umgebung bildet nun auch die Architektur des Installationsraumes, in der sich die Teilnehmer niederlassen. Wir nennen diese Formen in Anlehnung an den zeitgenössischen Architekten und Theoretiker Bernard Cache „Objektile". Die Peer-to-Peer-Software der Installation verwandelt Netzwerkprozesse in dreidimensionale abstrakte Filme und projiziert diese auf eine halbkreisförmige 180-Grad Leinwand. Der Blick fällt auf die Maschine im Betrachtermodus – konkret auf den Server. Die Netzwerk-Codes und Kommandos werden in audiovisuelle Movies übersetzt. Gleichzeitig sind sie spielbare Kommandozeilen in einer vernetzten Game-Umgebung.
Die Teilnehmer am Experiment sehen auf einer kleinen Kontroll-Konsole ihre individuelle Navigationsansicht, die eine subjektive Perspektive in die Server-Ansicht auf der Leinwand zeigt. Die Mitspieler verwenden ein

becomes a situationist détournement, an inversion. Attack is collaboration, shoot is communication, and playing becomes the editing of code!

The installation: an interactive / interpassive group experiment

Within the space itself another media change takes place. The architecture of the installation space where the participants take a seat is now shaped by the 3-D form of the virtual environment. Following contemporary architect and theorist Bernard Cache's example, we call these forms objectiles. The peer-to-peer software of the installation converts network processes into three-dimensional abstract movies and projects these onto a 180-degree screen. The view of the machine in spectator mode—specifically of the server—is rendered. The network codes and commands are converted into audio-visual movies. Simultaneously they are playable command lines in a networked game environment.
At a small control desk the participants see their individual view of navigation, which presents a subjective perspective at variance with the server

nybble-engine-movies

```
                          +--+
              SENDER |
              +--+  +--------+
              |          | TARGET |
              | topdump |-+  +--------+
                          |
                          |  +------------+
              +-[ping]-----+--| traceroute |
                          +------------+
```

peer-to-peer multiplayer

realtime action-bots

objectile dataprocessing

view on the screen. The players use an ordinary game pad to log onto the network of the installation and to enter into the shooter environment, where projectiles of data objects / data objectiles, action bots, in other words, artificial players with their own kinds of behaviour and minimal artificial intelligence, as well as other players are flying about. Each time a data-object is hit, network processes are triggered, each time a shot is fired with the game-pad, an anti-war email.

There are two choices for the spectator, either to become a spect-actor or player who concentrates on the small Gameboy monitors and successfully navigates and influences what is happening on the big screen, or to be one whose attention fluctuates and combines the different perspectives—man's and the machine's. If one concentrates on one's personal view, one influences the entire picture being simultaneously generated and projected. When no one is sitting in front of the installation, the action bots and online players that make the moves. Each bot or player's avatar carries a data objectile instead of a weapon. These data objectiles represent command lines

gewöhnliches Gamepad, um sich in das Netzwerk der Installation einzuloggen und ins Shooter-Environment einzutreten, wo Geschoße aus Datenobjekten, Action-Bots, also künstliche Spieler mit eigenem Verhalten und minimaler Artificial Intelligence, sowie andere Spieler umherschwirren. Bei jedem Auftreffen auf ein Datenobjekt löst man Netzwerkprozesse aus, bei jedem Shoot mit dem Gamepad eine Anti-War-Mail.

Es gibt für den Betrachter zwei Möglichkeiten: entweder zum „Spect-Acteur", zum Zuseh-Spieler zu werden, sich auf den kleinen Gameboy-Monitor zu konzentrieren und bei der Navigation und Beeinflussung des Geschehens auf dem großen Schirm erfolgreich zu sein oder aber seine Aufmerksamkeit fluktuieren zu lassen und die unterschiedlichen Blickwinkel – den des Menschen und jenen der Maschine – zu kombinieren. Wenn man sich auf die persönliche Ansicht konzentriert, beeinflusst man das gleichzeitig generierte und abgespielte Gesamtbild. Wenn niemand vor der Installation sitzt, handeln eben Action-Bots und Online-Player. Jeder Bot oder Avatar eines Mitspielers trägt an Stelle einer Waffe ein Daten-Objektil. Diese Daten-Objektile stellen Kommandozeilen und Prozesse dar. Als lasergesinterter Ausdruck sind diese Daten-Objektile auch Teil des

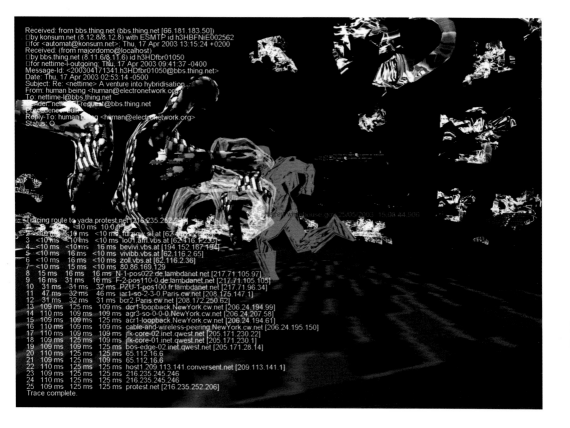

Received: from bbs.thing.net (bbs.thing.net [66.181.183.50])
 by konsum.net (8.12.8/8.12.8) with ESMTP id h3HBFNiE002562
 for <automat@konsum.net>; Thu, 17 Apr 2003 13:15:24 +0200
Received: (from majordomo@localhost)
 by bbs.thing.net (8.11.6/8.11.6) id h3HDfbr01050
 for nettime-l-outgoing; Thu, 17 Apr 2003 09:41:37 -0400
Message-Id: <200304171341.h3HDfbr01050@bbs.thing.net>
Date: Thu, 17 Apr 2003 02:53:14 -0500
Subject: Re: <nettime> A venture into hybridisation
From: human being <human@electronetwork.org>
To: nettime-l@bbs.thing.net
Sender: nettime-l-request@bbs.thing.net
Precedence: bulk
Reply-To: human being <human@electronetwork.org>
Status: O

Tracing route to yada.protest.net [216.235.252.206]
 1 <10 ms 10.0.0.1
 2 <10 ms <10 ms <10 ms furqtw.sil.at [62.
 3 <10 ms <10 ms <10 ms l000.arfl.vbs.at [62.116.2.235]
 4 <10 ms <10 ms 16 ms bevivi.vbs.at [194.152.167.194]
 5 <10 ms 16 ms <10 ms vivibb.vbs.at [62.116.2.65]
 6 <10 ms 16 ms <10 ms zoll.vbs.at [62.116.2.36]
 7 <10 ms 15 ms <10 ms 80.86.169.129
 8 15 ms 16 ms 16 ms N-1-pos022.de.lambdanet.net [217.71.105.97]
 9 16 ms 31 ms 16 ms F-2-pos110-0.de.lambdanet.net [217.71.105.105]
 10 31 ms 31 ms 32 ms PZU-1-pos100.fr.lambdanet.net [217.71.96.34]
 11 47 ms 32 ms 46 ms iar1-so-2-3-0.Paris.cw.net [208.175.147.1]
 12 31 ms 32 ms 31 ms bcr2.Paris.cw.net [208.172.250.62]
 13 109 ms 125 ms 109 ms dcr1-loopback.NewYork.cw.net [206.24.194.99]
 14 110 ms 109 ms 109 ms agr3-so-0-0-0.NewYork.cw.net [206.24.207.58]
 15 109 ms 109 ms 125 ms acr1-loopback.NewYork.cw.net [206.24.194.61]
 16 110 ms 109 ms 109 ms cable-and-wireless-peering.NewYork.cw.net [206.24.195.150]
 17 110 ms 109 ms 109 ms jfk-core-02.inet.qwest.net [205.171.230.22]
 18 109 ms 109 ms 125 ms jfk-core-01.inet.qwest.net [205.171.230.1]
 19 109 ms 109 ms 125 ms bos-edge-02.inet.qwest.net [205.171.28.14]
 20 110 ms 125 ms 109 ms 65.112.16.6
 21 109 ms 125 ms 109 ms 65.112.16.6
 22 110 ms 125 ms 125 ms host1.209.113.141.conversent.net [209.113.141.1]
 23 109 ms 125 ms 125 ms 216.235.245.246
 24 110 ms 125 ms 125 ms 216.235.245.246
 25 109 ms 125 ms 125 ms protest.net [216.235.252.206]
Trace complete.

Installations-Interfaces. In seiner reinen Form als Code-Äquivalent und als Diskursobjekt kann es sowohl als interaktives wie auch als interpassives Objekt verstanden werden.

and processes. Laser-sintered by a printer, these data objectiles are also part of the installation's interface. In its pure form as code equivalent and as discourse object it can be understood as both an interactive and interpassive object.

Margarete Jahrmann (A), artist and theorist, lives in Vienna and Zurich where she is professor for media art at the University of Art and Design. She graduated from the University of Applied Arts in Vienna. From 1994 to 1996 she made art CD-ROMs with Max Moswitzer. Between 1996 and 1998 she was a correspondent for the online journal *Telepolis*. Her publications include: *Intertwinedness, Überlegungen zur Netzkultur*, Jahrmann & Schneebauer (eds.), Ritter 2000; *Art_Server: Stargate to Netculture*, Jahrmann (ed.), O.K Center for Contemporary Art, Triton 2001. **Max Moswitzer, (A)**, artist, lives in Vienna. In 1990, experimental videos and co-founder of the artist group "You Never Know" with which he exhibited internationally. In 1996, he established the art server konsum.net with Margarete Jahrmann (*www.konsum.net/max/moswitzer*). He studied at the University of Applied Arts in Vienna, where he now lectures in hybrid media. His publications include: *datagold.priv.at*, Jahrmann & Moswitzer, MAK, Vienna 1997; *Nybble-Engine*, Jahrmann & Moswitzer, book / DVD, Vienna 2003. **Margarete Jahrmann (A)**, Künstlerin und Theoretikerin, lebt in Wien/ Zürich wo sie an der Hochschule für Gestaltung und Kunst Professorin für Medienkunst ist. Studium an der Universität für Angewandte Kunst in Wien. 94-96 Kunst CD-ROMs mit Moswitzer. 1996-98 war sie Korrespondentin des Online-Journals Telepolis. Publikationen: Intertwinedness, Überlegungen zur Netzkultur, Hg. Jahrmann/Schneebauer, Ritter 2000; Art_Server: Stargate to Netculture, Hg. Jahrmann/ O.K Centrum für Gegenwartskunst, Triton 2001. **Max Moswitzer, (A)**, Künstler, lebt in Wien. 1990 Experimentalvideos, Mitbegründer der Künstlergruppe „You Never Know", mit der er in internationalen Galerien ausgestellt hat. Er hat 1996 den Kunstserver konsum.net mit Jahrmann gegründet, *www.konsum.net/max/moswitzer*. Moswitzer hat an der Universität für Angewandte Kunst in Wien studiert, wo er nun Hybride Medien lehrt. Publikationen: *datagold.priv.at*, Jahrmann / Moswitzer, Hg MAK Vienna 1997; *Nybble-Engine*, Jahrmann / Moswitzer, Buch/ DVD, Wien 2003.

nybble-engine-toolZ—a radical meta-art system shooter

Tsukuba Series
Maywa Denki

Maywa Denki is an art unit produced by Nobumichi Tosa. It was named after the company that his father used to run in bygone days. The costume is designed as a typical working uniform of Japanese electric stores, symbolizing small / medium-sized enterprises that once supported Japan's economy during its high-growth period. Its unique style is indicated by a term he uses: For example, each piece of Maywa Denki's work is called "a product" and a live performance or exhibition is held as "a product demonstration." The products produced so far include "NAKI Series," fish-motif nonsense machines, "Tsukuba Series," original musical instruments, and "Edelweiss Series," flower-motif objets d'art. Although Maywa Denki is known and appreciated as an artist, its promotion strategies are full of variety: exhibition, live stages, performances, producing music, videos, writing, merchandising toys, stationery, and electric

Maywa Denki ist eine von Nobumichi Tosa geleitete „Kunsteinheit", benannt nach jener Firma, die sein Vater vor Jahren betrieben hat. Die Uniform der Mitwirkenden ist der typischen Arbeitskleidung japanischer Elektrogeschäfte nachempfunden und steht für jene kleinen und mittleren Unternehmen, die die japanische Wirtschaft in den Jahren ihres größten Wachstums getragen haben. Der einzigartige Stil der Gruppe wird auch durch die verwendeten Begriffe unterstrichen: So wird jedes einzelne von Maywa Denkis Werken „Produkt" genannt, und eine Live-Performance oder Ausstellung heißt dementsprechend „Produkt-Vorführung". Die bisherigen Produkte umfassen unter anderem die „NAKI-Serie" – Nonsense-Maschinen mit Fisch-Motiven –, die „Tsukuba-Serie" mit originellen Musikinstrumenten und die „Edelweiß-Serie" von Kunstobjekten mit Blumenmotiven. Obwohl Maywa Denki als Künstler bekannt und geschätzt sind, bleibt ihre Promotion-Strategie sehr vielfältig: Ausstellungen, Bühnenperformances, Musikproduktionen,

Videos, Texte, Merchandising-Spielzeug, Drucksorten und elektrische Geräte. Da Nobumichi ständig nach Möglichkeiten sucht, ein neues Publikum anzusprechen, beginnt Maywa Denki nun auch, seine Aktivitäten nach Übersee auszudehnen und in Europa auszustellen (Paris und London). Zum zehnten Geburtstag im Jahr 2002 wurden eine Konzerttournee „Jamboree" und Ausstellungen unter dem Titel „Romance Engineering" in mehreren großen Städten Japans abgehalten.

Tsukuba Music

Mit der Verbreitung von IT-Geräten wie Samplern, Synthesizern und PCs (Internet) hat sich die Musik heutzutage von ihrer „Substanz", das heißt, von ihren Musikinstrumenten, getrennt und wird vorwiegend als Information angesehen. Auch der Stil des Musikgenusses hat sich geändert, und in Folge dessen spricht man über Musik in Begriffen wie „Ich kenne so einen

devices. As Nobumichi is still looking for a new scheme for a different approach to the public, Maywa Denki is now beginning in earnest to extend its activities to overseas, holding exhibitions in Europe (Paris and London). In 2002, it was the 10th anniversary of Maywa Denki and memorial events; a concert tour "Jamboree" and exhibitions "Romance Engineering," were held in large cities in Japan.

Tsukuba Music

According to the spread of IT apparatus, such as a sampler, a synthesizer, and a personal computer (Internet) these days, music has been separated from "a substance" (= a musical instrument) and is now considered as "information." The style of enjoying music has changed, and as a result, people talk about music in the

fashion of: "I know such a maniac song", "I can remix the original song like this" or "I have a lot of music data". People are pleased by gathering "information on the music" that can be heard only through the speakers.

Tsukuba Music is designed to stir people's attention to notice the fact that "the live musical sound is created from a substance"—which the music once used to be in years past and they have totally forgotten.

Tsukuba Series is played by the movement of motors and / or electromagnets at 100V and makes a sound by physically beating/knocking a substance. It is a challenge to revive a live music sound with the power of machines. Tsukuba was named after Tsukuba City, a technological city in the Ibaragi prefecture in Japan.

Unique and original genres of music have often been born in specialized cities like Liverpool and

verrückten Song", „Ich kann den Originalsong so und so remixen" oder „Ich habe eine Menge Musikdaten". Den Leuten gefällt es, „Musikinformationen" zu sammeln, die nur durch die Lautsprecher gehört werden können. *Tsukuba Music* soll die Aufmerksamkeit des Publikums auf die Tatsache lenken, dass musikalischer Live-Sound aus einer echten „Substanz" gewonnen wird – wie die Musik früher, was vollkommen in Vergessenheit geraten zu sein scheint.

Die Instrumente der *Tsukuba-Serie* werden durch Motoren und / oder Elektromagnete bei Netzspannung gespielt und erzeugen ihre Klänge durch das Anschlagen einer Klangsubstanz.

Einen Livemusik-Klang durch Maschinenkraft wiederzubeleben ist eine Herausforderung. Der Name „Tsukuba" wurde von der gleichnamigen Stadt abgeleitet, einem Technologiezentrum in der Ibaragi-Provinz Japans. Eigenständige und originelle Musikgenres wurden häufig in spezialisierten Städten geboren, etwa in Liverpool

und Motown, den berühmten Industriestädten. Maywa Denki träumt davon, dass die nächste neue Musikform sich von Tsukuba aus, aus dem Zentrum der höchstentwickelten Technologie in Japan, in die ganze Welt verbreitet.

Motown, the famous industrial cities. Maywa Denki dreams that the next, new type of music will be created and spread worldwide from Tsukuba, the city of the most advanced technology in Japan.

Maywa Denki (J) was created in 1993 as an art unit of two brothers, Masamichi and Nobumichi Tosa. They started their career as an exclusive art unit belonging to Sony Music Entertainment, and later in 1998 transferred its management agency from SME to Yoshimoto Kogyo Co. Ltd. On Masamichi's retirement on 31st March, 2001, Nobumichi succeeded as the president. Nobumichi Tosa was born in 1967 and holds an MA from the Tsukuba University. **Maywa Denki (J)** wurde 1993 als Künstlergruppe von den Brüdern Masamichi und Nobumichi Tosa gegründet. Sie begannen ihre Karriere als exklusive Künstlergruppe, die zu Sony Music Entertainment gehörte, verlegten ihre Agentur aber 1998 zu Yoshimoto Kogyo Co., Ltd. Nach dem Ausscheiden Masamichis Ende März 2001 übernahm Nobumichi den Vorsitz der Gesellschaft. Nobumichi Tosa wurde 1967 geboren und graduierte an der Tsukuba University zum MA.

Last
Ross Cooper & Jussi Ängeslevä

Last is a clock that is a record of its own history. *Last* is like a familiar analogue clock, it has a second hand, a minute hand and an hour hand. The hand, are arranged in concentric circles, the outermost circle being seconds, the middle circle is minutes and the innermost circle hours. The major difference to a regular clock is that each of the hands of *Last* are made from a slice of live video feed. As the hands rotate around the face of the clock they leave a trace of what has been happening in front of the camera.

Last ist eine Uhr, die gleichzeitig die Aufzeichnung ihrer eigenen Geschichte ist. Wie jede übliche analoge Uhr hat sie einen Sekunden-, einen Minuten- und einen Stundenzeiger. Die Zeiger sind in konzentrischen Kreisen angeordnet, wobei der äußerste die Sekunden, der mittlere die Minuten und der innerste die Stunden anzeigt. Der größte Unterschied zu einer normalen Uhr besteht darin, dass die Zeiger von *Last* aus einem Streifen einer Live-Video-Zuspielung bestehen. Während sich die Zeiger um das Zifferblatt drehen, hinterlassen sie eine Spur dessen, was vor der Kamera geschehen ist.

Sobald *Last* mindestens zwölf Stunden gelaufen ist, erhält man ein einfach zu lesendes Mandala der archivierten Zeit.

Die Video-Zuspielung für *Last* kann jede beliebige Video-quelle verwenden: eine auf der Uhr selbst befestigte Kamera, die aufzeichnet, was vor der Uhr passiert, oder eine weiter entfernt positionierte Kamera, deren Bilder über Internet oder TV-Signal direkt in die Uhr eingespeist werden. So kann die Uhr den lokalen Raum, einen fernen Raum oder einen Medienraum anzeigen.

Physisch funktioniert *Last* besonders gut auf einem großen Display. Die Uhr lädt die Betrachter ein, mit ihr zu interagieren, wenn die Kamera den Raum vor der Uhr aufnimmt und so ständig veränderte und nicht selten wunderschöne interaktive digitale Gemälde schafft. Sie kann auch als ein dynamisches ästhetisches Objekt angesehen werden, das auf seine Umwelt reagiert und sie reflektiert und gleichzeitig einen Blick in die jüngste Geschichte dieses Raums ermöglicht.

Once *Last* has been running for at least 12 hours you end up with an easy-to read mandala of archived time.

The video feed for *Last* can be any video source: a camera mounted on the clock itself, looking at what is happening in front of it, a remote camera streamed over the Internet or TV signal fed directly to the clock. The clock can thus display the local space, remote space or media space respectively.

Physically *Last* works very well on a large display. It encourages people to interact with it (when the camera is in the same space) to create an ever changing, often beautiful, interactive digital painting. It can also be seen as a dynamic aesthetic object, responding to and reflecting its environment while providing an ambient view of the recent history of the space.

Ross Cooper (UK) is a recent graduate of the Interaction Design MA at the Royal College of Art and has a first class BA in Graphic Design from Central Saint Martin's College of Art and Design, where he is now a lecturer. Currently, he is working as a freelance designer and consultant for numerous companies as well as a practicing fine artist. **Jussi Ängeslevä (SF)** is a designer looking into embodied interfaces and the blending of the real and virtual. After co-founding the new media agency Prosopon Ltd. whilst an undergraduate at the University of Lapland, he continued his studies in the Interaction Design department at the RCA. Currently, he is based at the Media Lab Europe. **Ross Cooper (UK)** graduierte kürzlich zum MA aus Interaction Design am Royal College of Art und hat daneben auch den Grad eines BA aus Graphic Design am Central Saint Martins College of Art and Design erworben, wo er derzeit Lehrveranstaltungen abhält. Daneben arbeitet er als freiberuflicher Designer und Konsulent für zahlreiche Unternehmen und als freier Künstler. **Jussi Ängeslevä (SF)** ist Designer und beschäftigt sich mit integrierten Interfaces und mit der Verschmelzung des Realen mit dem Virtuellen. Nachdem er während seines Studiums an der University of Lapland die Agentur für neue Medien Prosopon Ltd. mitbegründet hatte, setzte er sein Studium des Interaction Design am Royal College of Art fort. Momentan arbeitet er am Media Lab Europe.

Aegis Hyposurface©
dECOi

Aegis is the name given to an innovative range of physically reconfigurable 3D screens, where the screen surface itself physically moves, producing precise and high-speed deformation across a "fluid" surface. It is enabled by a high-speed information bus that we have called *Hyposurface* technology.

Aegis Hyposurface effectively links information systems with physical form to produce dynamically variable, tactile "informatic" surfaces. Information translates into form. Most effectively it allows interactive systems to be physically articulate in their capacity for spatial reconfiguration.

The *Aegis Hyposurface* is a device whose surface topology is infinitely variable, allowing a continual emergence and dissipation of dynamic 3D motif (as rhythm, graphism or alphabetism). It releases the surface of inscription from 2 to 3 dimensions, but also acts as a temporal medium, *Aegis* as a now evolutive multi-dimensional medium. It ranges in its effect from hieroglyphics, a decorative / signifying 3D inscription, to nano-technics—a premonition of reconfigurable form. Most compelling is that *Aegis* communicates

Aegis ist der Name einer innovativen Serie von physikalisch umkonfigurierbaren 3D-Bildschirmen, bei denen sich die Bildschirmfläche selbst physisch bewegt und dadurch präzise und schnelle Deformationen über eine „flüssige" Oberfläche erzeugt. Dies wird durch einen Hochgeschwindigkeits-Informationsbus ermöglicht, den wir „Hyposurface Technology" genannt haben.

Aegis Hyposurface verbindet Informationssysteme effizient mit physischen Formen, um dynamisch variable, taktile Informationsoberflächen zu erzeugen. Information wird in Form übersetzt. Besonders effektiv erlaubt es interaktiven Systemen, physikalisch beweglich und räumlich umkonfigurierbar zu sein.

Das *Aegis Hyposurface* ist ein Gerät, dessen Oberflächentopologie unendlich variabel ist und ein ständiges Auftauchen und Verschwinden dynamischer 3D-Motive (wie Rhythmus, Graphik oder Schriftzeichen) erlaubt. Es verlagert die Oberfläche von Inschriften vom zweidimensionalen in den dreidimensionalen Raum, dient aber auch als zeitliches Medium, als ein entwicklungsfähiges vieldimensionales Medium. In seinen Effekten reicht es von Hieroglyphen – dekorativen und doch signifikanten 3D-Inschriften – bis zur Nanotechnik als Vorahnung einer rekonfigurierbaren Form. Besonders

faszinierend ist, dass *Aegis* auch über Körperempfindungen kommuniziert und zwischen einem architektonischen Bassregister (das körperlich wahrgenommen wird) und einem semiotischen digitalen „Meer" wechselt (das geistig aufgenommen wird) – das Virtuelle erhält eine Masse!

Entstanden als Serie stets weiterentwickelter Prototypen, verbindet *Aegis* einen leistungsfähigen generativen Computer über einen High-Performance-Information-Bus mit einer großen Matrix von Aktuatoren. Prototyp VI erzielt eine hohe Geschwindigkeit und Flüssigkeit und steuert 1000 pneumatische Aktuatoren mit Frequenzen bis zu 3 Hz, wobei Informationen im Hundertstelsekundentakt eingespeist werden. Es kann mit Hilfe eines generativen algorithmischen Programms ohne Zeitverzögerung ausgefeilte 3D-Muster, Lauftext, Stand- oder Videobilder als Relief darstellen.

Als digitale Matrix ist die *Hyposurface* inhärent interaktiv: Jeder digitale Input kann auf jeden digitalen Output abgebildet und so als Oberflächeneffekt dargestellt werden. Das System erlaubt Interaktivität mit Tänzern oder Musikern (Bewegungs- und Klanginteraktivität), wobei Video- und Klangerkennungssysteme eine programmierte Reaktionsfähigkeit erlauben. Als dynamisches Medium gestattet es auch direkte DJ/VJ-Operation, eine Art visuelles Musikinstrument, das den Traum Arcimboldos, der schon in der Renaissance ein „Farbenklavier" entwickelte, oder Brewsters gewagte Prophezeiungen über den Effekt des Kaleidoskops in der kinetischen Kunst erfüllt.

viscerally, alternating between a bass architectonic registration (sensed bodily), and a semiotic digital "sea" (registered cerebrally): the virtual given mass!

Developed as a series of evolving prototypes, *Aegis* links a powerful generative computer to a vast matrix of actuators via a high-performance information bus. Prototype VI attains high-speed fluidity, deploying 1000 pneumatic actuators at frequencies of up to 3Hz, information fed at 0.01 sec. It deploys sophisticated 3D patterning-in-time, running text, graphics or video images in relief, using a generative algorithmic program.

As a digital matrix, the Hyposurface is inherently interactive: any digital input can be linked to any digital output—to surface effect. It allows interactivity with dancers' or with musicians' (movement and sound interactivity), video- and sound-recognition systems offering a programmed responsiveness. But as a now dynamic medium it also allows direct DJ/VJ operation, a form of visual musical instrument that fulfills the dream of Arcimboldo who developed a "colour piano" back in the Renaissance or Brewster's delerious prophesy of the effect of the kaleidoscope on the kinetic arts.

A global network of architects, programmers, mechatronic engineers and mathematicians has developed all the hardware and software systems, *Aegis* born in the overlap of technical fields. **Design Team: dECOi:** Mark Goulthorpe, Oliver Dering, Arnaud Descombes, Gabriele Evangelisti, with Mark Burry, Grant Dunlop. Design Support: Prof Mark Burry and Grant Dunlop (Deakin University, now RMIT). Programming: Peter Wood (University of Wellington, NZ), Xavier Robitaille (University of Montreal, CDN). System Engineering / Design: Prof Saeid Navahandi, Dr Abbas Kouzani (Deakin University, AUS). Mathematics: Dr Alex Scott, Prof Keith Ball (University College London, UK). Engineering: David Glover of Group IV Ove Arup & Partners, London, UK. Technical Support: Facade Consultant: Sean Billings of Billings Design Associates, IRL. Rubber Research: RAPRA (UK), Burton Rubber (UK). Adhesive Research: Locktite Ltd. (UK). Pneumatic Systems / Fabrication: Univer Ltd, Bradford (UK). Facet Manufacture: Spanwall Ltd, Ireland. Funding: Sponsorship: National Endownment for Science, Technology and the Arts (NESTA, UK). The Arts Council (UK). PSG (D). Ein globales Netzwerk von Architekten, Programmierern, Mechatronik-Ingenieuren und Mathematikern hat die gesamte Hard- und Software-Systeme entwickelt – Aegis ist also disziplinenübergreifend entstanden. **Design Team bei dECOi:** Mark Goulthorpe, Oliver Dering, Arnaud Descombes, Gabriele Evangelisti, dazu Mark Burry, Grant Dunlop. Design Support: Prof. Mark Burry und Grant Dunlop (Deakin University, jetzt RMIT). Programmierung: Peter Wood (University of Wellington, NZ), Xavier Robitaille (University of Montreal, CDN). System Engineering / Design: Prof. Saeid Navahandi, Dr. Abbas Kouzani (Deakin University, AUS). Mathematik: Dr. Alex Scott, Prof. Keith Ball (University College London, UK). Engineering: David Glover von Group IV Ove Arup & Partners, London, UK. Technische Unterstützung: Facade Consultant: Sean Billings von Billings Design Associates (IRL). Gummi-Forschung: RAPRA (UK), Burton Rubber (UK). Klebstoff-Forschung: Locktite Ltd. (UK). Pneumatische Systeme/Herstellung: Univer Ltd, Bradford (UK). Herstellung der Facetten: Spanwall Ltd. (IRL). Finanzierung: Sponsorship: National Endownment for Science, Technology and the Arts (NESTA, UK). The Arts Council (UK, PSG D).

Aegis Hyposurface©

instant city
Sibylle Hauert / Daniel Reichmuth / Volker Böhm

instant city, ein elektronischer musik bau spiel automat is a music-building game-table. One or more players at a table can create architecture using semi-transparent building blocks and in the process make different modular compositions audible. Every performance is unique because the sequence, timing and combination possibilities are completely in the hands of the players! For each game one composition is chosen.

A spotlight hangs over the table and under the glass plate game board there is a field of light sensors. Each semi-transparent building block that is brought into position anywhere on the table establishes a filter dimming down the intensity of the downward-flashing spotlight. The resulting variations—a kind of grayscale continuum—can be registered by the sensor field under the glass plate. Each of these grayscale values corresponds to a particular parameter of the selected *instant city* composition. Exactly what is heard, however, depends upon where the building blocks are placed, how high they are, how many are on the table, and the sequence in which they are used.

An einem Tisch können eine oder mehrere SpielerInnen mit halbtransparenten Bausteinen Architekturen erstellen und damit modulare Kompositionen von verschiedenen KomponistInnen hörbar machen und spielerisch erforschen. Jede Aufführung ist einzigartig, weil Reihenfolge, Zeitfaktor und Kombinationsmöglichkeiten absolut in den Händen der Spieler liegen. Pro Spiel wird eine Komposition ausgewählt.

Über dem Tisch hängt ein Scheinwerfer, und unter der Spielfläche befindet sich ein lichtempfindliches Sensorfeld. Jedes halbtransparente Klötzchen, das irgendwo auf dem Tisch in Position gebracht wird, provoziert eine Abdämpfung des nach unten dringenden Scheinwerferlichts, einen so genannten Graustufenwert, der von dem unter der Glasplatte liegenden Sensorfeld registriert wird. Jeder dieser Graustufenwerte ist wiederum bestimmten Parametern der jeweiligen Komposition zugeordnet. Was zu hören ist, hängt so direkt davon ab, wo, wie hoch, mit welcher Anzahl Steine und in welcher Reihenfolge gebaut wird.

Zum heutigen Zeitpunkt haben acht Musiker eine solche Komposition, einen „Musikbausatz", hergestellt. Wir haben für diese ersten „Musikbausätze" Musikerinnen der verschiedensten Bereiche angefragt, um den

Spielern eine vielfältige Auswahl zu ermöglichen. Das Repertoire an Kompositionen kann und soll in Zukunft stetig erneuert / ergänzt werden, das heißt es steht jedem interessierten Musiker oder KomponistIn offen, einen „Musikbausatz" für *instant city* zu erstellen. Diese „Bausätze" werden mit einem speziell für die Bedürfnisse von *instant city* entwickelten Klang- und Detektions-Programm instant.tool geschrieben.

Für uns liegt der Reiz dieser interaktiven Installation in der Verführung des Publikums zur Aktion, und zwar nicht vor dem Bildschirm oder mit einer Tastatur, sondern mit Hilfe von physisch realen, sinnlich erfassbaren Gegenständen. Diese Aktion wiederum soll die Atmosphäre des gesamten Raums beeinflussen und weitere Menschen zum Spielen und Hören verführen ...

instant city ist eine interaktive Installation, ein modularer Musik-Sequencer, eine Kompositions-Software, eine Spielkonsole, ein Spiel, spielbar von einer/m oder mehreren SpielerInnen.

To date, eight different musicians have each produced special compositions which serve as the basic music building kits of instant city.

In order to give players a wide choice of compositions, we asked musicians working with very different kinds of music to create the first "music building kits". These "building kits" were created with a special sound and detection program that was especially developed to meet the requirements of *instant city*. In the modular creation of the software, the aim was to achieve a large range of tonal flexibility. The repertoire and compositions can and will be continually renewed / replenished, i.e. it is possible for any interested musician to create a "music building kit" for *instant city*.

For us the challenge of this interactive installation lies in enticing the audience into action, not only in front of the monitor or with a keyboard, but also in relation to physically real, sensually graspable objects. This action, on the other hand, should influence the atmosphere of the total space, luring other people to play and listen...

instant city is an interactive installation, modular music-sequencer, composition software, playing console, and game, which can be played by one or more players simultaneously.

Sponsored by: Kunstkredit Basel-Stadt
GGG, Gesellschaft für das Gute und Gemeinnützige
Fond Werkraum Warteck pp
Futurum Stiftung
Jubiläumsstiftung der Zürich Versicherungs-Gruppe
Alfred Richterich Stiftung
Demenga Glas AG

Sibylle Hauert (CH), born 1966, studied at the Scuola Teatro Dimitri in Verscio. She is a freelance actress, musician and performing artist. Member of the Performance and Musicians group Les Reines Prochaines, member of the Audio- und Videogenossenschaft, VIA, Basel and of the Verein für Kunst und digitale Medien. Foundation of the performance group "Any Affair" in 1999 together with **Daniel Reichmuth (CH)**. Born 1964, studies at "Scuola Teatro Dimitri" in Verscio. Actor, musician and performing artist. Member of "Werkraum Schlotterbeck" and co-founder of "Werkraum Warteck pp" in Basel, and "the Lodge". Member of the theater group "Theater KLARA". **Volker Böhm (D)**, born 1971, studied Music and Music Theory at the Musikhochschule Freiburg. **Sibylle Hauert (CH)**, geb. 1966; Studien an der Scuola Teatro Dimitri in Verscio, freiberufliche Schaupielerin, Musikerin und darstellende Künstlerin. Mitglied der Performance- und Musikgruppe „Les Reines Prochaines", der Audio- und Videogenossenschaft VIA, Basel, und des Vereins für Kunst und digitale Medien. 1999 Mitbegründerin der Performance-Gruppe „any affair" gemeinsam mit D. Reichmut. **Daniel Reichmuth (CH)**, geb. 1964. Studium an der Scuola Teatro Dimitri in Verscio. Schauspieler, Musiker und darstellender Künstler. Mitglied des „Werkraum Schlotterbeck" und Mitbegründer von „Werkraum Warteck pp" in Basel sowie von „the lodge". Mitglied der Theatergruppe Theater KLARA. **Volker Böhm (D)**, geb. 1971, studierte Musik und Musiktheorie an der Musikhochschule Freiburg.

Hyperscratch
Haruo Ishii

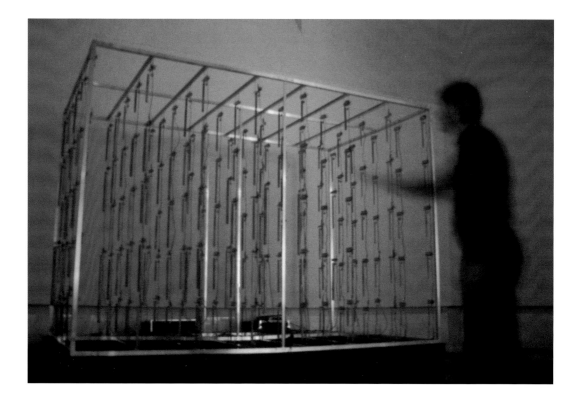

Hyperscratch is an interactive installation in which one can control light and sound by moving one's hand within a certain space.

There is an invisible three-dimensional interface in front of the participant. Within the interface are twelve horizontal rows, six vertical columns at five levels, front and rear, of invisible switches, 360 in total, which the participant can control by "touching" the switches which in turn operate the light and sounds of a device in front.

In front of the participant is a frame 8' in height, 13' wide, and 8' deep in which there are arranged again 360 (12 x 6 x 5) copper pipes with motors and LEDs. As the participant "touches" the invisible switches the pipe which corresponds to that switch emits sound and a light comes on. This endeavors to develop an interface which anyone can operate at will, freely, in a three-dimensional space, as well as produce such an interface which emits light and sound. The objects to be operated are spread out in a three-dimensional space and provide the participant

Hyperscratch ist eine interaktive Installation, bei der man Licht und Ton durch Handbewegungen innerhalb eines vorgegebenen Raums verändern kann.

Vor dem Mitwirkenden befindet sich ein unsichtbares dreidimensionales Interface aus insgesamt 360 virtuellen Schaltern, die in zwölf horizontalen Zeilen und sechs vertikalen Reihen auf fünf Ebenen angeordnet sind. Durch das „Berühren" dieser Schalter steuert der Teilnehmer Licht und Ton, die von einem vorne angeordneten Steuergerät generiert werden.

Vor dem Benutzer befindet sich ein 8 Fuß hoher, 13 Fuß breiter und 8 Fuß tiefer Rahmen, in dem wiederum 360 Kupferrohre in einem 12 x 6 x 5-Arrangement installiert sind. Jedes der Rohre ist mit LED und Motor ausgestattet und entspricht einem der Schalter. Beim „Berühren" eines Schalters gibt das zugehörige Rohr einen Klang von sich und schaltet sein Licht ein.

Ziel der Installation ist die Entwicklung eines Interface im dreidimensionalen Raum, das jeder nach Belieben bedienen kann, sowie die Produktion eines solchen Interface, das Licht und Ton von sich gibt. Die zu bedienenden Objekte sind im dreidimensionalen Raum

verteilt und bieten dem Mitwirkenden eine neue Erfahrung, nämlich jene, ein mechanisiertes Gerät an einem von ihm entfernten Ort zu bedienen.

Der aktivierte Klang wird nicht durch einen Computer generiert, sondern durch eine Glocke (ein Kupferrohr), die von einem Motor angeschlagen und von blinkendem Licht begleitet wird, was eine erfrischende Abwechslung für jene Ohren ist, die normalerweise computerisierten oder digitalisierten Tönen lauschen.

Computer und digitales Equipment werden zur Erkennung der Handbewegungen und zur Aktivierung von Licht und Ton eingesetzt, aber sie bleiben für den Mitwirkenden unsichtbar. Thema des Objekts sind die physische Bewegung der Hand des Mitwirkenden, der einfache, aber bedeutsame Klang der Kupferrohre und das Licht. Dies bringt meine persönliche Philosophie zum Ausdruck, nämlich dass Computer und andere High-Tech-Objekte, die unser tägliches Leben unterstützen, keine starke visuelle Präsenz haben sollten.

with a new experience, namely to operate a mechanized device in a remote place.

The sound activated is not made by a computer but is the sound of a bell (copper tube) hit by a motor and is accompanied by a flashing light; it will be a refreshing change to the ears of people accustomed to hearing computerized or digitalized sound.

Computers and digitalized equipment are used to detect hand movement and activate light and sound, but are not seen by the participant. The theme of this object is the physical movement of the participant's hand and the simple but meaningful sound of the copper pipe and the light. This expresses and symbolizes my personal philosophy that computers and other high-tech equipment, as it supports our daily lives, should not have a strong visual presence.

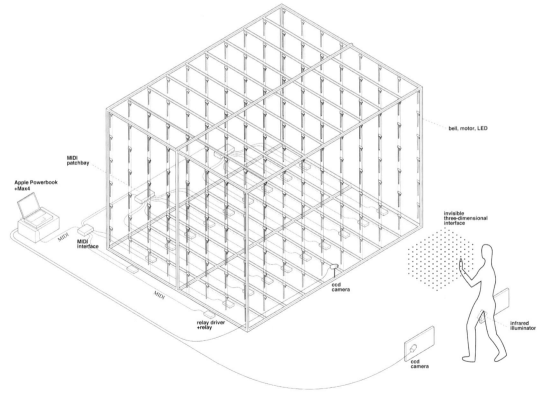

bell, motor, LED

MIDI patchbay

Apple Powerbook +Max4

MIDI

MIDI interface

invisible three-dimensional interface

ccd camera

MIDI

relay driver +relay

infrared illuminator

ccd camera

Haruo Ishii (J) is an artist whose works have been shown worldwide in museums and at international festivals including the Ars Electronica, SIGGRAPH, ISEA, Video Fest Berlin, Artport Nagoya, Digital Salon Europe, Visual Arts Museum New York and several more.
Haruo Ishii (J) ist ein Künstler, dessen Arbeiten weltweit in Museen und bei internationalen Festivals zu sehen waren und sind, u. a. bei Ars Electronica, SIGGRAPH, ISEA, beim Video Fest Berlin, bei Artpost Nagoya, Digital Salon Europe und im Visual Arts Museum New York.

Pockets full of Memories

George Legrady

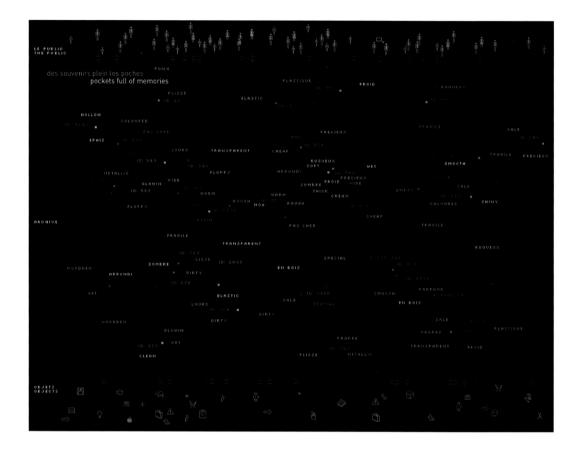

Pockets Full of Memories addresses current research interests in emergent algorithmic simulations in relation to data modelling. The audience creates an archive by contributing a digitized image of an object in their possession and then describing their properties through a touch screen questionnaire. The sum of the archive of objects is continuously being organized in a two-dimensional visual map by a Kohonen self-organizing map algorithm, relocating objects of similar descriptions in the map towards each other. The map is projected on a large gallery wall and accessed on the Internet for additional textual data entry. The database archive of objects contains such common items as phones, keys, toys, clothing, personal documents, currency, clothing textures, and others, The only limitation to what could be added to the archive was determined by the size of the opening of the scanning box. Surprisingly, the database includes an unusual number of

Pockets Full of Memories beschäftigt sich mit aktuellen Forschungen an emergierenden algorithmischen Simulationen und deren Bezug zu Datenmodellierung. Das Publikum schafft ein Archiv, indem jeder ein digitales Bild von einem Gegenstand in seinem Besitz beisteuert und anschließend anhand eines Touch-Screen-Fragebogens eine Beschreibung von dessen Eigenschaften abgibt. Die Summe dieses Objekt-Archivs wird von einem selbstorganisierenden Kohonen-Abbildungsalgorithmus ständig in einer zweidimensionalen visuellen Übersichtskarte aktualisiert, wobei Objekte mit ähnlicher Beschreibung auf der Übersicht zusammengerückt werden. Diese Übersicht wird auf eine große Galeriewand projiziert und ist für weitere Textdaten-Eingabe auch über das Internet zugänglich. Das Datenarchiv der Objekte enthält vor allem solch alltägliche Gegenstände wie Telefone, Schlüssel, Spielsachen, Kleidung, persönliche Dokumente, Kleingeld, Kleiderstoffe und Ähnliches. Die einzige Einschränkung hinsichtlich möglicher Hinzufügungen zum Archiv wurde durch die Öffnung der Scanner-Box vorgegeben.

Überraschenderweise findet sich in der Datenbank eine ungewöhnlich große Zahl eingescannter Köpfe, Hände und Füße, die das Archiv von einer reinen Objektsammlung zu einer Codierung des Ausdrucks der spezifischen Interessen und Unterschiede der Benutzergemeinschaft erweitert: Wer sie sind, wofür sie sich interessieren, wie sie sich selbst beschreiben – all das wird durch die zum Archiv beigesteuerten Objekte dargestellt. Die Übersicht organisierte sich bis zum Ende der Ausstellung stets selbst neu.

Die Ordnung der endgültigen Abbildung ist das Resultat des gesamten während der Ausstellungsdauer eingelesenen Inputs. Dieses Phänomen wird „Materielle Emergenz" genannt, da die Ordnung nicht vorgegeben ist, sondern erst durch die große Anzahl lokaler Interaktionen auf der Übersicht erscheint. Deswegen kann man das System auch als „selbstorganisierend" bezeichnen. Dank der aktiven Mitwirkung des Publikums kann das sich ergebende Archiv als Abbild der körperlichen Präsenz der Mitwirkenden angesehen werden.

scanned heads, hands and feet, extending the archive from simply being a collection of objects to encoding it with an expression of that particular community's interests and diversity: who they are, what they are interested in, how they described themselves represented through the objects donated to the archive. The map of objects continuously organized itself until that final moment of the end of the exhibition.

The order of the final map is a result of all the inputs read throughout the duration of the exhibition. This phenomenon is called material emergence as the order is not determined beforehand but emerges through the large number of local interactions on the map. This is why the system can be called 'self-organizing'. Through the audience's active participation, the resultant archive can be considered as the corporeal presence of the contributors.

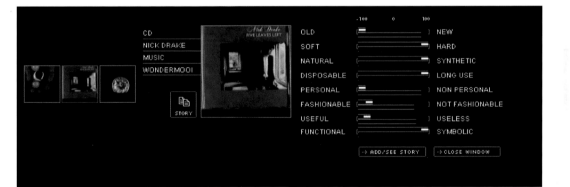

Concept & Creative Direction George Legrady. Initial Instigator of PFOM and Exhibition Curator for the Centre Georges Pompidou, Paris. Boris Tissot, Boris.Tissot@cnac-gp.fr. **Kohonen SOM Self-Organizing Map Integration** University of Art and Design Helsinki. Dr.Timo Honkela, Timo Koskenniemi and MediaLab team. http://scig.uiah.fi/. **Scan Station, Database, SOM System Integration.** c3 Center for Media and Communication, Budapest, Marton Fernezelyi, Zoltan Szegedy-Maszak. http://www.c3.hu. **DFEAF03 SOM, Data, System Integration** Ethan Kaplan, UCSB. ethankaplan@murmurs.com, http://www.murmurs.com. **Projection Visualization Design.** Andi Schlegel (DEAF 03 and after), http://www.sojamo.de. **Questionnaire Design and Data Analysis.** Dr. Brigitte Steinheider, Frauenhofer Institute, Stuttgart, University of Oklakoma, Tulsa. bsteinheider@ou.edu. **Internet Data Access, System Integration.** ATON/Create Research, UC Santa Barbara. Andreas Engberg, http://www.create.ucsb.edu. **Graphic Design & Visual Identity.** Projekttriangle Design, Stuttgart. Martin Grothmaak, Danijela Djokic, Juergen Spaeth. http://www.prokekttriangle.com. **Financial Support.** The Daniel Langlois Foundation for the Arts, Science and Technology, Montreal. The College of Letters and Science at the University of California, Santa Barbara.

George Legrady (USA) is Professor of Interactive Media, with joint appointment in the Media Arts & Technology program and the department of Art, UC Santa Barbara. He has previously held fulltime appointments at the Merz Akademie, Institute for Visual Communication, Stuttgart, the Conceptual Design / Information Arts program, San Francisco State University, University of Southern California, and the University of Western Ontario. He received the Masters of Fine Arts degree from the San Francisco Art Institute.

George Legrady (USA) ist Professor für Interaktive Medien und lehrt sowohl am Media Arts & Technology Program und am Department of Art, UC Santa Barbara. Zuvor unterrichtete er an der Merz Akademie, Institut für Visuelle Kommunikation, Stuttgart, am Conceptual Design / Information Arts Programm der San Francisco State University, University of Southern California, und an der University of Western Ontario. Er graduierte am San Francisco Art Institute zum Master of Fine Arts.

Cinéma Fabriqué
Justin Manor

Cinéma Fabriqué is a hardware and software environment that enables a single person to improvise video and audio programming in real time through gestural control. The goal of the system is to provide a means to compose and edit video stories and musical scores for a live audience with an interface that is both exposed and engaging to watch. Many of the software packages used today for realtime audiovisual performance are typically controlled by standard keyboard, mouse, or MIDI inputs, which were not designed for precise video control or live spectacle.

As an alternative, the Cinéma Fabriqué system integrates custom coded video editing and effects software and hand gesture tracking methods into a single system for audio-visual performance.

The user dons two lighted gloves, each a different color, while standing in front of a camera and display screen. The camera tracks the position of the user's hands and maps these to two on-screen cursors. A collection of media clips and live video feeds are available at the top of the display and can be accessed by raising a hand to 'grab' them and 'drag' them to the central canvas. Once a media object has been placed onto the canvas it can be edited or manipulated through hand movements and gestures.

The manner in which the media clip or live feed is altered is selected at the bottom of the display. Icons lined up in the lower portion of the screen

Cinéma Fabriqué ist ein Hardware- und Software-Environment, das einer Einzelperson erlaubt, Echtzeit-Video und Audio-Programmierung durch gestische Steuerung zu improvisieren. Ziel des Systems ist es, ein Tool zur Komposition und Bearbeitung von Video-Stories und Musikpartituren für ein Live-Publikum zu bieten, das als Interface sowohl exponiert als auch interessant zu beobachten ist. Viele der heute für audiovisuelle Echtzeit-Performances verwendeten Softwarepakete werden über ein Standard-Keyboard, eine Maus oder einen MIDI-Input gesteuert, die alle nicht unbedingt für präzise Video-steuerung oder Live-Aufführungen entwickelt wurden.

Als Alternative integriert das Cinéma Fabriqué-System eigens codierte Videoschnitt- und Effekt-Software sowie Trackingmethoden für Handgesten in ein einfaches System für audiovisuelle Aufführungen.

Der Anwender, der vor einer Kamera und einem Bildschirm steht, trägt zwei mit Lichtquellen ausgestattete Handschuhe von unterschiedlicher Farbe. Die Kamera verfolgt die Position der Hände des Users und bildet sie auf zwei Onscreen-Cursors ab. Eine Sammlung von Medienclips und Live-Video-Zuspielungen ist am oberen Rand des Displays verfügbar und kann jederzeit dadurch aufgerufen werden, dass man eine Hand hebt, das gewünschte Objekt „ergreift" und in die Mitte des Bildschirms „zieht". Sobald ein Medienobjekt auf der Arbeitsfläche liegt, kann es durch Bewegungen und Gesten der Hände editiert oder manipuliert werden.

Auf welche Weise der Medienclip oder die Live-Zuspielung bearbeitet wird, lässt sich am unteren Bildschirmrand

auswählen. Die dort aufgereihten Icons lassen sich durch
„Antippen" mit der Hand aktivieren. Clips können verkürzt
oder zur Schaffung von „Beats" zu Schleifen geformt
oder zerkratzt werden, indem man mit der Hand kreis-
förmige Bewegungen ausführt. In einem der Modi können
Farben aus dem Clip ausgewählt und extrahiert werden.
Darüber hinaus gibt es zahlreiche dreidimensionale Ver-
zerrungsmöglichkeiten und andere Möglichkeiten der
Video-Manipulation. Die Hände werden zum Drehen,
Schwenken und Zoomen der resultierenden skulpturalen
Formen eingesetzt.

Da Cinéma Fabriqué die Kontrolle der räumlichen und
zeitlichen Präsentation von Live-Video erlaubt, werden
hier die Steuerungsmöglichkeien einer Computer-Model-
ling-Software mit den expressiven Möglichkeiten einer
direkten Manipulation der Szene durch Handbewegungen
kombiniert. Der Anwender kann interessantes Bildmaterial
wiederholen oder aus jedem beliebigen Winkel oder mit
jeder gewünschten Geschwindigkeit selbst in winzige
Ausschnitte des Bildes einzoomen. Dadurch, dass Zeit-
änderungen und dreidimensionale Verzerrungen fast un-
merkbar oder aber abrupt vorgenommen werden können,
lassen sich die Betrachter in eine Welt ziehen, die gleich-
zeitig real und irreal ist. Da sich Performer und Publikum
in ein und derselben Umgebung befinden, kann diese
leicht und beliebig neu interpretiert werden, um hervor-
stechende Eigenschaften hervorzuheben oder neue
Bedeutungsinhalte einzuführen.

can be selected by bringing a hand down and
tapping them. Clips can be shortened and looped
to create beats or scratched by moving a hand in
circles. Colors can be separated and extracted
from the video in one of the modes. Several three
dimensional distortions and and manipulations of
the video are also available. The hands are used
to pan, rotate, and zoom the resultant sculptural
forms.

With the command over spatial and temporal
presentation of live video available in the Cinéma
Fabriqué system, the control possibilities of
computer modelling software are combined with
the expressive possibilities of direct scene
manipulations through hand movements. Users
can loop interesting footage or zoom into a tiny
portion of the scene from any angle or velocity.
With the ability to introduce time changes and
three dimensional distortions to live video subtly
or abruptly, viewers can be drawn into a world
that is simultaneously real and unreal. The shared
surroundings of performer and audience are easily
reinterpreted at will to exaggerate prominent
features or introduce new meaning.

Justin Manor (USA) has recently completed his studies under John Maeda in the Aesthetics
and Computation Group at the MIT Media Lab. His work there focused on the realtime
manipulation of video and audio, and the use of the body as a controller of media events.
He also received a Bachelor's Degree in Astrophysics from MIT, and modelled the
collisions of neutron stars and black holes. Between his stints at MIT he worked under designer David Small building museum
installations and physical information browsers. Justin's work has been shown in the London ICA, the Chicago Museum of Science
and Industry, the Asia Society Museum, and the Museum of Sex in New York. **Justin Manor (USA)** studierte unter John Maeda an
der Aesthetics and Computation Group am MIT Media Lab. Manor beschäftigte sich dort mit der Echtzeitmanipulation von Video
und Audio und dem Gebrauch des Körpers als Controller von Media-Events. Im Rahmen eines Baccalaureats in Astrophysik am
MIT modellierte er die Kollision von Neutronensternen und Schwarzen Löchern. Neben seiner Arbeit am MIT entwarf er unter dem
Designer David Small Museumsinstallationen und Informationsbrowser. Manors Arbeiten wurden im Londoner ICA, dem Museum
of Science and Industry in Chicago, dem Asia Society Museum und dem Museum of Sex in New York ausgestellt.

Earth Core Laboratory and Elf-Scan
Agnes Meyer-Brandis

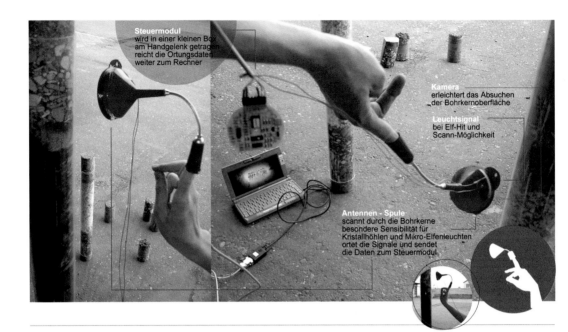

Steuermodul
wird in einer kleinen Box am Handgelenk getragen reicht die Ortungsdaten weiter zum Rechner

Kamera
erleichtert das Absuchen der Bohrkernoberfläche

Leuchtsignal
bei Elf-Hit und Scann-Möglichkeit

Antennen - Spule
scannt durch die Bohrkerne besondere Sensibilität für Kristallhöhlen und Mikro-Elfenleuchten ortet die Signale und sendet die Daten zum Steuermodul

In the English notion of "interface" not only two surfaces meet but also two faces. Two different bodies, worlds, normally separate entities, come together, turn towards one another, mesh, and by doing so generate something else. Interfaces are dramatic places. Places of difference between one thing and the other.

The interfaces which Agnes Meyer-Brandis develops on her research raft are artefacts of secret listening and voyeuristic watching. They are interfaces to worlds usually hidden or deliberately concealed from us: lovely subterranean coral reefs which according to the artist and head of the research institute do not only exist at the bottom of the sea or in special caves on the coast, but can be ubiquitous and migrate incessantly. As nomadic accumulations of coelenterates with calcium carbonate skeletons, they are able to spread and settle at all subterranean locations where there are large quantities of water. Such potential worlds require special protection and special care. As shadows of the visible terrestrial world they are incredibly more beautiful than tangible reality. Yet this is also why they are in constant danger. In their efforts to humanize the

Im angelsächsischen Begriff des Interface treffen sich nicht nur einfach zwei Oberflächen, sondern auch zwei Gesichter. Zwei unterschiedliche Körper, Welten, normalerweise getrennte Entitäten, begegnen einander, wenden sich einander zu, greifen ineinander und erzeugen durch dieses Zusammentreffen etwas Drittes. Schnittstellen sind dramatische Orte. Sie sind Orte der Differenz zwischen dem Einen und dem Anderen.

Die Interfaces, die Agnes Meyer-Brandis auf ihrem Forschungsfloß entwickelt, sind Artefakte des heimlichen Lauschens und des voyeuristischen Beobachtens. Sie sind Schnittstellen zu Welten, die uns gemeinhin verborgen sind oder gezielt vor uns verborgen gehalten werden: wunderschöne unterirdische Korallenriffe, die es nach Ansicht der Künstlerin und Leiterin des Forschungsinstituts nicht nur am tiefen Meeresgrund oder in besonderen Höhlen an den Küsten gibt, sondern die ubiquitär (allerortens) sein können und ständig wandern. Als nomadische Ansammlungen von Hohltieren mit Kalkskeletten können sie sich unterirdisch überall dort ausbreiten und aufhalten, wo große Mengen Wassers sind.

Solche Möglichkeitswelten benötigen besonderen Schutz und besondere Fürsorge. Als Schatten der sichtbaren terrestrischen Welt sind sie ungeheuer viel schöner als die greifbare Wirklichkeit. Aber gerade deshalb sind sie

auch permanent gefährdet. In ihrem Bestreben, auch die letzten Restbestände des noch nicht Vermenschlichten zu humanisieren, greifen die mit Sprache und Instrumenten für die Arbeit ausgestatteten Erdbewohner immer mehr in die sie umgebenden Möglichkeitswelten ein und machen sie zum Bestandteil ihrer eigenen Realität, bedrängen sie, unterwerfen sie, annektieren sie oder zerstören sie gar.

Deshalb sind die Interfaces, die Agnes Meyer-Brandis entwickelt und baut, von spezieller Anmut und keine Eindringlinge. Sie haben medialen Charakter. Es sind Suchgeräte für Möglichkeitswelten, sensible Ausdehnungen für unsere sinnlichen Organe, ohne die uns die mundus subterraneus, jene unterirdische Welt, nach der Athanasius Kircher im Dreieck der Vulkane Aetna, Stromboli und Vesuv schon vor mehr als 350 Jahren geforscht hat, unzugänglich und völlig unbekannt blieben. Kircher tat dies wie ein Astronom, der den Blick umkehrte. Er richtete ihn nicht auf die rätselhaften Erscheinungen von Planetensystemen, Sternenmeeren oder Milchstraßen, sondern auf die unterirdischen Feuer, die Eruptionen und Verschiebungen, die sie unter dem Meeresgrund oder subterrestrisch verursachen. Die Hörrohre, Lauschtrichter, Bildschirme und Sehkanäle, die im Institut für Riffologie entwickelt werden, können wir somit auch als Sonden einer verkehrten Astronomie, als feine mareonomische Instrumente begreifen.

Der eigens für das „Earth-Core-Laboratory" in Linz entwickelte Bohrkernscanner für das Aufspüren und die Erforschung des Lebens von Elfen in den unterirdischen Riffen, ist ein besonders schönes Exemplar behutsamer Interfaces. Er funktioniert taktil nur auf der Seite des Benutzers, aber ohne dass die zu beobachtenden Objekte selbst berührt werden oder sich angegriffen fühlen könnten; in den Ausmaßen ist er extrem reduziert, unscheinbar eher, und steht so im Kontrast zu den üppigen Welten, für deren Entdeckung und Erforschung er als Instrument dient.

(Siegfried Zielinski)

little which has not been humanized yet, inhabitants of the earth increasingly intervene—equipped with the language and instruments for the job—in the potential worlds around them, making them a part of their own reality, which means oppressing, subjugating, absorbing and even destroying them. This is why the interfaces which Agnes Meyer-Brandis has developed have a special grace and are not intruders. They have a medial character. They are search devices for potential worlds, sensitive extensions for our sensory organs, without which the *mundus subterraneus*—that underground world which more than 350 years ago Athanasius Kircher was searching for in the triangle of volcanoes formed by Mount Etna, Stromboli and Mount Vesuvius—would remain inaccessible and so entirely unknown. Kircher went about this like an astronomer who has turned his gaze inwards. Kircher did not direct his gaze at the mysterious phenomena of planetary systems, stellar populations or galaxies, but at subterranean fires, eruptions and shifts. The stethoscopes and ear trumpets, screens and optical channels developed at the Institute for Reefology are thus to be seen as probes of a reversed astronomy, as fine mareonomic instruments.

The drill core scanner for tracking down and exploring the lives of elves in these subterranean reefs, developed specifically for the *Earth Core Laboratory* in Linz, is a particularly beautiful example of a soft interface. It works by touch only on the user's page, though without the objects under observation being touched themselves or feeling they might be assaulted; it is extremely reduced in scale, quite inconspicuous, and thus in sharp contrast with the lush worlds for whose discovery and exploration it serves as an instrument.

(Siegfried Zielinski)

Agnes Meyer-Brandis (D), born 1973, attendes summer academy Salzburg (T. Munzlinger) in 1992, worked in Vienna for six months and studied sculpture at the art academy Maastricht, Netherlands and at the art academy Düsseldorf. She earned her bachelor of art degree in 2000 and since then attends the postgraduated art academy for new Media (KHM) in Cologne, where she is supposed to finish her Master of Media Art degree in Summer 2003. **Agnes Meyer-Brandis (D)**, geb. 1973, besuchte 1992 die Sommerakademie in Salzburg (T. Munzlinger), arbeitete ein halbe Jahr in Wien und studierte Bildhauerei an der Kunstakademie in Maastricht sowie an der Akademie der Künste in Düsseldorf. Im Jahr 2000 schloß sie die Akademie ab und studiert seither an der Kunsthochschule für Medien in Köln, wo sie im Sommer 2003 ihr Studium der Medienkunst mit dem Magisterium abschließen wird.

Streetscape
Iori Nakai

Streetscape is a device that extracts environmental sounds and city form, and immerses you in them so that you can imagine your surroundings. By tracing a map where the roads have been cut away, you can listen to sounds from that particular location using headphones. This idea emerged from wondering what we can see in the scenery of a city imagined through sound, and what kinds of memories will be brought to the surface. Usually pen tablets are used to "draw" pictures on the computer, but in Streetscape they allow you to "walk" while listening to the sounds of the city, and to feel the close connection between the map and sounds. Because I tried to create an environment of listening to natural sounds using natural movement, participants interact by tracing the indentations in the map with a pen, rather than with a mouse or their finger. This allows viewers to become more absorbed in the scenery.

Streetscape has been created and exhibited in seven cities in Japan and abroad, including Kyoto, Nagoya, Hamamatsu, Sendai, Roppongi, and Paris. Each piece was recorded in the city where it was scheduled to be shown, and I made a new map of the city. People living there experienced this work, and I also showed pieces created in

Streetscape ist ein Gerät, das Umweltklänge und Stadtformen extrahiert und den Zuhörer darin eintauchen lässt, sodass man sich seine Umgebung vorstellen kann. Mithilfe eines Stadtplans, auf dem die Straßen ausgeschnitten sind, sowie eines Kopfhörers kann man den zum jeweils ausgewählten Ort gehörigen Klang anhören. Dieser Gedanke entstand aus der Frage, was man wohl in der Szenerie einer Stadt sehen würde, wenn sie nur über den Klang dargestellt würde, und welche Erinnerungen sie heraufbeschwören würde.
Zeichentablett und Stift werden bei Computern normalerweise zum „Zeichnen" von Bildern verwendet, bei Streetscape aber erlauben sie einem zu „wandern", während man den Klängen der Stadt lauscht, und die enge Verbindung zwischen Stadtplan und Klang zu erspüren. Da ich versucht habe, eine Hörumgebung für natürliche Klänge zu erstellen, die mit natürlichen Bewegungen erschlossen wird, interagieren die Besucher, indem sie mithilfe des Stifts die Einkerbungen im Plan nachfahren und nicht mit der Maus oder einem Touchpad, wodurch sie tiefer in die Szenerie eintauchen können.
Streetscape wurde in sieben Städten in und außerhalb Japans gezeigt, darunter Kyoto, Nagoya, Mamamtsu, Sendai, Roppongi und Paris. Für jede dieser Städte wurde das Stück neu aufgenommen und ein eigener

Stadtplan angelegt. Die jeweiligen Einwohner konnten so ihre eigene Stadt erfahren. Außerdem habe ich auch die Stücke gezeigt, die in anderen Städten entstanden sind, um die Erfahrung so real wie möglich werden zu lassen. Für das Publikum ist es eine besonders intensive Erfahrung, seine übliche Umgebung Seite an Seite mit einer völlig unbekannten zu erleben.

Obwohl ich dieses Werk für viele unterschiedliche Städte geschaffen habe, ist es nicht mein Ziel, für jeden Ort sozusagen einzigartige Klänge einzufangen. Wollte ich dieses tun, so würde ich meine Subjektivität zwischen Werk und Publikum stellen und das Ergebnis würde wesentlich distanzierter sein. Ich nehme Bedacht auf Klangqualität und -präsenz, wenn ich die Geräusche des Alltags in Schichten strukturiere, und nicht so sehr auf die stereotypische Stadtlandschaft. Natürlich kommen immer wieder Szenen vor, die man nur zu einem bestimmten Moment an einem bestimmten Ort hören kann. Lausche ich der Umgebung, die ich normalerweise ignoriere, so fühle ich die Existenz der Stadt, der Menschen und meine eigene Präsenz im Hier und Jetzt. Ich hoffe, Arbeiten zu schaffen, die einen Blick auf jenes zauberhafte Drama erlauben, das im Hintergrund abläuft.

Ich plane, *Streetscape* in Workshops weiterzuentwickeln, damit andere ihr persönliches „Streetscape" erzeugen können, indem sie ihre Lieblings-Soundumgebung aufzeichnen. Daneben arbeite ich auch an der Archivierung von Klängen von einem neuen originellen Standpunkt aus, indem ich die vertikalen Veränderung des Klangs in Form von „Skyscapes" ausdrücke, oder den Kalender verwende, um darzustellen, wie sich der Klang im Laufe des Tages an einem bestimmten Ort verändert.

cities far away, in an effort to make the experience as real as possible. For the audience, there is a big impact in experiencing both usual and unusual environments, juxtaposed side by side. Although I create this work in many different cities, my aim is not to capture sounds unique to each place. If I took this approach, I would end up interjecting my own subjectivity between the work and the audience, and the result would be increased distance. I take sound quality and presence into consideration as I layer the ordinary sounds of life, as opposed to the stereotyped cityscape. Undoubtedly, scenes emerge that you can only encounter at that place at that moment. By listening to the surroundings that I usually ignore, I feel the existence of the city, the people, and my own presence in the here and now. I hope to create work that gives a glimpse of the miraculous drama being played out in the background. I'm planning to develop *Streetscape* into workshops, where people create "My Streetscape" or their own personal "Streetscape" by recording their favorite sound environment. Also, I am working on archiving sound from an original point of view, such as expressing the vertical change in sound through "skyscapes," or using the calendar as a motif for showing how sound changes during the course of the day for a particular place.

Iori Nakai (J), born 1980, became interested in digital music in 1996 and bought a synthesizer. In 1999 he entered the Institute of Advanced Media Art and Sciences (IAMAS), and came face to face with a place for artistic expression using electronic equipment. He did collaborative projects with many artists, and through working with others developed the ability of self-expression. In 2000 he debuted with *Streetscape* as his first work. **Iori Nakai (J)**, geb. 1980, begann sich 1996 für digitale Musik zu interessieren und kaufte sich einen Synthesizer. 1999 trat er ins Institute of Advanced Media Art and Sciences (IAMAS) ein und fand sich plötzlich mit einem idealen Ort für künstlerischen Ausdruck mittels elektronischer Medien konfrontiert. Er wirkte in Gemeinschaftsprojekten mit vielen anderen Künstlern mit und erwarb dadurch die Fähigkeit zum eigenen Ausdruck. *Streetscape* (2000) ist sein Debut als Solokünstler.

Block Jam

Henry Newton-Dunn / Hiroaki Nakano / James Gibson / Ryota Kuwakubo

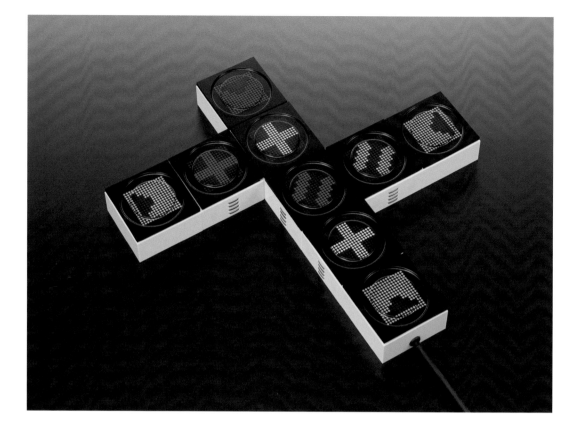

Block Jam is a musical interface controlled by the arrangement of 25 tangible blocks. By arranging the blocks, musical phrases and sequences are created, allowing multiple users to play and collaborate. We believe in a future where music will no longer be considered a linear composition, but a dynamic structure and musical composition will extend to interaction.

We want to put the group experience back into music. We understand that the musical experience changes with technology. Musical technology allows greater control and more possibilities than ever before and greater access for the beginner or novice. The way we receive and listen to music is also changing, not just in terms of Low-Fi to Hi-Fi or Phono to Tape to CD to MD to MP3, but also in terms of experience;

Block Jam ist ein musikalisches Interface, das durch ein Arrangement von 25 physischen Blöcken gesteuert wird. Durch die Anordnung der Blöcke werden musikalische Phrasen und Sequenzen geschaffen, wobei die Mitwirkung und Zusammenarbeit mehrerer User möglich ist. Wir glauben an eine Zukunft, in der die Musik nicht länger als eine lineare Komposition angesehen wird, sondern als eine dynamische Struktur, deren Komposition stark auf Interaktionen zurückgreift. Es ist klar, dass sich die Musikerfahrung mit der Technologie ändert – die Technologie in der Musik erlaubt größere Kontrolle und mehr Möglichkeiten als je zuvor und erleichtert auch dem Anfänger oder Neuling den Zugang.

Auch die Art und Weise unseres Hörens und unserer Musikwahrnehmung ändert sich, nicht nur von Low-Fi zu Hi-Fi oder vom Phonographen zum Band zur CD zu MD zu MP3, sondern auch hinsichtlich der Erfahrung:

Die Musik wird von einem sozialen Ereignis zu einem persönlichen Erlebnis, vom Lagerfeuer zum Orchester zum Wohnzimmer zum Walkman. Es erfolgte eine schrittweise Trennung zwischen Komponisten und Aufführenden sowie zwischen Aufführenden und Publikum, und dieser Trend setzt sich fort. Andererseits bewegt sich die Technologie in Richtung Gemeinschaft, Gruppe und Netzwerk.

Wir haben die Vision einer musikalischen Erfahrung, die vom Neuling wie vom geübten Musiker geteilt werden kann, die zwar den Begriff des Autors und Komponisten bewahrt, aber dem Benutzer genug kreative Flexibilität lässt, dass er dem Werk seinen eigenen Stempel aufdrücken kann. Wenn die Handlungen des Benutzers durch die kollaborative Mitwirkung anderer in einen größeren Zusammenhang gestellt werden, wird die Erfahrung geteilt und ist vielleicht doch nicht mehr so weit entfernt vom Lagerfeuer von einst …

music is moving from a social experience to a personal experience, from campfire to orchestra to living room to Walkman. Degrees of separation have occurred between the composer and the performer, the performer and the audience. This trend is continuing. Inversely, technology is moving towards community, towards the group, towards the network.

We envision a musical experience that can be shared equally by the novice or the musically adept, retaining a notion of author and composer, yet allowing the user enough creative flexibility to add their own stamp. When the user's actions are contextualised by the collaborative actions of others, the experience will become shared, and perhaps not so far from the campfire of yore.

Henry Newton-Dunn (GB), is an associate design researcher for Sony Computer Science Laboratories Interaction Lab, where he specializes in interactive music. He is also an active member of the Creative Development Group at Sony Corporation. **Hiroaki Nakano (J)** works in interface design and development for Sony Corporation. He has spent time in the development of professional video editing systems and joined several project teams, which released innovative consumer products such as the VAIO home computer. **James Gibson** is a senior designer at the Sony Design Center Europe Human Interface Group, where he has led projects for digital TV and mobile handsets based around the community building. Before joining Sony, he was a director of a leading European Web design and development company. **Ryota Kuwakubo (J)** graduated from the Master's Program in Art and Design, Tsukuba University/M.A, (1996) and Art and labo course of IAMAS (2002). He is specialized in toy or product developing. **Henry Netwon-Dunn (GB)** ist Associate Design Researcher am Sony Computer Science Laboratories Interaction Lab, wo er sich auf interaktive Musik spezialisiert hat. Daneben ist er auch aktives Mitglied der Creative Development Group der Sony Corporation. **Hiroaki Nakano (J)** arbeitet an der Entwicklung von Interfaces für Sony Corporation. Er hat längere Zeit an der Entwicklung professioneller Videoschnittsysteme und an zahlreichen Projektgruppen mitgewirkt, die so innovative Konsumprodukte wie die VAIO-Home-Computer zur Marktreife gebracht haben. **James Gibson** ist Senior Designer bei der Sony Design Center Europe Human Interface Group, wo er Projekte für digitales Fernsehen und Mobiltelephonie rund um den Begriff des „Community Building" geleitet hat. Vor seinem Eintritt bei Sony war er Direktor eines führenden europäischen Webdesign- und Entwicklungsunternehmens. **Ryoto Kuwakubo (J)** graduierte 1996 mit einem Master of Arts (Kunst und Design) an der Tsukuba University und absolvierte einen Laborkurs am IAMAS (2002). Er ist in der Entwicklung von Spielsachen und anderen Produkten tätig.

Pol
Marcel.lí Antúnez Roca

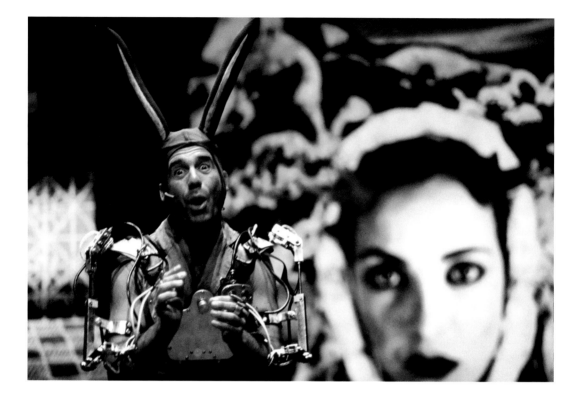

Pol is tale told in the form of a mechatronic show: an ironic and poetic fable for all audiences; an interactive story, product of the dialogue between machines, performers and spectators; a new form of technology, a mutation of stage production.
In its origins, *Pol* draws on the popular European fable. We have chosen this genre not out of any nostalgia for children's stories or desire to follow an ethnic tradition, but for its narrative characteristics. Fables are structured with a simplicity, pace and sequence of events—magical, unexpected, disconcerting—that makes them very apt for the construction of a particular graphic universe and for fostering key moments through interaction.
Although inspired in the genre, *Pol* isn't a reworking of any particular popular tale. The story of *Pol* traces the perilous journey of a rabbit in search of love. The loss of his teeth, a biological

Pol ist eine Erzählung, die in Form einer mechatronischen Show dargeboten wird, eine ironische und poetische Fabel für jede Art von Publikum, eine interaktive Geschichte, Produkt eines Dialogs zwischen Maschinen, Mitwirkenden und Zusehern – eine neue Form der Technologie, eine Mutation der Bühnenproduktion.
Zu den ursprünglichen Quellen von *Pol* gehört zweifellos das klassische europäische Märchen. Wir haben dieses Genre weder aus Nostalgie oder einer besonderen Vorliebe für Kindergeschichten gewählt noch aus dem Wunsch, einer ethnischen Tradition zu folgen, sondern wegen seiner erzählerischen Charakteristiken. Märchen und Fabeln sind einfach strukturiert, haben ein Tempo und eine Abfolge der Ereignisse – magisch, unerwartet, beunruhigend –, wodurch sie sich sehr gut dafür eignen, ein spezielles grafisches Universum aufzubauen und Schlüsselmomente durch Interaktion zu fördern.

Auch wenn *Pol* vom Genre des Märchens inspiriert ist, handelt es sich nicht um eine Neufassung irgendeiner bekannten Erzählung. Die Geschichte von *Pol* beschreibt die gefahrvolle Reise eines Hasen auf der Suche nach der Liebe. Der Verlust seiner Zähne – ein biologischer Unfall in seiner Kindheit und eine physiologische Veränderung, wie sie der Körper auch in anderen Lebensstadien durchmacht – bildet ein Leitmotiv seiner Odyssee. Ein zweites ist seine Suche nach Liebe. Pols Abenteuer, die mit neuen Zähnen und letztlich einem Substitut für die Liebe belohnt werden, illustrieren archetypische Leidenschaften und Ängste: gewalttätige Euphorie, die Angst vor Infektion und den Alptraum der Drogen. Nach dem Verlust seiner Zähne beschränkt sich die Diät Pols des Hasen auf Weichfutter, und er findet vor allem an einer speziellen Sorte Dosenwurst Gefallen. Während er sich durch Dose um Dose frisst, verliebt sich unser Nager in das Mädchen auf dem Etikett, Princepollu, die Tochter des bösen Cervosatan. Pol begibt sich auf der Suche nach seiner Liebe auf eine Initiationsreise. Im Laufe der Reise muss er die Hindernisse überwinden, die ihm von den böse gesinnten Dienern von Cervosatan – Jaba, Lopa, Sap und Serpe – in den Weg gelegt werden. Bei jeder Prüfung gewinnt er einen neuen Zahn dazu, bis er ein ganzes neues Gebiss als Symbol der Stärke hat. Und dann kann er seine Feinde unterwerfen, Cervosatan besiegen und seine Liebe erringen.

accident of his infancy and physiological change akin to that which the body undergoes in other stages of life, emerges as one of the leitmotifs of the odyssey. His quest for love is another. *Pol*'s adventures, with the reward of new teeth and, in the end, a substitute for love, bring out archetypical passions and fears: violent euphoria, fear of infection and the narcotic nightmare.
After losing his teeth Pol the rabbit finds his diet limited to soft food, and he gets hooked on a particular brand of tinned sausage. As he eats his way through tin after tin, our rodent falls in love with the girl on the label, Princepollu, daughter of the evil Cervosatan. Pol sets off on a journey of initiation in search of his love. Along the way he must overcome the obstacles thrown up in his path by Cervosatan's scheming henchmen: Jaba, Lopa, Sap and Serpe. With each test he wins another tooth until he has regained the full set, symbol of strength. Only then can he subdue his enemies, vanquish Cervosatan and win the object of his love.

Marcel.lí Antúnez Roca (E), born 1959, is an artist specialized in the use of new technologies. He graduated in Fine Arts at the University of Barcelona and he is one of the founders of "La Fura dels Baus". He is also one of the founders and shareholders of the Total Art Group "Los Rinos". On an individual basis he has worked in cinema. His mechatronic performances have had a wide international reception. These performances gather an artistic practice proposing a new formal model: interactive drama. This system, linked to computer science, includes the interactive control in real-time of robots, music and animation and the use of new interfaces like exoskeletons. **Marcel.li Antúnez Roca (E)**, geb. 1959, ist spezialisiert auf den Einsatz neuer Technologien. Er hat ein Kunststudium an der Universität Barcelona abgeschlossen und war einer der Mitbegründer von „La Fura dels Baus". Er ist auch einer der Gründer und Anteilseigner der Total-Art-Gruppe „Los Rinos". Als unabhängiger Künstler hat Roca vor allem für das Kino gearbeitet. Seine mechatronischen Performances stellen ein neues formales Modell vor: das interaktive Drama. In der Verknüpfung mit Informatik erlaubt dieses System die interaktive Echtzeit-Steuerung von Robotern, Musik und Animation sowie den Einsatz neuer Interfaces wie des Exoskeletts.

Access is a public art installation that applies web and surveillance technologies, allowing web users to track individuals in public spaces with a unique robotic spotlight and acoustic beam system, without people wearing any gear, exploring the ambiguities among surveillance, control, visibility and celebrity.

The robotic spotlight automatically follows the tracked individuals while the acoustic beam projects audio that only they can hear. The tracked individuals do not know who is tracking them or why they are being tracked, nor are they aware of being the only persons among the public hearing the sound. The web users do not know that their actions trigger sound towards the target. In effect, both the tracker and the tracked are in a paradoxical communication loop.

Access addresses and explores the impact of detection and surveillance within contemporary society. It presents control tools that combine surveillance technology with the advertising and Hollywood industries, creating an intentionally ambiguous situation, revealing the obsession-fascination for control, vigilance, visibility and celebrity: scary or fun.

Access was primarily influenced by the beauty of the surveillance representations (X-rayed bodies, luggage or vehicles, 3D laser scans, satellite reconnaissance imagery, etc.), the invisibility of the collected data, the power generated by means of surveillance practices, and the fascination certain people have for being "in the spotlight" (the TV shows such as Big Brother, websites such as JenniCam, etc.).

Beware. Some individuals may not like the idea of being under surveillance.

Beware. Some individuals may love the attention.

Access ist eine öffentliche Installation, die Web- und Überwachungstechnologie einsetzt und den Web-Usern ermöglicht, einzelne Individuen im öffentlichen Raum mithilfe eines einzigartigen robotergesteuerten Scheinwerfer- und Audio-Beamer-Systems zu verfolgen, ohne dass dafür eine spezielle Ausrüstung am Körper getragen werden müsste. Hier wird die Grauzone zwischen Überwachung, Steuerung, Sichtbarkeit und Berühmtheit ausgelotet.

Der robotergesteuerte Scheinwerfer folgt automatisch den zu verfolgenden Individuen, während der Audio-Beamer Töne aussendet, die nur sie hören können. Die verfolgten Personen wissen nicht, wer sie beobachtet und warum, und sie wissen auch nicht, dass sie als Einzige im Publikum die Klänge hören können. Die Web-User ihrerseits wissen nicht, dass ihre Aktionen Klänge in Richtung Ziel auslösen. Letztlich hängen sowohl der Überwacher wie der Überwachte in einer paradoxen Kommunikationsschleife.

Access untersucht die Auswirkungen von Erkennung und Überwachung in unserer heutigen Gesellschaft. Es präsentiert Steuerungswerkzeuge, die Überwachungstechnologie mit Techniken der Werbung und Hollywoods verbinden und schafft so eine bewusst zweideutige Situation, die die Faszination und Obsession von Überwachung, Wachsamkeit, Sichtbarkeit und Berühmtheit bloßlegt – Schrecken oder Spaß.

Access ließ sich vor allem von der Schönheit der von Überwachungstechnologien erzeugten Bilder inspirieren (Röntgenaufnahmen von Körpern, Gepäckstücken oder Fahrzeugen, 3D-Laser-Scans, Bilder aus der Satellitenaufklärung usw.), von der Unsichtbarkeit der gesammelten Daten, von der Macht, die mittels der Überwachungspraktiken aufgebaut wird, und von der Faszination, die für manche Leute darin besteht, im Rampenlicht zu stehen (etwa in TV-Shows wie „Big Brother", auf Websites wie JenniCam usw.).

Aber Vorsicht: Einige Individuen könnten sich mit dem Ideal der Überwachung nicht anfreunden.

Und Achtung: Einige Individuen könnten die Aufmerksamkeit lieben.

A⊕CCESS

Marie Sester (F) is living and working in New York City. She began her career as an architect, having earned her master degree in architecture from the École d'Architecture in Strasbourg, France in 1980. Sester has since worked as a media artist exploring the ways that societies implement forms, focusing primarily on the ideas of transparency, visibility, and access. Her interactive installations typically create an immersive experience for the viewer/participant. Marie Sester has exhibited internationally and has taught in France and the United States. **Marie Sester (F)** lebt und arbeitet in New York City. Sie begann ihre Karriere als Architektin, nachdem sie 1980 das Studium an der École d'Architecture in Straßburg mit dem Master-Grad abgeschlossen hatte. Seither arbeitet sie als Medienkünstlerin und erforscht, wie Gesellschaften Formen implementieren, wobei sie vor allem Transparenz, Sichtbarkeit und Zugang untersucht. Ihre interaktiven Installationen schaffen stets eine immersive Erfahrung für die Betrachter / Mitwirkenden. Marie Sester hat international ausgestellt und in Frankreich und den USA gelehrt.

Deep Walls
Scott Snibbe

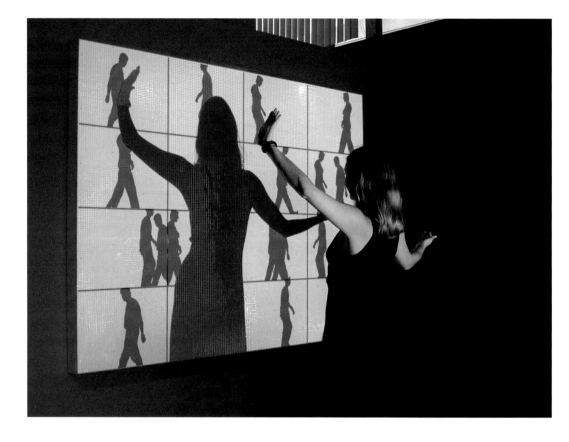

Deep Walls creates a projected cabinet of cinematic memories. Within each of 16 rectangles, the movements of different viewers within the space are projected, played back over-and-over, and reduced into the space of a small cupboard. Initially, when a viewer or viewers move into the larger rectangle of the entire projection, their shadows begin to be invisibly recorded, and one box within the projection (the eventual destination of the current movements) is cleared out. When all of these viewers leave the larger frame, their shadows are replayed within that smaller, single box, looping indefinitely. Thus the work presents memories of the space, organized and collected into a flat cinematic projection.

Deep Walls erzeugt ein projiziertes Kabinett kinematischer Erinnerungen. Bewegungen unterschiedlicher Besucher innerhalb des Raums werden in jedes seiner 16 Rechtecke projiziert, stets wiederholt und auf die Größe eines kleinen Wandschranks reduziert. Wenn sich am Anfang ein oder mehrere Betrachter in das größere Rechteck der Gesamtprojektion begeben, werden ihre Schatten unbemerkt aufgezeichnet, und eine Box innerhalb der Projektion (das spätere Ziel der derzeitigen Bewegungen) wird gelöscht. Wenn alle Besucher den größeren Rahmen verlassen, werden ihre Schatten innerhalb dieser kleineren einzelnen Box in einer Endlosschleife abgespielt. So präsentiert das Werk Erinnerungen an den Raum, gesammelt und in eine flache kinematische Projektion organisiert.

Deep Walls erforscht die Natur von Sammlungen – wie individuelle Objekte durch Organisation, Repetition und Darstellung größere symbolische Bedeutung erlangen und gleichzeitig ihre wörtliche Bedeutung verlieren. Durch das Sammeln der Schatten der „Betrachter" untersucht die Arbeit, auf welche Weise Sammlungen den Sammler reflektieren. Rhythmisch gesehen zeigt das Werk eine komplexe zeitliche Beziehung zwischen kinematischen Schleifen. Jeder kleinere gesammelte Schattenfilm dauert genauso lang wie seine Aufzeichnung. Ein einzelnes Objekt in der Sammlung kann also wenige Sekunden, aber auch etliche Stunden dauern. Die zeitliche musikalische Beziehung der 16 Rahmen untereinander wird sehr kompliziert – ähnlich wie Brian Enos Tonband-Experimente –, weil stets einzelne Aufnahmen in einer Schleife laufen und dennoch zusammen ein einzigartiges Ganzes bilden. Die Repetitionsperiode für das Gesamtwerk kann somit die Größenordnung von Tagen oder gar Monaten erreichen.

Deep Walls ist stark von den surrealistischen Filmen eines Jan Svankmajer und der Brüder Quay sowie von den Skulpturen von Joseph Cornell inspiriert. In all diesen Werken stellen kleine Körper und eine nachgerade besessene Organisation von Objekten in diverse Schubladen und Kästchen innerliche psychische und geistige Zustände dar. Der rationale Prozess der Organisation dient nur dazu, die unbewusste Irrationalität herauszustreichen.

The work explores the nature of collections—how individual objects gain in symbolic meaning, while losing literal meaning, through organization, repetition and display. By collecting the "viewers" own shadows, the work examines how collections reflect the collector. Rhythmically, the work presents a complex temporal relationship between cinematic loops. Each smaller collected shadow-film has the precise duration of its recording. A single item in the collection might last anywhere from a few seconds to several hours. The temporal, musical relationship between the sixteen frames becomes extremely complex, like Brian Eno's tape loop experiments, always looping individual recordings, yet presenting a unique whole—the repetition period for the entire work can be of the order of days or even months.

The work is particularly inspired by the surrealist films of Jan Svankmajer and the Quay Brothers and the sculpture of Joseph Cornell. In these works, small bodies and obsessive organization of objects into drawers and cabinets symbolically represent interior, psychological and spiritual states. The rational process of organization only serves to bring out an unconscious irrationality.

Scott Snibbe (USA) is an artist whose output consists primarily of electronic media installations that directly engage the body of the viewer in a reactive system. Snibbe was born in 1969 in New York City. He holds Bachelor degrees in Computer Science and Fine Art, and a Master in Computer Science from Brown University. Snibbe studied experimental animation at the Rhode Island School of Design and his films have been widely shown internationally. He has taught media art and experimental film and has held research positions at Adobe Systems and Interval Research. His research is documented in a number of academic papers, several patents, and in the special effects program *Adobe After Effects*. **Scott Snibbe (USA)**, geb. 1969, arbeitet vor allem mit Medieninstallationen, die den Körper des Betrachters unmittelbar in ein reaktives System einbeziehen. Snibbe ist Bachelor aus Computer Science und Fine Art sowie Master aus Computer Science (Brown University). Er studierte experimentelle Animation an der Rhode Island School of Design, und seine Filme waren weltweit zu sehen. Er hat Medienkunst und experimentellen Film unterrichtet und Forschungsstellen bei Adobe Systems und Interval Research innegehabt. Seine Forschungen sind in etlichen akademischen Schriften, Patenten und vor allem im Special-Effects-Programm *Adobe After Effects* dokumentiert.

COMPUTER ANIMATION / VISUAL EFFECTS

Art or Experiment?
Kunst oder Experiment?

Bob Sabiston & Rita Street

Als Juroren stellen wir uns die Angst und das Zittern der Künstler vor, die uns ihre Werke zur Beurteilung einreichen. Wir stellen uns vor, wie sie sich uns vorstellen – wie wir arrogant da sitzen, unsere kubanischen Zigarren im behaglichen Vorführraum rauchen, kritisieren, grübeln, große Gedanken hegen, große Worte machen, deklamieren, proklamieren und letztlich ohne Grund auch eliminieren.

Ach, wenn die bloß wüssten ... Unsere Erfahrung als Juroren unterscheidet sich grundlegend von diesen Fantasien. Bei der Kategorie „Computeranimation / Visual Effects" geht's nicht um Komfort und um Egos, sondern um Ausdauer und Gemeinschaft. Können wir wirklich 375 Filme in drei Tagen begutachten und sind unsere frisch geknüpften Freundschaften schon gefestigt genug, um diesen Prozess der Auswahl eines Siegers zu überleben?

Entgegen den möglichen Erwartungen der Künstler gibt es tatsächlich ein geheimes Verlangen, den unausgesprochenen Wunsch einer jeden Jury beim Prix Ars Electronica, doch jenen perfekten Moment erleben zu können, in dem alle spontan und einstimmig ausrufen: „Ja, ja, das ist der Gewinner der Goldenen Nica, daran besteht kein Zweifel!" Und genau dieser Wunsch nach dem Gefühl, gemeinsam eine gute und richtige Entscheidung getroffen zu haben, treibt uns an.

Gelängen wir als Jury zu einer einstimmigen Entscheidung, dann wäre das fast, als würden wir selbst eine Goldene Nica gewinnen!

Heuer schweißte uns ein Film für die ersten eineinhalb Tage zusammen und drohte die restlichen eineinhalb Tage, uns zu trennen. Bei dem Film handelte es sich um den brillanten, intelligenten und handwerklich hervorragenden *Tim Tom*. Auch wenn diese Animation mit dem Computer generiert ist, so bietet sie doch eine organische Qualität, die an die besten Tonpuppen-Trickfilme erinnert. Sie erzählt von zwei Figuren, die statt Köpfen kleine Spiralblöcke haben. Die Seiten dieser Blöcke werden einfach abgerissen, um Änderungen im Gesichtsausdruck zu zeigen, wobei die Gesichter ganz einfach auf die Blockseiten gezeichnet sind. Tim und Tom wünschen

As jurors we imagine the fear and trepidation of artists submitting their work for our evaluation. We imagine them imagining us—how we arrogantly sit, smoking our Cuban cigars in the comfort of our dark screening room, critiquing, musing, thinking big thoughts, talking big talk, declaring, proclaiming and ultimately—for no particular reason—eliminating.

Wow! If they only knew. Our experience as jurors was so profoundly different from that imaginary picture. The Computer Animation / Visual Effects Prix is not about comfort or egos; it's about endurance and community. Can we actually view 375 films in three days and can our new found friendships survive the process of declaring a winner?

Contrary to what artists might expect, there is a secret desire, a hidden wish held by every Prix Ars jury to have a perfect moment, a moment when we all agree and say, "Yes! Yes! That film is the Golden Nica! No doubt about it." It is this desire to agree and feel that we have made a good and right decision that drives us.

For a jury, coming to a unanimous decision is like winning a Golden Nica ourselves.

This year, one film brought us together for the first day and a half but, for the last day and a half, threatened to tear us apart. That film was the brilliant, clever and extremely well crafted *Tim Tom*. Although computer-generated, the animation boasts an organic quality that resembles clay stop-motion.

The storyline features two figures with paper notepads for heads. The pages of their notepads tear off to show changes in their expressions which are drawn, quite simply, onto the blank surface of the pads. Tim and Tom want nothing more than to shake hands across a stage (perhaps the stage of life?). Unfortunately their salutations are foiled by divine intervention: the giant hand of the animator himself reaches in to separate

the two little figures. Again and again the characters approach each other only to be aggravated by the mischievous animator.

Tim Tom boasts excellent timing and character animation. Its plot is clever, full of self-aware references to filmmaking and animation. At one point Tim falls through a hole in the frame of the film and lands on the optical soundtrack. Anxious to help, his friend blows a horn, which produces a ramp in the soundtrack for the character to climb up, back into the frame. *Tim Tom* is definitely a homage to the films of Keaton and Chaplin, yet it is very much its own creation; a unique offering that stands on its own. It is silly and fun and could very easily have been made by animation greats like Chuck Jones, Tex Avery or Bob Clampett.

In every sense *Tim Tom* meets the qualifications of animation's highest form of art; it is a perfect cartoon—a perfect cartoon made, not by two directors from Walt Disney or Warner Bros., but two students Romain Seguad and Christel Pougeoise from France's noteworthy academy, Supinfocom. Of course, this was almost reason enough to award *Tim Tom* the Golden Nica, the fact that such mastery could be achieved by artists just learning their craft, but *Tim Tom* exemplifies one other very important quality for the 2003 jury—it did not look, feel, or "act" computer animated.

As never before in the history of the Prix Ars Electronica we saw films that we did not immediately think to evaluate on a technical basis. We would estimate that at least half of the films submitted impacted us not for their digital wizardry but for their ability to tell a story. Suddenly we were faced with evaluating submissions as works of filmmaking art rather than experiments in a medium.

And, more interesting, we weren't always able to tell how some of these films were made. In years past there was a very obvious thumbprint on both technique and software, so that we could say, "Oh, that visual effect was created using a particle tool inside Softimage, however, that character model was obviously set-up in Maya." As if to highlight this conundrum, we were presented with *Atama Yama* (*Mt. Head*). We were particularly intrigued by the subtle combination of traditional drawings, computer animation, digital ink-and-paint, digital compositing and editing in this beautiful Grimm-like tale from Japan's Koji Yamamura. It is, quite simply, breathtaking.

The story is a fable about a man who is so stingy that rather than discard the pits of the cherries he has scavenged, he eats them. Karma being

sich nichts sehnlicher, als sich auf einer Bühne (der Bühne des Lebens?) die Hände schütteln. Unglücklicherweise wird ihrer Verbrüderung durch sozusagen göttliche Intervention stets verhindert: Die große Hand des Animators selbst greift ein, um die beiden Gestalten zu trennen. Immer wieder nähern sich die beiden, nur um vom boshaften Animator neuerlich geärgert zu werden.

Tim Tom kann sich vor allem seines exzellenten Timings und seiner Character Animation rühmen. Die Geschichte ist pfiffig, voller (auch selbst-)bewusster Bezüge auf die Geschichte von Film und Animation. An einer Stelle beispielsweise fällt Tim durch ein Loch aus einem Kader des Films und plumpst auf die Lichtton-Spur. Um ihm zu helfen, bläst sein Freund Tom ein Horn, was den Ausschlag auf der Tonspur so ansteigen lässt, dass Tim über diese Rampe wieder ins Bild klettern kann.

Tim Tom ist in einem gewissen Sinn eine Hommage an die Filme von Keaton und Chaplin, und dennoch ist es eine eigenständige Schöpfung – ein herausragendes Werk, das für sich allein steht. Es ist übermütig und witzig und könnte auch gut von einem der Großen des Trickfilms wie Chuck Jones, Tex Avery oder Bob Clampett stammen.

Kurzum – *Tim Tom* ist in jeder Hinsicht Animation auf allerhöchster Ebene. Es ist ein perfekter Cartoon – aber eben nicht von zwei Regisseuren von Disney oder Warner Brothers, sondern von den beiden Studenten Romain Seguad und Christel Pougeoise von der bekannten französischen Akademie Supinfocom. Nun wäre allein die Tatsache, dass solch ein Meisterwerk von zwei Leuten stammt, die ihr Metier gerade erst erlernen, schon fast Grund genug für die Goldene Nica, aber *Tim Tom* verkörpert noch eine andere der Jury 2003 wichtige Qualität: Er sah und fühlte sich in keiner Weise computergeneriert an.

Wie nie zuvor in der Geschichte des Prix Ars Electronica bekamen wir Filme zu sehen, bei denen wir nicht gleich ihre Technik als Beurteilungskriterium hernahmen. Wir schätzen, dass gut die Hälfte der eingereichten Arbeiten uns nicht durch ihre digitale Zauberkunststücke beeindruckten, sondern durch ihre Fähigkeit, eine Geschichte zu erzählen. Plötzlich waren wir damit konfrontiert, Einreichungen eher als Produkte eines künstlerischen Filmemachens zu bewerten denn als Experimente mit einem Medium.

Und interessanterweise konnten wir in einigen Fällen nicht einmal mehr sagen, wie diese Filme gemacht wurden. In vergangenen Jahren zeigte sich noch stark der technische Stempel der verwendeten Software, sodass wir damals leicht feststellen konnten: „Ah, dieser Effekt entstand durch Verwendung eines Partikel-Werkzeugs aus Softimage, jene Figur hingegen wurde offensichtlich in Maya erstellt." Ein Rätsel war in dieser Hinsicht für uns *Atama Yama* (*Mt. Head*). Besonders faszinierend war die subtile Kombination aus traditionellen Zeichnungen, Computeranimation, digitalem

„Ink-and-Paint", digitaler Komposition und Schnitt in dieser an Grimms Märchen erinnernden Erzählung des Japaners Koji Yamamura – einfach atemberaubend.

Die Erzählung ist eine Fabel um einen Mann, der so geizig ist, dass er auch noch die Kerne jener Kirschen isst, die er irgendwo aufgelesen hat. Und weil Schicksal Schicksal ist, wächst ihm bald ein Kirschbaum aus dem Kopf. Als die Leute beginnen, sich im Schatten des blühenden Baumes zu erholen, bekommt er es mit der Angst zu tun und reißt den Baum aus. In der Grube, die der Baum auf dem Kopf hinterlässt, sammelt sich Wasser, und sie lockt fröhliche Badefreunde an. Der misanthrope Geizkragen, der den Verlust seiner Privatsphäre nicht ertragen kann, fällt zuletzt in die von ihm selbst geschaffene nasse Grube …

Der Film ist komplex und unterhaltsam und spielt auf ansprechende Weise mit Maßstab und Logik. Da er mehrere Bedeutungsebenen umfasst und es sich lohnt, ihn mehr als einmal anzuschauen, gaben wir *Atama Yama* eine von zwei Auszeichnungen.

Und damit kommen wir wieder zu den Cartoon-Cartoons. Zugegeben, jedes einzelne der insgesamt 15 preisgekrönten und ausgezeichneten Werke schien irgendwann einmal unter den möglichen drei Preisträgern auf, aber *Gone Nutty* von Carlos Saldanha und Blue Sky Studios hatte jenes gewisse Etwas, das uns fesselte und immer wieder zum Lachen brachte. Anfangs hatten wir eigentlich gar nicht vor, es zum Preisträger zu küren, aber dieser dumme Scrat, das Säbelzahn-Eichhörnchen aus dem Erfolgsfilm *Ice Age* der 20th Century Fox, hielt uns einfach gefangen. Und immer wenn wir ärgerlich oder mutlos wurden, ließen wir einfach alles liegen und stehen und sahen uns *Gone Nutty* nochmals an – nicht um es zu bewerten, sondern nur so, zur Erleichterung. Es ist schwer zu sagen, warum wir *Gone Nutty* dem nicht minder ansprechenden diesjährigen Angebot von Pixar, *Mike's New Car*, einem Nebenprodukt von *Monsters, Inc.*, vorzogen. Beide sorgten für schallendes Gelächter, aber der lächerliche Scrat mit seiner knopfäugigen Leidenschaft und seiner Gier nach auch der allerletzten Eichel hat es irgendwie geschafft. Von der technischen Seite her faszinierte uns vor allem der Einsatz sekundärer Animationstechniken (Nebenbewegungen, die man normalerweise nur in traditionellen Trickfilmen sieht), wie sie etwa in den Flatterbewegungen des fantastisch flauschigen Schwanzes von Scrat offensichtlich werden.

Und da waren sie wieder, unser Schuldgefühl und unsere inneren Kämpfe: Wie können wir nur einen der Hauptpreise einem Cartoon verleihen? Sollten denn nicht die Nica und die Auszeichnungen viel eher an Werke gehen, die unser Herz anrühren und nicht unsere Lachmuskeln? Und ist das nicht die gleiche Frage, die sich auch beim Oscar stellt, der regelmäßig an Dramen geht und kaum einmal an eine Komödie? Konnten wir allen Ernstes die Goldene Nica an einen Cartoon vergeben?

karma, the man soon grows a cherry tree out of the top of his skull. When people congregate on his head to relax in the shade of the tree's blossoms, he gets angry and chases them away. When he rips the tree from his head, he creates a hole that fills with water that attracts happy swimmers. The stingy man, unable to cope with the loss of his privacy, eventually falls into a watering hole of his own.

The film is complex and funny; it plays with scale and logic in appealing ways. Because it exhibits multiple layers of meaning and rewards repeated viewings, we gave *Atama Yama* one of our two awards of distinction. And then we were back to rewarding more cartoon-cartoons. Admittedly, all of our top 15 selections made it into the top three positions at one point, but there was something about *Gone Nutty* from Carlos Saldanha and Blue Sky Studios that grabbed us and kept us laughing. We didn't really mean to give it an award, but that silly Scrat, the Sabertooth Squirrel from the 20th Century Fox blockbuster, *Ice Age*, just got to us. In fact, when we were feeling really grumpy and disheartened, we simply stopped everything to watch it again—not to judge it, just to get some relief.

Actually, it's hard to say why we choose *Gone Nutty* over the equally appealing offering this year from Pixar, the cartoon spin-off from *Monsters, Inc.*, *Mike's New Car*. Both made us belly laugh, but that ridiculous Scrat with his bug-eyed passion and ridiculous quest to keep his acorn nabbed us. On the technical side we were particularly impressed by the artists' use of secondary animation techniques (follow-through movements typically seen only in traditional animation) evident in the movements of Scrat's furry and fantastic tail.

Yet, here again was the horror and guilt of awarding a major prize to a cartoon. Shouldn't the Nica and the Awards of Distinction go to works that pulled at our heartstrings rather than tapped our funny bones? And isn't this the ultimate conundrum of the Oscars, that the award to best picture typically goes to a drama and seldom to a comedy? This was the big talk we were engaged in as jurors. Could we, in all seriousness, award the Golden Nica to a cartoon?

Well, yes, of course we could and we did. But it was this question; a question concerning content and appropriateness that bothered us for long hours. It shot *Tim Tom* down and, in the end, it brought *Tim Tom* up. Although we were never wholly united on this front; although we did not have a unanimous "Ah, this is it!," we did leave our experience as jurors happy and fulfilled.

Art or Experiment?

Yes we were exhausted. No we did not sit in comfortable chairs. Yes, we smoked, but outside. Yes we drank, but Red Bull, not wine as you might imagine … (Well, we did sneak in a few beers). No we didn't agree. Yes we enjoyed our experience. And, now, more than ever when we imagine contestants imagining us, we hope they imagine us as a different sort of jury—not a group of technologically savvy elitists but as a handful of jittery and very excited members of what every contestant wants most of all—a great audience.

Following are our thoughts and comments on the Honorary Mentions:

The Dog Who was a Cat Inside: Siri Melchior; DK / UK

If only we could have seen this short as children, we could have carried it with us our entire lives as inspiration. The story of finding love inside ourselves, this little treasure is an intriguing combination of handdrawn illustrations, gorgeous animation and CG composites.

Pipe Dream: Wayne Lytle; ANIMUSIC, USA

Pipe Dream is a very cool integration of computer animation with a musical score. Lytle uses physics simulations to generate a series of balls that fly through the air; they magically land in just the right places on his three-dimensional rendered musical instruments to produce the perfectly synchronized soundtrack. The more you watch it, the more you are amazed.

Gestalt: Thorsten Fleisch; D

We received a fair number of abstract and experimental pieces of animation this year. Although many of them used impressive techniques that are both innovative and unusual, everyone agreed that it is just a lot harder to make a successful abstract film. Perhaps because our jury consisted mostly of narrative filmmakers, we were not eager to award films which existed solely to showcase a specific technique or algorithm. That said, everyone on the jury did agree that *Gestalt* displayed a spectacular use of fractal set techniques. Fleisch shows exceptional deftness in assembling a series of algorithmic transformations that are beautiful and really visually interesting.

Natürlich konnten wir, und wir haben's ja auch getan. Aber diese Frage nach Inhalt und Angemessenheit hat uns lange beschäftigt. Sie schoss *Tim Tom* von der Spitzenposition herunter und brachte letztlich *Tim Tom* auch wieder hinauf. Wenn wir auch in dieser Frage nie hundertprozentig einig waren, wenn wir auch dieses erträumte „Ja, das ist es!" nicht wirklich aussprechen konnten, so konnten wir doch unsere Jurorentätigkeit glücklich und erfüllt abschließen.

Und natürlich waren wir erschöpft. Denn wir saßen nicht in bequemen Lehnstühlen. Es wurde auch geraucht – aber draußen. Es wurde getrunken – aber Red Bull und nicht etwa Wein, wie man meinen könnte (naja, das eine oder andere Bier …). Wir haben unsere Erfahrung genossen. Und jetzt, wenn wir uns vorstellen, dass sich Künstler die Jury vorstellen, hoffen wir mehr denn je, dass sie uns als eine andere Art von Jury sehen – nicht als eine Gruppe elitärer Technologiekundiger, sondern eher als ein sehr aufgeregter und faszinierter Teil dessen, was sich jeder der Einreichenden wünscht: ein großartiges Publikum.

Hier noch einige unserer Gedanken und Kommentaren zu den Anerkennungen:

The Dog Who was a Cat Inside: Siri Melchior; DK / UK

Hätten wir diesen Kurzfilm doch bloß als Kinder sehen können, wir hätten ihn unser ganzes Leben lang als Inspiration mitgenommen! Die Geschichte, wie man in sich selbst Liebe finden kann, dieser kleine Schatz, ist eine beachtenswerte Kombination aus handgezeichneten Illustrationen, großartiger Animation und CG-Montage.

Pipe Dream: Wayne Lytle; ANIMUSIC, USA

Pipe Dream ist eine sehr coole Integration von Computeranimation und einer Musikpartitur. Lytle verwendet physikalische Simulationen, um eine Serie von Bällen zu erzeugen, die durch die Luft fliegen und wie von Zauberhand genau an den richtigen Stellen auf seinen dreidimensional dargestellten Musikinstrumenten landen und so einen perfekt synchronisierten Soundtrack generieren. Je öfter man es ansieht, umso erstaunlicher wirkt es.

Gestalt: Thorsten Fleisch; D

Wir haben dieses Jahr wieder eine ganze Menge abstrakter und experimenteller Animationen erhalten, und wenn auch manche von ihnen beeindruckende und sowohl innovative als auch ungewöhnliche Techniken verwendeten, so herrschte doch Einigkeit darüber, dass es einfach wesentlich schwerer ist, einen erfolgreichen abstrakten Film zu machen. Es mag damit zusammenhängen, dass die Jury vorwiegend aus narrativen

Filmemachern bestand, dass wir nicht besonders daran interessiert waren, Filme auszuzeichnen, die nur zur Demonstration einer bestimmten Technik oder eines Algorithmus existieren. Ungeachtet dessen war sich die Jury einig, dass *Gestalt* mit der Anwendung von fraktalen Techniken wahrhaft spektakuläre Ergebnisse erzielte. Fleisch zeigt eine außergewöhnliche Geschicklichkeit und Sicherheit in der Zusammenstellung einer Serie algorithmischer Umwandlungen, die sich zu einem schönen und visuell fesselnden Gesamtwerk fügen.

The ChubbChubbs: Eric Armstrong; Sony Pictures Imageworks, USA

Der diesjährige Oscar-Gewinner *ChubbChubbs* ist eine gut gemachte, wirklich unterhaltende Kurzgeschichte – und dazu noch ein sehr witziges Stück Character Animation. Auch wenn dieser Kurzfilm eigentlich nur als Machbarkeitsstudie für eine spezielle Produktionslinie entstand, merkt man ihm den Spaß an, den seine Macher damit hatten, und der springt direkt vom Screen in die Lachmuskeln über!

Mantis: Jordi Moragues; Kunsthochschule für Medien Köln, D

Alle Juroren waren der Meinung, dass dies ein sehr eleganter und sehr ruhiger Film ist. In wunderbar komponierten Aufnahmen, die an kolorierte Holzschnitte erinnern, zeigt *Mantis* das Leben einer gewöhnlichen Gottesanbeterin. Der Film wird dreidimensional gerendert, aber abschließende Filter- und Nachbearbeitungsprozesse lassen ihn wie reine Handarbeit wirken. Sparsamer, aber dramatischer Einsatz von Farbe und die natürliche, realistische Animation machen diesen Film einzigartig.

3D Character Animation for Blockbuster Entertainment: Tippett Studio; USA

Was wäre lustiger (oder frustrierender) zu animieren als ein Hamster und ein Kaninchen? Diese Werbekampagne für eine Videoverleihkette ist für ihre vollwertigen Charaktere zu preisen. Egal, wo der Betrachter wohnt oder wer er ist – diese zwei Persönlichkeiten kennt man sofort. Beeindruckend war auch der Reichtum an gut gerendertem Fell und an guter Beleuchtung.

Au bout du fil: Jérôme Decock, Cécile Detez de la Dreve, Olivier Lanères, Mélina Milcent; Supinfocom, F

Was für eine überaus seltsame Geschichte: Eine Figur, die im wahrsten Sinne des Wortes einem Faden durch das ganze Leben und verschiedene Situationen folgt. Nicht nur die Transformationen in diesem Film sind einmalig, uns gefiel auch das Design der Hauptfigur. Großartige Computeranimation und Hintergründe – so

The ChubbChubbs: Eric Armstrong; Sony Pictures Imageworks, USA

This year's Academy award winner, *The ChubbChubbs* is a well done, really entertaining short story and a very funny bit of character animation. Although this short was created as an experiment into the viability of a particular production pipeline, you can tell the filmmakers had a blast making it. The fun slips right off the screen and into your lap!

Mantis: Jordi Moragues; Kunsthochschule für Medien Köln, D

We all agreed that this is an elegant, very quiet film. In beautifully composed shots that recall brush-and-ink prints, *Mantis* depicts the life cycle of an ordinary praying mantis. The film is rendered three-dimensionally, but it has a filter or post-process applied which makes the whole thing look hand-done. Spare but dramatic use of color and the natural, realistic animation make this film a standout.

3D Character Animation for Blockbuster Entertainment: Tippett Studio; USA

What could be more fun to animate (or more frustrating), than a hamster and a rabbit? This commercial campaign for the video-rental chain deserves praise for its fully-blown characters. No matter who you are or where you live, you immediately know these two personalities. We were also impressed with the abundance of well-rendered fur and good lighting.

Au bout du fil: Jérôme Decock, Cécile Detez de la Dreve, Olivier Lanères, Mélina Milcent; SUPINFOCOM, F

What a strange, strange story: a character that literally follows a thread through various worlds and situations. Not only were the transformations in this story unique, we all liked the design of the lead character. Great CG animation and backgrounds. This should have come from a studio, but it is another amazing piece of filmmaking mastery from Supinfocom.

The most outstanding of the visual effects entries were *Dolce Vita* (Luc Froehlicher; La Maison, F) and *Untitled* (Christoph Ammann; Vancouver Film School, CDN). *Dolce Vita* is a commercial that features a sophisticated combination of effects and live action, depicting two nude

figures: a male immersed in a sea of realistic, beautifully rendered bubbles, and a female descending in a cloud of swirling feathers. The piece as a whole is graceful and elegant. Ammann's *Untitled* impressed us equally. In this experiment, computer-generated robot scouts prowl around a live-action set. The motion of the robots is believable and the integration with the background is seamless.

Mike's New Car: Pete Docter, Roger Gould; Pixar Animation Studio, USA

Pixar's entry this year, *Mike's New Car* is a short film that features the main characters from last year's Golden Nica winner *Monsters Inc.* While the film was not a technical innovation over last year's entry, it exhibited such a mastery of character animation and timing that it unquestionably belonged in our list of honorees. Specifically, the level of actual acting by these characters was remarkable.

Justice Runners: Satoshi Tomioka; Kanaban Graphics, J

This film is definitely a trip down the White Rabbit's hole. Although this short has a comic storyline, basically an escape from paying the landlord, it has all the horrible anxious feelings of a really bad nightmare; those super frightening ones that are set in broad daylight rather than deep night. We appreciated the complexity of imagery, the pacing, the amazing amount of CG models and especially the brilliant color palette of this over-the-top gem.

einen Film hätte man von einem Studio erwartet, aber er ist wiederum eine erstaunliches filmisches Meisterstück von Supinfocom.

Die herausragendsten unter den Visual-Effects-Einreichungen waren *Dolce Vita* (Luc Froehlicher, La Maison, F) und *Untitled* (Christoph Ammann, Vancouver Film School, CDN). *Dolce Vita* ist ein Werbespot, der eine ausgefeilte Kombination von Effekten und Live-Aufnahmen enthält und zwei nackte Gestalten zeigt: einen Mann, der in einem Meer aus realistischen und wunderschön gerenderten Blasen schwimmt, und eine Frau, die in eine Wolke aus wirbelnden Federn taucht. Das Stück ist als Ganzes einfach graziös und elegant. Ammans *Untitled* beeindruckt nicht minder. In diesem Experiment bewegen sich computergenerierte Roboter-Scouts durch ein Live-Action-Set. Die Bewegung der Roboter ist glaubhaft und ihre Integration in den Hintergrund absolut nahtlos.

Mike's New Car: Pete Docter, Roger Gould; Pixar Animation Studio, USA

Die diesjährige Einreichung von Pixar, *Mike's New Car*, ist ein Kuzzfilm mit den Hauptgestalten des letztjährigen Nica-Preisträgers *Monsters, Inc.* Wenn auch dieser Film gegenüber dem vergangenen Jahr keine technische Innovation bringt, so zeigt er doch solch eine Meisterschaft in der Animation der Figuren und im Timing, dass er ohne Frage in die Liste unserer Anerkennungen gehört. Besonders bemerkenswert sind die schauspielerischen Qualitäten der beiden Gestalten.

Justice Runners: Satoshi Tomioka; Kanaban Graphics, J

Dieser Film ist ohne Zweifel eine Reise durch ein Labyrinth. Auch wenn er eine komisch anmutenden Story zu haben scheint – was passiert, wenn man seine Miete nicht zahlt? –, so vermittelt er doch all die Angstgefühle eines Albdrucks, und zwar eines besonders schrecklichen, die nicht bei Nacht, sondern im hellen Tageslicht spielen. Wir haben die Komplexität der Bildwelt bewundert, das Tempo, die erstaunliche Anzahl von CG-Modellen und ganz besonders die brillante Farbpalette dieses etwas verschrobenen Juwels.

Remind me: H5 / Ludovic Houplain / Hervé de Crécy, F

Das Video von H5 für den Röyksopp-Song *Remind me* ist vor allem wegen seines äußerst ausgefeilten Designs bemerkenswert. Regisseur Ludovic Houplain verwendet so ziemlich jede bekannte Form statistischer Grafik, um seine Geschichte vom Arbeitstag einer Frau in London zu erzählen. Vom Zeitpunkt ihres Aufwachens bis zum Einschlafen werden die verschiedenen Aspekte ihres Lebens komisch, aber auch etwas beunruhigend durch Torten- und Säulendiagramme, Querschnittillustrationen und dergleichen dargestellt. Der Animationsstil etwa, als sie sich anzieht, ähnelt den Zeichnungen auf den Sicherheitshinweisen im Flugzeug, die den Gebrauch der Notausgänge erläutern. Ihre U-Bahn-Fahrt zur Arbeit wird von einer grafischen Darstellung der relativen Geschwindigkeiten der Verkehrsmittel begleitet: Fußgänger, U-Bahn, Auto, Flugzeug. Wenn sie beim Mittagessen einen Milchshake trinkt, so sehen wir eine technische Skizze aller von dieser Milch durchgemachten Verarbeitungsschritte: vom Glas zum Milchshake-Mixer, zurück zur Pasteurisierung, weiter bis hin zur Melkmaschine. Der ununterbrochene Fluss informativer Grafiken ist sehr schön animiert und eine gute Begleitung zur Musik. Als Gesamteffekt werden wir sehr pointiert an jene Mechanisierung erinnert, durch die ein großer Teil unseres Lebens geregelt wird.

Remind me: H5 / Ludovic Houplain / Hervé de Crécy, F

H5's video for the Röyksopp song *Remind Me* is most remarkable for its sophisticated use of design. Director Ludovic Houplain utilizes nearly every well-known style of statistical graphic in order to tell a story; that of one woman's workday routine in London. From the time she awakens to the time she goes to sleep, the various aspects of her life are represented comically, but also a bit disturbingly, by pie-charts, bar-graphs, cross-sectional illustrations and the like. The style of animation as she gets dressed and applies makeup is similar to the drawings on an airline safety-card—the one that points out all of the exits. Accompanying her subway ride to work is a graphical depiction of the relative speeds of the various modes of travel: walking, subway, car, plane. At lunch, as she drinks a milkshake, we see a technical breakdown drawing of the steps the milk has taken to get to her: from the glass to the milkshake machine, to the pasteurization plant, back to the machines milking the cows. The nonstop flow of informational motion graphics is beautifully animated and accompanies the music well. The overall effect is to poignantly remind us of the mechanization with which much of our lives are regulated.

Art or Experiment?

Tim Tom
Romain Segaud / Christel Pougeoise

We met at SupInfoCom, one of the top animation schools in France with an emphasis on teaching CGI animation. There we collaborated on a five minute animated film that took 16 months to create. The simple scenario features two animated characters trying to meet against the wishes of a giant omnipotent human hand. There is no dialogue but the thoughts and expressions of

Wir haben uns an der Supinfocom kennen gelernt, einer der führenden französischen Schulen für Animation, die in der Lehre einen besonderen Schwerpunkt auf Computergrafik legt. Dort haben wir an einer fünfminütigen Animation zusammengearbeitet, was insgesamt 16 Monate in Anspruch genommen hat. Das einfache Szenario der Animation umfasst zwei Gestalten, die nichts anderes wollen, als zueinander zu finden –

gegen den Wunsch einer riesigen allmächtigen menschlichen Hand. Es gibt keine Dialoge, aber die Gedanken und Gefühle der Hauptdarsteller sind ihnen sozusagen ins Gesicht geschrieben, das wie ein Notizblock aufgebaut ist. Unter Verwendung von Maya, Photoshop und After Effects haben wir die 3D-Animation so aufgebaut, dass die Gestalten wie Puppen aus Knetmasse und Papier aussehen – ein bewusster Bezug auf die klassischen

the protagonists are written on their notepad faces. Using Maya, Photoshop, and After Effects, the 3D computer animation is made to look like realistic puppets made of clay and paper. It's a reference to old stop-motion films. We also chose a 40's jazz soundtrack (Django Reinhardt) and a black and white image to provide the film overall with the aesthetics of the classic films of Méliès,

Tim Tom

Trinka, Dudock de Wit, and Svankmayer. Romain came up with the original idea and I liked it so much I decided to work with him. During the third year, we worked on the screenplay and storyboards and during the last year we modeled the characters, animated them, rendered the movie with computers, added the sound, and then transferred it all to 35mm film. Tim Tom has played at several festivals in Europe and US, has received the LEAF award in London and the prix de la SCAM in France.

Trickfilme. Dazu haben wie einen Soundtrack der 40er Jahre (Django Reinhardt) verwendet und die Bilder in Schwarzweiß gehalten, um dem Film insgesamt die Ästhetik der Filmklassiker von Méliès, Trinka, Dudock de Wit und Swankmayer zu geben.

Die ursprüngliche Idee kam von Romain, und sie gefiel mir so gut, dass ich beschloss, mit ihm das Projekt zu realisieren. In unserem dritten Studienjahr haben wir Szenario und Drehbuch ausgearbeitet, im Abschluss-jahr dann die Charaktere modelliert, sie animiert, den Film gerendert, den Soundtrack hinzugefügt und schließlich alles auf 35mm-Film übertragen.

Tim Tom war bei etlichen Festivals in Europa und den USA zu sehen und wurde mit dem LEAF Award in London und dem Prix de la SCAM in Frankreich ausgezeichnet.

Romain Segaud (F), born in 1980. After earning a Bachelor of Science degree, he attended the Supinfocom
school in Valenciennes in northern France. After four years, he codirected his first film, *Tim Tom*, with Christel
Pougeoise. **Christel Pougeoise (F)** first wanted to study cinema, but she was very attracted to animation
as well, which is why she attended Supinfocom and began working with Romain Segaud. *Tim Tom* is her first
film. Their inspiration for the film came from Georges Méliès, Svankmayer, Norman McLaren, and many
others. **Romain Segaud (F)**, geb. 1980, besuchte nach einem naturwissenschaftlichen Gymnasialab-
schluss die Supinfocom in Valenciennes. Als Abschlussarbeit des vierjährigen Studiums führte er gemeinsam mit Christel
Pougeoise Regie bei seinem ersten Film *Tim Tom*. **Christel Pougeoise (F)** wollte eigentlich zunächst Kinematografie studieren,
war dann aber von der Animation so angetan, dass sie ebenfalls die Supinfocom besuchte, wo sie Romain Segaud kennen lernte.
Tim Tom ist ihr erster Film, die Inspiration dazu bezogen sie aus den Werken von Georges Méliès, Svankmayer, Norman McLaren
und vielen anderen.

Gone Nutty
Carlos Saldanha / Blue Sky Studios, 20th Century Fox

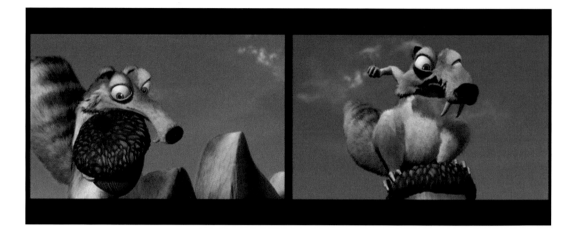

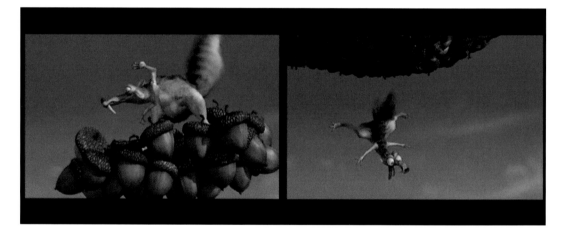

Carlos Saldanha's *Gone Nutty*, also known as *Scrat's Missing Adventure*, is a sharp follow-up to Blue Sky Studios' 2002 Oscar-nominated CG feature *Ice Age*. In this four-minute short, the beleaguered critter from the movie once again struggles to gain control of an oversized nut. Believe it or not, the short also clues in the viewers on the scientific basis of the formation of the continents as we know them today. Scrat's frantic movements and the project's well-timed animation are reminiscent of classic

Carlos Saldanhas *Gone Nutty*, auch bekannt als *Scrat's Missing Adventure*, ist ein pointiertes Follow-Up des für den Oscar nominierten Films *Ice Age* von Blue Sky Studios (2002). In diesem vierminütigen Kurzfilm kämpft die gefangene Kreatur aus dem Film wieder einmal damit, die Herrschaft über eine überdimensionale Nuss zu erlangen. Und ob man's glaubt oder nicht: Der Kurzfilm informiert die Seher auch über den Stand der Wissenschaft hinsichtlich der Entstehung der heutigen Kontinente. Die frenetischen Bewegungen Scrats und die präzise getimte Animation erinnern an die klassischen *Road-*

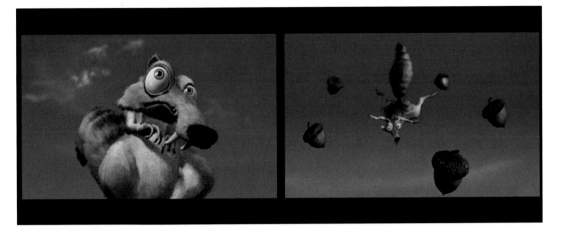

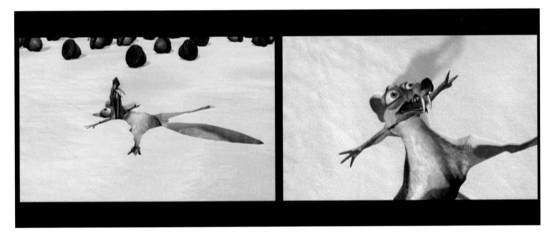

runner- und *Wile E. Coyote*-Shorts von Chuck Jones. Es ist interessant, diese jüngste Errungenschaft von Blue Sky mit deren Oscar-Gewinner *Bunny* (Regie: Chris Wedge) von 1998 zu vergleichen und zu sehen, wie sich der vom Studio selbst entwickelte Renderer CGI Studio weiterentwickelt hat.

Mit der Produktion von *Bunny* hat Blue Sky bewiesen, dass CGI Studio höchst realistische Fell-Effekte und fotorealistische anorganische Texturen erstellen kann. In *Gone Nutty* werden die Fortschritte vor allem in einer großartigen, von Eis umschlossenen Welt präsentiert,

Chuck Jones's *Road Runner* and Wile E. Coyote shorts. It's interesting to compare Blue Sky's latest achievement to the studio's 1998 Oscar-winning short *Bunny* (directed by *Ice Age*'s Chris Wedge) and see the evolutionary power of the digital shop's proprietary renderer CGI Studio.

With the production of *Bunny*, the use of CGI Studio proved that Blue Sky could produce highly realistic fur effects and photorealistic non-organic textures. In *Gone Nutty*, advances

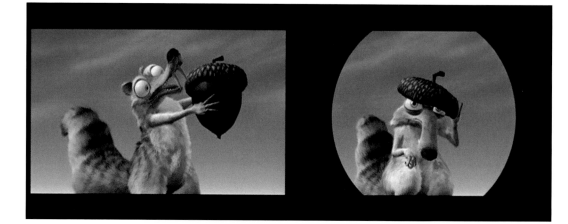

in CGI Studio are showcased in a glorious ice-bound world, an extremely blue sky and the hyper-attractive movements of Scrat's furry tail. This lovely fluffball squashes, stretches, whips, whirls and wobbles in every fantastic fashion imaginable, and yet, due to Blue Sky's mastery of programming lines, the viewer is never aware that this on-screen representation is only a mass of 1s and 0s.

einem extrem blauen Himmel und den hyper-attraktiven Bewegungen des buschigen Schwanzes von Scrat. Dieser herzige Flauschball drückt sich und streckt sich und wackelt und wirbelt und wuselt in jeder nur erdenklichen fantastischen Weise – und dennoch ist dank Blue Skys meisterhafter Programmierung der Linien dem Zuseher niemals bewusst, dass diese Bildschirmdarstellung nicht mehr ist als ein Haufen aus Einsern und Nullen.

(By Ramin Zahed, Editor, *Animation Magazine*)

(von Ramin Zahed, Redakteur, *Animation Magazine*)

Carlos Saldanha (USA) has been part of Blue Sky Studios' creative team since 1993. He has won several awards, including the People's Choice Award at Images du Futur in Montreal and Best Artistic Film at the International Computer Film Festival in Geneva. Saldanha was Blue Sky's Supervising Animator for the talking and dancing roaches in the feature film *Joe's Apartment* (1996). He was also the Director of Animation for the computer generated characters in *A Simple Wish* (1997) and *Fight Club* (1999). In addition to feature projects, Saldanha has directed and animated a number of television commercials. Saldanha earned an M.F.A. degree in animation from the School of Visual Arts in New York, where he discovered his passion for animation. **Carlos Saldanha (USA)** ist seit 1993 Mitglied des Kreativteams von Blue Sky Studios. Er hat zahlreiche Preise gewonnen, darunter den People's Choice Award bei Images du Futur in Montreal und Best Artistic Film beim internationalen Computerfilm-Festival in Genf. Für Blue Sky Studios war Saldanha unter anderem Supervising Animator der tanzenden und singenden Küchenschaben im abendfüllenden Film *Joe's Apartment* (1996) sowie Director of Animation der computergenerierten Gestalten in *A Simple Wish* (1997) und *Fight Club* (1999). Neben diesen Projekten für Spielfilme hat Saldanha bei einer Vielzahl von TV-Werbespots Regie geführt und die Animation geleitet. Saldanha graduierte zum MFA aus Animation an der School of Visual Arts in New York, wo er seine Leidenschaft für die Animation entdeckt hatte.

Atama Yama ("Mt. Head")
Koji Yamamura

After a stingy man eats some cherry seeds, a cherry tree grows on his head and he gets into a lot of trouble. The animated film *Atama Yama ("Mt. Head")* is a modern interpretation of the traditional Japanese Rakugo story *Atama Yama ("Mt. Head")* set in contemporary Tokyo. The story draws to an end, overwhelming the audience with an accumulation of cuts filled with information.

Ein geiziger, reizbarer Mann isst Kirschen samt den Kernen, bis ein Kirschbaum aus seinem Kopf wächst und ihn in eine Menge Schwierigkeiten bringt. Die Animation *Atama Yama ("Mt. Head")* ist eine moderne Interpretation der traditionellen japanischen Rakugo-Erzählung *Atama Yama*, übertragen in das Tokio der Gegenwart. Die Geschichte überwältigt den Betrachter bis zum Ende mit jeder Menge Bildinformation in dicht geschnittenen Szenen.

Der Zeichnungsstil ist äußerst ausgefeilt, die Geschichte und ihr Umfeld bleiben aber rein japanisch. Zur Begleitung eines Shamisen (japanisches Saiteninstrument) singt eine Stimme von der Geschichte eines Mannes, der so unfreundlich und so in sich selbst eingesponnen ist, dass er sich letztlich selbst zerstört. Das auf seinem Kopf stattfindende Kirschblütenfest ist absolut surreal und unvergesslich.

The drawing style is sophisticated, yet the ambience and story are pure Japanese. Accompanied by a *shamisen* (Japanese strings), a voice chants the story of a man so stingy, so inside his own head, that he destroys himself. The cherry blossom festival, happening on top of the man's head, is surreal and unforgettable.

Yamamura says: "A lot of my work is aimed at children, dialogue is limited, and the voice is

small and sweet. Meaning is transferred through the visual. In *Atama Yama*, I collaborated with scriptwriter Shoji Yonemura. Here the words play a big part. Those films may be different, yet there is a theme running through all of them that is about communication. I am sure that if President Bush and Saddam Hussein could understand each other's position, could really communicate, we would not have the political problems of today.

I planned to animate the story of *Atama Yama*, a nonsense Rakugo, a comical story telling, hoping to express the theme of identity and social involvement as far as the constant thought about the enigma of world existence. Since the work is a complete access production, I worked on it between my jobs and so it took six years. I am truly grateful that the work is highly valued and acknowledged now.

The animations of *Atama Yama* were created with no 3D-CG guiding or roto-scoping, but with a classic hand-drawn technique on paper. I also drew lights and shadows separately on paper with pencil, scanned them, and combined them in RETAS! Pro, a Japanese multi-level animation software program, to give the characters a 3-D effect. As drawing materials for the outlines of the characters I used watercolor ink pens, oil markers, and color pencils.

I had installed RETAS! Pro only. During the month of production, as I was gradually mastering the software, I realised that I was managing to create more material at a faster pace, which was encouraging. Prior to digitising, the production of my material was then, and still is, analogue. I did not use 3D guide when I made *Atama Yama*. The system I use for production on my personal computer, a Mac. is extremely simple. I use an application of RETAS! Pro: Traceman for flat materials and scan them. Once I have converted the animation into a movie file I rarely use software to make further enhancements. Adjusting each individual image with Adobe Photoshop is an extension of drawing each image in analogue. I use Adobe Photoshop for color adjustment and masks for compositing.

Yamamura sagt: „Viel von meiner Arbeit ist auf Kinder orientiert, die Dialoge sind stark reduziert, und die Sprechstimme ist hell und süß. Inhalt und Bedeutung werden vor allem durch das Bild übertragen. Bei *Atama Yama*, wo ich mit dem Drehbuchautor Shoji Yonemura zusammengearbeitet habe, kommt dem gesprochenen Wort jedoch eine große Rolle zu. Meine Filme mögen unterschiedlich sein, aber alle durchzieht ein gemeinsames Thema: Kommunikation. Ich bin überzeugt, könnten Präsident Bush und Saddam Hussein die Position des jeweils anderen verstehen, könnten sie wirklich kommunizieren, so hätten wir die politischen Probleme der Gegenwart nicht.

Ich wollte *Atama Yama* – eine komische und unsinnige Rakugo-Geschichte – als Animation bringen – in der Hoffnung, das Thema ‚Identität und soziale Integration' als eines der grundlegenden Rätsel der Existenz der Welt auszudrücken. Da diese Arbeit mein Privatvergnügen war, habe ich sie über einen Zeitraum von sechs Jahren neben und zwischen meinen beruflichen Tätigkeiten fertiggestellt, und ich bin wirklich dankbar für die Wertschätzung und Anerkennung, die es gefunden hat.

Alle Animationen von *Atama Yama* wurden ohne 3D-Grafik oder Rotoskopie hergestellt, sondern entstanden in klassischer Technik als Handzeichnungen auf Papier. Auch die Lichter und Schatten wurden gesondert mit dem Bleistift gezeichnet, anschließend wurden die Teile eingescannt und in RETAS! Pro, einem japanischen Multi-Level-Animationsprogramm, zu den 3D-Effekten der Figur zusammengefügt. Als Material für die Umrisse der Figuren verwendete ich Aquarellstifte, Ölkreiden und Buntstifte. Ich hatte an Software nur RETAS! Pro installiert. Während meiner einmonatigen Arbeit mit dem Programm merkte ich, wie mit der Beherrschung der Software auch meine Arbeitsgeschwindigkeit stieg, wofür ich dankbar war. Vor der Digitalisierung war und ist jedoch meine Produktionsweise ausschließlich analog. Bei *Atama Yama* habe ich auch keine 3D-Hilfslinien verwendet.

Als Produktionssystem verwende ich meinen eigenen einfachen Mac. Die zu RETAS! Pro gehörige Software Traceman wurde zum Einscannen der Flachbilder verwendet. Sobald ich die Animation in ein Movie-Format umgewandelt habe, mache ich normalerweise keine weitere Nachbearbeitung mit Software mehr. Allerdings verstehe ich die Bearbeitung der Einzelbilder mit Adobe Photoshop als eine Erweiterung des analogen Gestaltungsprozesses, wobei ich Photoshop für Farbkorrekturen und Ebenenmasken einsetze.

Die gesamte Erstellung der Zeitregie sowie Montage, Rendering und Ausgabe als Movie-File erfolgten durch eine weitere RETAS! Pro-Anwendung: CoreRETAS. Der Schnitt erfolgte auf Final Cut Pro.
Atama Yama hat zwei große Preise und drei weitere Auszeichnungen gewonnen und wurde für den Oscar 2003 – den 75. Academy Award – nominiert."

To put timesheets together, compositing, rendering and conversion into movie files, my tool is an application of RETAS! Pro: CoreRETAS. I edit on Final Cut Pro.
Mt. Head has been awarded two grand prizes and three best prizes around the world and has also been nominated for the 2003 Oscar, 75th Academy Awards."

Koji Yamamura (J), born 1964, made his first animation film in 1977 at the age of 13. Ten years later he graduated from Tokyo Zokei University. His works have been shown in 30 countries and awarded various honorable prizes. His retrospective screenings have been held in Toronto, Seoul, Paris, Girona etc. He is a member of the board of directors of the Japan Animation Association (JAA) and member of the International Animated Film Association (ASIFA). **Koji Yamamura (J)**, geb. 1964, stellte seine erste Animation 1977 im Alter von 13 Jahren her. Zehn Jahre später schloss er sein Studium an der Tokyo Zokei University ab. Seine Werke wurden in 30 Ländern gezeigt und haben zahlreiche Preise errungen. Eine Retrospektive seiner Arbeiten war u. a. in Toronto, Seoul, Paris und Girona zu sehen. Er ist Vorstandsmitglied der Japan Animation Association (JAA) und Mitglied der International Animated Film Association (ASIFA).

Untitled
Christoph Ammann

This short film was made within six months as a final project for the Vancouver Film School. The goal of the project was to animate a complex robot to move like an animal, and so unite interesting aspects of the mechanical world and the organic world in one figure. The sequences of movement were worked out before actually designing the figure, so that the proportions of the individual parts were able to guarantee that animation went smoothly. Since only minimal travelling shots were planned, the images for the background were made with a digital still camera for reasons of quality. Later the high-resolution of the images made travelling shots during post-production possible.

Technically the most sophisticated shot was the wall's perforation. The broken area was digitally painted out of the original picture and background added for perspective. Afterwards, the missing stones were rendered in 3-D and the process broken down into smaller pieces. The effect of the wall breaking was produced with the aid of a dynamic simulation model. To complete things, dust and smaller stones were generated with

Dieser Kurzfilm wurde innerhalb von sechs Monaten in Form einer Abschlussarbeit an der Vancouver Film School erstellt. Ziel des Projektes war es, einen komplexen Roboter tierhaft zu animieren, um damit die interessanten Aspekte der mechanischen und organischen Welt in einem Charakter zu vereinen. Die Bewegungsabläufe wurden vor dem eigentlichen Design der Figur ausgearbeitet, sodass die Proportionen der einzelnen Teile einen reibungsfreien Animationsprozess garantieren konnten. Da nur minimale Kamerafahrt vorgesehen war, wurden die Hintergrundbilder aus Qualitätsgründen mit einer digitalen Still Camera erstellt. Die hochaufgelösten Bilder erlaubten später eine Kamerafahrt in der Postproduction.

Der technisch anspruchsvollste Shot war der Mauerdurchbruch. Aus dem Originalbild wurde die Bruchstelle digital herausgepainted und mit Hintergrund perspektivisch ergänzt. Anschließend wurden die fehlenden Steine in 3D erstellt und prozedural in kleinere Stücke aufgeteilt. Der Effekt des Zerberstens wurde mit Hilfe einer dynamischen Simulation erzeugt. Staub und kleinere Steine wurden als ergänzende Elemente mit zahlreichen Partikelsystemen generiert. Das Composite der verschiedenen Ebenen galt es

dann noch mit Tiefen- und Bewegungsunschärfe zu versehen.

Für das realistische Aussehen des Roboters waren detaillierte Texturen und gute Beleuchtung entscheidend. Da die Figur hauptsächlich aus Metall bestand, waren natürliche Reflektionen der Umgebung ein wichtiges Element. Dafür wurden vor Ort zusätzliche Bilder der Umgebung geschossen und später zu einer großen 360-Grad-Umgebungs-Map zusammengeführt. Aufgrund der sehr limitierten Anzahl von Shots war eine in sich abgeschlossene Erzählung praktisch unmöglich. Trotzdem sollten die Charaktere sowie der Ablauf des Filmes lebhaft und konsistent erscheinen. Darum wurde in der Vorproduktion eine ganze Geschichte inklusive Art Direction geschrieben, von welcher dann nur ein kleiner Ausschnitt für den eigentlichen Film verwendet wurde.

Alle 3D-Elemente entstanden in Maya, inklusive Simulation und Rendering. Für das Compositing wurde hauptsächlich Combustion verwendet.

numerous particle systems. Depth-of-field and motion blur effects had then to be added to the composite of the different levels.

Detailed textures and good lighting were decisive for creating the robot's realistic appearance. Since the figure was made almost entirely of metal, the natural reflections of the surroundings were an important element. To achieve this effect, additional pictures of the area were shot on location and later assembled into a large 360° map of the surroundings.

Due to the very limited number of shots, a cohesive story was practically impossible. Nevertheless, both the figures and the events in the film were to seem vivid and consistent, which is why an entire story with art directions was written during pre-production. Only a small part was used for the actual film.

All the 3-D elements were done using Maya, including their simulation and rendering. For compositing, the software Combustion was chiefly used.

Christoph Ammann (CH) was born in 1980. He completed a college preparatory school for mathematics and the natural sciences, the Gymnasium Rähmibühl in Zurich, in 2000. Afterwards he worked as a 3-D animator at Frame Eleven in Zurich for a year. In fall 2002, he graduated from the Vancouver Film School after a one-year 3-D animation and visual effects course. Since March 2003, he has been working at Framestore CFC in London as an FX animator for feature films. **Christoph Ammann (CH)**, geb. 1980. Er schloss im Jahr 2000 das Mathematisch Naturwissenschaftliche Gymnasium Rähmibühl in Zürich ab. Danach arbeitete er für ein Jahr bei Frame Eleven Zürich als 3D-Animator. Er schloss im Herbst 2002 einen einjährigen 3D-Animation und Visual-Effects-Kurs an der Vancouver Film School ab. Seit März 2003 arbeitet er bei Framestore CFC London als FX-Animator in Feature Films.

The ChubbChubbs
Eric Armstrong / Sony Pictures Imageworks

The ChubbChubbs is the first animated all-CG short to be produced by Imageworks, the award-winning character animation and visual effects division of Sony Pictures. Honored with an Academy Award® for Best Animated Short Film, The ChubbChubbs introduces the alien inhabitants of the Planet Glorf, including our hapless hero Meeper, a singing Diva, the Zyzaks and the ChubbChubbs. In this debut short, Meeper valiantly tries to warn the patrons of the Ale-E-Inn, an intergalactic watering hole with its own constellation of stars, of impending danger, only to find himself face to face with the toughest creatures in the universe.

The ChubbChubbs began as a test of Imageworks' production pipeline and workflow process as the live action visual effects company moved toward its goal of producing all-CG animated features. The story was refined and polished, layout and timing established, more than 40 characters digitally created and humanly voiced, music licenses locked and an original score composed. The lighthearted parody of Yoda and Darth Vader and their equally famous sci-fi friends as denizens of the Ale-E-Inn was well received by their respective originators, who were appreciative of the affectionate homage.

As the tale of a little alien with a big problem neared completion, it was screened for the Motion Picture Group at Sony Studios and before long, the epic short was enjoying a theatrical release with Men in Black II. Recognized at film festivals around the world, The ChubbChubbs was nominated for a BAFTA Award and ultimately took home the Oscar, much to the delight of everyone at Sony Pictures Imageworks.

The ChubbChubbs ist der erste rein computergrafisch animierte Kurzfilm, den Imageworks – die preisgekrönte Character-Animation- und Visual-Effects-Division von Sony Pictures – jemals hergestellt hat. Als Gewinner des Oscars für die beste Kurzfilmanimation stellt The ChubbChubbs die außerirdischen Bewohner des Planeten Glorf vor, darunter unseren ungeschickten Helden Meeper, eine singende Diva, die Zyzaks und natürlich die ChubbChubbs. In diesem seinem Kurzfilmdebut versucht Meeper tapfer, die Insassenschaft des Ale-E-Inn, eines intergalaktischen Beisels, vor drohender Gefahr zu warnen, nur um letztlich den gefährlichsten Kreaturen des Universums Auge in Auge gegenüberzustehen.

The CubbChubbs war eigentlich nur als Test der Produktionspipeline und des Arbeitsflusses von Imageworks gedacht, weil das bisher auf Live-Action-Visual-Effects spezialisierte Unternehmen zukünftig auch komplett computergenerierte abendfüllende Produktionen herstellen will.

Die Geschichte wurde ausgefeilt und poliert, Layout und Timing wurden festgelegt, über 40 Figuren wurden digital geschaffen und mit menschlichen Stimmen versehen, Musiklizenzen wurden angekauft und eigene Musik in Auftrag gegeben. Die fröhliche Parodie von Yoda und Darth Vader sowie ihren nicht minder berühmten Sci-Fi-Freunden als Stammgästen des Ale-E-Inn kam auch bei ihren ursprünglichen Schöpfern gut an, die diese herzliche Hommage zu schätzen wußten.

Als sich die Erzählung vom kleinen Alien mit den großen Problemen der Vollendung näherte, wurde sie erstmals für die Motion Picture Group bei Sony Studios aufgeführt und schon kurz danach gleichzeitig mit Men in Black II der Öffentlichkeit vorgestellt. The ChubbChubbs wurde nicht nur bei Filmfestivals auf der ganzen Welt ausgezeichnet, sondern auch für einen BAFTA-Preis nominiert und gewann letztlich sogar den Oscar – sehr zur Freude aller bei Sony Pictures Imageworks.

Eric Armstrong (CDN) was the director of The ChubbChubbs, Sony Pictures Imageworks' first CG animated short and winner of an Academy Award® for Best Animated Short Film. At Imageworks, Armstrong was the animation supervisor on Stuart Little 2. Previously, Armstrong was the animation director on Harry Potter and the Sorcerer's Stone. He has also supervised work on Stuart Little and Anaconda. From 1991 to 1995, Armstrong worked at Industrial Light and Magic (ILM), where he worked for the feature films Star Trek VI, Jurassic Park, The Flintstones, Casper and Jumanji. Armstrong, a graduate of Toronto's Sheridan College, was raised in Brantford, Ontario, Canada. **Eric Armstrong (CDN)** war Regisseur von The ChubbChubbs, dem ersten vollständig computeranimierten Kurzfilm von Sony Pictures Imageworks und Gewinner eines Oscar als bester animierter Kurzfilm. Bei Imageworks war Armstrong auch der Animation Superviser bei Stuart Little 2, davor Animationsregisseur bei Harry Potter und der Stein des Weisen. Auch an Stuart Little und Anaconda hat er als Supervisor mitgearbeitet. 1991 bis 1995 arbeitete Armstrong bei Industrial Light and Magic (ILM) unter anderen an den abendfüllenden Filmen Star Trek VI, Jurassic Park, The Flintstones, Casper und Jumanji. Armstrong ist Absolvent des Sheridan College in Toronto und ist in Brantford, Ontario (CDN), aufgewachsen.

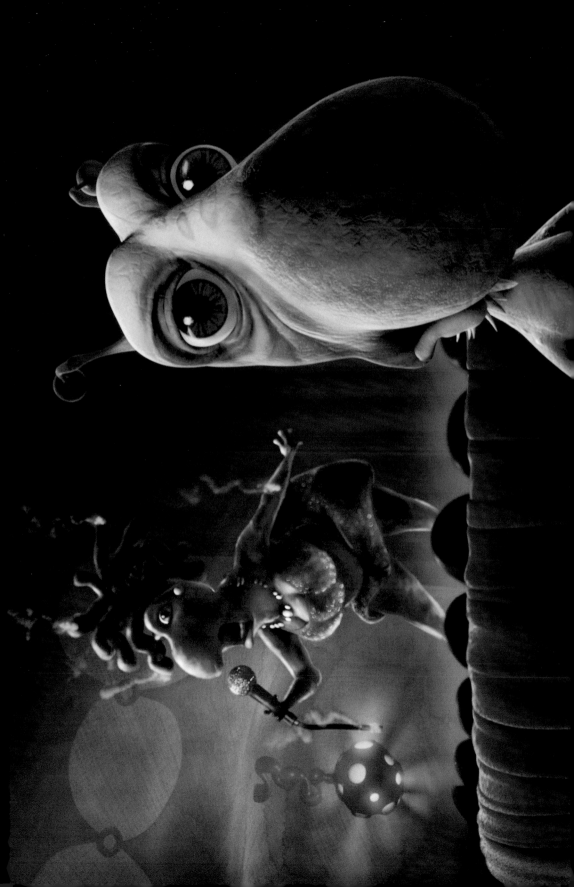

Au bout du fil

Jérôme Decock / Olivier Lanerès / Mélina Milcent / Cécile Detez de la Dreve

A man finds himself projected, to his surprise, into universes emerging from his own imagination. What was interesting for us in this movie was to bring the audience into these ever more eccentric environments via the main character. Indeed each place in which he has been led contains his partaking of real and unreal that reflects his tormented spirit. We have been consciously working on transitions between these universes in order to catch the audience by surprise, like the film hero. The character's madness is the only link to these worlds, the only continuing thread of his exploration. This thread is followed in going back to the source of his madness. We wish to play with the audience in the same way as we did with our character and let the audience be intrigued about the issue.

This animation film, totally in 3D, has been achieved in the course of our studies and has

Ein Mann findet sich zu seiner großen Überraschung in ein Universum projiziert, das seiner eigenen Imagination entspringt. Wir wollten in diesem Film den Betrachter gemeinsam mit der Hauptfigur in diese immer exzentrischere Umgebung versetzen. Jeder Ort, an den der Mann gezogen wird, hat hat sowohl reale als auch irreale Anteile, die seinen gequälten Geist reflektieren. Wir haben die Übergänge zwischen diesen Universen bewusst so gestaltet, dass der Zuseher genauso sehr wie die handelnde Person davon überrascht wird. Der Wahn des Helden ist die einzige Verbindung zwischen diesen Welten, der einzige „rote Faden", der sich durch seine ganze Reise zieht. Und diesem Faden folgt die Figur und kommt letztlich zum Ausgangspunkt ihres Wahns zurück. Wir wollten mit dem Zuseher auf die gleiche Weise spielen wie mit unserer Figur und ihn der Faszination des Filmthemas ausliefern.

Die vollständig in 3D entstandene Animation entstand im Zuge unseres Studiums und hat uns zwei Jahre

Arbeit abverlangt. Neben dem Erlernen der Software haben wir zunächst ein Szenario geschrieben, danach wurde ein Drehbuch erstellt, das erst einmal in 2D umgesetzt wurde. Dies hat uns die Möglichkeit geboten, ein Gefühl für Rhythmus und Schnitt zu bekommen und einen ersten Soundtrack hinzuzufügen. Diese ersten groben Schätzungen wurden mit Hilfe einer 3D-Animation weiter verfeinert, bevor wir zum endgültigen Film übergingen.

Bei der Figur haben wir uns vor allem von der Animation *The Sandman* von Paul Berry inspirieren lassen. Wichtig war uns, einen ziemlich seltsamen, mickrigen Mann zu zeichnen, dem man ansieht, wie ihn das Gewicht der Ereignisse drückt. Die Figuren jenes Kurzfilms waren geschnitzte Marionetten. Wir haben Anleihen beim ziemlich kantigen Gesicht der Mutter genommen, um

taken two years' work. While learning the software, we first wrote a scenario, then produced a script that was initially transposed into 2D. This enabled us to obtain an idea of the rhythm, the cutting out and to place a first sound tape. We have improved these estimations, thanks to a 3D animation, before getting the final result. For the character, we were inspired by the animation film *The Sandman* directed by Paul Berry. It is very important for us to have such a puny, strange man who seems to suffer from the event s weight. The characters of this short film were carved marionettes. We took our lead from the rather angular face of the mother, to give our creation the most suffering facial expression possible. Like our main character, we were interested in

unserer Gestalt einen möglichst leidenden Gesichtsausdruck zu verleihen. Wie unsere Hauptfigur interessierte auch uns die Umgebung, die wir durch Störungen in den Proportionen oder durch Herumspielen mit grafischen Metaphern beunruhigend zu gestalten gesucht haben.

finding a disrupted aspect in the sets making appropriate allowances or playing with graphic metaphors.

Jérôme Decock (F). After one year studying graphism, he studied at Supinfocom for 4 years. He has directed short films for the Cannes Festival and cultural broadcasts. **Olivier Lanerès (F)**. After a two-year technical degree in video effects, he went on to study at Supinfocom. He is currently working at the Quai Branly Museum and he has recently worked on the Mediavision *Hulk* trailer. **Mélina Milcent**

(F). After studying graphic arts, she studied at Supinfocom. Today, she's 22 years old and she is a graphic designer. **Cécile Detez de la Dreve (F)**. After studying graphic arts, she has continued to study at Supinfocom. **Jérôme Decock (F)**. Nach einem einjährigen Graphik-Studium trat er für vier Jahre in die Supinfocom ein. Er hat bei Kurzfilmen für das Festival in Cannes und Kultursendungen Regie geführt. **Olivier Lanerès (F)**. Nach einem zweijährigen audiovisuellen Studium hat auch er seine Studien bei Supinfocom fortgesetzt. Er arbeitet derzeit als Computergrafiker am Musée de Quai Branly und hat am Mediavision-Werbespot für *Hulk* mitgewirkt. **Mélina Milcent (F)** hat nach einer Matura in angewandter Kunst an der Supinfocom weiterstudiert und ist jetzt 2D/3D-Grafikerin. **Cécile Detez de la Dreve (F)** studiert nach einem Grafikstudio an der Supinfocom weiter.

Mike's New Car
Roger Gould / Pete Docter / Pixar

Thanks to his promotion at Monsters Inc., Mike Wazowski is finally able to do a little something extra for that special someone: himself. He's bought a sensible new car—an all-terrain, off-road, extreme sports car, complete with six wheel-drive. And he wants to give his pal Sulley a ride to show off with his brand new vehicle. But everything works against Mike as his beautiful new car turns into his own worst enemy.

Dank seiner Beförderung bei Monsters, Inc. kann Mike Wazowski endlich einmal etwas ganz besonderes für jemand ganz Besonderen tun: für sich selbst. Er hat sich ein tadelloses neues Auto gekauft – einen gelände-gängigen universellen Extremsportwagen mit Sechsrad-antrieb. Und er will natürlich seinen Freund Sulley zu einer Fahrt einladen, um mit seinem nagelneuen Vehikel etwas anzugeben. Aber alles hat sich gegen Mike verschworen, und das schöne neue Auto erweist sich als sein eigener größter Feind ...

Roger Gould (USA) studied computer graphics at Brown University and traditional animation at Rhode Island School of Design. He joined Pixar Animation Studios in 2001 as the Creative Director of the Shorts Division. Before joining Pixar he spent six years at Walt Disney Feature Animation. Prior to Disney, Roger worked for many years at Pacific Data Images. **Pete Docter (USA)** studied character animation at CalArts in Valencia. A protegé of John Lasseter, he began his association with Pixar in 1990. He was part of the original story team of *Toy Story* and also took on the role of supervising animator. Prior to Pixar he was involved in creating hand-drawn animation for Disney, Bob Rogers and Company, Bajus-Jones Film Corp. and Reelworks in Minneapolis. **Roger Gould (USA)** studierte Computer-grafik an der Brown University und traditionelle Animation an der Rhode Island School of Design. Er trat 2001 bei den Pixar Animation Studios als Creative Director der Kurzfilmabteilung ein. Bevor er zu Pixar kam, arbeitete Roger etliche Jahre bei Pacific Data Images. **Peter Docter (USA)** studierte Character Animation an der CalArts in Valencia. Seine Verbindung zu Pixar begann 1990 als Protegé von John Lasseter. Er gehörte dem ursprünglichen Drehbuch-Team für *Toy Story* an und übernahm auch die Aufgabe des Super-vising Animators. Vor seinem Eintritt bei Pixar arbeitete er an handgezeichneten Trickfilmen für Disney, Bob Rogers and Company, Bajus Jones Film Corp. und Reelworks in Minneapolis.

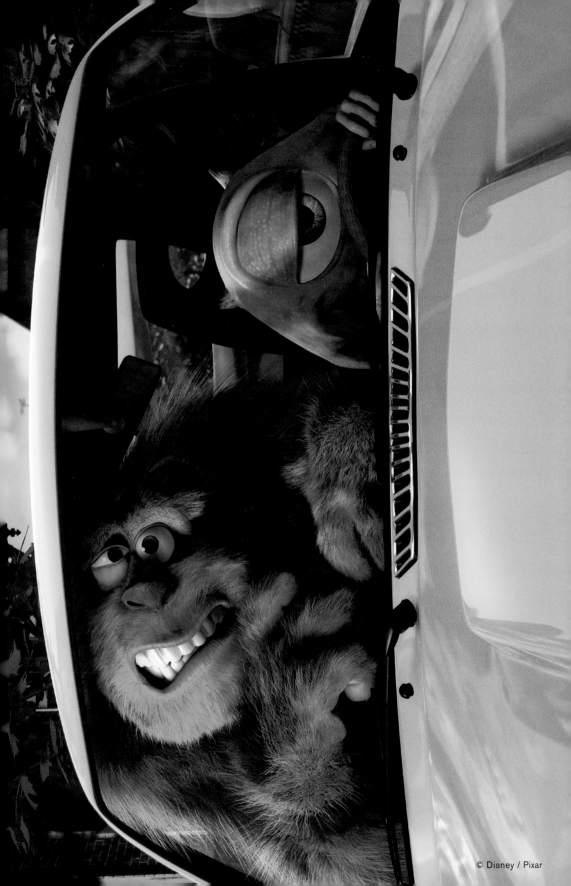

Gestalt
Thorsten Fleisch

Four-dimensional quaternions (a special group of fractals) are made visible by projection into three-dimensional space. Instead of modelling objects or scenes stemming from the human imagination with, for instance, the aid of 3-D software, the mathematics behind such software become the principle focus. Thus science is turned into something which can be experienced with the senses, which strips it and in particular mathematics of the distance and coldness commonly associated with them. Pythagorean scholars understood science and mathematics as an expression of divine order. Numbers (which in their non-materiality are inherently mystical) were not mere aids but the manifestation of divine force—the only force capable of explaining the nature of the world. The spirit of the Pythagorean scholars lives on in a branch of elementary physics exploring the superstring theory. With it researchers hope to unify the four elementary forces of our universe (the gravitational, electromagnetic, weak nuclear and strong nuclear forces) in one formula. Depending on the approach, this formula operates somewhere between at least ten-dimensional

Vierdimensionale Quaternionen (spezielle Gruppe von Fraktalen) werden durch Projektion in den dreidimensionalen Raum sichtbar gemacht. Anstatt der menschlichen Vorstellung entsprungene, mittels z. B. 3D-Modeling-Software erstellte Objekte oder Szenen wurde hier die Mathematik, die hinter dieser Software steckt, selbst zum Mittelpunkt des Interesses erklärt. Wissenschaft soll so sinnlich erfahrbar werden, um somit der Wissenschaft, insbesondere der Mathematik, die Distanz und Kälte zu nehmen, mit der sie gemeinhin assoziiert wird.
Von den Pythagoräern wurden Wissenschaft und Mathematik als Ausdruck göttlicher Ordnung verstanden. Zahlen (in ihrer Nichtstofflichkeit an sich schon von mystischer Qualität) waren nicht bloß Hilfsmittel, sondern Manifestation göttlicher Kraft – der einzigen Kraft, welche das Wesen der Welt zu erklären vermochte.
Der Geist der Pythagoräer lebt weiter in einem Forschungszweig der Elementarphysik, der sich mit der Superstring-Theorie befasst. Von dieser Theorie erhoffen sich die Forscher die Vereinigung der vier Grundkräfte unseres Universums (Gravitation, elektromagnetische Kraft, schwache Kernkraft und starke Kernkraft) in einer Formel. Diese Formel ist je nach Ansatz in einen mindestens zehndimensionalen, aber auch bis zu sechsundzwanzig-dimensionalen Raum eingebettet.

Bei dem mathematischen Körper in *Gestalt* handelt es sich um die Visualisierung der mathematischen Formel $(x[n+1]=x[n] \wedge p{-}c)$. In Anlehnung an die Ambitionen der Superstring-Theorie, die unser Universum in eine elegante Formel einschließen möchte, gehe ich den umgekehrten Weg und zeige das fremdartige Universum einer anderen, wesentlich simpleren mathematischen Formel. Bei der Arbeit an der Gestalt (durch Veränderung der Variablen der Formel, womit ich Einfluss auf die Ausformungen nahm) fühlte ich mich auch an die Anfänge der Malerei erinnert, als religiöse Motive vorherrschten – Malerei als direkter Ausdruck von Spiritualität. Da Mathematik auch spirituelles Potenzial in sich birgt, übte die unmittelbare Beschäftigung mit ihr eine starke Faszination auf mich aus.

Es entbehrt nicht einer gewissen Spannung, direkt mit den Bausteinen zur Beschreibung unseres Universums zu arbeiten. Um ein Gefühl für die Formengenese der Gestalt zu bekommen, beschäftigte ich mich nahezu ein Jahr mit der Manipulation der Variablen. Fast ein weiteres Jahr war außerdem nötig um die ausgewählten Sequenzen schließlich in höherer Auflösung zu rendern. Um die Bilder zu erstellen, benutzte ich die Freeware quat 1.1 von Dirk Meyer. Da das Programm leider keine Bildsequenzen erstellen kann, war ich gezwungen, ein kleines Zusatzprogramm zu schreiben, das quat 1.1 mit den notwendigen Daten für die Bildsequenzen meiner Wahl füttert.

Vor meiner Arbeit an *Gestalt* habe ich mich schon länger mit Mandelbrot-Fraktalen (so genannten Apfelmännchen), der Geometrie der vierten Dimension (welche relativ kurz nach ihrer Beschreibung durch Georg Bernhard Riemann Mitte des 19. Jahrhunderts von Okkultisten und Spiritisten für ihre Theorien über z. B. Geisterwesen vereinnahmt wurde) und der Superstring-Theorie beschäftigt. Als ich dann die Quaternionen für mich entdeckte, vereinigten sich in ihnen einige Bereiche meiner eben genannten populärwissenschaftlichen mit meinen kunstschaffenden Interessen.

space and 26-dimensional space. With the mathematical body in *Gestalt*, it is a matter of visualizing the mathematical formula $(x[n+1]=x[n] \wedge p{-}c)$. In view of the ambitions of the superstring theory, which would like to find an all-embracing elegant formula for our universe, I would like to take the opposite course and present the strange universe of a different, considerably simpler, mathematic formula. While working on the gestalt (by changing the variables of the formula I influenced its formation), I was reminded of the early days of painting, when religious motifs prevailed and painting was a direct expression of spirituality. And because mathematics also possesses a spiritual potential, the direct occupation with it exercised a strong fascination on me.

There is a certain thrill in working directly with the building blocks used to describe our universe. To get a feeling for the formation process in generating the gestalt, I spent almost a year manipulating variables. Rendering the selected sequences into a higher resolution took almost another year. To generate the images I used the freeware program Quat 1.1 by Dirk Meyer. Since the program is not able to produce image sequences, I was forced to write a small plugin that would feed Quat 1.1 with the necessary data for the image sequences of my choice.

Before beginning to work on *Gestalt*, I had spent much time exploring Mandelbrot fractals (in German so-called *Apfelmännchen* ["apple men"]), the geometry of the fourth-dimension (which relatively shortly after its description by Georg Bernhard Riemann in the mid 19th century was appropriated by occultists and spiritualists for their theories on, e.g., spiritual beings) and the superstring theory. When I then discovered quaternions, several of these popular-scientific fields of interest which I have just mentioned converged with my artistic interests.

Thorsten Fleisch (D), born 1972, studied art history, musicology and media studies in Marburg as well as avant-garde film at the Städelschule in Frankfurt with Peter Kubelka. He is a member of the board of artistic directors of the Telluride International Experimental Cinema Exposition. He has received numerous prizes for his films, including the Ann Arbour Award and the Kodak Award at the New York Expo. He has received grants for his films from the Filmbüro North-Rhine Westphalia and the Museum of Contemporary Cinema. **Thorsten Fleisch (D)**, geb. 1972, studierte Kunstgeschichte, Musikwissenschaft und Medienwissenschaft in Marburg sowie Avantgarde-Film bei Peter Kubelka an der Städelschule Frankfurt. Er ist Mitglied des Board of Artistic Directors der Telluride International Experimental Cinema Exposition. Für seine Filme erhielt er u.a. Preise wie den Ann Arbour Award und den Kodak Award auf der New York Expo. Seine Arbeiten werden gefördert durch das Filmbüro Nordrhein-Westfalen und das Museum of Contemporary Cinema.

Dolce Vita
Luc Froehlicher / La Maison

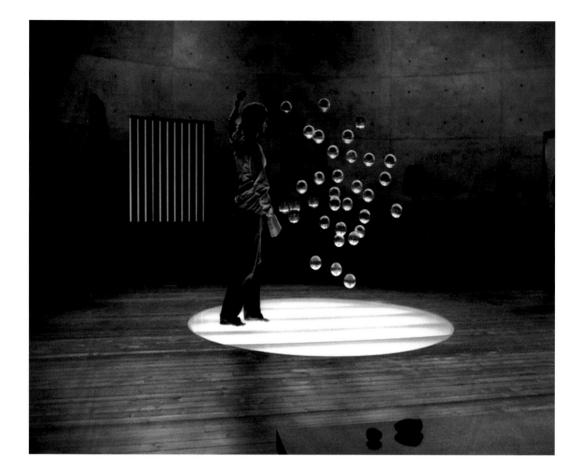

This commercial, directed by Bruno Aveillan, was done to introduce the French Gas de France users with the company new positioning and logo. The whole idea of the spot is to associate Gas heating with comfort, simplicity and weightlessness.

The film is divided into three parts: Father and son on a floating sofa made of glass bubbles; a woman dressed with a floating feather coat that makes her fly; a man taking his bath in a floating bubble of water.

Glass bubbles sequence
Real balls were present as reference in each shot. We had the chance to test the Spheron HDR device on stage. It gave us a 13000 by 5000 pixel HDR map containing 26 f-stops in 20 minutes' work. We didn't use so much data of course and after reducing everything a little

Dieser Werbespot entstand unter der Regie von Bruno Aveillan, um die Kunden von Gas de France mit der neuen Positionierung und dem neuen Logo des Unternehmens vertraut zu machen. Die Grundidee des Spots ist, Gasheizung mit Begriffen wie „Komfort", „Einfachheit" und „Schwerelosigkeit" zu verknüpfen.

Der Film ist in drei Abschnitte geteilt: Vater und Sohn auf einem schwebenden Sofa aus Glaskugeln: eine Frau in einem schwebenden Federkleid, das ihr zu fliegen erlaubt; ein Mann, der in einer schwebenden Wasserblase ein Bad nimmt.

Glaskugelsequenz
Echte Kugeln waren als Bezugspunkte in jeder Einstellung vorhanden. Wir konnten das Spheron HDR-Gerät vor Ort testen, und es bot uns eine 13.000 mal 5.000 Pixel große HDR-Map mit 26 Blendenstops in nur 20-minütiger Arbeit. Natürlich brauchten wir keine so große Datenmenge, aber nach einer angemessenen Reduzierung war es sehr

hilfreich, um die richtigen Reflexionen und Brechungen analog zu den echten Kugeln zu erstellen. Jede Figur wurde rotoskopiert und über die Kamera so gemappt, dass ihre Brechungen in die Kugeln fielen.

Federmantel-Sequenz
Für den zweiten Teil haben wir eine Software geschrieben, um das Partikelverhalten rund um den Körper und den Mantel des Mädchens zu steuern. Jede Feder bestand aus einer einfachen gemappten geometrischen Form plus Haare für eine sanfte Schattierung und wurde anschließend auf die Partikel übertragen, die die Rotation und Position jeder einzelnen Feder bestimmten.

Wasserblase
Der Mann wurde in einer Plexiglas-Wanne aufgenommen. Wir begannen mit einer einzelnen Oberfläche um seinen Körper und verwendeten RealWave, um schnell gleichmäßige Wellen rund um diese Oberfläche zu generieren. Dann haben wir die die Oberfläche deformierenden Gitter von Hand animiert, um die globale Verformung und das Schweben der Animation zu erzeugen. Die Interaktion zwischen Mann und Wasser wurde ebenfalls mit RealWave simuliert. Zuletzt wurden zahlreiche Ebenen mit Reflexionen, Refraktionen, Spitzenlichtern und Schatten erzeugt und mit der Live-Action zusammenmontiert.

bit it was very useful to get the right reflections and refractions to match the real balls. Each character was rotoscoped in CG and camera mapped to get the refractions of them inside the balls.

Coat of feathers sequence
For the second part, we wrote software to control particle behaviour around the body and the coat of the girl. Each feather was made of a simple mapped geometry plus hairs to give a soft shading and then was instanced on the particles, which would control the rotation and position of each feather.

Bubble of water
The man was shot in a plexi bath. We started with a single surface around his body. We used realwave to quickly generate uniform wave around this surface. Then we hand-animated lattices deforming the surface to give the global deforming and floating animation. RealWave was also used to simulate the interactions between man and water. We would then output many layers like reflections, refractions, highlights, mattes and composite them together with live action.

Luc Froehlicher (F), born 1964, holds an Engineering Diploma and a DEA in Digital image processing from the University of Strasbourg. Since 1987 he has worked as head of the CG-department on Feature Film and for the first HDTV-Studio in New York. Later he worked at Medialab as 3D animator, technical director of the TV Series Department and as the head of 3D in the VFX department. Since 2001 he has been head of the 3D department of "La Maison". **Luc Froehlicher (F)**, geb. 1964, ist Diplomingenieur und graduierte an der Universität Straßburg zum DEA in digitaler Bildverarbeitung. Ab 1987 arbeitete er als Leiter der Computergrafik-Abteilung bei Feature Film und für das erste HDTV-Studio in New York. Später war er bei Medialab als 3D-Animator, als technischer Leiter der TV-Serien-Abteilung und als Leiter der 3D-Abteilung im VFX-Department tätig. Seit 2001 steht er der 3D-Abteilung von La Maison vor.

Remind Me
H5 / Ludovic Houplain / Hervé de Crécy

The video for to album *Remind Me* of the Norwegian band Röyksopp is made exclusively with graphics that are part of the common currency of daily life—from aircraft safety instructions to magazine and newspaper graphics. It tells the story of an ordinary person's life working in the City in London. Each shot of the video is conceived as a technical illustration of a phenomenon, statistic or notice. The whole environment of the character—a 30 year-old woman working in the financial district of London—is thus detailed, from the wake-up time to the 6 o'clock beer at the end of the working day. Each shot follows a pure explanatory logic, illustrated by a succession of animated graphs, charts, diagrams and maps.

Das Video für das Album *Remind Me* der norwegische Band Röyksopp wurde ausschließlich mit Grafiken erstellt, die dem Gemeingut des Alltags angehören – von Sicherheitsinstruktionen aus dem Flugzeug bis zu Margarine- und Zeitungsgrafiken. Es erzählt die Geschichte vom Alltag einer ganz gewöhnlichen Person, die in der Londoner Innenstadt arbeitet. Jede Einstellung des Videos ist als technische Illustration eines Phänomens, als Statistik oder als Hinweisschild konzipiert. Die gesamte Umgebung der Figur – einer 30-jährigen Frau, die im Finanzdistrikt Londons arbeitet – wird so aufgeschlüsselt, vom morgendlichen Aufstehen bis zum abendlichen Bierchen als Abschluss des Arbeitstags. Jede Einstellung folgt einer rein erläuternden Logik und wird von einer Folge von animierten Grafen, Diagrammen, Plänen und Skizzen illustriert.

Labels: Virgin disques
Producer: John Payne for Black Dog Films
Commissioner: John Moule for Wall of Sound 2002
Best Video MTV Europe Music Award 2002

H5 (F) is a graphic studio essentially dedicated to the music domain, specifically to the labels and the groups of the French Touch. The H5 crew were at the beginning, Ludovic Houplain and Antoine Bardou Jaquet, both of them former students of ESAG (Paris Superior School in Graphic Art). Later Hervé de Crécy joined in. Since 1999 H5 has moved into video: at first, the Alex Gopher video clip, followed by two commercials for Vodafone and Bank of Scotland. They have a great reputation for their sleeve designs for Alex Gopher and Super Discount, and the music videos for Alex Gopher entitled *The Child*. The latter represented the whole city with only typography and is excellent with innovative style and quality. **H5 (F)** ist ein Grafikstudio, das sich vorwiegend dem Musikbereich widmet und hier wiederum besonders den Labels und Gruppen des French Touch. Anfänglich bestand die H5-Crew aus Ludovic Houplain und Antoine Bardou Jaquet, beide ehemalige Studenten der École Supérieure des Arts Graphiques, später stieß noch Hervé de Crécy hinzu. Seit 1999 ist H5 im Videobereich tätig, zunächst mit dem Videoclip für Alex Gopher, gefolgt von zwei Werbespots für Vodaphone und die Bank of Scotland. Das Studio erwarb mit seinen Umschlagdesigns für Alex Gopher und Super Discount sowie mit dem ebenfalls für Alex Gopher entstandenen Musikvideo *The Child* einen guten Ruf in der Szene. Letzteres stellte die gesamte Stadt ausschließlich mit Mitteln der Typografie dar und ragt wegen seines innovativen Stils und seiner Qualität heraus.

Pipe Dream
Wayne Lytle / ANIMUSIC

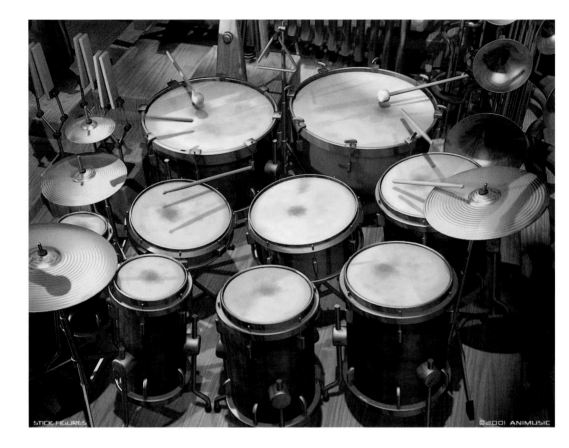

Pipe Dream shows a captivating performance of balls flying out of pipes and landing on instruments, sounding notes and rhythms as the balls hit. The observer should notice such details as wear on the instruments (from repetitive hitting in the same spot) and the realistic vibration and movement when the balls strike the xylophone and marimba.

Pipe Dream appears on the DVD entitled "ANIMUSIC: A Computer Animation Video Album". This is the first commercially available work by ANIMUSIC, a computer animation studio specializing in music-driven animation. The DVD features seven videos of never- before-seen instruments playing on their own, often in incredible feats of coordination. The original score for each piece is performed on a different stage with different instruments.

Pipe Dream zeigt eine fesselnde Performance mit Bällen, die aus Rohren herausschießen, auf Instrumenten landen und bei ihrem Aufschlag Klänge und Rhythmen erzeugen. Man beachte auch solche Details wie die Abnutzung an den Instrumenten (durch das Auftreffen der Bälle auf immer denselben Stellen) und die realistischen Bewegungen und Schwingungen, wenn die Bälle auf die Marimba und das Xylophon aufschlagen.

Pipe Dream erscheint auf einer DVD mit dem Titel „ANIMUSIC: A Computer Animation Video Album", bei der es sich um das erste kommerziell erhältliche Werk von ANIMUSIC handelt, einem Computeranimationsstudio, das sich auf musikgesteuerte Animationen spezialisiert hat. Auf der DVD werden insgesamt sieben Videos von nie zuvor gesehenen Musikinstrumenten gezeigt, die teilweise mit erstaunlich präziser Koordination gespielt werden. Die Originalpartitur für jedes Stück wird auf einer gesonderten Bühne mit anderen Instrumenten gespielt.

Das Video-Album ist wirklich einzigartig und entzieht sich jeder Kategorisierung. Hier einige Beispiele, wie Zuseher das Werk beschreiben:
– Eine Kreuzung aus *Toy Story* und einem Pink-Floyd-Konzert
– Fesselnder als der Cirque du Soleil
– Rube Goldbergs New Lounge Act
– Teils Laserlicht-Show, teils *Fantasia*
Egal, womit man es vergleicht: Der Inhalt von ANIMUSIC ist eine bestechende Durchmischung von Musik und Bild, die Betrachter jeder Altersstufe unterhält. Und da die Musik instrumental ist, gibt es auch keine Sprachbarriere. ANIMUSIC-Videos sind rund um den Globus populär geworden und haben gerade in Südostasien eine beträchtliche Anhängerschaft.

ANIMUSIC ist eine auf Inhalte spezialisierte Firma mit dem Schwerpunkt auf der Produktion von 3D-Computergraphik-Musikanimationen.
Sowohl die Grafik wie die Musik werden vollständig digital synthetisiert. Virtuelle Instrumente werden erfunden, indem Computergrafik-Modelle von Objekten erstellt werden, die etwa dem Klang der zugehörigen Synthesizermusik entsprechen. Diese grafischen Objekte können an existierende Instrumente erinnern oder aber völlig abstrakt sein.

The video album is truly unique and defies categorization. Here's how some people have described it:
– A cross between *Toy Story* and a Pink Floyd concert
– More mesmerizing than Cirque du Soleil
– Rube Goldberg's New Lounge Act
– Part laser-light show, part *Fantasia*
Whatever the comparison, ANIMUSIC's content is an intricate melding of music and visuals that entertains viewers of all ages. And since the music is instrumental, language is not a barrier. ANIMUSIC videos have gained popularity around the globe, with a considerable following in Southeast Asia.

ANIMUSIC is a content creation company and the principal focus is the production of 3D computer graphics music animation.
Both the graphics and the music are entirely digitally synthesized. Virtual instruments are invented by building computer graphics models of objects that would appear to create the sound of the corresponding music synthesizer track. Graphical instruments range from being reminiscent of existing instruments to arbitrarily abstract.

Wayne Lytle (USA) studied classical piano before switching over to computer music. After completing graduate work at Cornell University in 1988 he joined the Cornell Theory Center as a scientific visalization producer. In 1989 he produced early music animation experiments. His 1990 music animation "More Bells and Whistles" has been shown in the US and abroad. He received awards both for his animations and for his technical papers. Wayne Lytle formed ANIMUSIC in 1995, released its first DVD video album in late 2001 and has sold thousands of copies around the world. **Wayne Lytle (USA)** studierte klassisches Klavier, bevor er sich der Computermusik zuwandte. Nach seiner Abschlussarbeit an der Cornell University 1988 arbeitete er als Produzent wissenschaftlicher Visualisierungen am Cornell Theory Center. 1989 produzierte er die ersten Experimente mit Musikanimationen. Seine 1990 entstandene Animation *More Bells and Whistles* wurde in den USA und im Ausland gezeigt. Wayne wurde sowohl für seine Animationen als auch für seine wissenschaftlichen Aufsätze ausgezeichnet. 1995 gründete er ANIMUSIC, Ende 2001 wurde das erste DVD-Videoalbum herausgebracht und in Tausenden Exemplaren auf der ganzen Welt verkauft.

The Dog Who was a Cat Inside
Siri Melchior

The Dog Who was a Cat Inside is a special animal. The dog and cat live together in the same body, but this causes conflict. When the dog tries to make friends with other dogs, the cat goes to sleep, so he can't join in with their games and when the cat meets a cat friend, the dog barks and chases him off. The Dog Who was a Cat Inside feels lonely and rejected by all other animals. As it sits dejectedly besides the river, the Dog and Cat have a furious argument and fall into the water. At first they struggle against each other, but eventually they realise that by swimming together they can save themselves.

Siri Melchior says, The Dog Who was a Cat Inside is based on an illustration I did for the Danish proverb "Don't judge a dog by its fur". The idea for the film developed from playing with the theme of cats and dogs. The difference between these two animals came to represent inner conflict, and the story is about learning to live with it. The visual style is inspired by Cubism and how that style can illustrate many facets of the same thing at once. I worked with both shapes and textures inspired by Cubism to create the feeling of movement and space.

The animation is a mixture of traditional and painted drawn animation and 3D computer animation. The dog/cat character was animated by hand, painted and scanned into the computer. After being cleaned up and manipulated in Photoshop, the drawings were edited using Premiere and composited with cut-out animation in 3D Studio Max.

The Dog Who was a Cat Inside – der Hund, der innerlich eine Katze ist, ist ein ganz besonderes Tier, denn die beiden Wesen leben in einem gemeinsamen Körper, was allerdings zu gewissen Konflikten führt. Wenn der Hund sich mit anderen Hunden anfreunden will, geht die Katze schlafen und kann sich so an den Hundespielen nicht beteiligen. Und wenn die Katze einen Katzenfreund kennen lernen will, bellt der Hund und verjagt ihn. So fühlt sich der Hund, der innerlich eine Katze ist, einsam und von allen anderen Tieren verstoßen. Als das Tier geknickt am Fluß sitzt, streiten Hund und Katze in ihm recht heftig und fallen in den Fluss. Zunächst noch raufen sie miteinander, bald aber merken sie, dass sie sich nur durch gemeinsames Schwimmen retten können.

Siri Melchior sagt: „The Dog who was a Cat Inside basiert auf einem Bild, mit dem ich das dänische Sprichwort ‚Beurteile nie einen Hund nach seinem Fell' illustriert habe. Beim Herumspielen mit dem Thema Hund und Katze entstand dann die Idee zum Film. Der Unterschied zwischen diesen beiden Tieren drückt die Existenz von inneren Konflikten aus, und letztlich geht es darum, mit diesen leben zu lernen. Der visuelle Stil ist vom Kubismus inspiriert, dem es gelingt, viele unterschiedliche Facetten eines Dings zugleich zu illustrieren. Ich habe sowohl mit kubistischen Formen wie Texturen gearbeitet, um das Raum- und Bewegungsgefühl des Films zu schaffen."

Die Animation ist eine Mischung aus traditioneller hand-gezeichneter bzw. gemalter und 3D-Computeranimation. Die Gestalt des Katzenhundes wurde von Hand animiert, gemalt und in den Computer gescannt. Nach der Reinigung und Bearbeitung der Einzelbilder in Photoshop wurden die Zeichnungen mittels Premiere geschnitten und mit Cut-Out-Animation in 3D Studio Max zusammengebaut.

Siri Melchior (DK), born 1971, holds a BA in Art History from the University of Copenhagen, a Graphic Design Diploma from the Danish Design School and an MA in animation from the London Royal College of Art. She has worked as an illustrator in Copenhagen since 1991 and received an artist working grant in 2000 from the Danish Ministry of Culture. Since 1997 she has worked as an animator and director at Passion Pictures and other animation companies in London. Furthermore she taught animation at London College of Printing from 1999 to 2001. **Siri Melchior (DK)**, geb. 1971, hat einen BA aus Kunstgeschichte an der Universität Kopenhagen erworben, ein Diplom für Grafisches Design an der Dänischen Designschule und einen MA aus Animation am Royal College of Art in London. Sie arbeitet seit 1991 als Illustratorin in Kopenhagen und erhielt 2000 ein Arbeitsstipendium für Künstler vom dänischen Kulturministerium. Seit 1997 arbeitet sie als Animatorin und Regisseurin bei Passion Pictures und anderen Animationsfirmen in London. Daneben hat sie 1999 bis 2001 am London College of Printing Animation gelehrt.

Mantis
Jordi Moragues

They are beautiful and carnivorous. Sometimes, the female devours the male during copulation. They have a special elegance, as if in their slow and deliberate movements they were deeply absorbed in thought. I knew little more about mantises when I first had the idea to make a film about them, so I started to investigate exactly how they lived, moved, hunted, mated, reproduced, and died. This investigative phase was going to completely change the character and intention of the project.

I found the different aspects of mantis life fascinating, and I wanted to transmit that fascination. In the natural world there is no good or evil, no moral. Only life, transformation and death. But life all over again. My intention became to show a poetic meditation about this cycle and the instinct for survival and preservation. The importance that the cannibalistic sexual behaviour had had on my original treatments also faded to a secondary place, as just another characteristic of mantids.

Schön sind sie und Fleischfresser. Manchmal frisst das Weibchen das Männchen noch bei der Kopulation auf. Ihnen ist eine besondere Eleganz zu eigen, als wären sie bei ihren gemessenen und gezielten Bewegungen tief in Gedanken versunken. Viel mehr wusste ich nicht über Gottesanbeterinnen, als ich erstmals auf den Gedanken kam, einen Film über sie zu machen, und so begann ich mich damit zu beschäftigen, wie sie wirklich leben, sich bewegen, jagen, sich paaren, sich fortpflanzen und sterben. Diese Forschungsphase sollte Art und Intention des gesamten Projekts verändern.

Ich fand die verschiedenen Aspekte des Lebens der Gottesanbeterin faszinierend und wollte diese Faszination vermitteln. In der Welt der Natur gibt es weder Gut noch Böse, es gibt keine Moral. Nur Leben, Veränderung und Tod – aber immer wieder von neuem Leben. Ich steckte mir das Ziel, eine poetische Meditation über diesen Zyklus und den Überlebens- und Arterhaltungsinstinkt zu zeigen. Das kannibalistische Sexualverhalten, das in meinen ersten Exposés noch eine große Bedeutung hatte, trat ebenso in den Hintergrund wie andere Charakteristika dieser Gattung.

Doch ich wollte erzählerisch sein und eine Erfahrung vermitteln, nicht eine Lektion in Naturkunde. Meine Faszination für diese Insekten war so intensiv geworden, dass ich den biologischen Fakten treu bleiben wollte. Nur ein paar Mal ließ ich der dramatischen Ader freien Lauf. Auch wollte ich eigentlich einen größeren Maßstab anlegen, wollte die Sonne und die Erde zeigen, ich wollte zeigen, wie Ebbe und Flut auch das Leben im kleinen Maßstab beeinflussen, das Leben der Insekten. All das fühlte sich kontemplativ an, ursprünglich und subtil. Ich musste also entscheiden, wie das aussehen sollte. Ich war mit der Kunst des Ostens vertraut, mit der Kalligrafie, den Reispapierrollen mit ihren zart dargestellten Blumen und Vögeln, den kraftvollen Wasserfällen, den fließenden Linien, die Landschaften, Fische oder Insekten beschreiben. In meinem Film finden sich viele dieser Elemente wieder. Die Grazie und Schlichtheit dieser Zeichnungen, die Art und Weise, wie ihr Nicht-Realismus die Essenz ihres Objekts viel besser einfängt, als es ein Foto könnte, machten meine Wahl einfach. Ich begann also zu lernen, wie orientalische Künstler die Welt malen. Ihr Zugang zur Komposition, Perspektive, Farbe, Balance, zu Licht und Schatten ist einmalig. Sie interessieren sich nicht dafür, wie ein Objekt aussieht, sondern was das Objekt ist oder was es darstellt.

Der Sound zu *Mantis* entwickelte sich auf eine ähnliche Weise und wurde mit der Zeit einfacher und einfacher. Von Anfang an war klar, dass der Soundtrack naturalistisch und atmosphärisch zu sein hatte. Auch hielt ich es für wichtig, irgendeine Form von Musik zu haben, um bestimmten Szenen einen emotionalen Tonfall zu geben.

But I wanted to be narrative and provide an experience, not give a lesson in natural sciences. My fascination with those insects had grown so deep, that I wanted to stay true to the biological facts. But on a couple of occasions I favoured my dramatic arc.

I also had the idea of showing a bigger scale, the sun and the earth, and suggesting how its ebb and flow affected the small scale, the insects and their lives. It all felt contemplative, primal and subtle. I had to decide how this would look.

I knew oriental art, the beautiful calligraphy, the vertical rice-paper rolls with delicately rendered flowers and birds, energetic waterfalls, flowing lines depicting landscapes, fish, or insects. My film had many of those elements. Something about the grace and simplicity of those drawings, the way their non-realism captured the essence of the subject better than a photograph would have, made the choice obvious.

I started learning about how oriental artists paint the world. Their way of approaching composition, perspective, colour, balance, light and shadow is unique. They are not interested in how an object looks, but what that object is, or represents.

The sound for *Mantis* evolved in a similar way, becoming simpler and simpler. From the beginning it was clear that the soundtrack would be naturalistic and atmospheric. I still thought that it was important to have music of some sort, to suggest an emotional tone to certain scenes.

Jordi Moragues (E), born 1970, dedicated himself to computer animation in the environment of advertising post-production. In 1993 he joined the Master of Image Synthesis and Computer Animation at the University of the Balearic Islands. Between 1994 and 1997 he taught computer animation at the Pompeu Fabra University. At present he works as a fellow at the Academy for Media Arts Cologne. **Jordi Moragues (E)**, geb. 1970, arbeitet im Bereich Computeranimation in der Postproduktion. 1993 absolvierte er das Master-Programm aus Bildsynthese und Computeranimation der Universität der Balearen. Zwischen 1994 und 1997 lehrte er Computeranimation an der Universität Pompeu Fabra, derzeit ist er Fellow an der Kunsthochschule für Medien in Köln.

3D Character Animation for Blockbuster Entertainment
Tippett Studio

It's the continuing adventures of Carl & Ray, the funny, furry *Blockbuster* spokes-characters created by the artists of Tippett Studio utilizing a proprietary fur tool. In this year's montage, the Tippett artists and crafts people have further refined and built on the artistic and technical challenges of bringing photo real house pets, a rabbit and Guinea pig, into the realm of the fantastic. Whether they be dancing, sliding, juggling, or dripping with water, Carl & Ray continue to entertain audiences worldwide while setting new standards in seamless CG character animation. Working closely with Doner Advertising and Director Steve "Spaz" Williams of Complete Pandemonium, the Tippett team achieved three overlapping technical and artistic challenges; we built believable computer-generated house pets; we extrapolated our house pets' reality into the realm of the fantastic as our characters exaggerate their humorous anthropomorphic qualities; and lastly, we continued to further refine photo realistic fur.

Weiter geht es mit den Abenteuern von Carl & Ray, den beiden witzigen fellbedeckten Firmensprechern von Blockbuster, die von den Künstlern der Tippett Studio mit Hilfe eines eigenen Fellwerkzeugs geschaffen wurden. In der diesjährigen Montage haben die Künstler und Handwerker von Tippett sich mit noch größerem Erfolg der künstlerischen und technischen Herausforderung gestellt, fotorealistische Haustiere – einen Hasen und ein Meerschweinchen – in das Reich des Fantastischen zu übertragen. Ob sie jetzt tanzen, rutschen, jonglieren oder pitschnass sind, Carl & Ray unterhalten weiterhin ein weltweites Publikum und setzen gleichzeitig neue Maßstäbe in der nahtlosen Animation von Computergrafik-Gestalten.

In enger Zusammenarbeit mit Doner Advertising und dem Regisseur Steve „Spar" Williams von Complete Pandemonium hat das Tippett-Team drei voneinander nicht zu trennende technische und künstlerische Aufgaben bewältigt: Wir haben glaubhafte computergenerierte Haustiere erzeugt; wir haben die Realität unserer Haustiere in das Reich des Fantastischen extrapoliert, indem wir unsere Figuren ihre witzigen anthropomorphen Eigenschaften übertreiben lassen; und wir haben die fotorealistische Darstellung von Fell weiter verfeinert.

Tippett Studio (USA) is an Academy Award-winning full service visual effects facility that specializes in CG character animation for movies and television commercials. Founded in 1984 by Phil Tippett, the Studio now employs over 200 artists and technicians in Berkeley, CA. The VFX-Supervisors of this work have been: Scott Souter, Frank Petzold, Joel Friesch and Jim McVay. Current productions include *The Matrix: Revolutions*, *League of Extraordinary Gentlemen*, *Hellboy*, *Stepford Wives*, and other award-winning television commercials. **Tippett Studio (USA)** sind eine mit Oscars ausgezeichnete Full-Service-Facility für Visual Effects, der sich auf Character Animation für Filme und Fernsehspots spezialisiert hat. Das 1984 von Phil Tippett gegründete Studio beschäftigt in Berkeley, Kalifornien, inzwischen über 200 Künstler und Techniker. Die Visual-Effects-Supervisors bei dieser Arbeit waren Scott Souter, Frank Petzold, Joel Friesch und Jim McVay. Zu den aktuellen Produktionen gehören unter anderem *The Matrix: Revolutions*, *League of Extraordinary Getlemen*, *Hellboy*, *Stepford Wives* und andere preisgekrönte TV-Werbespots.

Justice Runners
Satoshi Tomioka

Tokyo Station suddenly appears in the railway field, where five conductors of *Justice Runners* start their trains. The five trains visit a terrace house and punish the poor, silly and stinky people living there because they haven't paid the rent for a long time.

Der Bahnhof von Tokio erscheint plötzlich im Eisenbahnfeld, und fünf zu den *Justice Runners* gehörige Lokführer starten ihre Züge. Diese Züge besuchen ein Mehrfamilienhaus und bestrafen dessen arme, dumme und miefige Bewohner, weil sie schon seit langer Zeit die Miete schuldig geblieben sind.

Satoshi Tomioka (J), born in 1972, has been CG operator at Dream Picture Studio Inc., freelance CG operator and is currently CG operator at Kanaban Graphics. He holds awards from GAGA C&R in the Character Animation Contest of SGI, the Silver Wing Prize in the Multimedia Contest, the Grand Prize in the animation division in the SKIP Creative Human Award, the Entertainment Prize in the CG division in the Multimedia Grand Prix 2000 and the Excellence Prize in the digital art (non-interactive) division in the Media Arts Festival from the Agency for Cultural Affairs. **Satoshi Tomioka (J)**, geb. 1972, war CG Operator bei Dream Picture Studios Inc., freiberuflicher CG Operator, und ist derzeit CG Operator bei Kanaban Graphics. Er hat zahlreiche Preise gewonnen, darunter GAGA C&R im Character Animation Contest von SGI, den Silver Wing Prize im Multimedia-Contest, den Grand Prize in Animation beim SKIP Creative Human Award, den Entertainment Prize in Computergraphik beim Multimedia Grand Prix 2000 sowie den Excellence Prizes für nicht-interaktive digitale Kunst des Media Arts Festival der Agency for Cultural Affairs.

DIGITAL MUSICS

A New Ambiguity: Human and Digital
Eine neue Zwiespältigkeit – menschlich und digital

David Toop & Naut Humon

"If I was given a choice between listening to something I really liked and nothing at all – very often I would choose nothing at all."

David Toop

„Wenn ich die Wahl habe, etwas anzuhören, was ich wirklich mag, oder gar nichts zu hören, dann höre ich oft lieber gar nichts."

David Toop

At this point in time, digital technology has become ubiquitous in our lives. Even for an acoustic guitarist, the recording, mixing, editing, mastering, distribution, promotion and playback of music is likely to be digital to some degree. In 2003, a digital music jury is faced with a dilemma: how can digital music be distinguished from any other category of music? Some relatively recent trends in music can be interpreted as a response to digital technology, even if the means of generating sound are located within the body or in instruments made from wood or metal.

Digital listening is one aspect of this change. The microscopic focus on small sounds allowed by the computer, along with the minute transformations typical of audio software programs, has affected timbre and form in many different types of music-making. Even the reduced noise floor of recording and playback that comes with digitization has opened up new possibilities for performers to explore an unprecedented ratio of silence to noise, or inactivity to activity. In a broader context, the information overload characteristic of digitized societies has been the catalyst for a backlash where withdrawal, subtlety and silence are the watchwords.

Audio work produced from this philosophical position is essentially fugitive in nature, structured according to principles that are less clearly evident, the 'narrative' less transparently devel-opmental or dramatic than any existing aesthetic of digital sonic arts. This raised excruciating issues for this year's jury (and juries to come) in that a prize such as the Golden Nica implies a 'masterpiece', a work unassailable in its completeness, its virtuosity and its mastery of

Inzwischen ist die digitale Technologie in unserem Leben allgegenwärtig geworden. Selbst für einen akustischen Gitarristen erfolgen Aufnahme, Abmischung, Schnitt, Mastering, Distribution, Promotion und Wiedergabe von Musik mit größter Wahrscheinlichkeit in irgendeiner Hinsicht mit digitalen Mitteln. Im Jahr 2003 sieht sich die Digital-Musics-Jury mit einem Dilemma konfrontiert: Wie kann digitale Musik noch von anderen Musikformen unterschieden werden? Einige der neuesten Trends in der Musik lassen sich als Antwort auf die digitale Technologie interpretieren, auch wenn die Mittel zur Klangerzeugung innerhalb des Körpers liegen oder in Instrumenten aus Holz oder Metall.

Digitales Hören ist einer der Aspekte dieser Verände-rung. Der mikroskopische Schwerpunkt auf den kleinen Klängen, die der Computer in Verbindung mit den winzigen Transformationen, die für Audio-Software-Programme typisch sind, erlaubt, hat Timbre und Form vieler verschiedener Arten des Musikschaffens be-einflusst. Selbst der reduzierte Geräuschteppich bei Aufnahme und Wiedergabe, der mit der Digitalisierung einhergeht, bringt all jenen Musikern neue Möglichkeiten, die ein bisher unbekanntes Verhältnis von Geräusch und Stille oder Inaktivität zu Aktivität erforschen wollen. In einem größeren Zusammenhang hingegen hat sich die überbordende Informationsflut, die für digitalisierte Gesellschaften typisch ist, zu einem Katalysator für eine Gegenbewegung entwickelt, in der Rückzug, Subtilität und Stille zu Kernbegriffen geworden sind. Die aus einer solchen philosophischen Position entstan-denen Audiowerke zeigen im Wesentlichen eine Art Fluchtverhalten; sie sind nach weniger offensichtlichen Prinzipien strukturiert, ihre „narrative Gestalt" entwickelt sich weniger transparent oder dramatisch als in irgend-einer der bestehenden ästhetischen Formen digitaler Klangkunst. Dies hat für die diesjährige Jury einige

schwer zu beantwortende Grundsatzfragen aufgeworfen (und wird es wohl auch für die kommenden Jurys tun): Ein Preis wie die Goldene Nica impliziert stets ein „Meisterwerk", ein in seiner Gesamtheit und in seiner technischen, technologischen und formalen Virtuosität unangreifbares Stück. Und das Problem könnte durchaus sein, dass man bei Wettbewerben dazu neigt, automatisch nach den „großen Statements" zu suchen und die kleineren, eher persönlich gehaltenen Stücke dabei zu übersehen.

Aber ist das im 21. Jahrhundert überhaupt noch von Bedeutung, in einer Zeit, in der der Wandel so rapide erfolgt und die Publikumsgruppen so aufgesplittet und so unterschiedlich sind? So ein enormer Paukenschlag, wie ihn eine alle Grenzen durchbrechende Komposition wie etwa Karlheinz Stockhausens *Telemusik* darstellte, scheint der Vergangenheit anzugehören. Ob zum Vorteil oder Nachteil – die Quantität scheint einer der entscheidenden Trends der digitalen Musik zu sein. Da es inzwischen schon sehr simpel geworden ist, auf einem Heim-PC mit Standardsoftware-Paketen Aufnahmen zu machen und die Ergebnisse dann auf CDRs zu brennen, hat sich eine wahre Lawine von technisch durchaus ausgefeilter, aber dennoch häufig uninspirierter Musik über uns ergossen. Ein bemerkenswerter Aspekt vieler der Werke, die sich dieses Jahr über den allgemeinen Sumpf erhoben, war, dass sie im positiven Sinn neue Möglichkeiten eröffnen und weniger in Richtung Beschränkung gehen. Auch wenn dies auf den ersten Blick eine bescheidene Errungenschaft scheint, so können ihre Implikationen und Einflüsse doch viel profunder sein als jene eines lauteren, großartigeren Werks.

Ein gutes Beispiel in dieser Hinsicht ist der Gewinner der Goldenen Nica 2003, eine Aufnahme von zwei Duos: die Vokalistin Ami Yoshida mit dem Synthesizer-Spieler Utah Kawasaki („Astro Twin") und Yoshida mit Sachiko M („Cosmos"), die die in einem digitalen Sampler installierten Sinewaves spielt. Diese drei Musiker sind in einer Szene engagiert, die den subversiven Einsatz von Technologie erforscht und sich dem Minimalismus,

technology, technique and form. And the problem might be that when you're getting into competitions, one is almost automatically looking for big statements and the smaller, more personal pieces are often overlooked in comparison.

But is this meaningful in the 21st century, in an era when change is so rapid and audiences are so fragmented and diverse? Do these shortened attention spans indicate any sort of real progress? The enormous impact of a breakthrough composition, such as Karlheinz Stockhausen's *Telemusik* now seems to be the mark of a previous era. For better or worse, quantity is one of the defining trends of digital music. The ease of recording on home computers with generic software packages, then burning CD-Rs of the results, has unleashed a torrent of technically capable yet often unengaging music. A striking aspect of many of the works that emerged out of the general morass this year is that they represent a positive sense of opening possibilities, rather than closure. At first glance the achievement can seem modest, yet the implications and influence may be far more profound than a noisier, grander work.

A good case in point is the winner of the Golden Nica in 2003, a recording of two duos: vocalist Ami Yoshida with synthesizer player Utah Kawasaka ("Astro Twin"), and Yoshida with Sachiko M ("Cosmos"), who plays the sine tones installed in a digital sampler. All of these players are engaged in a scene that explores minimalism, subverted technologies, restraint, silences and the outer limits of auditory perception. The scene is distinctly Japanese yet also international – part of a wider approach that can no longer be contained under any rubric of improvisation, minimalism, electronic music or composition. The players are very adaptable in one sense, yet they limit the range of their activities in order to avoid the 21st century temptations of all things being possible.

A New Ambiguity: Human and Digital

Terms such as strength or interaction are called into question, just as received views of music, noise and silence were challenged by John Cage in the 1950s. Above all, this kind of music questions the relevance of defining or celebrating any kind of audio activity in relation to a single technological approach. The utopian dreams of the 20th century have been tempered by experience. Our future as humans depends upon a relationship with technology that sustains our own humanity.

As digital musicians continue to actively consider the role that software plays in the character and identity of their special sound, one is led to wonder how much these processes color a listener's identification with unusual particularities an artist may be attempting to convey. Is the creator simply subscribing to an electronic genre's compositional expectation and style, or is there an effort to transcend trendy musical anachronisms to seek a technological transparency where obvious software demonstration seems to "disappear" into a deeper experiential organism? Traditionally, much of modern electronic music takes acoustic or synthetic source materials and disguises them through transformative signal processing or non-destructive editing techniques. Where developments in physical modeling programs attempt to emulate accurately older analog tape and instrument sounds, there is an equivalent opposite movement amongst some human improvisers with analog synthesizers, voice and live instrumental lineups who are conveying a "digital" attitude and influence in their works.

It is precisely at this junction that the realm of digital musics intersects with its analogue predecessors to realize a hybrid of fresh "audentities" not always tied to their anticipated sources. Several of this year's chosen selections reflected this increasing tendency to further blur these less-defined audio terrains.

The uncommon qualities we found in Ami Yoshida's collaborative ventures with Sachiko M and Utah Kawasaki represents inconspicuous areas of improvisation seldom investigated in the past years of Prix Ars Electronica.

astro twin & cosmos seemed to constantly rise to the surface of our discussions as one of the primary examples in this younger, unassuming music milieu. There was reason to care but not be overly serious about all the intentions in their live explorations as they seemed to be surprised themselves at the subtle directions in which their sounds would move. Ami's voice, which is never really singing, sounds like a technical artifact

der Zurückhaltung und Stille und der Auslotung der äußersten Grenzen der Gehörwahrnehmung verschrieben hat. Diese Szene ist ebenso eindeutig japanisch wie international und Teil einer größeren Bewegung, die sich nicht länger in irgendeiner Rubrik wie Improvisation, Minimalismus, elektronische Musik oder Komposition einordnen lässt. Die Musiker sind einerseits sehr anpassungsfähig, andererseits beschränken sie ihren Aktivitätsbereich ganz bewusst und umgehen die Verlockungen des 21. Jahrhunderts, in dem alles möglich ist.

Begriffe wie Stärke oder Interaktion werden infrage gestellt, genau wie John Cage in den 50er Jahren die überkommenen Ansichten von Musik, Geräusch und Stille in Frage stellte. Vor allem hinterfragt diese Art von Musik die Relevanz von Definitionen jedweder Art von Audio-Aktivität in Zusammenhang mit einem einzelnen technologischen Ansatz. Die utopischen Träume des 20. Jahrhunderts sind durch die Erfahrung gedämpft worden. Unsere Zukunft als Menschen hängt von einer Beziehung zur Technologie ab, die unsere eigenen Humanität unterstützt.

Solange digital arbeitende Musiker weiter die Rolle, die Software für Charakter und Identität ihres speziellen Klanges spielt, aktiv erforschen, fragt man sich, wie sehr solche Prozesse die Identifikation eines Hörers mit den vielleicht ungewohnten oder unüblichen Details beeinflusst, die der Künstler zu transportieren versucht. Verschreibt sich der Künstler einfach den kompositorischen Erwartungen und dem Stil eines elektronischen Genres, oder bemüht er sich, über trendige musikalische Anachronismen hinauszugehen und eine technologische Transparenz zu suchen, wo die offensichtliche Demonstration der Software in einem tieferen, erfahrungsorientierten Organismus zu „verschwinden" scheint? Traditionellerweise benützt ein großer Teil der modernen elektronischen Musik akustisches oder synthetisches Quellenmaterial und verkleidet es durch transformierende Signalbearbeitung oder nicht-destruktive Schnitttechniken. Wenn einerseits neu entwickelte Programme zur physikalischen Modellierung versuchen, ältere analoge oder instrumentale Klänge exakt zu emulieren, gibt es andererseits bei einigen menschlichen Improvisatoren, die mit analogen Synthesizern, Stimme und Live-Instrumenten arbeiten und die in ihren Werken eine Art digitaler Haltung und digitalen Einflusses vermitteln, eine diesem Trend ebenbürtige Gegenbewegung.

Und genau an diesem Schnittpunkt kreuzt sich das Reich der digitalen Musik mit dem seiner analogen Vorgänger und bringt frische hybride „Audentitäten" hervor, die keineswegs immer mit ihren vermuteten Quellen verbunden sind. Zahlreiche der heuer ausgewählten Werke reflektieren die immer deutlicher werdende Tendenz, diese Grenzen zwischen den ohnehin nur mehr schwach unterschiedenen Audio-Terrains noch weiter zu verwischen.

Die außergewöhnlichen Qualitäten, die wir in Ami Yoshidas Zusammenarbeit mit Sachiko M und Utah Kawasaki fanden, repräsentieren unscheinbare Bereiche der Improvisation, die in den vergangenen Jahren des Prix Ars Electronica nur selten Thema von Einreichungen waren.

astro twin & cosmos waren immer wieder Thema unserer Diskussionen, denn sie sind ein herausragendes Beispiel für dieses jüngere unprätentiösen Musikmilieus. Wir hatten zwar einen Grund, über alle mit ihrer Live-Erforschung verknüpften Intentionen nachzudenken, aber übertrieben ernsthaft fiel dieses Nachdenken nicht aus, da die Musiker selbst von den subtilen Richtungsänderungen ihrer Klänge überrascht zu sein schienen. Amis Stimme – die niemals wirklich singt – klingt wie ein technisches Artefakt von einer gesprungenen CD, wenn sie Utahs analog generierten Ausbrüchen gegenüber gestellt wird, die ihrerseits wiederum heftigst nach „digital" klingen. Sachiko Ms Sinuswellen-Klangbetten beeinflussten Yoshidas Stimmeinlagen hin zu eher insulären stimmlichen Äußerungen – insgesamt also ein sehr personalisierter „Kosmos" aus Texturen und Nuancen.

Als diese beiden Gruppen angespielt wurden, gab es so etwas wie einen Knackpunkt, der den Raum und die Atmosphäre zu verändern und gleichzeitig den Brennpunkt unserer Aufmerksamkeit zu verschieben schien. Und solche Momente blieben in unserem Gedächtnis haften und führten letztlich zu dieser überraschenden Goldenen Nica – und zur Auswahl einiger sehr signifikanter anderer Werke.

Eine der diesjährigen Anerkennungen ist *Foldings*, ein Live-Dokument einer Performance von Mark Wastell, Taku Sugimoto, Tetuzi Akiyama und Toshiimaru Nakumara auf präparierter akustischer Gitarre, Turntable, Kontaktmikro, Verstärker, Druckluftreiniger und einem No-Input-Mischpult. Hier sind die elektronischen Klänge rar, die Momente der Stille hingegen lang. Diese Live-Vorgänge sind so subtil, dass das Aufmerksamkeits- und Spannungsniveau bei Ensemble und Publikum extrem erhöht ist. Diese Hingabe an den Klang als reinen Klang versetzt Musiker wie Hörer in ein neues Hyper-Bewusstsein. Fast verschwunden sind jene überstrapazierten Performance-Techniken vieler Generationen freier Improvisation. Der „neue" Musiker hat nichts, hinter dem er sich verstecken könnte. Es sind der Fleiß und die Sorgfalt, mit denen diese gefühlvollen Umgebungen erarbeitet werden, die die übrigen Kernbestandteile eines jeden mikroklanglichen Ereignisse vorantreiben. Hier handelt es sich um eine Improvisationssprache aus definierten Methoden und Parametern, getränkt mit einer „digitalen" Sensibilität. Solch eine Aufnahme wäre im vor-digitalen Zeitalter unmöglich gewesen. Die hier agierenden Personen haben auf alle Details gelauscht, die in der digitalen Musik möglich sind, und gelangen zu Ergebnissen, die sich stark von der Vinyl-Werktreue früherer Dekaden unterscheiden.

from a cracked CD or something, against Utah's analog generated burstings which seem starkly digital in character. SachikoM's sine wave soundbeds affected Yoshida's vocals towards more insular utterances; a more personalized 'cosmos' of texture and nuance.

There was a premier moment when these two groups came on that changed the room and the atmosphere changed too, along with our focus. It was times like these that lingered in our memories and led to this Golden Nica surprise along with very significant others.

One of this session's honorable mentions is *Foldings*, a live document performed by Mark Wastell, Taku Sugimoto, Tetuzi Akiyama and Toshiimaru Nakumara on prepared acoustic guitar, violoncello, turntable, contact mic, amplifier, air duster and a no-input mixing board. Here the electronics are scarce and the silences are long. So subtle are the live proceedings that the attention-tension level of the ensemble and its audience are extremely elevated. This commitment to sound as *pure sound* places a fresh hyper-awareness onto the players and non-players. Almost vanished are the overstated performance techniques of many generations in free improvisation. The new musician has nowhere to hide. The care and diligence taken in these sensitive surroundings must enhance the spare core ingredients of each microsonic occurrence. It is an improvisational language of defined methods and parameters imbued with a "digital" sensibility. This would have been an impossible recording in the pre-digital era. The people playing here have been listening to the kind of detail you get in digital music and are arriving at results quite different from the vinyl fidelities of former decades.

Both the *astro twin / cosmos* configurations and the *Foldings* group reflect part of a reductionist music community which explores the concentration on this quieter, intimate aesthetic. There are parts in these recordings that remain underdeveloped, half-formed, or very fragile, acknowledging these remarkable smaller scenes reaffirms the Prix Ars Electronica open statement that a project that's quite obscure, less mature or even technically sparse can still obtain a fair chance at our yearly roundtable. This signal to the digital musics community should illustrate the constant challenge of creating new tools and sounds amidst a saturated climate where electronic music and computers are everywhere and nothing quite that special anymore.

A New Ambiguity: Human and Digital

But what can still be special is the long term effect digital music has interfused with other ways of making music. What we are questioning is how the active technology has shaped the music in good or bad ways. And in terms of issues of control, are groups like these moving away from this romantic idea of the composer somehow taking over or controlling every aspect of the listener's response using technology to make a narrative connection? All of these approaches are in a state of flux and becoming very blurred and ambiguous. Our verdicts were mixed.

What about some of the rest?

One of the two distinction winners, Florian Hecker, works on several fronts: Hecker is in a dialogue with (digital) instrument developers and referencing an experimental academic aesthetic without all of the trappings of scholastic brainwashing. He emerges with a very customized purpose for altering software and sounds that don't follow the usual rules. Every track on *Sun Pandämonium* utilizes a different approach to a scientific synthesis that is raw, dense and sometimes even baffling. Even the clarity of intention expressed in his arbitrary formations blazes an intuitive trail through the inner worlds of microsound and its offspring.

Maja Solveig Kjelstrup Ratkje is the other notable distinction award winner whose extended solo vocal treatments form the foundation for her *Voice* CD from Norway, is the other recipient of the notable distinction award. This collaboration with Ratkje and Jazzkammer's John Hegre and co-producer Lasse Marhaug features furiously fucked-up and sample shredded articulations that squall, jabber, babble and bark over time-stretched layers of her clamorous percussive cutups and walls of noise. At first this dynamic downpour both riveted and repelled our startled panel. Repeated listening didn't seem to dispel the controversy either, but for some reason seemed to hold the mutual attention steadfast to the last. Whether these virtuoso implications seem overly dramatic to some or disturbing to others, it's hard to deny the power of her brave, possessed spirit of the tongues.

Another improvisational figure who made the migration from massacred guitar to laptop absorption is Kevin Drumm. His aptly titled *Sheer Hellish Miasma* combines these two approaches into a brutal, swirling chaos of grumbling distortion and swelling, piercing tones. It brought to the

Sowohl die *astro twins / cosmos*-Konfiguration wie auch die *Foldings*-Gruppe reflektieren einen Teil einer reduktionistischen Musik-Community, die die Konzentration auf diese stillere, intimere Ästhetik untersucht. Es gibt Teile in diesen Aufnahmen, die unterentwickelt bleiben und nur halb ausformuliert oder fragil sind, aber mit der Anerkennung dieser bemerkenswerten kleineren Szene bestätigt sich einmal mehr der Anspruch des Prix Ars Electronica, dass auch ein Projekt, welches ziemlich obskur, weniger ausgereift oder sogar technisch sehr sparsam ist, noch immer eine gute Chance bei den jährlichen Jurysitzungen hat. Dieses Signal an die Digital-Musics-Community soll auch zeigen, welche Herausforderung es bedeutet, in einem gesättigten Klima, in dem elektronische Musik und Computer überall präsent und längst nichts Außergewöhnliches mehr sind, noch neue Werkzeuge und Klänge zu schaffen.

Das Außergewöhnliche dabei ist aber unter Umständen der Langzeiteffekt, dass nämlich die digitale Musik mit anderen Arten des Musikschaffens verschmolzen ist. Womit wir uns hier auseinandersetzen, ist die Frage, wie die aktive Technologie die Musik zum Guten oder zum Schlechten geformt hat. Und was die Frage nach der Kontrolle betrifft – bewegen sich Gruppen wie diese weg von der romantischen Idee, dass der Komponist dank des Einsatzes von Technologie zur Gestaltung einer narrativen Verbindung jeden Aspekt der Zuhörerreaktion vorhersehen und steuern kann? All diese Ansätze sind noch im Fluss, sind verschwommen und vieldeutig. Unser Urteil war keineswegs einmütig.

Und was gibt es über einige der anderen Arbeiten zu sagen?

Der Gewinner einer der beiden Auszeichnungen, Florian Hecker, arbeitet an zahlreichen Fronten: Hecker steht in einem Dialog mit Entwicklern digitaler Instrumente und bezieht sich auf eine experimentelle akademische Ästhetik, ohne in die Fallen der scholastischen Gehirnwäsche zu tappen. Er verändert Software und Klänge nach seinen eigenen Bedürfnissen, die nicht den üblichen Regeln folgen. Jeder Track auf *Sun Pandämonium* verwendet einen anderen Ansatz zur wissenschaftlichen Synthese – roh, dicht und manchmal sogar verblüffend. Selbst die Klarheit der Intention, die in seinen arbiträren Formationen zum Ausdruck kommt, bahnt sich einen intuitiven Pfad durch die inneren Welten von Microsound und dessen Nachkommenschaften.

Die Norwegerin Maja Solveig Kljestrup Ratkje ist die andere bemerkenswerte Auszeichnung; ihre ausgedehnten vokalen Bearbeitungen stellen die Grundlage für ihre CD *Voice* dar. Die Zusammenarbeit von Ratkje mit John Hegre von Jazzkammer und dem Koproduzenten Lasse Marhaug umfasst wild durcheinandergewürfelte und als Samples zerschredderte stimmliche Äußerungen,

die über zeitlich gestreckte Ebenen ihrer perkussiven laulststarken Cut-ups und Klangwände dahin babbeln, bellen, quackeln und quietschen. Zunächst hat dieser dynamische Platzregen uns überraschte Juroren gefesselt und gleichzeitig auch abgeschreckt. Auch durch wiederholtes Hören blieb diese Gegensätzlichkeit bestehen, ja, sie fesselte eher die Aufmerksamkeit bis zum Ende. Aber egal ob diese virtuosen Implikationen den einen allzu dramatisch erschienen oder den anderen allzu beunruhigend – es ist schwer, die Kraft des mutigen, geradezu besessenen Geists zu leugnen.

Eine weitere improvisierende Gestalt, die den Übergang von Gitarren-Massakern zur Laptop-Absorption geschafft hat, ist Kevin Drumm. Sein zutreffend *Sheer Hellish Miasma* genanntes Album kombiniert beide Ansätze in ein brutales wirbelndes Chaos knurrender Verzerrungen und anschwellender durchdringender Töne. Es erinnerte die Jury an die Tradition der Metal Machine Music, als ob diese durch einen etwas weniger explizit an den reinen Noise-Sektor gebundenen Filter gelaufen wäre. Drumms Einsatz von Drones in dieser Aufnahme ist trügerisch, spastisch und alles durchdringend und zeigt in Richtung einer persönlichen Signatur in seinem anschwellenden Werkkatalog.

Selbst zwanzig Jahre nach ihrer Gründung ist die britische Gruppe Whitehouse noch immer zu extrem, um eine Mehrheit in dieser Jury zu finden. Die Band hat sich von einem ambivalenten „80s Industrial" zu einem zeitgemäß klingenden digitalen Blast hin entwickelt und konzentriert sich stärker als je zuvor auf ihre Anliegen. Offensichtlich, aber nicht offensichtlich genug, ist Whitehouse eines von wenigen Kollektiven, die explizit politische Fragen mit ihren extremen und kontroversen Anliegen verknüpft. Angesprochen werden Themen von Macht, Medien, Gewalt, Missbrauch und Fetischismus, und Whitehouse löste die heftigsten Debatten unter den Juroren aus. Der voyeuristische Aspekt ihrer Werke erschien den einen von uns bloß als choreografierte Provokation, den anderen wiederum als abstoßende Theatralik. Aber allein die Tatsache, dass die Qualität der Abscheu, des Widerspruches oder der Faszination, die ihre Musik und deren dialektische Botschaft auslöste, in der Jury eine derartige Polarisierung bewirken konnte, war Garant dafür, dass unsere geteilte Meinung letztlich zu einem heiß diskutierten Platz unter den Anerkennungen führte. Die ungebrochen kraftvollen Live-Spektakel und die wilden Soundworks sind ein untrüglicher Beweis für die brutale Kraft dahinter. Mögen die Exzesse weitergehen!

Gert-Jan Prins brachte uns sein *Risk* zu Gehör. Er verwendet absolut nichts als Instrument, was man im Laden kaufen kann. Technisch gesehen, könnte dies ein Nebenprodukt eines eigens entwickelten mechanischen

panel's mind the tradition of *Metal Machine Music*, as though it were run through a filter less explicitly tied to the strictly noise sector. Drumm's use of drones on this recording is treacherous, spastic and severely penetrating, pointing toward a signature position in his surging catalog.

The UK group Whitehouse are still too extreme to find a majority on this jury panel 20 years after their first appearance. They have shifted from the paradigm of being an ambivalent "80s industrial" band towards a contemporary-sounding digital blast. They focus on their issues more precisely than ever. Obvious, but not obvious enough, Whitehouse are one of the few collectives to twist political issues explicitly with their extreme and controversial works. Addressing topics of power, media, violence, abuse or fetish, Whitehouse caused the heaviest debate amongst our committee. The voyeuristic aspect of their work struck some of us as choreographed provocation and others as disgusting theatrics. But the very fact of the panel's polarization over the kind of abhorrence, rejections and fascination their music and message conveys raised the discourse to grant them, with our divided passions, a disputed place in the final honorable mentions. Their unrelenting live spectacles and savage soundworks are an inexorable testament to a brute strength. Let the outrage continue!

Gert-Jan Prins took his *Risk* to our incidental ears. He is using nothing you can buy in a shop as proper instrument. In terms of technology, this could be a by-product of a customized mechanical process that assembles the likes of radio transmitters and other objects for aural projection of frequency interference onto crowds, and eventually, Pro Tools. This is sharp. There's a snap to it. It's really differentiated and shaped. It pulses madly and is very raw. This isn't music as we generally know it, but it does utilize a technical structure that can be perceived as a nonlinear musical sound experience. Jump, cut and crazy whir. Are we judging artists, techniques, objects or pieces? In this unusual case of a person manipulating small analog machines on a table, we find him guilty of all charges! Are we reacting to names or what we hear? Well, this wasn't just another electro-acoustic "squeaky toy" narrative – this was skilled in a blunt, rugged manner – these are fresh ways of connecting devices together – just who is this guy anyway? And what is this about? It's not trying to put the listener into some special state that is supposed to tell you something. It's a direct impetus.

The sound work of Toshiya Tsunoda represents a radical rethinking of the concept of field recordings. With the meticulously scientific approach of a cataloguist, Tsunoda captures the depth of the landscape, the vital breathing of things. Each one of his works is similarly noted for the compositional structure that he discovers to be inherent in the sounds of found objects. The results are surprisingly beautiful electronic works that bear little resemblance to what we would normally consider evironmental recording. Tsunoda bases his methodology on electrically vibrating, found objects by attaching sensors to them that transmit weak electrical currents, which render them audible. Tsunoda then records the results, which are typically recorded out of doors, near bodies of water. Among the objects Tsunoda has used for the sources of his recordings are the motion of air inside a glass bottle, cracks in manhole covers, and the movement of air across—or in certain instances inside of—solid surfaces at specific site locations such as seaports and storage facilities.

Nymphomatriarch just happened to be made from the physical alchemy of framing the sex sounds of partners Rachael Kozak (Hecate) and Aaron Funk (Venetian Snares). Freakish sets of moans, grunts and skin strikes were molded into choirs, drumbeats and other timbral constructions. Although the jury noted this sexual morphology, it did not get hung up in the intrigue. What jumped out from this personal investigation was the style and punch of the music itself regardless of the provocative sources. It stood on its own as a haunting, harrowing work dealing with breakcore dynamics and visceral mood treatments that had nothing to do with porno music, but everything to do with the organic musical expression of animalistic instincts.

Oren Ambarchi treats the guitar as a sound generator. His interpretation of the instrument sounds not unlike a Fender Rhodes at times, creating echo and reverb-drenched melodies that seem to suspend themselves, creating slowly turning narratives and repeating patterns that at times resemble locked vinyl grooves in whose repetition abstract patterns rise and fall. Switch clicks and cracks, string scrapes, cable noise and feedback rumble have a certain musicality to them, which Ambarchi captures and uses to compose with. The results are simply stunning, unique and at times sound like Ambarchi is playing a totally undiscovered instrument. To quote Ambarchi, his guitar technique *simply* involves

Prozesses sein, der Radiosender und andere Objekte versammelt, um aurale Projektionen von Frequenz-Interferenzen auf Publikumsmassen (und irgendwann auch auf ProTools) loszulassen. Das ist scharf. Das hat schon was. Es ist wirklich differenziert und geformt. Es pulsiert wie wild und ist sehr roh. Nein, das ist keine Musik, wie wir sie normalerweise kennen, aber es verwendet eine technische Struktur, die man als nicht-lineare Klangerfahrung wahrnehmen kann. Jump Cuts und wildes Drehen. Beurteilen wir Künstler, Techniken, Objekte oder Stücke? In diesem besonderen Fall einer Einzelperson mit kleinen analogen Geräten auf einem Tisch müssen wir den Angeklagten in allen Punkten schuldig sprechen! Reagieren wir auf Namen oder auf das, was wir hören? Nun, dies war nicht einfach eine weitere elektroakustische „Quietsche-Spielzeug"-Narration, dies war auf eine grobe, massive Weise sehr geschickt – das zeigt eine frische Art, Geräte zusammen-zufügen, und überhaupt, wer ist der Kerl eigentlich? Und worum geht es? Es versucht nicht, den Hörer in irgendeinen besonderen Zustand zu versetzen, der ihm dann irgendwas erzählen soll. Hier haben wir den direkten Ansturm.

Die Klangarbeit von Toshiya Tsunoda stellt eine radikale Neuinterpretation des Konzepts von Vor-Ort-Aufnahmen dar. Mit dem peinlich genauen wissenschaftlichen Ansatz eines Sammlers fängt Tsunoda die Tiefe der Landschaft, den lebensspendenden Atem der Dinge ein. Jedes seiner Werke ist allein schon wegen der kompositorische Struktur bemerkenswert, die, wie er beweist, den Klän-gen gefundener Objekte inhärent ist. Das Ergebnis sind erstaunlich schöne elektronische Werke, die nur wenig Ähnlichkeit mit dem aufweisen, was wir normaler-weise unter „Umweltaufnahmen" verstehen. Tsunoda basiert seine Methodologie auf elektrisch vibrierende Objets Trouvés, an denen er Sensoren anbringt, die schwache elektrische Ströme transportieren, was sie letztlich hörbar macht. Die Ergebnisse zeichnet Tsunoda typischerweise im Freien und in der Nähe von Wasser auf. Zu den Objekten, die Tsunoda als Aufnahmequellen verwendet, gehören die Luft innerhalb einer Glasflasche ebenso wie die Risse in Kanaldeckeln oder die Luftbe-wegungen oberhalb – oder in besonderen Fällen inner-halb – von festen Oberflächen an speziellen Orten wie Häfen oder Lagereinrichtungen.

Nymphomatriarch war aus der physikalischen Alchimie des Einfangens der Sexgeräusche der Partner Rachael Kozak (Hecate) und Aaron Funk (Venetian Snares) gemacht. Ein freakiges Set aus Stöhnen, Grunzen und Schlägen auf die Haut wurde in Chöre, Drumbeats und andre timbrale Konstruktionen geformt. Auch wenn die Jury diese sexuelle Morphologie bemerkte, maß sie ihr doch kaum Bedeutung zu. Was aus dieser sehr persön-lichen Untersuchung jedoch herausragte, waren der

Stil und der Punch der Musik selbst – unabhängig von ihren provokativen Quellen. Sie stand eigenständig vor uns, als ein beklemmendes Werk, das sich mit markerschütternder Dynamik und einer aus dem Bauch her behandelten Stimmung beschäftigte und nichts mit Pornomusik zu tun hatte, aber alles mit dem organischen musikalischen Ausdruck animalischer Instinkte.

Oren Ambarchi behandelt die Gitarre als Sound-Generator. Seine Interpretation des Instruments klingt nicht unähnlich einem Fender Rhodes von früher, wenn er in Echo und Hall ertrinkende Melodien schafft, die sich selbst aufzuhängen scheinen, dazu langsam drehende Narrative und sich wiederholende Muster, die bisweilen klingen wie hängengebliebene Vinylscheiben, innerhalb deren Wiederholungen abstrakte Muster aufsteigen und fallen. Schaltklicks und Knacken, Saitenquietschen, Kabelgeräusche und Rückkopplungsbrummen haben auch ihre eigene Musikalität, die Ambarchi einfängt und zum Komponieren verwendet. Das Ergebnis ist schlichtweg atemberaubend, einzigartig, und bisweilen meint man, Ambarchi spiele ein bislang unentdeckt gebliebenes Instrument. Um mit Ambarchi selbst zu sprechen – seine Gitarrentechnik besteht *nur* darin, das „Instrument in eine Zone fremder Abstraktion umzuleiten, in der es nicht mehr so leicht als das identifiziert werden kann, was es ist, sondern ein Laboratorium für eine erweiterte klangliche Untersuchung darstellt".

Die Gruppe Rechenzentrum verarbeitet Klangdesign, Musik und Videobilder in raue, emotional komplexe Melodramen, in denen sich die Ereignisse zu sich ständig verschiebenden Konflikten verbinden. Klänge und Rhythmen werden zu Darstellern, schaffen kaum lösbare Spannungen, rufen Szenen unterdrückter Bedrohlichkeit hervor. In dem, was ihr interdisziplinäres Werk einfängt, liegt etwas inhärent Lebendiges, das über die Unterscheidbarkeit ihrer ästhetischen Hybris hinausgeht. Verstimmte Saiten, Dance-Floor-Dumb, minimaler Techno, Hip-Hop und post-industrielle Klangcollagen verbinden sich mit einer Bildwelt aus Text, Autobahnen, Maschinen und Instrumentalensembles und schaffen wunderbar dunkle kinematische Allegorien, die uns dazu zwingen, ästhetische Erfahrungen durch die narrativen Art und Weise zu rekonstruieren, in der die Gruppe ihr aurales und visueller Grundmaterial verarbeitet. Der systematische Überfluss gesteuerter Bedeutungen, wie sie die Produktionen von Rechenzentrum kommunizieren, verweist auf seltsame Methoden der Kunstproduktion, die viele jener ästhetischen Möglichkeiten realisieren, die uns von der AV-Produktions- und Multimedia-Theorie seit den späten 1960ern versprochen wurde.

Im Sektor der Liederschreiber fiel uns die Persönlichkeit von Tujiko Moriko auf, deren *Hard ni sasete*-Projekt

"re-routing the instrument into a zone of alien abstraction where it's no longer easily identifiable as itself. Instead, it's a laboratory for extended sonic investigation."

Rechenzentrum engineer sound design, music and video images into bleak, emotionally complex melodramas where the events are joined in constantly shifting conflict. Sounds and rhythms become protagonists, creating barely resolved tensions, evoking scenes of subdued menace. There's something inherently alive in what their interdisciplinary work captures that transcends the distinction of their aesthetic hybridity. De-tuned strings, dance floor dub, minimal techno, hip-hop and post-industrial sonic collages combine with the imagery of text, freeways, machines and instrumental ensembles to create beautifully dark cinematic allegories which force us to reconstruct aesthetic experience through the narrative manner in which the group processes its aural and visual source material. The systematic surplus of controlled meanings communicated by Rechenzentrum's productions points to odd manners of making art that fulfills many of the aesthetic possibilities promised by AV production and multimedia theory since the late 1960s.

From the songwriting sector we came across the personality of Tujiko Noriko whose *Make Me Hard* project focused on experimental orchestrations with bits of harmonies, noise, and beats. The challenge of forming something interesting out of this quirky blend of fairly straightforward elements seemed to be met as something different from much of the purely abstract works that the jury predominantly listens to. By applying her voice in so many ways, Noriko achieves a blurry romanticism occasionally disturbed by dissonance and intervention of unlikely arrangements. Whether one builds a relationship to the songs as people might with pop frameworks seems less important here. The overall atmosphere was compelling enough.

No one has taken the Viennese Aktionist tradition as a musical blueprint further than Rudolf Eb.er and the Swiss Schimpfluch ("abuse") artists who started in 1987. Particularly when you consider the themes of Eb.er's work: domestic violence, the re-enactment of foundational experiences of trauma, and purposeful regressions to experiences of sheer pain. In his other identity as Runzelstirn & Gurgelstock, Eb.er performs concerts that seek violent resistance from audience members by combining improvised immediacy, extreme

taboo-breaking behavior and self-conscious theatrics. Audio documents of these events are marked by jarring voice punctuations, gasped breathing and extended tense silences. In terms of his compositional work, Eb.er's editing technique is unique in its deeply precise dissection of his recordings. Using traditional analogue methods of editing—reel to reel tape with scissors and scalpels—the collages which Eb.er creates using this material are compared by him to biologically dividing and growing his own sounds. Given the visceral nature of his recorded output, and the extremely physical nature of his performances, the notion of growing musical cells, in Eb.er's case, is entirely appropriate.

Conceptually, the idea of Phill Niblock's piece, *The Movement of People Working*, struck a chord with our panel. This longstanding composer and filmmaker records the instruments from many musicians and assembles them into drone-like sound paintings which accompany his visual odyssey. The images on the DVD depict workers from various global locales going about their daily repetitive tasks supported by a broad continuum of slowly evolving musical layers. A no-compromise aesthetic effect seems to permeate and resonate with many audiences who attend his ongoing live presentations.

Yuko Nexus 6 Kitamura composes works that remind us of a sound diary. Beginning her interest in music by recording over her father's Bach and Beethoven cassettes as a child, Kitamura now begins piecing together her work by exchanging cassettes with friends, each of whom records over the same cassette using source material recorded from diverse locations such as the street. Kitamura calls the music which emerges

einen Schwerpunkt auf experimentelle Orchestrierung mit Elementen aus Harmonien, Noise und Beats legte. Die Herausforderung, die darin liegt, aus dieser doch eher seltsamen Mischung an sich recht einfacher Elemente etwas Interessantes zu machen, wurde positiv bewältigt: Es entstand etwas anderes als die rein abstrakten Werke, die die Jury zumeist zu hören bekommt. Durch den Einsatz ihrer Stimme auf so vielfältige und unterschiedliche Weise erzielt Noriko eine verschwommen romantisch gefärbte Stimmung, die gelegentlich von Dissonanzen und der Intervention ungewöhnlicher Arrangements unterbrochen wird. Ob man nun eine Beziehung zu den Songs aufbauen kann, wie das vielen Leuten im Rahmen der Popmusik gelingt, ist nebensächlich – die Gesamt-atmosphäre war fesselnd genug.

Niemand hat die Tradition des Wiener Aktionismus als Vorlage für musikalische Werke weiter entwickelt als Rudolf Eb.er und die Schweizer Schimpfluch-Künstler, die 1987 damit begannen. Die Themen von Eb.ers Werken sprechen für sich: Gewalt in der Familie, das Wiedererleben grundlegender traumatischer Erfahrungen, die bewusste Rückkehr zu nackten Schmerzerfahrungen. In seiner anderen Identität als Runzelstirn & Gurgel-stock führt Eb.er Konzerte auf, die den gewaltsamen Widerstand des Publikums geradezu herausfordern, indem sie improvisierte Unmittelbarkeit, extrem tabu-brechendes Verhalten und selbstbewusste Theatralik einsetzen. Audiodokumente dieser Events zeichnen sich durch kreischende Stimmakzente, stoßweise Atmung und ausgedehnte gespannte Stille aus. In kompositorischer Hinsicht ist Eb.ers Schnitttechnik durch ihre präzise Sezierung seiner Aufnahmen einzigartig. Durch traditio-nelle analoge Schnittmethoden – Tonbandschnitt mit Schere und Skalpell – entstehen Collagen aus diesem Material, die Eb.er gerne mit der biologischen Teilung und Zucht seiner Klänge vergleicht. Angesichts der eher bauch-orientierten Natur seines Outputs und der extrem körperbetonten Art seiner Performances ist in

Eb.ers Fall der Begriff des Heranzüchtens musikalischer Zellen durchaus angebracht.

Konzeptuell hat der Gedanke hinter Phill Niblocks Stück *The Movement of People Working* bei den Juroren sofort Widerhall gefunden. Dieser langgediente Komponist und Filmemacher nimmt die Instrumente vieler Musiker auf und assembliert sie in Drone-ähnliche Klanggemälde, die seine visuelle Odyssee begleiten. Die Bilder auf der DVD zeigen arbeitende Menschen von verschiedenen Orten des Globus, wie sie ihrer täglichen repetitiven Tätigkeit nachgehen, begleitet von einem breiten Kontinuum sich langsam entfaltender musikalischer Ebenen. Ein kompromissloser ästhetischer Effekt, der auch die vielen Publikumsgruppen anspricht, die seine häufigen Live-Präsentationen besuchen, und bei ihnen Anklang findet.

Die Kompositionen von Yuko Nexus 6 Kitamura erinnern uns an ein Klangtagebuch. Als Kind hatte sie ihr musikalisches Interesse dadurch gezeigt, dass sie über die Bach- und Beethoven-Kassetten ihres Vaters aufgenommen hat; jetzt beginnt Kitamura, ihr Werk zusammenzusammeln, indem sie Kassetten mit Freunden austauscht, von denen jeder über das vorherige Material aufnimmt, und zwar Quellenmaterial, das an diversen Orten, z. B. auf der Straße, aufgenommen wird. Kitamura nennt die bei diesem Prozess entstehende Musik „Kotatsu"-Musik: nach einem kleinen japanischen Tisch mit darunter eingebautem Heizgerät, um den sich japanische Familien im Winter versammeln. Die ausdrücklich soziologische Bedeutung ist in Kitamuras Projekt der musikalischen ebenbürtig: Durch diese in Kollaboration entstehenden Aufnahmen auf den immer wieder überkopierten Kassetten will sie die Aufmerksamkeit auf die Beziehung der Musik zur Lebensweise der Menschen und auf die gemeinschaftsbildende Funktion lenken, die aufgezeichnete Musik für diese hat, wenn sie über die Zeit hinweg unter ihnen ausgetauscht wird.

from this process "Kotatsu" music, named after a little Japanese table with a heater underneath it, which Japanese families like to sit next to in the winter in order to stay warm. Kitamura's project has a particularly sociological significance as much as it has a musical one: through these collaborative recordings using the same recorded-over cassettes, her point is to recall music's relationship to the way that people live, and the communal function pre-recorded music has for them as they exchange it with one another over time.

A New Ambiguity: Human and Digital

astro twin / cosmos
Ami Yoshida, Sachiko M, Utah Kawasaki

astro twin

Boring sounds / unevolving sounds / unproductive sounds / lazy Sounds / garbage-like sounds ...

These infinitely divided sounds are scattered everywhere. Each sound is junk but some sounds may be important. They are for you to seek. We want you to find them. That is astro twin's request.

"astro twin" is the duo of Ami Yoshida and Utah Kawasaki. It was started around 1996. Yoshida gave the duo its name, taken from the manga of the same name by Keiko Takemiya. It comes from the astrological term for beings born on the same day although these two have different birthdays. Their sign, however, is the same – Taurus.

Disc 1 – astro twin 1. recorded at Uplink Factory, Tokyo Japan (Mar. 17, 2001). 2. recorded at Spitz, UK (Mar. 27, 2002)

cosmos

Sachiko M: sinewaves, contact microphone on objects. Ami Yoshida: voice

cosmos has no concept.
cosmos has no discussion.
cosmos accepts all sounds. Then it ignores them.

Sounds that are released in an instant from lull-like stagnation. Sometimes overlapping, sometimes turning away from each other, the sounds are of limitless beauty and strength.
cosmos is invincible.

"cosmos" is the duo of Sachiko M and Ami Yoshida. It was formed in 1997, in an extremely natural fashion. The only thing set down at the beginning was the name cosmos, provided by Ami. Although the unit has given only one or two concerts a year since its formation, it has, through its unique feeling of space and its overwhelming presence, gained an enthusiastic following which continues to grow.

astro twin

Langweilige Klänge / entwicklungslose Klänge / unproduktive Klänge / faule Klänge / abfallähnliche Klänge …

Diese unendlich aufgeteilten Klänge sind überall verstreut. Jeder Klang ist Mist, aber einige davon könnten wichtig sein. Und diese muss man suchen. Wir wollen, dass du sie findest – das ist der Wunsch von astro twin.

„astro twin" ist das Duo aus Ami Yoshida und Utah Kawasaki und wurde um 1996 gegründet. Yoshida gab dem Duo den Namen, der vom gleichnamigen Manga von Keiko Takemiya stammt und sich auf den astrologischen Begriff für Lebewesen bezieht, die trotz unterschiedlicher Geburtstage unter der gleichen astrologischen Konstellation geboren wurden – in diesem Fall im Zeichen des Stiers.

Disc 1 – astro twin 1. aufgenommen bei Uplink Factory, Tokio (17. März 2001); 2. aufgenommen bei Spitz, GB (27. März 2002).

cosmos

Sachiko M: Sinewaves, Kontaktmikriphone auf Objekten. Ami Yoshida: Stimme

cosmos hat kein Konzept.
cosmos enthält keine Diskussion.
cosmos akzeptiert alle Klänge. Dann ignoriert es sie.

Klänge, die als Moment einer einlullenden Stagnation entspringen. Manchmal überlappend, manchmal sich voneinander entfernend, sind diese Klänge von grenzenloser Schönheit und Stärke.
cosmos ist unbesiegbar.

„cosmos" ist ein Duo aus Sachiko M und Ami Yoshida, das auf sehr natürliche Weise 1997 entstand. Festgelegt war anfänglich einzig der Name – cosmos –, beigesteuert von Ami. Wenn auch die Formation seit ihrer Gründung nur ein bis zwei Konzerte im Jahr gegeben hat, so hat sie doch wegen ihres einzigartigen Raumgefühls und ihrer überwältigenden Präsenz eine ständig wachsende enthusiastische Anhängerschaft gewonnen.

2002 erschienen das erste und zweite Album: *Tears* (Erstwhile) und *astro twin / cosmos* (F.M.N. Sound Factory).

In 2002 astro twin / cosmos releases its first and second albums: *Tears* (Erstwhile), and *astro twin / cosmos* (F.M.N. Sound Factory).

Disc 2 – cosmos. Aufgenommen bei Spitz, GB (27. März 2002)

Disc 2—cosmos recorded at Spitz, UK (Mar. 27, 2002)

Ami Yoshida (J), born 1976. Originator of the "howling voice," strives for a barely audible sound that is perceived as sound itself rather than as vocalization. In May 1997 Yoshida released the solo CD *Spiritual Voice*, and since then has been active in wide-ranging projects including albums by Otomo Yoshihide. **Sachiko M (J)** performed from 1994 to 1997 as a member of Ground Zero (which disbanded in March 1998) at festivals and concerts around the world. She played an important role in the group's chopped-up, "plunderphonic" (or "plagiaristic" sampling) sound. From 1997, Sachiko M has pursued a unique performance style which brings to the forefront the sampler's own test tones and noise, to develop nearly memory-free sampling works. Her solos consisting entirely of sine waves have attracted a great deal of attention. Sound, rather than the instrument, is paramount for Sachiko. She is also involved in such electronic improvisation projects as the trio I.S.O., with Yoshimitsu Ichiraku and Otomo Yoshihide; another duo with Toshimaru Nakamura (no-input mixing board) on the CD entitled *UN* and the powerful post-sampling project *Filament* with Otomo Yoshihide. **Utah Kawasaki (J)**, born in Tokyo in 1976. Inspired by his visits to the Paris Peking record shop, Utah Kawasaki began producing music in 1994, and between 1994 and 1995 released so many titles on tape that he himself lost count. In 1996 he released a solo CD on Zero Gravity, a sub-label of Transonic Records. Since then he has contributed to a number of compilation CDs. Kawasaki toured Europe in October 2000 with the group Mongoose, which he formed with Taku Sugimoto and Tetuzi Akiyama. He also put out a seven-inch single record on the faux-Mexican label Dolor del Estomago. Current and past projects include a solo CD which came out in 2002 on Radio, a sub-label of Shiranui. He is also involved in a project (unnamed) with Tetsuro Yasunaga. He plans to change his name to Uro Kawasaki.

Ami Yoshida (J), geb. 1976, Erfinderin der „Howling Voice", bemüht sich um einen kaum hörbaren Klang, der eher als reiner Klang denn als Stimme wahrgenommen wird. Im Mai 1997 brachte sie die Solo-CD *Spiritual Voice* heraus, seither ist sie an zahlreichen Projekten unterschiedlichster Art beteiligt, darunter auch Albums von Otomo Yoshihide. **Sachiko M (J)** spielte 1994–97 mit der im März 1998 aufgelösten Gruppe Ground Zero bei Festivals und Konzerten auf der ganzen Welt. Ihr kam eine bedeutende Rolle in der zerhackten „Plünderophonie" (dem plagiatorischen Sampling-Sound) der Gruppe zu. Ab 1997 entwickelte Sachiko M einen einzigartigen Performancestil, der die eigenen Testtöne und Geräusche des Samplers in den Vordergrund stellt, und machte daraus nahezu Memory-freie Sampling-Werke. Ihre ausschließlich mit Sinusschwingungen operierenden Solos haben eine Menge Aufmerksamkeit erregt. Für Sachiko ist der Klang viel wichtiger als das Instrument. Sie ist auch an elektronischen Improvisationsprojekten wie dem Trio I.S.O gemeinsam mit Yoshimitsu Ichiraku und Otomo Yoshihide beteiligt, einem weiteren Duo mit Toshimaru Nakamura (No-Input-Mischpult) auf der CD namens *UN* und dem kraftvollen Post-Sampling-Projekt Filament gemeinsam mit Otomo Yoshihide. **Utah Kawasaki (J)**, geb. 1976, begann 1994 – inspiriert von seinen Besuchen im Paris-Peking-Plattenladen – Musik zu machen und brachte zwischen 1994 und 1995 so viele Titel auf Band heraus, dass er selbst den Überblick verloren hat. 1996 spielte er eine Solo-CD auf Zero Gravity ein. Seither hat er zu zahlreichen Kompilationsaufnahmen beigetragen. Im Oktober 2000 war er mit der Gruppe Mongoose, die er gemeinsam mit Taku Sugimoto und Tetuzi Akiyama gegründet hat, auf Europatournee. Weiters hat er auch eine Sieben-Zoll-Single beim Label Dolor del Estomagao herausgebracht. Zu den jüngsten und laufenden Projekten gehören eine Solo-CD (2002 bei Radio, einem Sublabel von Shiranui, erschienen) und die Einbindung in ein (noch unbenanntes) Projekt mit Tetsuro Yasunaga. Er hat vor, seinen Namen auf Uro Kawasaki zu ändern.

Sun Pandämonium
Florian Hecker

Sun Pandämonium ist das dritte große Release von Florian Hecker. In einer Wegbewegung vom harschen digitalen Buzz and Wash der ersten beiden Full-length-Computermusikalben Heckers überrascht *Sun Pandämonium* den Hörer in mehrfacher Hinsicht mit einer Bandbreite feuriger, dynamischer elektronischer Szenarios. Diese CD ist kurz gesagt eine der feinsten Computer-Audio-Exkursionen, die in den letzten Jahren auf den Markt gekommen ist. Ein Rezensent merkte an: „Diese Aufnahme ist elektronische Musik als Psilocybin-Forschung." Das amerikanische Online-Journal *Pitchforkmedia* formulierte es so: „Laut und überwältigend bei egal welcher Lautstärkeneinstellung", enthält *Sun Pandämonium* „nicht nur die Klänge und Frequenzen von Diamanten, die gerade geschliffen werden, sondern verwendet sie, um unmittelbar die Linsen Ihres optischen Abspielgeräts zu gravieren. Egal, ob man ihn einen abgefuckten Kranken nennen will, ein Genie oder den Antichrist persönlich – dies reinigt jedenfalls den Gaumen des Hörgenießers, während es einem die Zähne herausknallt."

Sun Pandämonium is the third full-length release from Florian Hecker. Moving away from the harsh digital buzz and wash of his previous two full-length computer music albums, *Sun Pandämonium* strikes the listener from many angles with a diverse range of fiercely dynamic electronic scenarios. This CD is quite simply some of the finest computer audio excursions unleashed in recent years. As one reviewer stated, "This record is electronic music as psilocybin science." Or, as the American online journal *Pitchforkmedia* states: "Loud and overwhelming at any volume setting," *Sun Pandämonium* contains "the sounds and frequencies not only of diamonds being sharpened, but then being used to etch directly on the lenses of your optical readers. Call him a sick fuck, a genius, or even Mister Antichrist, but this will cleanse the audio palate as it blows your teeth out."

Florian Hecker (A) first started making music with computers in 1996. Ever since then he has spent a great deal of time doing research on mobile performance tools and the use of laptop computers, especially since the first wave of Mego-related concerts in 1996. Involved in various sonic projects, and recording for labels like Mego and Or, Hecker's current activities also include audio publishing in formats such as .ogg and .mp3 via the FALS.CH Internet project. Hecker is also a frequent live and studio collaborator with the likes of Farmersmanual, Russell Haswell, Yasunao Tone, Zbigniew Karkowski, Shunichiro Okada, Marcus Schmickler, Voice Crack and Merzbow. **Florian Hecker (A)** begann 1996 Musik mit Computern zu machen. Seither hat er einen Gutteil seiner Zeit damit verbracht, mobile Performance-Werkzeuge und den Einsatz des Laptops zu erforschen, besonders seit der ersten Welle von Konzerten im Zusammenhang mit Mego 1996. Zu den Aktivitäten Heckers, der an zahlreichen Klangprojekten beteiligt ist und bei Labels wie Mego und Or herauskommt, zählen auch Audio-Publikationen in Formaten wie .ogg und mp3 über das Internetprojekt FALS.CH. Hecker ist auch häufiger Live- und Studiomitarbeiter bei Farmersmanual, Russell Haswell, Yasunao Tone, Zbigniew Karkowski, Shunichiro Okada, Marcus Schmickler, Voice Crack, Merzbow und anderen.

Voice
Maja Solveig Kjelstrup Ratkje

Experimental singer Maja Ratkje released her first solo album a few months after the second CD by her main group, SPUNK. The album is co-produced by Ratkje and Jazzkammer's John Hegre and Lasse Marhaug, although the term "co-produced" remains a bit vague and the collaboration most likely runs a little deeper. The 11 pieces on the CD use only Ratkje's voice as a sound source, but they cover a wide spectrum of textures and dynamics, from echo-drenched *a cappella* singing (at the beginning of "Vacuum") to torturing noise assaults ("Insomnia"), going through a number of sample- and processed file-based constructions in between. Ratkje is messing with listeners' minds as she toys with sharp contrasts of quiet / loud, soft / harsh, and seductive / painful. Ratkje knows she has a beautiful, flexible voice that can both charm and puzzle and she purposefully deceives the listener.

Die experimentelle Sängerin Maja Ratkje hat ihr erstes Soloalbum nur wenige Monate nach der zweiten CD ihrer Hauptgruppe SPUNK herausgebracht. Das Album ist eine Koproduktion von Ratkje mit John Gegre und Lasse Marhaug von Jazzkammer, auch wenn der Begriff „Koproduktion" etwas vage ist und die Zusammenarbeit durchaus etwas tiefer gehen könnte. Die elf Stücke verwenden ausschließlich Ratkjes Stimme als Klangquelle, aber sie decken ein breites Spektrum von Texturen und Dynamik ab, von einem in Echos ertrinkenden A-Capella-Gesang (am Anfang von *Vacuum*) bis hin zu quälenden Klangattacken (*Insomnia*) und etlichen auf Sampling und Dateibearbeitung basierenden Konstruktionen dazwischen. Raktje treibt Schabernack mit dem Geist der Zuhörer, wenn sie mit scharfen Kontrasten zwischen Leise/Laut, Weich/Brüchig und Verführerisch/Peinigend spielt. Sie weiß, dass sie eine schöne, flexible Stimme hat, die bezaubernd und rätselhaft sein kann, und sie täuscht damit den Hörer ganz bewusst.

Trio beginnt sanft mit überlagerten, brummenden Texturen und einem aus der Stimme hergeleiteten Beat, um dann in ein wildes verzerrtes Kreischen auszubrechen. *Vacuum* ist das Opus Magnum der Scheibe, eine fesselnde zwölfminütige Komposition, die den Hörer in ihren Bann zieht und mit ihrer Stimme vertraut macht. *Dictaphone Jam* macht das Beste aus der beschränkten Klangqualität des Aufnahmegeräts. Das abschließende *Insomnia* ist wohl das seltsamste Stück: Nach einem Ausbruch von Multi-Track-Schreien, unterbrochen von Gelächter, hängt das Stück noch drei Nachspiele an, jedes ruhiger als das vorhergehende, fast wie kurze Träume.

Scharfkantiger als die meisten Leute es erwartet hätten und Jazzkammer näher als Spunk, versteckt *Voice* Ratkjes beeindruckende vokale Meisterschaft unter einer Mauer aus Elektronik. Sobald der anfängliche Schock verflogen ist, muss man allerdings zugeben, dass es eine gute Idee war. Empfehlenswert, aber nichts für furchtsame Gemüter.

(François Couture)

Trio starts softly with overlaid, droning textures and a voice-derived beat, only to burst into mad, distorted screaming. *Vacuum* is the magnum opus of the disc, a captivating 12-minute composition that takes listeners up close and personal with her voice. *Dictaphone Jam* makes the best out of the low fidelity of the recording device. The closing "Insomnia" is the strangest track: after an outburst of multi-tracked screams interrupted by laughter, the piece adds three postludes, each quieter than the previous one, like short dreams.

Harsher than what most people were expecting and closer to Jazzkammer than Spunk, *Voice* hides Ratkje's impressive vocal prowess under a wall of electronics. After the initial shock wears off, one can only admit that it was a good idea. Recommended, but definitely not for the faint of heart.

(François Couture)

Maja Solveig Kjelstrup Ratkje (N), born 1973, is a performer, improvisor and composer. Her music is released on rune grammofon, ECM, Grappa and Albedo among other labels. Ratkje was the first composer to receive the Norwegian Arne Nordheim Prize in 2001. She has studied composition at the Norwegian State Academy of Music and holds a position in composition at the Norwegian University of Science and Technology (NTNU). As a performer Maja Solveig Kjelstrup Ratkje mainly works with her voice and various electronics and is regularly heard in connection with the girls in the improv/noise collective including SPUNK and Fe-mail with whom she shares a studio in Oslo. Her home page may be visited at *www.kunst.no/majar*. **Maja Solveig Kjelstrup Ratkje (N)**, geb. 1973, ist Performerin, Improvisatorin und Komponistin. Ihre Musik ist unter anderem bei rune grammofon, ECM, Grappa und Albedo erschienen. Ratkje ist die erste Komponistin, die 2001 den norwegischen Arne-Nordheim-Preis erhielt. Sie hat Komposition an der staatlichen norwegischen Musikakademie studiert und hat eine Stelle für Komposition an der norwegischen Universität für Wissenschaft und Technik NTNU inne. Als Performerin arbeitet Maja Solveig Kjelstrup Ratkje vorwiegend mit ihrer Stimme und mit Elektronik und ist regelmäßig im Zusammenhang mit den Mädchen des Improv/Noise-Kollektivs zu hören, darunter mit SPUNK und Fe-mail, mit denen sie ein Studio in Oslo teilt. Ihre Homepage ist unter *www.kunst.no/majar* zu finden.

Triste
Oren Ambarchi

The germination of themes explored in Ambarchi's VPRO radio appearance and subsequent Mort Aux Vaches *Song Of Separation* recording, take root and flourish in this live performance recorded in Nijmegen on June 14, 2001, using one guitar and a handful of guitar effect pedals.

Recorded recently after losing his father, *Triste* is Ambarchi's meditation on growth, decay and regeneration.

The first side begins with small tones emerging from silence. Here Ambarchi employs a kind of tonal pointillism to explore the relativity of various frequencies cocooned between silences. These disembodied notes are incrementally layered, taking on new value and meaning as they beat and resonate in sympathy with each other, culminating in glorious harmonic clusters.

As the second side begins these tones coalesce into one note, shimmering with harmonic resonance. Stasis then erupts into cataclysmic, chaotic entropy. The cycle of formation and disintegration resumes when the record is turned over, to begin again.

Die Themen, die bereits bei Oren Ambarchis Auftritt bei VPRO Radio und anschließend in der „Mort Aux Vaches"-Aufnahme *Song of Separation* anklangen, finden ihre volle Entfaltung in der Live-Performance mit Gitarre und einigen Gitarren-Effektpedalen, die am 14. Juni 2001 in Nijmegen aufgezeichnet wurde. Dieser Mitschnitt war kurz nach dem Tod von Ambarchis Vater erfolgt, und *Triste* ist Ambarchis meditative Aufarbeitung von Themen wie Wachstum, Verfall und Regeneration.

Die erste Seite beginnt mit kleinen Tönen, die aus der Stille auftauchen. Ambarchi bedient sich eines fast pointillistischen Ansatzes, um die Relativität der unterschiedlichen, zwischen Stillephasen gleichsam eingesponnenen Frequenzen zu erforschen. Diese körperlosen Noten werden Schritt für Schritt übereinander gelegt und erlangen neue Werte und Bedeutungen, indem sie in Resonanz zueinander widerhallen, um schließlich in strahlenden harmonischen Clustern ihren Höhepunkt zu finden.

Wenn die zweite Seite beginnt, fügen sich diese Töne in eine Note zusammen, die von Obertonresonanzen gleichsam schimmert. Aus dieser Stasis bricht eine kataklysmische, chaotische Entropie hervor. Der Zyklus von Formation und Desintegration wird wieder aufgenommen, wenn die Platte umgedreht und zum Anfang zurückgegangen wird.

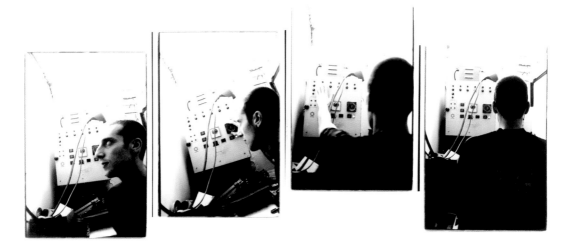

Oren Ambarchi (AUS), born 1969, is an electronic guitarist and percussionist with longstanding interests in transcending conventional instrumental approaches. He has been performing live since 1986 and is also co-organiser of the "What Is Music?" Festival, Australia's premier annual showcase of local and international experimental music. **Oren Ambarchi (AUS)**, geb. 1969, ist ein Elektro-Gitarrist und Perkussionist, der schon seit langem daran interessiert ist, die konventionellen instrumentalen Ansätze zu überwinden. Er tritt seit 1986 live auf und ist Mitorganisator des „What Is Music"-Festivals, der größten jährlichen Veranstaltung Australiens zur lokalen und internationale experimentellen Musik.

Birdseed
Whitehouse

Birdseed wird von vielen Kritikern als die bisher komplexeste Arbeit von Whitehouse angesehen. Auch diese Aufnahme enthält noch immer Whitehouses unverfälschte Texte samt ironischen Seitenhieben auf Unglückliche, aber die Band steht an diesem Punkt ihrer Karriere auf einer intellektuell viel subtileren und hinterfragenderen Ebene, insbesondere im Hinblick darauf, wie die Texte versuchen, mit den kulturell Stigmatisierten und unserer Therapie- und Selbsthilfe-Kultur zurecht zu kommen. Viel davon wurde dem Abgang des früheren Mitglieds, Autors und Publizisten Peter Sotos und der Reduzierung der Gruppe auf das Duo William Bennett / Philip Best zugeschrieben. Musikalisch haben sich die Dinge ebenfalls geändert bei dieser Gruppe, die als Pionier der in den 1990-ern entstandenen „Power Electronics" gelten. Mit *Birdseed* hat Whitehouse nicht nur eine neue lyrische Subtilität gefunden, sondern auch eine musikalische Innovation geschaffen, die durchaus als Fortsetzung ihrer musikalischen Karriere angesehen werden kann.

Birdseed has been regarded by many critics as Whitehouse's most mature, diverse and complex release to date. Still containing Whitehouse's unadulterated lyrics, and ironic swipes at the misfortunate, this recording finds the band at a far more intellectually sophisticated and psychologically interrogative stage in its career, particularly in terms of how its lyrics attempt to grapple with the culturally stigmatized therapy and self-help culture. Much of this has been attributed to the departure of former member, author and publisher Peter Sotos and the shrinkage of the group to a duo of William Bennett / Philip Best. Musically, things have equally changed for this group, credited with having pioneered what became known in the 1990s as "power electronics." With *Birdseed*, Whitehouse have found not only new lyrical insight and sophistication, but musical innovation that is keeping with their career achievements thus far.

„Die Welt der Kunst erlaubt eine solche sichere postmoderne Distanzierung. Genau wie sie Tretmühlen-Fetischisten brauchen. Genauso wie sie müde Perverse ausspeien, wenn sie sich frenetisch gegen Strafverfolgung zu verteidigen suchen. Sich abstrampelnde Künstler auf Jobsuche und Kunstliebhaber, die es vorziehen, dass die Kunst ‚Fragen aufwirft', sind sicherlich ebenso abstoßend wie jene Stielaugen machenden Dilettanten, die erkennen, dass die Antworten nur eine Wichsvorlage sind. Sobald man der Volksschule entwachsen ist, kann man bloße Fragen nicht mehr genießen. Außer natürlich, man zieht es vor, die Antworten nicht zur Kenntnis zu nehmen, die diese Fragen in der Öffentlichkeit hervorbringen. Und deswegen hält man besser sein verdammtes Maul." (aus *CRUISE*)

"The artworld allows for such safe postmodern distancing. Just like treatmill fetishists need. Just as reduced lazy perverts spout when they're franatically trying to defend themselves against criminal persecution. Grubbing job hunting artists and art aficionados who prefer that art 'raises questions' are certainly as disgusting as those rubbered dilettantes who recognise that the answers are what you masturbate over. Once you're out of elementary school, you can't appreciate mere questions. Unless, of course, youl'd prefer to not acknowledge the responses that those questions produce in public. So better just shut your fucking mouth." (from *CRUISE*)

Founded in London in 1980, **Whitehouse** have recorded 17 full-length recordings. Long considered an alternative to punk and 'alternative', Whitehouse have always taken a confrontational stance towards the prejudices of middle class liberal ideology. Frequently decried for being right-wing in their dispositions without much reference to their ironic indulgence of stereotypically conservative discourses of victimization, Whitehouse remain a well-kept secret favorite of artists and critics worldwide. Led by founding members, writer, DJ and electronic musician William Bennett, who formed the band at age 18, and Philip Best, who ran away from home at age 14 to join a group of Spanish anarchists, Whitehouse's 2003 recording for Susan Lawly, *Birdseed*, finds the group at it's creative peak, 23 years after it first formed. Die 1980 in London gegründete Gruppe **Whitehouse** hat insgesamt 17 Full-length-Aufnahmen eingespielt. Lange als Alternative zu Punk und „Alternative" angesehen, ging die Gruppe stets auf Konfrontation mit den Vorurteilen der liberalen Ideologie der Mittelklasse. Häufig als rechtslastig verschrien, ohne dass man dabei ihrem ironischen Schwelgen in den stereotypen konservativen Diskursen der Opferdiskussion viel Beachtung geschenkt hätte, bleibt Whitehouse ein gepflegter Geheimfavorit bei Künstlern und Kritikern auf der ganzen Welt. Unter der Führung ihrer Gründungsmitglieder, dem Autor, DJ und Elektronik-Musiker William Bennett, der die Band im Alter von 18 gegründet hat, und Philip Best, der mit 14 von zu Hause weglief, um sich einer Gruppe spanischer Anarchisten anzuschließen, zeigt das 2003 für Susan Lawly eingespielte *Birdseed* die Gruppe auf ihrem kreativen Höhepunkt – 23 Jahre nach ihrer Formation.

Sheer Hellish Miasma
Kevin Drumm

Employing guitar, tapes, mics, pedals, analogue synthesizer and some computer assistance, *Sheer Hellish Miasma* is a sonic beast comprising two extended tracks bookended by shorter works. Like the churning output of heavy metal's distorted overdrive, this CD takes on an intense journey of wailing feedback, chaotic audio and radical processing. The extreme end of power electronics is present throughout much of Drumm's first full-length recording for Austria's entirely appropriate Mego label.

The two centerpieces of *Miasma* encapsulate this record's aesthetic core: "Hitting the Pavement" is a twenty minute blizzard-like drone, while the 24-minute epic "Inferno" overwhelms the listener with a hail of torrential electronics, jackhammer sinewaves and general "evil" disguised as "music".

Unter Einsatz von Gitarren, Tapes, Micros, Pedalen, analogem Synthesizer und einiger Computerunterstützung ist *Sheer Hellish Miasma* ein klangliches Biest aus zwei sehr ausgedehnten Tracks, die von kürzeren Werken eingerahmt werden. Wie der wirbelnde Output eines verzerrten Heavy-Metal-Overdrive verführt diese CD den Hörer auf eine intensive Reise durch heulendes Feedback, chaotische Klänge und radikale Bearbeitung. Über weite Strecken ist dieses erste Album von Drumm, das für das – hier durchaus angemessene – österreichische Mego-Label eingespielt wurde, Powerelektronik pur.

Die beiden zentralen Teile von *Miasma* beinhalten den ästhetischen Kern dieser Aufnahme: *Hitting the Pavement* ist ein 20-minütiger schneesturmgleicher Brummton, während das 24-minütige epische *Inferno* den Hörer mit einem Hagel aus wild dahinschießender Elektronik, vorschlaghammerartigen Sinuswellen und allgemein mit einem als „Musik" verkleideten „Bösen" überwältigt.

Kevin Drumm (USA) is one of electronic and experimental music's noteworthy talents. He has performed with ensembles of various sizes and has released numerous solo and duet recordings. Drumm began his career as a table-top guitarist, laying electric guitars on the surfaces of tables. Drumm treated the instrument as a conduit for registering all manner of touch and the presence of its own internal electrical current. Amplifier buzz, hum and static were the dominant part of his vocabulary, making him one of the few musicians for whom the addition of a laptop computer to his repertoire of instruments is in fact natural. *Sheer Hellish Miasma* is Drumm's fifth full-length release, and third solo recording. Past collaborative LPs include recordings with Dan Burke and Axel Dorner. **Kevin Drumm (USA)** ist eines der bemerkenswerten Talente der elektronischen und experimentellen Musik. Er hat mit Ensembles verschiedener Größe gespielt und zahlreiche Solo- und Duettaufnahmen herausgebracht. Drumm begann als Table-top-Gitarrist und behandelte die flach auf den Tisch gelegte E-Gitarre als Kanal für die Aufnahme aller Arten von Touch und ihres eigenen internen elektrischen Stromflusses. Das Summen, Brummen und Knacken der Verstärker wurden zum dominanten Part seines Vokabulars und machte ihn zu einem der wenigen Musiker, für die die Erweiterung seines Repertoires an Instrumenten durch einen Laptop-Computer tatsächlich eine natürliche Entwicklung ist. *Sheer Hellish Miasma* ist das fünfte Release von Drumm in voller Länge und seine dritte Soloaufnahme. Zu seinen früheren LPs gehören u. a. Aufnahmen mit Dan Burke und Axel Dorner.

Humpa.Zerkörpert
Rudolf Eb.er

Rudolf Eb.er, ein Schweizer Musiker, der heute in Osaka lebt, begann seine Karriere ursprünglich in der industriellen Tape-Szene. *Humpa.Zerkörpert* ist das jüngste seiner Miniatur-Cut-up-Werke, die alle einen einzigartigen und ausgefeilten Stil aufweisen. Es besteht aus aufgeschnittenen Klängen physikalischer und körperlicher Aktionen. Besonders überzeugend ist Eb.ers dramatischer Einsatz von Action und Stille innerhalb des Kontexts von bisweilen absurd klingenden und geradezu Cartoon-haften Arrangements, die dennoch in ihrer Präsentation spezifisch und klar bleiben. Seine Collage-Arbeiten wie *Humpa.Zerkörpert* vermitteln ebenso wie seine selbst beschriebenen „Live Actions" bei aller Konzeptualität durchgehend das erfrischende Gefühl, in Echtzeit produziert zu sein.

Rudolf Eb.er, a Swiss musician living in Osaka, started off working in the industrial tape scene. *Humpa.Zerkörpert* is the latest outcome of his highly unique and elaborate style of miniature cut-up works, consisting of sliced up sounds of physical and bodily actions. Particularly convincing is Eb.er's dramatic use of action and silence within the context of what are at times absurd-sounding and cartoonesque arrangements that are nevertheless specific and clear in their presentation. Collage works of Eb.er's such as *Humpa.Zerkörpert*, as well as his self-described "live actions," for all of their conceptuality, consistently embody a refreshing sense of having been produced in real-time.

Rudolf Eb.er (CH) is well-known for his extreme "action" performances, which are notable due to how provocative they are both to his audiences and at times to his installations' curators. Nearly all of Eb.er's recorded and performed output provides relatively profound examples – as is heard on his *Physical Tests and Trainings* recording – of how the imagination is always inspired by all audible information sources. Eb.er's work, both in the analogue and digital realms, is similarly consistent. *Humpa.Zerkörpert* is as good a testament as any as to where Rudolf Eb.er's future will lead him.

Rudolf Eb.er (CH) ist weithin bekannt für seine extremen „Action"-Performances, die vor allem deswegen bemerkenswert sind, weil sie das Publikum ebenso provozieren wie bisweilen die Kuratoren seiner Installationen. Fast der gesamte von Eb.er aufgezeichnete und dargebotene Output liefert vergleichsweise profunde Beispiele – etwa in seiner Aufnahme *Physical Tests and Trainings* – dafür, wie die Imagination stets von allen hörbaren Informationsquellen gespeist wird. Eb.ers Werk ist im analogen wie im digitalen Bereich ähnlich konsistent. *Humpa.Zerkörpert* ist der beste Hinweis darauf, wohin Rudolf Eb.ers Zukunft ihn führen wird.

The Movement of People Working
Phill Niblock

The Movement of People Working, by composer, filmmaker and photographer Phill Niblock portrays human labor in its most elementary form. According to Niblock, "It is the combination of his slowly evolving harmonic music that creates an otherworldly masterpiece. The films and the music combine elements that seem contradictory, creating tension as a result. Impersonal motion patterns filmed in vibrant 1970s Kodachrome move side by side with glorious sounds that are caused by an acoustic phenomenon. However, there are striking parallels between the image and sound as well, not because one was made as a companion to the other, but because of correspondences at a deeper level. Both display movements within a larger frame that changes at an exceedingly slow rate, evoking simultaneous sensations of movement and immobility. Both transcend the strictly personal, thereby acquiring extra import. In juxtaposition they can bring about a curiously alert trance-like condition, in which associations have free rein."

The Movement of People Working des minimalistischen Komponisten, Filmemachers und Fotografen Phill Niblock portraitiert die menschliche Arbeit in ihrer elementarsten Form. Laut Niblock ist es „die Kombination der sich langsam entfaltenden harmonischen Musik, die ein jenseitiges Meisterwerk erschafft. Die Filme und die Musik verbinden Elemente, die zunächst widersprüchlich erscheinen, und schaffen so eine Spannung. Unpersönliche Bewegungsmuster, gefilmt im lebhaften Kodachrome der 1970er, bewegen sich Seite an Seite mit machtvollen Klängen, die durch ein akustisches Phänomen hervorgerufen werden. Dennoch gibt es überraschende Parallelen zwischen Bild und Klang, nicht etwa weil eines als Begleitung zum anderen entstanden wäre, sondern wegen ihrer Übereinstimmung auf einer tieferen Ebene. Beide zeigen Bewegung innerhalb eines größeren Rahmens, der sich nur mit extrem niedriger Geschwindigkeit verändert und so gleichzeitige Gefühle von Bewegung und Stillstand hervorruft. Beide gehen über das rein Persönliche weit hinaus und bringen so weitere Elemente ins Spiel. In ihrer Gegensätzlichkeit können sie einen seltsam wachen Trance-ähnlichen Zustand hervorrufen, in dem den Assoziationen die Zügel locker gelassen werden."

Phill Niblock (USA), born 1933, has become known not only for his music but for the experimental documentary films that usually also form part of any Niblock live performance. Niblock's films portray human labor in its most basic manifestations, such as construction work, harvesting, planting and fishing. Niblock's narrative style emphasizes continually repeated movements, while his subjects' faces are always absent. In Niblock's music – composed for traditional instruments, either solo, or in trios and quartets – acoustic conditions are crucial. What listeners hear depends on the space where it is being played, on the exact spot where the listener is positioned (or the way they move around in its sounds), on the quality of the sound system, the volume at which the music plays, the position of the loudspeakers and, on the placement or movement of a musician in live presentations and the notes the musician chooses to play. Since 1971, Niblock has been the Professor of Video and Film Production and Photography, Department of Performing and Creative Arts at the College of Staten Island, at the City University of New York.

Phill Niblock (USA), geb. 1933, ist nicht nur für seine Musik bekannt, sondern auch für seine experimentellen Dokumentarfilme, die normalerweise auch Teil jeder Niblockschen Live-Performance sind. Niblocks Filme portraitieren die menschliche Arbeit in ihren grundlegendsten Ausprägungen, etwa auf dem Bau, bei der Ernte, bei der Aussaat und beim Fischen. Niblocks narrativer Stil unterstreicht kontinuierlich wiederholte Bewegungen, während die Gesichter seiner Subjekte nie sichtbar sind. In Niblocks Musik – komponiert für traditionelle Instrumente als Soli, Trios oder Quartette – spielen die akustischen Bedingungen eine besondere Rolle. Was der Zuhörer hört, hängt vom Raum ab, in dem gespielt wird, vom genauen Ort, an dem der Zuhörer positioniert ist (oder von der Art, wie er sich durch die Klänge bewegt), von der Qualität des Soundsystems, der Lautstärke, mit der gespielt wird, der Position der Lautsprecher und natürlich von der Platzierung oder Bewegung der Musiker bei der Live-Präsentation sowie den Noten, die der Musiker sich zu spielen entschließt. Seit 1971 ist Niblock Professor für Video- und Filmproduktion sowie Fotografie am Department of Performing and Creative Arts des College of Staten Islands an der City University of New York.

Journal de Tokyo
Yuko Nexus 6

Yuko Nexus 6' Bericht über die Entstehung von Journal de Tokyo fasst auch die Natur dieser Aufnahme bestens zusammen: „Ich habe eine 45-minütige Session mit meinem Freund auf DAT-Band aufgenommen und anschließend viele Melodien darüber gelegt. Die ursprüngliche Session wurde zusammengeschnitten, deswegen kann man auch nur mehr einige Fragmente des Originals hören. Das Werk ist nicht nur eine CD, sondern auch eine Kassette, deswegen sind auch einige Geräusche zu hören, wie sie für die Tonbandkassetten von früher typisch waren. Ich empfehle, die Tracks nach dem Zufallsprinzip anzuhören."

Kitamura stellt den Inhalt ihres Werks in folgenden Zusammenhang: „Einige Stücke auf dieser Scheibe basieren auf dem Werk des japanischen Autors Hyakken Uchida (1889–1971). Japanische Leser finden sie als Taschenbücher im Buchhandel. Zwei berühmte japanische Filmregisseure haben Uchidas Romane und Essays in ihren Filmen verarbeitet: Sijun Suzuki in *Zigeunerweisen* und Akira Kurosawa in seinem letzten Film *Maadadayo*."

Yuko Nexus 6' account of how *Journal de Tokyo* was put together best sums up the nature of this recording: "I recorded a 45-minute session with my friend on a DAT tape, and then recorded many tunes over it. Our session got cut up, so you can only hear some fragments of the original. This is not only a CD but a cassette tape as well. You can hear some noises that are typical in cassettes from the good old days. Random order listening is also recommended."

Placing the work's content in context, Kitamura states: "Some pieces on this disc are based on the work of Japanese author Hyakken Uchida (1889–1971). Japanese readers can find his paperbacks in bookshops. Two famous Japanese film directors used Uchida's novels and essays in their films: Seijun Suzuki's *Zigeunerweisen* and Akira Kurosawa's last film *Maadadayo*.

Yuko Nexus 6 (J), born 1964, attended Kansai University in Osaka, Japan and holds a B.A. Degree in Sociology. Kitamura has frequently performed in Asia, Canada and the USA. She has been a part-time lecturer at Chukyo University since 2001 and a part-time lecturer at Nagoya University of Arts and Sciences since 2002. Kitamura has been a member of Women's Performance Art Osaka since 2001. **Yuoko Nexus 6 (J)**, geb. 1964, besuchte die Kansai University in Osaka und graduierte zum B.A. aus Soziologie. Kitamura ist häufig in Asien, Kanada und den USA aufgetreten. Seit 2001 ist sie als Lektorin an der Chukyo University teilzeitbeschäftigt und seit 2002 ebenfalls in Teilzeit an der Nagoya University of Arts and Sciences. Seit 2001 ist Kitamura Mitglied von Women's Performance Art Osaka.

Risk
Gert-Jan Prins

2003's *Risk* is an electronic composition based on the digital reorganisation of music materials using Digidesign's Protools multitrack editing application. *Risk*'s source work is generated using customized transmitters that feed back on themselves. An artist working in a mutation tradition of David Tudor's manipulated circuit boxes, Prins' homemade creations "spit, fizz, judder, let off steam, ripple and pulse with analogue and sometimes ear-splitting precision," according to Phil England, who profiled Prins in the January 2003 edition of *The Wire*. A drummer who has spent the last several years customizing consumer audio circuitry, Prins works with a sound-generating system based on four distinct transmitters and receivers whose output signals are routed into a mixing desk, and according to Prins, "four laboratory square-wave generators which can manipulate the chain of feedback giving the rhythmic sounds, which I can also make with the radio boxes themselves."

Risk aus dem Jahr 2003 ist eine elektronische Komposition, die auf der digitalen Reorganisation von Musikmaterial mit Hilfe der Multitrack-Schnittanwendung Protools von Digidesign basiert. Das Quellenmaterial von *Risk* wird mittels eigener Transmitter generiert, die eine Rückkoppelung auf sich selbst liefern. Prins ist ein Künstler, der in einer Art mutierten Tradition der manipulierten Schaltboxen eines David Tudor arbeitet, und seine selbstgebauten Kreationen „spucken, zischen, vibrieren, lassen Dampf ab, rattern und pulsieren mit analoger und manchmal ohrenbetäubender Präzision", wie Phil England schreibt, der Prins in der Jänner-Ausgabe 2003 von *The Wire* porträtiert. Als Schlagzeuger, der viele der letzten Jahre mit dem Umbau von handelsüblichen Audiogeräten zugebracht hat, arbeitet Prins mit einem Klanggenerator-System, das auf vier einzelnen Transmittern und Receivern basiert, deren Output-Signale in ein Mischgerät geleitet werden, sowie laut Prins „vier Rechteckpuls-Generatoren aus Laborbeständen, die die Rückkopplungskette manipulieren können und so die rhythmischen Klänge ergeben, die ich auch mit den Radioboxen selbst erzeugen kann."

During the last four years, Amsterdam-based **Gert-Jan Prins (NL)** has established himself as one of the most exciting custom builders in improvised music. Prins' innovative electronic performance system makes use of radio and transmitter technology, and creates provocatively compelling noises with tremendous physical energy. Besides his solo-work, Prins was commissioned to create a composition for the Quartetto New Amsterdam, and has colloborated with equally adventerous artists ranging from Mats Gustafsson, Misha Mengelberg, Christian Fennesz, Fred Van Hove, and Lee Renaldo to Thomas Lehn, Peter Von Bergen, E-RAX, The Flirts with Cor Fuhler, MIMEO, and the Vacuum Boys. Prins' solo and collaborative recordings appear on the Creamgarden, Sub 8/9, Grob, Fire Inc. and Erstwhile labels. In den letzten vier Jahren hat sich der in Amsterdam beheimatete **Gert-Jan Prins (NL)** als einer der aufregendsten Musiker im Bereich der improvisierten Musik etabliert, der seine Technologie selbst entwickelt. Prins' innovatives elektronisches Performance-System verwendet Radio- und Sendertechnologie und erzeugt provokativ-fesselnde Geräusche mit einer überragenden physikalischen Energie. Neben seinen Solowerken hat Prins auch einen Kompositionsauftrag für das Quartetto New Amsterdam erhalten und mit nicht minder abenteuerlustigen Künstlern zusammengearbeitet: mit Mats Gustafsson, Misha Mengelberg, Christian Fennesz, Fred Van Hove und Lee Renaldo ebenso wie mit Thomas Lehn, Peter Von Bergen, E-RAX, The Flirts with Cor Fuhler, MIMEO und den Vacuum Boys reichen. Prins' Solo- und Gemeinschaftsaufnahmen sind bei den Labels Creamgarden, Sub 8/9, Grob, Fire Inc. und Erstwhile erschienen.

Director's Cut
Rechenzentrum

Rechenzentrum bringt Material in zahlreichen Formaten heraus und testet dabei die Möglichkeiten und Beschränkungen eines jeden einzelnen, was häufig die Zusammenarbeit mit Künstlern aus anderen Medien und Genres mit sich bringt. Laut Rechenzentrum entspringt die hinter diesem Ansatz steckende Philosophie der Notwendigkeit, die Grenzen des Aufführungszusammenhangs – sei es beim Spiel in Museen oder bei Festivals Neuer Musik, in Clubs und Undergrund-Events – niederzureißen. Aber dies war nicht der eigentliche Grund für die Gründung der Gruppe. Ihre anfänglichen Anliegen waren ganz elementar: Niemand spielte die Musik, die Rechenzentrum gerne gehört, oder die Videos, die man gerne gesehen hätte – und schon gar nicht in einer innovativen und ansprechenden Kombination. Fünf Jahre später hat die Gruppe – anhand der eigenen Erfahrung wie der von ihr hervorgerufenen Publikumsreaktionen – herausgefunden, dass ihr extrem phantasievoller Do-it-yourself-Ansatz größtenteils erhalten geblieben ist und zahlreiche kreative Möglichkeiten eröffnet hat, wie Rechenzentrum in seinen Anfängen sie nie für möglich gehalten hätte.

Rechenzentrum release material in numerous formats, testing the possibilities and limitations of each, often involving collaborations with artists based in other media and genres. According to Rechenzentrum, the philosophy behind this approach is that it is necessary to break down borders of performative context, from playing in museums and new music festivals to clubs and underground music events. However, this was not why the group originally started. Their initial concerns were quite basic: no one was releasing the kind of music that Rechenzentrum wanted to hear or the kind of video that it wanted to see, let alone combined them in innovative and appealing ways. Five years later, the group has largely found—both for itself and in terms of the audience reaction that it has generated—that their extremely imaginative DIY approach has largely prevailed and opened up numerous creative possibilities that they did not anticipate being available to them when Rechenzentrum first started.

Rechenzentrum (D) (German for "data processing center,") first formed at Documenta 97. Their aesthetic mandate is the exploration of new processes of synthesizing music and visual image production, and in the live realm, refining forms of presentation which create an on-stage dialogue between audio and video. This appropriately-named trio consists of three principal artists: Lillevan (moving imagery), Marc Weiser (music, composition) and Christian Conrad (music, sound design). Rechenzentrum's interdisciplinary approach to AV work is influenced by various twentieth century artistic traditions such as Lettrisme, Dadaism, Burroughs' cut-up narrative techniques, and punk, among many other cultural sources. Having recorded two full-lengths for the Kitty Yo label, 12" singles for the Shitkatapult and Vertical Form imprints, Rechenzentrum's third full-length production is the DVD/CD release *Director's Cut*, issued in 2003 by Mille Plateaux. **Rechenzentrum (D)** formierte sich erstmals zur documenta '97. Das ästhetische Mandat der Gruppe ist die Erforschung neuer Prozesse zur Synthetisierung von Musik, zur Produktion von Bildern sowie – im Live-Bereich – zur Verfeinerung von Präsentationsformen, die einen On-Stage-Dialog zwischen Audio und Video ermöglichen. Das passend benannte Trio besteht aus drei Hauptkünstlern: Lillevan (bewegte Bildwelten), Marc Weiser (Musik, Komposition) und Christian Conrad (Musik und Sound Design). Rechenzentrums interdisziplinärer Ansatz in der AV-Arbeit wird von zahlreichen künstlerischen Traditionen des 20. Jahrhunderts beeinflusst, darunter Letterismus, Dadaismus, Burroughs' narrativen Techniken und – nebst vielen anderen kulturellen Quellen – auch Punk. Nach zwei Full-length-Einspielungen für das Kitty Yo Label, 12"-Singles für Shitkatapult und Vertical Form, ist die dritte Rechenzentrum-Produktion in voller Länge die DVD/CD *Director's Cut*, die im Mai 2003 bei Mille Plateaux herausgekommen ist.

Hard ni sasete

Tujiko Noriko

Tujiko Noriko's music is a stutter of eccentric fractals, a kaleidoscope of delicate and demanding surprises. There are many different textural, cultural, and personal ideas at play on *Hard ni sasete* ("Make Me Hard"). Noriko is definitely a considerable figure of avant-garde technique, but she doesn't make us suffer for it. She lets us into her sandbox and shows us all her toys. Her interjections of found melodies, concrete noise, affecting sense of disparate elements matched together, and Noriko's extremely emotive voice, are all placed in the expansive background of repetition. Noriko's song style depicts fictions and stories all in Japanese and is so charmingly "100 per cent nerdy glitch-boy free". Tujiko's exercises in distressed digitalia sound strictly hand-crafted and full of color, are far-reaching and complex, toggling through thousands of pieces of aural detritus, throbbing for the next step.

Tujiko Norikos Musik ist ein Gestotter aus exzentrischen Fraktalen, ein Kaleidoskop aus delikaten und anspruchsvollen Überraschungen. Bei *Hard ni sasete* („Make Me Hard") sind viele verschiedene texturale, kulturelle und Ideen im Spiel. Noriko ist sicherlich eine beachtenswerte Figur in der Avantgarde-Technik, aber sie lässt uns nicht darunter leiden. Sie führt uns in ihre Sandkiste und zeigt uns alle ihre Spielsachen. Ihre Einwürfe aus gefundenen Melodien, konkreten Geräuschen, das berührende Gefühl von aufeinander abgestimmten disparaten Elementen und nicht zuletzt Norikos extrem eingängige Stimme werden alle in einen weitläufigen Hintergrund aus Repetition gestellt. Norikos Gesangsstil zeigt uns rein japanische Fiktionen und Geschichten und ist so bezaubernd hundert-prozentig frei vom „Nerdy Glitch-Boy"-Klang. Tujikos Übungen in einem farbigen und komplett handgestrickten Digitalia-Klang sind weit ausholend und komplex und wühlen sich durch Tausende Stücke von auralem Verfall, stets auf den nächsten Schritt hin pulsierend.

Tujiko Noriko (J/F) lives in Paris, France. She started singing around 1978-79, and bought her first synthesizer and sampler in 1999. Noriko's first album, Keshou To Heitai ("Makeup and Soldiers"), was recorded in January 2000, with her first live performance of that material taking place around the same time in Kyoto. Noriko released her Mego debut, Shojo Toji, in 2001, followed by her I Forgot the Title 12" and Make Me Hard CD in 2002. She is a member of the Slidelab design organization, and helped launch the magazine OK Fred. Noriko's fourth full-length recording, From Tokyo To Naiagara, was released by the Tomlab label in June 2003.

Tujimo Noriko (J/F) lebt derzeit in Paris. Sie begann um 1978-79 zu singen und kaufte 1999 ihren ersten Syntesizer und Sampler. Ihr erstes Album Keshou To Heitai („Makeup und Soldaten") wurde im Januar 2000 aufgenommen, um die gleiche Zeit fand auch die erste Live-Performance dieses Materials in Kyoto statt. Ihr Debut bei Mego, Sojo Toji, brachte Noriko 2001 heraus, gefolgt von ihrer I Forgot the Title-12"-Scheibe und der Make Me Hard-CD 2002. Sie ist Mitglied der Slidelab Design-Organisation und hat beim Launch des Magazins OK Fred mitgeholfen. Norikos vierte Full-length-Aufnahme, From Tokyo To Naiagara, wurde im Juni 2003 beim Tomlab Label publiziert.

pieces of air
Toshiya Tsunoda

Unsere Körper sind von Luft umgeben. Die Luft füllt den Raum vollständig aus. Aber wir sind uns der Existenz der Luft in unserem Alltagsleben kaum bewusst. Wir bemerken die Luft auf gewisse Weise durch Vibrationen, durch Hitze und im Licht – sie erscheint uns als und wie ein Medium. Luft verteilt physikalische Vibration durch den Raum wie eine Feder. Wenn Klang durch den Raum reist, wiederholt er seine Reflexion im Raum und wird dadurch überlagert. Die ursprüngliche Schwingung kommt umgekehrt zurück, ähnlich wie eben auch die Bewegung einer Sprungfeder. Dazu erscheint auch eine Zeitdifferenz im Klang, die von der Form des Raums abhängig ist. Die Bewegung dieses Mediums setzt sich stark mit Fragen von Raum und Zeit auseinander, mehr noch: Es betrifft die Bewegung vom Vergangenen zum Gegenwärtigen, vom Fernen zum Nahen. Es ist interessant, die Bewegung einer physikalischen Vibration in diesem Medium zu beobachten, selbst wenn man ihre Ursache nicht erkennt. Wir finden darin eine wunderbare Ordnung.

Die Sammlung von Werkaufnahmen unter dem Titel *pieces of air* besteht aus Aufnahme-Setups, die jeweils ortsspezifisch eingerichtet waren, sowie aus den Umweltklängen verschiedener Orte. Alle Aufnahmen wurden mit zwei identischen Rundmikrofonen aufgezeichnet, ausgenommen die Tracks 2, 12 und 13, für die ein einfaches selbstgebautes Mikrofon verwendet wurde. Keines der hier kompilierten Werke wurde nachbearbeitet.

Our bodies are surrounded by air. Air fills space completely. But we are not clearly conscious of the existence of air in our daily lives. We notice air's existence somehow by the actions of vibration, heat and light. Air appears as a medium in our observation. Air spreads physical vibration into a space like a spring. When sound travels through space, it repeats its reflection in space and is then overlapped. The original vibration returns reversed, similar to the action of a spring. Next, a time difference appears in the sound depending on the form of the space. Movement of this medium is greatly concerned with space and time. Moreover, it is also concerned with movement from past to present and from far to near. It is interesting to observe movement of this medium by physical vibration even without discovering its cause. We can find beautiful order there.

This collection of recorded works titled *pieces of air* consists of site-specific recording setups and the environmental sound of various places. All recordings were made with two identical micro omnidirectional microphones except tracks 2, 12 and 13, which were recorded with a simple handmade microphone. No processing was done on any recorded work compiled here.

Toshiya Tsunoda (J), born 1964, holds an MFA from the Tokyo National University of Fine Art and Music. In 1994 he established and organized the label WrK with Minoru Sato. He has produced installations for museums, recordings and has received several prizes all over the world. **Toshiya Tsunoda (J)**, geb. 1964, graduierte an der Tokyo National University of Fine Art and Music zum MFA. 1994 gründete und organisierte er gemeinsam mit Minoru Sato das Label WrK. Er hat Installationen für Museen und Musikeinspielungen produziert und weltweit zahlreiche Preise errungen.

Nymphomatriarch
Aaron Funk (Venetian Snares) & Rachael Kozak (Hecate)

On *Nymphomatriarch*, musicians Aaron Funk (Venetian Snares) and partner Rachael Kozak (Hecate) captured the sounds of their privately recorded debaucharies while on tour in Europe and Canada. Interviewed for an article on new concrete-sound based electronic records in the *Manchester Guardian*, Funk summarizes his first sense of the musical value of his recordings: "I remember thinking, 'That slap will make a good snare drum'". Based on samples derived from the sounds of Funk and Kozak engaging in anal and oral sex, bondage, caning, spanking and microphone insertion on MiniDisc, the resultant gulps and gasps, groans and slaps, were subsequently crafted into into a cutting edge collection of drill and bass-driven breakcore and ambient atmospherics.

Auf *Nymphomatriarch* haben die Musiker Aaron Funk (Venetian Snares) und seine Partnerin Rachael Kozak (Hecate) die Klänge ihrer privat aufgezeichneten wollüstigen Ausschweifungen während ihrer Tour durch Europa und Kanada eingefangen. In einem Interview für einen Artikel des *Manchester Guardian* über neue elektronische Scheiben auf der Basis konkreter Klänge fasst Funk seine Einschätzung zum musikalischen Wert dieser Aufnahmen so zusammen: „Ich erinnere mich daran, gedacht zu haben:, Dieser Schlag wird eine tolle Snaredrum abgeben!'" Basierend auf Samples, die von den Geräuschen, die Funk und Kozak bei analem und oralem Sex, SM-Spielen und bei der Einführung von Mikrofonen auf MiniDisc aufgenommen haben, wurden die dabei mitgeschnittenen Stöhn- und Schluckgeräusche, Schläge und Seufzer anschließend in eine Cutting-Edge-Sammlung von Drill und Bass-getriebenem Breakcore und Umweltatmosphäre umgearbeitet.

Aaron Funk (CDN) seamlessly synthesizes drum and bass, jungle, noise, free jazz, hardcore, IDM and electro-acoustics into mashed up musical hybrids. Having released multiple recordings on a variety of underground electronic labels including Planet Mu, Isolate and Hymen since the late 1990s, he has quickly established a worldwide reputation for his eclectic, humorous and hard driving soundworks. Venetian Snares is representative of a second generation laptop culture that has assimilated the influences of 1990s IDM, and is in the process of coalescing a new youth-driven musical idiom with similarly avant-garde compositional leanings. **Rachael Kozak (CH)** is a vigorous, versatile interdisciplinary engenue: musician, artist, video editor, web designer, label head. There are very few areas of cultural creativity she is not involved in. As Hecate, Kozak has released scores of material on the Zhark, Zhod and Praxis labels (to name a few) and scored remixes for the likes of Le Tigre and Lustmord, with no signs of slowing down. Kozak has been a part of the infamous female artists collective, the Homewreckers Foundation, and is currently the art director of her own multimedia imprint, Zhark International. Her first full-length album, *The Magick of Female Ejaculation*, was released at the end of January 2003 on the Praxis label. **Aaron Funk (CDN)** synthetisiert Drum und Bass, Jungle, Nois, Free Jazz, Hardcore, IDM und Elektroakustik nahtlos in gut durchgemischte musikalische Hybride. Seit den späten 90er Jahren hat er zahlreiche Aufnahmen auf diversen Underground-Labels wie Planet Mu, Isolate und Hymen herausgebracht und dank seiner eklektischen, humorvollen und mit hartem Drive ausgestatteten Klangwerke schnell einen weltweiten Ruf erworben. Venetian Snares repräsentiert jene Laptop-Kultur der zweiten Generation, die die Einflüsse der IDM der 90er assimiliert hat und dabei ist, ein neues jugendgetriebenes musikalisches Idiom mit ähnlich avantgardistischen kompositorischen Neigungen zusammenzubringen. **Rachael Kozak (CH)** ist eine vielseitige interdisziplinäre Begabung: Musikerin, Künstlerin, Video-Editor, Webdesignerin, Label-Chefin – es gibt nur wenige Bereiche kultureller Kreativität, in denen sie nicht engagiert ist. Als Hecate hat Kozak jede Menge Material auf den Labels Zhark, Zhod und Praxis (um nur einige zu nennen) herausgebracht und Remixes für Gruppen wie Le Tigre und Lustmord zusammengestellt – und es gibt keine Anzeichen dafür, dass sie im Tempo nachlässt. Kozak war Mitglied des anrüchigen Künstlerinnenkollektivs „The Homewreckers Foundation" und ist derzeit Art Director ihres eigenen Multimedia-Imprints Zhark International. Ihr erstes Full-length-Album *The Magick of Female Ejaculation* ist Ende Januar 2003 bei Praxis herausgekommen.

Foldings
Mark Wastell / Toshimaru Nakamura / Taku Sugimoto / Tetuzi Akiyama

Bei einer im Tokioter Offsite im Januar 2002 mitgeschnittenen Performance führte der Cellist-Gitarrist Mark Wastell gemeinsam mit dem No-Input-Mixer-Spieler Toshimaru Nakamura, mit Taku Sugimoto, der auf einer präparierten akustischen Gitarre spielte, und mit Tetuzi Akiyama am Turntable samt Druckluftreiniger eine Sammlung minimalistischer Micro-Improv-Kompositionen auf, die eine „neue reduktionistische Prozedur" abbilden, die mit ihren kaum vernehmlichen verstreuten Elementen in der klangbewussten Aktivität nach einem hyper-aufmerksamen Zuhören verlangt. Die im Vordergrund stehende Verwendung von weniger lautem Material und Stille stellt eine bewusste Analogie zur Musik und Dynamik des digitalen Zeitalters her, zum Bewusstsein von Pre- und Post-Electronica, Live-Laptop-Processing, zu digitaler Klangkunst und anderen Instrumentalgruppen wie AMM. *Foldings* kanalisiert diese Einflüsse erfolgreich in einen nicht-elektronischen Kontext und schafft neue ästhetische Möglichkeiten für kammermusikalische Gruppenaufführungen und Komposition. Die Musik ist auf einem wohl definierten Kontrast zwischen der Anwesenheit und Abwesenheit von Klang aufgebaut, bei dem die winzigsten Gesten Bände sprechen, ohne eine dominante Amplitude aufzuweisen. Wie bei „Still Art" gibt es auch hier eine körperhafte Festigkeit in der Architektur und ein hohes klangliches Bewusstsein. Die Art und Weise, wie diese Musik aufgeführt wird, kann zu sehr stillen oder statischen Musikern führen – es gibt ja sehr wenig zu beobachten –, aber sie dreht sich ausschließlich um eine zurückhaltende Klangsprache mit sorgfältig ausgewählten Spielern und deren „digitalen Ohren".
Wie Morton Feldman sagt: „Jetzt, wo die Dinge so einfach sind, gibt es so viel zu tun."

Recorded live at Tokyo's Offsite venue in January 2002, cellist-guitarist Mark Wastell, along with no input mixer-player Toshimaru Nakamura, prepared acoustic guitarist Taku Sugimoto and Tetuzi, Akiyama on turntable with air duster performed a collection of minimalist micro-improv compositions which portray a "new reductionist procedure" that requires hyperattentive listening to the barely audible, sparse elements in the sound-conscious activity. The prominent use of less loud material and silence draws an informed analogy to the music and dynamic range of the digital era, as influenced by awareness to pre and post-electronica, live laptop processing, digital sound art and other instrumental groups such as AMM. *Foldings* succeeds in channeling these influences in a non-electronic context, creating a new sense of aesthetic possibility for chamber group performance and composition. It's a music constructed of defined contrasts between sound occurrence and sound absence where the smallest gestures speak volumes without a dominant amplitude. As with "still art" there is a solidness of sculpture, architecture and high sonic awareness. The nature of the way this music is performed can result in very still or static musicians – there is very little to actually watch – it's all about an understated sound language with carefully chosen players and their "digital ears".
As Morton Feldman said "Now that things are so simple, there's so much to do."

Much of **Mark Wastell's (UK)** relationship with his chosen instrument is concentrated on the tactile, textural and sonic possibilities of violoncello, bow, contact mics and prepared amplified electronics. He is increasingly interested in working with extreme elements drawn from frequency, timbre and pitch. Wastell's current instrumental material primarily focuses on using abstract principles; of space, time and texture. **Toshimaru Nakamura (J)** developed a unique style, playing the "no-input mixing board" after working with guitar. **Taku Sugimoto (J)** plays cello and guitar and has gradually shifted from a loud, heavy sound to the extremely quiet sound, full of silences, which he has established through solo and group projects. **Tetuzi Akiyama (J)** is a highly unique and experimental guitarist, who also plays electronics, viola, and self-made instruments. Viel in der Beziehung zwischen **Mark Wastell (UK)** und seinem Lieblingsinstrument konzentriert sich auf die taktilen, texturalen und klanglichen Möglichkeiten von Violoncello, Bogen, Kontaktmikrofonen und präparierter verstärkter Elektronik. Er interessiert sich zunehmend für die Arbeit mit extremen Elementen, die sich aus Frequenz, Timbre und Tonlage ableiten. Wastell setzt seinen Schwerpunkt beim derzeitigen instrumentalen Material auf die Anwendung abstrakter Prinzipien von Zeit, Raum und Textur. **Toshimaru Nakamura (J)** entwickelte einen einzigartigen Stil am No-Input-Mixer, nachdem er lange mit Gitarre gearbeitet hat. **Taku Sugimoto (J)** spielt Cello und Gitarre und hat sich nach und nach von einem lauten Heavy-Sound hin zu einem extrem leisen Klang voller Momente der Stille entwickelt, den er in Einzel- und Gruppenprojekten erarbeitet hat. **Tetuzi Akiyama (J)** ist ein einzigartiger experimenteller Gitarrist, der auch Elektonics, Viola und selbstgebaute Instrumente spielt.

U19 Freestyle Computing
Martin Pieper

Da sitzt man als Jury für ein paar Tage in einem abgedunkelten Raum im ORF-Landesstudio Oberösterreich und vergräbt sich in den über tausend Einsendungen von Unter-19-Jährigen und fragt sich, was sie gemeinsam haben und was sie voneinander unterscheidet: Volksschulklassen und Maturanten, Einzelkämpfer und Projektgruppen, Webdesigner und Spielprogrammierer, Männer und leider – immer noch – weniger Frauen. Sind diese über tausend Einsendungen ein repräsentativer Querschnitt durch das Freestyle Computing von jungen Menschen in Österreich? Die schiere Anzahl scheint die Frage mit „Ja" zu beantworten. Dass der Computer – oder, allgemeiner gesagt, die digitale Technik – gerade bei Jugendlichen so massiv in den Alltag eingedrungen ist, lässt uns aber hoffen, dass da draußen noch mindestens weitere tausend kreative Köpfe an ihren Ideen arbeiten. Das titelgebende „Freestyle"-Prinzip könnte ruhig noch mehr Einfluss auf die Einsendungen haben. Vielleicht zeigen die Preisträger 2003 aber auch weniger das, was wir in Zukunft von Programmierern, Roboter-Architekten, Webdesignern und Künstlern erwarten können, sondern das, was die Einsendenden glauben, dass von digitalen Projekten heutzutage erwartet wird. Die herausragenden Arbeiten dieses Jahrgangs haben jedenfalls oft eine Grenze überschritten, sei es in technischer Hinsicht, in Fragen des Oberflächendesigns oder in den Anwendungsgebieten.

Webpages zu programmieren, mit Inhalt zu befüllen und in eine dem User zugängliche Struktur zu bringen, das zieht sich mittlerweile quer durch alle Altersschichten. Es hat sich auch heuer wieder gezeigt, dass Inhalt als Qualitätskriterium nach wie vor unterschätzt wird. Die „schöne" Homepage ist heutzutage auch bei Schülern schon fast Standard geworden, für eine Auszeichnung reicht das allerdings noch nicht. Überzeugt hat uns dann die Seite *i² – was ist eine tolle Seite?* von Anna Obermeier, Alexandra Voglreiter und Katharina Krummel. Ein Projekt einer Gruppe von Mädchen zwischen elf und 13 Jahren, die einerseits Einblicke in ihr Leben bieten, das Internet aber auch dazu benutzen, sich selbst über Ländergrenzen hinaus, zu vernetzen. Einen gut nutzbaren

As a jury member you sit for several days in a dark room at ORF's Upper Austrian Regional Studio, immersed in over a thousand entries from young people under the age of 19. You then begin to wonder what they have in common and how they differ: primary school classes and students taking their A levels, individual contenders and project groups, web designers and game programmers, young men and sadly—once again—not as many women. Are these over thousand entries a representative cross section of freestyle computing by young people in Austria? The sheer number seems to answer the question in the affirmative. Yet the fact that the computer or—to put it more broadly—digital technology has so strongly invaded the daily lives of young people, makes us hope that there are at least another thousand creative minds out there working on ideas of their own. Though the "freestyle" principle that originally engendered the title could, by all means, have a greater impact on the entries. But then again, maybe the prize-winners of 2003 do not so much reveal what we can expect in the future from programmers, robot builders, web designers and artists, but reflect what the entrants believe is expected from digital projects today. At any rate, this year's outstanding works often cross borders, be it technically, in matters related to interface design or areas of application.

Programming web pages, filling them with content and putting them in a structure accessible to users can now be found across all age groups. And this year again, content as a criterion for quality has been underestimated. Indeed even for school kids, the "beautiful" homepage has become more or less the norm, but it alone does not suffice for an award. One work we found convincing was *i²—What is a great page?* by Anna Obermeier, Alexandra Voglreiter and Katharina Krummel. This project was realized by a group of girls between the ages of eleven and thirteen, who

allow us a look at their lives while also using the Internet to connect across national borders. Dominik Dorn's *lyrix.at*, one of two entries presenting song texts (the other was *www.songtexte.com*), offers quite practical contents and a lively community, packaged attractively. And Georg Gruber at *inflex.org* explores the customary interfaces of websites.

In the entertainment industry, computer games have long had a status equal to movies and music. As regards graphics, appearance and marketing costs, u19 contributors can hardly compete with these elaborate games, with their large project development teams, high specialization and several years' lead time. Yet a fun game and a "good idea" cannot be bought, even with lots of money. This fact was demonstrated, for instance, by the many retrogame entries that surprised us in 2003: e.g., the innovative revival of a good old text adventure such as acknowledged in Thomas Hainscho's *School's Out for Rosh Hodesh Adar II*. The project *:.be A bee.:* by fourteen-year-old pupils Armin Ronacher and Nikolaus Mikschofsky revolves, it is true, around cute little bees, but is a fantastic and complex economic simulation too.

Computer graphics are also well represented. It is a field which chiefly attracts primary school classes who engage themselves with commitment and zest. Instead of crayons and felt pens, mice and graphics programs have taken over drawing lessons. Loosely speaking, the older the entrants, the more animated the images. And in the end it was a 3-D animated film which grabbed the Golden Nica: the jury found *Rubberduck* by Georg Sochurek not only convincing due to its technical ingenuity but above all because of its pensive story. How the filmmaker succeeds in turning a lifeless object like a "rubber duck" into a surface for the projection of the viewer's emotions is astonishing. In their perfection, the script,

Content samt lebhafter Community in ansprechender Ausführung bietet *Lyrix.at* von Dominik Dorn, eine von zwei Einreichungen (die andere war *www.songtexte.com*), die Songtexte anbieten. Georg Gruber befragt auf *inflex.org* die gewohnten Oberflächen von Websites. Computergames stehen in der Unterhaltungsindustrie schon längst gleichwertig neben Film und Musik. Die aufwändigen Spiele mit vielköpfigen Entwicklungsteams, hoher Spezialisierung und mehrjähriger Vorlaufzeit sind in Sachen Grafik, Erschienungsbild und Marketingaufwand von den u19-Teilnehmern kaum zu übertreffen. Spielspaß und die „gute Idee" sind aber auch mit viel Geld nicht zu kaufen. Das beweisen unter anderem die vielen Retro-Games Einsendungen, die uns 2003 überrascht haben, etwa die originelle Rückkehr zum guten alten Text-Adventure, wie die Anerkennung *School's Out For Rosh Hodesh Adar II* von Thomas Hainscho zeigt. *:.:.be A bee.:.:* von den erst 14-jährigen Schülern Armin Ronacher und Nikolaus Mikschofsky handelt zwar von niedlichen Bienen, ist aber eine astreine und komplexe Wirtschaftssimulation.

Stark vertreten waren auch Computergrafiken, ein Bereich, in dem sich vor allem viele Volksschulklassen mit viel Engagement und Einsatz ausgetobt haben. Statt Ölkreide und Filzstift übernehmen Maus und Grafikprogramme den Zeichenunterricht. Je älter die Einsender, desto bewegter die Bilder, könnte man salopp formulieren. Ein 3D-Animationsfilm konnte schlussendlich auch die Goldene Nica einsacken: *Rubberduck* von Georg Sochurek überzeugte neben technischer Brillanz vor allem durch die nachdenkliche Geschichte. Wie der Filmemacher das leblose Objekt „Gummiente" zur Projektionsfläche für Emotionen des Zuschauers macht, ist verblüffend. Buch, Schnitt und Tonspur kommen in ihrer Perfektion den offensichtlichen Vorbildern aus Amerika schon sehr nahe.

Einer der jüngsten Teilnehmer beim u19-Wettbewerb, der siebenjährige David Hackl, hat mit seiner nur wenige Sekunden dauernden Animation *Die Fliege* gezeigt, dass weniger oft mehr ist. In Sachen Flash-Animation hat uns das Weltraumabenteuer von Manuel Fallmanns

System Interrupted mit seiner an Comix geschulten Bildsprache überzeugt. Ein schöner Sonderfall ist auch die Arbeit Der Sprung ins Ungewisse von der HS Steinerkirchen, die mit einer Mischung aus Realfilm und digitaler „Übermalung" des Materials der klassischen „Boy meets Girl"-Geschichte einen neuen Dreh geben. Im Grenzbereich von Webseite, Grafik und Animation sind die „Klangbilder von den Schülerinnen des Borg 3 in Wien und die Arbeit Bewegung von Schülerinnen der HBLA für Kunst in Linz angesiedelt: tönende Grafik, bewegte Sprache, sichtbarer Klang.

Besonders angetan ist die Jury von unkonventionellen Lösungen, die High-tech- mit Low-tech-Attributen verknüpfen. In diesem Sinne haben Tobias Schererbauer, Mathäus König und Sebastian Schreiner mit einer gewissen Bastler-Mentalität Das Studio und die Green Box entwickelt. Auch Sehhilfen für Menschen mit Behinderung (Die akustische Lesehilfe für Sehbehinderte von Franz Wengler und Christof Haidinger) oder selbst medizinische Geräte (Listheseanalysegerät von Sigrun Astrid Fugger und Martin Leonhartsberger) finden ihren Platz unter den u19-Preisträgern.

Und wenn sich eine Jury etwas wünschen darf, dann: Bitte nächstes Jahr wieder mehr elektronische Musik bei u19, denn auch Jury-Mitglieder tanzen gerne.

editing and soundtrack come very close to what were most obviously the film's American models. One of the youngest participants in the u19 competition, seven-year-old David Hackl, was able to demonstrate with his animation The Fly—which lasts only a few seconds—that less is often more. With respect to Flash animation, we found Manuel Fallmann's space adventure system interrupted and its imagery, so well versed in comics, very compelling. A lovely exception is also the work Leap into the Unknown by HS Steinerkirchen, a secondary modern school: a mixture of real-life shots and digital "overpaints" of the footage gives the classic boy-meets-girl story a new twist. Sound Images created by pupils from the college preparatory school Borg 3 in Vienna, and Movement by pupils from the secondary school HBLA for Artistic Design in Linz can both be regarded as operating at the boundary between web page, graphics and animation: with audible graphics, moving language and visible sounds.

The jury was especially taken by unconventional solutions combining high-tech features with low-tech ones. It was along these lines and with a certain do-it-yourself mentality that Tobias Schererbauer, Mathäus König and Sebastian Schreiner developed The Studio and the Green Box. Also visual aids for people with disabilities (Acoustic Reading Aids for the Visually Impaired by Franz Wengler and Christof Haidinger) and even medical devices (The Listhesis Analysis Device by Sigrun Astrid Fugger and Martin Leonhartsberger) placed among the u19 prize-winners.

And if a jury may wish for something, then please, submit more electronic music to u19 again next time: for even jury members like to dance.

Rubberduck
Georg Sochurek

Rubberduck tells a strange tale of woe about a little rubber duck in the guise of a modern fable: it revolves around topics like being different, suffering, the wickedness of the world and of fate. Even if the term "drama" seems a bit exaggerated here, it is exactly what the film is supposed to be. It should make people think and feel compassion, as well as ask what parallels exist between the story and the real, "wicked" world.
But first things first:
Everything begins with a little rubber duck floating about all alone on the sea. Soon a few "real" ducklings appear who then take off to get their mother so they can show her their strange find. After briefly examining the lifeless body, the duck family decides to take in the rubber duck. Yet the little rubber duck cannot adapt to family life; it is expelled and once again floats about all alone on the sea.
Suddenly a sea monster shows up out of nowhere and gobbles it up. When the rubber duck

Rubberduck erzählt die seltsame Geschichte vom Leidensweg einer kleinen Gummiente in Form einer modernen Fabel: Es spricht vom Anderssein, vom Leiden, von der Bosheit der Welt und des Schicksals. Auch wenn der Begriff „Drama" etwas zu stark gewählt scheint, soll der Film genau das sein. Seine Aufgabe ist es, die Leute zum Nachdenken zu bewegen, zum Mittrauern; wo ergeben sich Parallelen zwischen der Geschichte und der echten „bösen" Welt?
Aber alles der Reihe nach:
Alles fängt damit an, dass ein kleines Gummientchen einsam auf dem Méer treibt. Schon bald tauchen ein paar „echte" Entenküken auf, die auch sofort ihre Mutter holen, um ihr den seltsamen Fund zu zeigen. Nach einer kurzen Untersuchung des reglosen Fremdkörpers beschließt die Entenfamilie, das Gummientchen in ihre Reihen aufzunehmen. Durch seine Unvermögen sich anzupassen, wird es ausgestoßen und treibt wieder alleine auf dem Meer herum.
Plötzlich taucht wie aus dem Nichts ein Seemonster auf und verschlingt es. Man findet es wieder, mit Bissspuren

auf den Wellen treibend. Aber die Einsamkeit soll nicht lange anhalten: Schon bald taucht eine bezaubernde Entendame auf, die das Entchen wieder aufrichtet und an sich drückt. Doch das Glück währt nicht lange: Die beiden treffen auf zwei Schläger-Enten, die es offensichtlich auf das Gummientchen abgesehen haben. Aber dahinter verbirgt sich gleich noch ein zweiter, sadistischer Schicksalsschlag: Anstatt dem Gummientchen zu helfen, entpuppt sich die Entendame als Freundin der beiden Schläger, die das Entchen nur in eine Falle gelockt hat und schließlich seinen Freunden das Zeichen gibt, es zu erledigen. Gesagt – getan. Nachdem die drei weg sind (das Gummientchen befindet sich nun schon in sehr desolatem Zustand), trifft es auf seine letzte Herausforderung: Aus der Dunkelheit schälen sich zwei gewaltige Steinenten, stumme Wächter eines seltsamen Wasserfalls. Prompt gerät das Entchen auch in dessen Sog, aber kurz bevor es hinunterstürzt, rettet ihm ein Steinschlag das Leben (Leben?). Doch während es von dessen Wellen in Sicherheit gespült wird, lässt das Entchen das erste (und letzte) Mal Gefühle erkennen: Es erinnert sich an all das Böse, das ihm wiederfahren ist, beginnt zu weinen und fasst einen Entschluss: Es dreht um, lässt sich vom Wasserfall erfassen und stürzt in die Tiefe. Aus. Ende. Oder doch nicht?

Während des ganzen Films wird immer eine gewisse Mystik gewahrt: Lebt das Gummientchen? Denkt es? Oder ist es wirklich nur ein lebloses Stück Plastik, wie es scheint?

Woher kommt es überhaupt? Was passiert nach dem Sturz vom Wasserfall?

reappears, bobbing on the waves, it has bite marks. But its loneliness is not to last long: soon a delightful lady duck swims up—she rights the little duck and clasps it tightly to her. Yet this happiness is short-lived: they soon run into two thuggish ducks who are evidently out to get the rubber duck. And here lurks immediately another, sadistic misfortune: the lady duck does not come to the rubber duck's aid, but turns out to be a friend of the two thugs—she has merely lured the little duck into a trap. In the end, she gives her friends a sign to do the little rubber duck in. No sooner said—than done.

Afterwards, when the three are gone, (the rubber duck is now in a very sorry state) it encounters its final challenge: suddenly, out of the dark, two mighty stone ducks loom large, silent guardians of a strange waterfall. And how could it be otherwise—the little duck is whisked off by the current, but just before it plunges over the ledge, falling rocks save its life (its *life*?). But then, at the very moment when the waves from the rocks are washing the little duck to safety, it shows emotion for the first (and last) time: it remembers everything wicked which has happened to it, starts to cry and comes to a decision: it turns round and lets itself be swept towards the falls, plunging into the depths—or is this not what happens?

During the entire film a certain mystical quality prevails: Is the rubber duck alive? Can it think? Or is it really just the lifeless piece of plastic it appears to be?

Where did the rubber duck come from, anyway? And what happens after it plunges over the falls?

Georg Sochurek, born 1985, is currently in his 8th and last year of college preparatory school at the Gymnasium der Englischen Fräulein in St. Pölten. He has been working with 3-D animation for about two years now.
Georg Sochurek, geb. 1985, besucht zur Zeit die 8. Klasse (Maturajahrgang) des Gymnasiums der Englischen Fräulein in St. Pölten. Mit 3D-Animation beschäftigt er sich seit etwa zwei Jahren.

Gerät zur Messung und Analyse von Spondylolisthese

Martin Leonhartsberger / Sigrun Astrid Fugger

The project *A Device for Measuring and Analysing Spondylolisthesis* concerns itself with an ailment afflicting much of the population: when vertebrae slip forward over another vertebra and the resulting complications. Our objective was to detect such "slipped vertebrae" at an early stage and thus be able to prevent surgery by physiotherapeutic treatment.

The idea for using this kind of diagnosis was first conceived more than ten years ago by the qualified physical therapist Johann Leonhartsberger (Head of Physiotherapy at the Wagner Jauregg Regional Neurological and Psychiatric Clinic in Linz). The so-called provocation test is conducted by trained therapists and is now an accepted method. The suggestion to measure this phenomenon with the aid of an analysing device goes back to June 2001. In February 2002, I decided to work on this idea as a graduation project. Sigrun Fugger and I began to look for a company which could finance and

Das Projekt *Gerät zur Messung und Analyse von Spondylolisthese* beschäftigt sich mit einem in der Bevölkerung weit verbreiteten Leiden: dem Abrutschen bestimmter Wirbelkörper mit all seinen Konsequenzen. Ziel war es, dieses „Wirbelgleiten" bereits im Frühstadium zu erkennen und einer operativen Therapie mit physiotherapeutischen Behandlungen vorzubeugen.

Die Idee zu der von uns verwendeten Diagnosemöglichkeit wurde bereits vor über zehn Jahren von OASS. Dipl. PT Johann Leonhartsberger (Leiter der Physiotherapie an der Landesnervenklinik Linz Wagner-Jauregg) geboren. Der so genannte Provokationstest wird von speziell geschulten Therapeuten durchgeführt und ist mittlerweile anerkannt. Der Vorschlag, dieses Phänomen mittels eines Analysegerätes zu messen, hatte bereits im Juni 2001 seinen Ursprung.

Im Februar 2002 beschloss ich, dieses Projekt als Maturaprojekt auszuführen, und machte mich gemeinsam mit Sigrun Fugger auf die Suche nach einer Firma, die dieses Gerät finanzieren und bauen könnte. Nach einigen

Rückschlägen fanden wir die Fa. LeoTec, die sich bereit erklärte, das Projekt zu unterstützen und zu finanzieren. Im Gegenzug übernimmt die Fa. LeoTec sämtliche Rechte an der Entwicklung.

Nach anfänglichen Schwierigkeiten, das Projekt genehmigt zu bekommen, begann dann die Entwicklung im Sommer 2002. Als Projektbetreuer fanden sich DI Franz Cibej und DI Alfred Mair.

Ziel war es, ein Diagnosegerät zu entwickeln (Mechanik, Elektronik, Microcontroller Software, PC Software – NT, 2K, 9x). Die Ergebnisse sollten in grafisch ansprechender und verständlicher Form dem behandelnden Arzt oder Therapeuten präsentiert werden. Die Entwicklung lief zu Beginn sehr flott, die ersten funktionierenden Elektronikschaltungen und das PC-Programm waren bereits im November fertiggestellt. Die Probleme tauchten dann im Detail auf. Eine zwar im Prinzip funktionierende Elektronik verfälschte Messergebnisse bis zu 35 Prozent. Die PC-Software „vergaß" bei der USB-Übertragung hin und wieder auf ein paar Datenpakete usw. ...

Dank der tatkräftigen Hilfe sowohl in der Fa. LeoTec als auch unserer Professoren gelang es, die technischen Ursachen dieser Schaltungsprobleme zu finden und zu lösen. Abschließendes Ziel ist es, einen Prototypen im Testeinsatz in einem Krankenhaus auf Praxistauglichkeit zu erproben (zur Zeit im Wagner-Jauregg Krankenhaus in Linz).

construct this device. After several setbacks, we found LeoTec—they agreed to support and finance the project. In return, LeoTec was given all rights to the development.

After initial difficulties in getting the project approved, development began in summer 2002. Project supervisors were the engineers Franz Cibej and Alfred Mair.

The objective was to develop a diagnostic device (the mechanics, electronics, micro-controller software, PC software (NT, 2K, 9x)). The results of the analysis were to be presented graphically in a way which was attractive and easily understandable to the doctor or therapist treating a patient. To begin with, development went very quickly, the first functioning electronic circuit and the PC program were completed by November. Yet problems began to surface in details. The electronics worked in principle but falsified results by as much as 35%. Now and then, during USB transfer, the PC software "forgot" a few data packets, and so on...

Thanks to the active assistance of LeoTec as well as our professors, it was possible to find and resolve the causes of these technical problems. Our final goal was to test the practicality of a prototype in a hospital (this is currently being done at Wagner-Jauregg Hospital in Linz).

Sigrun Astrid Fugger, born 1984, is currently attending technical secondary school at the HTBLA II for Mechatronics in Linz. During her holidays and as a trainee she has worked in the department for diesel systems development at BOSCH und for VÖEST-Alpine Mechatronics. **Martin Leonhartsberger**, born 1984, is also attending the HTBLA II for Mechatronics in Linz. He is a certified Cisco network administrator and has worked as a trainee at the computer center of the Wagner Jauregg Regional Hospital of Upper Austria, as well as in the department for diesel systems development at BOSCH. In 2001, he received an Award of Distinction at the Prix Ars Electronica in the category Cybergeneration – u19 freestyle computing. **Sigrun Astrid Fugger**, geb. 84, besucht die HTBLA II für Mechatronik in Linz. In den Ferien und als Praktikantin hat sie in der Dieselentwicklung bei BOSCH und in der voestalpine Mechatronics gearbeitet. **Martin Leonhartsberger**, geb. 1984, besucht die HTBLA II für Mechatronik in Linz, ist zertifizierter Cisco-Netzwerk-Administrator und hat als Praktikant im Rechenzentrum des Landeskrankenhauses Wagner Jauregg des Landes Oberösterreich sowie in der Dieselentwicklung bei BOSCH gearbeitet. Im Jahr 2001 hat er eine Auszeichnung beim Prix Ars Electronica cybergenaration – u19 freestyle computing erhalten.

:.be A bee.:
Armin Ronacher / Nikolaus Mikschofsky

:.be A bee.: was developed between November 2002 and March 2003. The idea occurred to us when Niki's sister got a beehive. We really liked the social life of the bees, and their diligence impressed us. So we launched "Bee Manager 2002". This was what we first called :.be A bee.:. It all began with a simple Qbasic application. Within the same month we ported it all to Delphi. Though here the programming turned out to be a lot more complicated. We developed our own script engine which did the calculations. Displays are up-dated only once a day, but calculations are made every second. The first view was from one fixed camera position and had a single field of vision, which left little scope for action. Perhaps the graphics were, at first glance, somewhat

:.be A bee.: entstand von November 2002 bis März 2003. Die Idee kam uns, als Nikis Schwester einen Bienenstock bekam. Uns gefiel das Gesellschaftsleben der Bienen sehr und ihr Eifer beeindruckte uns. Also begannen wir mit dem „Bienenmanager 2002". Das war nämlich unser erster Name für :.be A bee.:. Angefangen hat es mit einer einfachen Qbasic-Anwendung. Diese wurde noch im selben Monat nach Delphi portiert. Allerdings wurde dort die Programmierung um einiges komplexer. Wir entwickelten eine eigene Script-Engine, die die Berechnungen durchführt. Es werden die Anzeigen zwar nur nach jedem Tag aktualisiert, allerdings wird innerhalb jeder Sekunde die Berechnung durchgeführt. Die erste Ansicht kam noch von einer fixen Kameraposition aus und mit einem festen Feld, welches keinen Handlungsfreiraum ließ. Die Grafik mag zwar auf den

ersten Blick etwas besser gewesen sein, allerdings wirkten die Bienen fehlplatziert, und der Spielspaß blieb aus.

Der nächste Schritt war dann die Implementierung der neuen Funktionen und der Innenräume. Die Innenräume wurden damals im selben Fenster wie die Übersicht angezeigt, und man konnte so nichts vom Äußeren sehen.

Ende Jänner hatten wir die Idee von *finalcut. finalcut* war der Name der letzten *:.be A bee.:*-Version. Wir bauten damals die ersten 3D-Detailansichten auf. Die Wettereffekte waren damals noch nicht implementiert, und so waren die ersten 3D-Bilder nicht sehr gut. Dass wir 3D-Bilder verwenden konnten, verdanken wir Corel Bryce5. Wir hatten damals drei PCs zur Verfügung. Wir installierten die 15-Tage-Testverison auf PC1. Dort entwarfen wir die Bienen und die 3D-Innenansichten, die sich seit v1 nicht verändert haben. Damals entstand auch der *:.be A bee.:*-Kurzfilm und das Active-4-Logo. Nach den 15 Tagen Testzeit war die 3D-Spielerei vorbei. Die Daten sicherten wir allerdings auf unseren PCs. Im Jänner brauchten wir die neuen Versionen der Bilder. Die Außenansichten machten wir auf PC2. Dort installierten wir es ein zweites Mal. Damals entstand das Handbuch in der ersten Version. Auch die Bauwerke für die Detailansichten wie das Kino entstanden in dieser Zeit. Der letzte Schritt war dann die Implementierung der Musik und des FX-Parts. Bis zum 19. März arbeiteten wir dann an der Animation der Biene, die übrigens von Niki gemacht wurde.

better, but the bees looked out of place and the fun was missing. The next step was to implement the new functions and interiors. At this point, the interiors were still being displayed in the same window as the overall view, which meant you couldn't see the exterior at all. At the end of January we had the idea for *finalcut. finalcut* was the name of the previous *:.be A bee.:* version. This was when we began constructing the first 3-D views of details. Weather effects weren't implemented yet, so the first 3-D pictures weren't very good. That we were able to use 3-D pictures at all was thanks to Corel Bryce5. At the time we had 3 PCs at our disposal. We installed the 15-day test version on PC1. On it we designed the bees and the 3-D interior views, these haven't changed much since v1. This is also when we made the *:.be A bee.:* short film und the Active-4 logo. After 15 days of testing it all out, we were done playing around with 3-D—though we did store the data on our PCs. In January we needed new versions of the pictures. We did the exterior views on PC2. We installed it all there a second time. And this was when the first version of the guidebook evolved. Also the structures for views of details as well as the cinema came into being at this time. The last step was to implement the music and FX parts. Until March 19th we worked on animating the bees which, by the way, was done by Niki.

Armin Ronacher, born 1989, is currently attending college preparatory school at the BORG Hermagor and majoring in computer science for programmers. **Nikolaus Mikschofsky**, born 1989, is also attending the BORG Hermagor and majoring in computer science. Besides snowboarding, swimming and cycling, they both enjoy programming most. **Armin Ronacher**, geb. 1989, besucht das Borg Hermagor mit dem Zweig Informatik für Programmierer. **Nikolaus Mikschofsky**, geb. 1989 in Villach, besucht das BORG Hermagor (Informatikzweig). Neben Snowboarden, Schwimmen und Radfahren ist das Programmieren das liebste Hobby der beiden.

It all began sometime in spring 1997. One day, on our daily train ride to school, my cousin Jeanny showed me a folder bulging with song texts which she had copied out of magazines.

At the time my homepage was relatively boring— and this was a chance to pep it up a bit. So I asked Jeanny whether she had the texts on disk. Luckily this was the case.

The next day I started inserting the texts on my homepage. I then uploaded it to my server. After that came the search engine and my friends' guest books, and it was not long till I had a few visitors. Jeanny was constantly supplying me with new texts. The number of hits rose steadily and quickly, and I began receiving emails from people and they sent me their texts. The whole thing really started to be fun, everyday there were more visitors and new texts. In May 2000 I moved to a new host and my page went online with more than 1,500 song texts. The number of visitors rose radically, my counter recorded up to 6,000 hits per day!

After a number of changes, I made a new version and the number of texts increased rather astronomically: over 140,000 texts and over 38,000 registered users have now been recorded by the counter and there's no end in sight.

Angefangen hat alles irgendwann im Frühling 1997. Eines Tages zeigte mir meine Cousine Jeanny bei der täglichen Zugfahrt zur Schule eine Mappe, prallgefüllt mit Liedertexten, die sie aus Magazinen abgeschrieben hatte.

Meine damalige Homepage war relativ fad – und dies die Chance, sie ein wenig aufzumöbeln. Ich fragte also Jeanny, ob sie die Texte auf Diskette habe. Zum Glück war dies der Fall.

Am nächsten Tag startete ich zu Hause mit dem Einfügen auf meiner Homepage. Diese habe ich dann auf meinen Server hochgeladen. Daraufhin kamen dann die Suchmaschinen und Gästebücher meiner Freunde dran, und nach nicht langer Zeit hatte ich auch schon einige Besucher. Laufend bekam ich neue Texte von Jeanny. Die Besucherzahlen stiegen ständig und rasch, und es meldeten sich die ersten Leute bei mir per E-Mail und schickten mir ihre Texte. Das Ganze begann richtig Spaß zu machen, täglich kamen mehr Besucher, neue Texte. Im Mai 2000 zog ich auf einen neuen Host um, und meine Seite ging mit über 1500 vorhandenen Texten online. Die Besucherzahlen stiegen nun extrem an, mein Counter zählte bis zu 6.000 Besucher pro Tag!

Nach einigen Umstellungen gab es abermals eine neue Version, und die Textanzahl stieg in – verhältnismäßig – astronomische Höhen an: über 140 000 Texte und über 38 000 angemeldete Benutzer zählt der Zähler im Moment, und das geht auch fleißig so weiter.

Dominik Dorn, born 1985, lives in Lustenau, Vorarlberg. His hobbies include his homepage (*lyrix.at*) and music. His favorite groups are Clawfinger, Limp Bizkit, Blink182, Liquido, etc. **Dominik Dorn**, geb. 1985, wohnt in Lustenau. Seine Hobbies sind seine Homepage (*lyrix.at*) und Musik. Seine Lieblingsgruppen sind Clawfinger, Limp Bizkit, Blink182, Liquido etc.

INFLEX.ORG
INDIVIDUAL INTERFACE
REQUIREMENTS: FLASH 6 PLUGIN || FAST MACHINE || JAVASCRIPT || MIN 1024 x 768
BEST VIEWED WITH: BROADBAND AND OPEN EYES

Wünscht sich nicht jeder von uns, einmal ganz persönlich behandelt zu werden, und dann noch ein kleines Stück Schokolade am Kissen …

Nun ja, das mit der Schokolade schafft *www.inflex.org* wahrhaftig nicht, aber einzigartig und individuell wird der Besuch der Seite ganz bestimmt, denn die visuelle Oberfläche generiert sich hier auf jedem Computer völlig individuell. Indem technische Eigenschaften wie etwa Betriebssystem oder Bildschirmauflösung des PC des jeweiligen Benutzers ausgelesen und anschließend in ASCII-Werte transformiert werden, können diese als Parameter zur Gestaltung der grafischen Oberfläche benutzt werden – etwa Form, Position, Größe oder Drehung bestimmter Objekte.

Auch Daten wie die aktuelle Uhrzeit fließen in die Gestaltung ein. Aber auch der Benutzer selbst kann beeinflussend eingreifen. Wenn er sich auf die Frage nach der Beschreibung der eigenen Person etwa als „systematisch" bezeichnet, wird das Gesprächsinterface viel geordneter sein, als wenn er sich als Chaot bezeichnet. Der Spiegelung der eigenen Persönlichkeit wird hier also die Technik entgegengesetzt und diese beiden Pole werden miteinander verschmolzen.

Don't we all have the desire to be treated completely personally for once, and to find a small piece of chocolate on our pillow… Well, to be truthful, *inflex.org* can't provide the chocolate, but a visit to this page is most definitely extraordinary and individual, because it generates itself entirely individually on each computer that visits it. By selecting technical properties, for instance the operating system or screen resolution of a user, and transforming them into ASCII values, these properties can be used as parameter for designing the visual interface, such as the form, position, size or rotation of specific objects.

Data, like the actual time, also flow into the design. But also users themselves can effectively influence the design. For example, if a user describes him or herself as systematic, the page interface will be much more orderly than if the user describes him or herself as chaotic.

Hence the reflection of a person's personality is pitted against technology and these two poles merged into one.

Georg Gruber has been attending technical secondary school at the HTL for Graphics and Communications Design in Innsbruck since 1998 and will graduate in 2003. His interests and hobbies include: art and design (à la Stefan Sagmeister or Valie Export), film and animation, music (à la Spex and FM4), playing footbag (hacky sack); he is a member of AFA, the Austrian Footbag Association. He received an Honorary Mention at the Prix Ars Electronica 2002 in the category Cybergeneration – u19 freestyle computing. **Georg Gruber** besucht seit 1998 die HTL für Grafik und Kommunikationsdesign in Innsbruck (Abschluss 2003). Interessen und Hobbys: Kunst und Design (à la Stefan Sagmeister oder Valie Export), Film und Animation, Musik (à la Spex und FM4), Footbag spielen (Hackysack), Mitglied der AFA Austrian Footbag Association. Bereits 2002 gewann er eine Anerkennung in der Kategorie cybergeneration – u19 freestyle computing.

system interrupted
Manuel Fallmann

system interrupted is set in a future where all processes are controlled by a gigantic, central computer network. This network is regulated by a main computer. When this computer takes on a life of its own, the entire network goes haywire—humanity is in danger and, what is more, totally defenseless. So a kind of soldier is sent out who should fight his way through to the main computer and place an EMP bomb there. Through the electromagnetic impulse of this bomb, the main computer—and along with it the entire network—is to switch off for a second, long enough to reconfigure the system.
I first had the idea for "system interrupted" in mid-2002. I then made some initial sketches. In the summer I started toying with the idea of making a game out of it. In November I began the whole project all over again, as an animation. After about 10 to 12 weeks I had finally completed system interrupted.

system interrupted spielt in einer Zukunft, in der sämtliche Vorgänge durch ein zentrales, gigantisches Computernetzwerk kontrolliert werden. Dieses Netzwerk wird von einem Hauptcomputer gesteuert. Als dieser sein Eigenleben entwickelt, gerät das ganze Netzwerk außer Kontrolle, die Menschheit schwebt in Gefahr und ist noch dazu absolut wehrlos. Deswegen wird eine Art Soldat losgeschickt, welcher sich zum Hauptcomputer durchkämpfen soll, um dort eine E.M.P.-Bombe zu platzieren. Durch den elektromagnetischen Impuls dieser Bombe sollen der Hauptcomputer und mit ihm das gesamte Netzwerk für kurze Zeit abgeschaltet werden, um eine Rekonfiguration des Systems vornehmen zu können.
Die Idee zu system interrupted hatte ich Mitte 2002. Ich fing damals an, Skizzen zu zeichnen. Im Sommer spielte ich mit dem Gedanken, ein Spiel daraus zu machen. Im November begann ich das Projekt wieder ganz von vorne, als Animation. Nach ungefähr zehn bis zwölf Wochen hatte ich dann system interrupted endlich vollendet.

Manuel Fallmann lives in Neulengbach and is currently in his eighth and last year of college preparatory school at the Gymnasium der Englischen Fräulein in St. Pölten. He has been working with Flash for about 2 or 3 years now and realizes that he is rather addicted to it. He received an Honorary Mention at the Prix Ars Electronica 2002 in the category cybergeneration – u19 freestyle computing. **Manuel Fallmann** wohnt in Neulengbach und besucht zur Zeit die 8. und letzte Klasse des Gymnasiums der Englischen Fräulein in St. Pölten. Mit Flash beschäftigt er sich mittlerweile zwei bis drei Jahre und muss feststellen, dass er im Grunde genommen ziemlich süchtig danach ist. Er hat bereits 2002 eine Anerkennung beim Prix Ars Electronica gewonnen.

Die Fliege
David Hackl

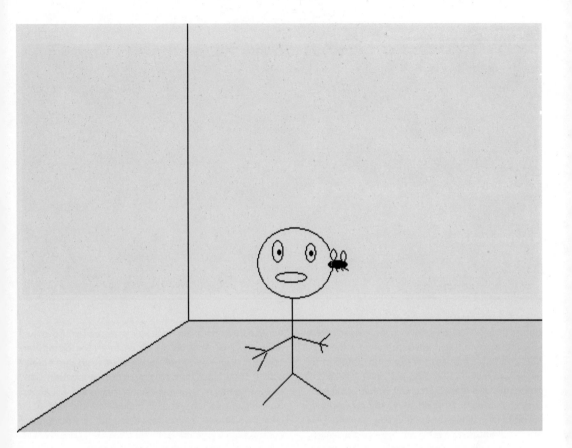

Als mir meine Mama von dem Wettbewerb erzählt hat, wollte ich zuerst ein Bild zeichnen. Aber dann hat mir mein Papa gezeigt, dass man durch Ausschneiden und Verschieben einen richtigen kleinen Film machen kann. Das hat mir sehr gut gefallen.

Zuerst wollte ich ein Gesicht mit rollenden Augen machen, aber dann ist mir die Idee mit der Fliege gekommen. So viele Bilder zu zeichnen war aber dann gar nicht so einfach. Lustig war noch das Aufnehmen der Geräusche und das Ansehen der fertigen Animation.

When my mom first told me about the competition, I had wanted to draw a picture. But then my dad showed me that by cutting and pasting, it was possible to make a real little film. I liked that a lot.

First I wanted to make a face with rolling eyes, but then I had the idea of the fly. Though it wasn't all that easy to draw so many pictures. I also enjoyed recording the sounds and watching the final animation.

David Hackl, born 1995, is currently in the second grade at the Volksschule 26 Harbach in Linz. His favorite pastime is to run around with his friends; he also enjoys riding his bike, swimming, reading lots of books, as well playing and drawing on his computer. Unfortunately he is not always allowed to play as long as he would like to. **David Hackl**, geb. 1995 in Linz, besucht zur Zeit die 2. Klasse der Volksschule 26 Harbach in Linz. In seiner Freizeit tollt er am allerliebsten mit seinen Freunden herum, fährt gerne mit dem Rad, schwimmt, liest viele Bücher und spielt und zeichnet auch sehr gerne am Computer. Leider darf er nicht immer so lange spielen, wie er gerne möchte.

School's Out for Rosh Hodesh Adar II

Thomas Hainscho

```
D:\WINNT\System32\cmd.exe                                    _ □ X

Und du schlägst die Augen auf. Zuerst erschrickst du, weil du nicht weißt, wo
du bist. Dann betrachtest du die Umgebung genauer. Du bist in deiner Schule.
Es ist der 4. März und weil du Jude bist, hast du für die nächsten 3 Tage
(einschließlich heute) frei. (Du feierst das Roch Hodes Adar II)
Aber was machst du dann in der Schule?
Plötzlich erinnerst du dich. Kurz vor Schulende haben dich Günter, Rüdiger und
Adolf zusammengeprügelt und hinter dem großen Baum in der Schulhalle liegen
lassen.
Du bist jetzt alle drei Tage alleine in der Schule eingesperrt!

Du merkst schon jetzt, dass du viel Spaß haben wirst...,

School's Out For Rosh Hodes Adar II
Ein 'spannendes' Textadventure, (c) 2003 Thomas Hainscho
Version 1.0 vom 06.03.2003

Eingangshalle

Diese Halle ist ein sehr großer Raum. Du bist bereits sehr oft hier gewesen.
Du siehst hier einen alten großen Baum in einem großen Blumentopf. Daneben
steht eine Bank mit einem Tisch. Rechts daneben hängt eine Pinwand.
                                                                      [...]
```

Before May 2002 I had never even played a text adventure game. (Text adventures were the very first computer games; they are navigated and played via text input and output only). I found my first game of this kind on a CD which came with a game magazine. I immediately liked it and during my summer holidays spent my time learning TAG (Text Adventure Generator), the programming language developed specifically for text adventures. Over Christmas vacation 2002 I began making my first game. I was inspired by other games, by different books and films.

My game is about a school kid who gets locked in his school over three Jewish holidays. He has to solve different problems and tasks to finally make his way out of the school building. The title of the game refers to the Jewish holidays which are closest to my birthday. Adar II is a leap month and Rosh Hodesh is the festival at the beginning of the month (though in reality schools aren't closed for these three days).

Vor Mai 2002 hatte ich noch kein einziges Text-Adventure gespielt (Text-Adventures sind die ersten Computerspiele, die es überhaupt gab; man steuert und spielt solche Spiele nur durch Textein- und -ausgabe). Das erste solche Spiel fand ich auf der Beipack-CD eines Spielemagazins. Ich war sofort begeistert und habe mich in den Sommerferien mit der eigens für Text-Adventures entwickelten Programmiersprache T.A.G. (Text Adventure Generator) beschäftigt. In den Weihnachtsferien 2002 begann ich dann mit meinem ersten Spiel. Ich wurde dabei von anderen Spielen, von verschiedenen Büchern und Filmen inspiriert.

Mein Spiel handelt von einem Schüler, der über drei jüdische Feiertage hinweg in seiner Schule eingesperrt ist. Er muss verschiedene Rätsel lösen und Aufgaben bewältigen, um am Ende wieder aus dem Schulgebäude heraus zu kommen. Der Titel des Spiels bezieht sich auf die jüdischen Feiertage, die meinem Geburtstag am nächsten lagen. Adar II ist ein Schaltmonat, und Rosh Hodesh ist das Fest am Beginn des Monats (allerdings haben Schulen in Wirklichkeit über diese drei Tage nicht geschlossen).

Thomas Hainscho, born 1987 in Klagenfurt, moved with his family to Maria Saal when he was five. After primary school, he began college preparatory school at the BG Tanzenberg. Since his 5th year there he has been able to attend a trial program for "web design and web publishing". **Thomas Hainscho**, geb. 1987 in Klagenfurt, zog mit fünf Jahren mit seiner Familie nach Maria Saal. Nach der Volkschule besuchte er das BG Tanzenberg. Ab der 5. Klasse bot sich ihm dort die Gelegenheit, den Schulversuch „Webdesign und Webpublishing" zu besuchen, den er seither belegt hat.

Der Sprung ins Ungewisse
Hauptschule Steinerkirchen / Traun

Filmvorbild zu diesem Realtrickfilm war Stefan Mittlböck-Jungwirths gemalter Animationsfilm *Die Heimfahrt*. Vier verschiedene Drehbücher wurden daraufhin erarbeitet. *Der Sprung ins Ungewisse*, eine Skaterromanze, machte das Rennen. Die gesamte Handlung wurde real abgefilmt, geschnitten und vorläufig vertont. Dann mussten Sequenzen des Films in Einzelframes zerlegt, gescannt und ausgedruckt werden. Diese Frames waren Vorlage für die Malbilder – insgesamt 833 gemalte bzw. gezeichnete Einzelbilder. Über 30 SchülerInnen konnten sich für diese Arbeit während des Sommersemesters begeistern. Die so entstandenen Einzelframes wurden gescannt, animiert und mit dem Realfilm zusammengefügt.

The both real-life and animated film *Leap into the Unknown* was modelled after Stefan Mittlböck-Jungwirth's hand-drawn animated film *Die Heimfahrt* ["The Journey Home"].
First we developed four different screenplays. *Leap into the Unknown*, a skater romance came in first. The entire story was first filmed with real people, edited and given a provisional soundtrack. Then these sequences had to be broken down into their individual frames, scanned and printed out. These frames formed the basis for the drawings. Altogether 833 individual pictures were painted or drawn. Over 30 pupils avidly did the work during the summer semester. The resulting frames were then scanned, animated and combined with the real-life shots.

A secondary modern school: **Hauptschule Steinerkirchen/Traun**, Landstraße 20. Film artist: Stefan Mittlböck-Jungwirth. Teaching team: Hans Kanzi, Wolfgang Wurm. Contributing pupils: Gretchel Hörtenhuber, Nadine Dvorak, Daniela Kienbauer, Elisabeth Neuböck, Pia Stockhammer, Sandra Truckenthanner, Eva Maria Neuböck, Christoph Lehner, Yvonne Greindl, Karl Krumphuber, Markus Lang, Christoph Breitwieser, Thomas Trückl, Gerald Wolf, Bernhard Katzinger, Daniela Truckenthanner, Manuela Radner, Anita Obermair, Marlene Neuböck, Christina Hager, Susanne Wieser, Eva Lindinger, Stefanie Auinger, Denise Stinglmayr, Andreas Gasperlmair, Astrid Seiner,Erika Rath, Eva Phringer, Stefanie Prem, Kerstin Strassmair, Sonja Lichtenmair, Karin Rau, Christine Wimmer, Kathi Wimmer, Elisabeth Stacheneder, Martin Zehetner, Jörg Gebeshuber, Achim Pichler, Claudia Peterleitner.
Hauptschule Steinerkirchen / Traun, Landstraße 20. Filmkünstler: Stefan Mittlböck-Jungwirth. Lehrerteam: Hans Kanzi, Wolfgang Wurm. Beteiligte SchülerInnen: Gretchel Hörtenhuber, Nadine Dvorak, Daniela Kienbauer, Elisabeth Neuböck, Pia Stockhammer, Sandra Truckenthanner, Eva Maria Neuböck, Christoph Lehner, Yvonne Greindl, Karl Krumphuber, Markus Lang, Christoph Breitwieser, Thomas Trückl, Gerald Wolf, Bernhard Katzinger, Daniela Truckenthanner, Manuela Radner, Anita Obermair, Marlene Neuböck, Christina Hager, Susanne Wieser, Eva Lindinger, Stefanie Auinger, Denise Stinglmayr, Andreas Gasperlmair, Astrid Seiner,Erika Rath, Eva Phringer, Stefanie Prem, Kerstin Strassmair, Sonja Lichtenmair, Karin Rau, Christine Wimmer, Kathi Wimmer, Elisabeth Stacheneder, Martin Zehetner, Jörg Gebeshuber, Achim Pichler, Claudia Peterleitner.

i² – was ist eine tolle Seite?

Alexandra Voglreiter, Katharina Krummel, Anna Obermeier

Alexandra had the idea for this project in spring 2003, after we had heard about u19. Katharina put together the homepage, Anna did a few graphics. Then Alexandra told us that she wouldn't be able to contribute 100 per cent to the project anymore, because she was under stress at school. But we were anyway almost finished and the participants were busy making their individual theme pages. It wasn't long till we had registered our project for u19 and we could settle down to the more peaceful part of our work. We all had a lot of fun doing the project.

Die Projektidee hatte Alexandra im Frühling 2003, nachdem wir von u19 erfahren hatten. Die Projekt-Homepage erstellte Katharina, Anna ein paar Grafiken. Dann musste uns Alexandra mitteilen, sie könne nicht mehr hundertprozentig mitmachen, da sie Schulstress hatte. Wir hatten aber fast alles fertig, und die Teilnehmer bauten schon fleißig an den einzelnen Themenpages. Die Anmeldung unseres Projektes bei u19 war bald erledigt, und es konnte zum ruhigen Teil der Arbeit übergegangen werden. Das Projekt hat uns allen viel Spaß gemacht.

Alexandra Voglreiter, born 1990, lives in Salzburg and is attending her third year of college preparatory school at the Gymnasium der Ursulinen. **Katharina Krummel**, born 1992. She is attending her first year of college preparatory school. For several years now she has worked on Internet projects (won first place in the German Netdays Competition and contributed to developing "Kinder Community" *www.cyberworks.net*). **Anna Obermeier**, born 1989, is attending her fourth year of college preparatory school at the Gymnasium Biondekgasse in Baden. **Alexandra Voglreiter**, geb. 1990, wohnt in Salzburg und besucht die 3. Klasse im Gymnasium der Ursulinen. **Katharina Krummel**, geb. 1992 in München (D). Besucht die 1. Klasse Gymnasium. Seit einigen Jahren betreibt sie Internet-Projekte (1. Platz beim deutschen Netdays-Wettbewerb und Aufbau der Kinder-Community *www.cyberworks.net*). **Anna Obermeier**, geb. 1989, besucht die 4. Klasse des Gymnasiums Biondekgasse in Baden.

Bewegung

Project Group from the Secondary School HBLA for Artistic Design, Garnisonstraße / Linz
Projektgruppe der HBLA für künstlerische Gestaltung, Garnisonstraße / Linz

Thema der Arbeit ist Bewegung – Begriffsvisualisierung mit Hilfe von Typografie und Animation.
Die Aufgabe bestand darin, das Thema multimedial umzusetzen, sinngehalten verständlich, aussagekräftig, einprägsam zu visualisieren. Die Schrift wurde als Ausdrucksmittel eingesetzt: Spannung, Ruhe, Kontrast, Akzentuierung ergaben sich durch die form-, rhythmus- und formationsbezogene Gestaltungsmöglichkeiten der Schrift. Die Animation und der Ton wurden als Wahrnehmungsverstärker eingesetzt.
Es handelt sich um ein Semesterprojekt, bei dem die Mechanismen des Mediums, visuelle Rhetorik, Gesetzmäßigkeiten der Dramaturgie gelehrt wurden.

The theme of this work is movement—the visualization of concepts by means of typography and animation.
Our assignment was to implement this theme using multi-media, to create visuals which would get across meanings expressively and so that they are easy to remember. Lettering was used as a means of expression: tension, calm, contrast, emphasis were all produced by making use of the possibilities of typographic design with regard to form, rhythm and formation. Animation and sound were used to heighten perception.
It was a semester project in which we were instructed in the mechanisms of media, visual rhetoric and dramaturgical principles.

The following pupils participated in the project group from the secondary school **HBLA for Artistic Design**, Garnisonstraße / Linz: Aigner Stephanie, Gratzer Magdalena, Hiotu Annina, Hold Ulrike, Hörschläger Susanne, Hutter Simone, Immervoll Leonhard, Kaltenberger Tamara, Kisilak Melanie, Lehner Elisabeth, Mayr Juliana, Baumgartner Stella, Morawetz Elisabeth, Pröll Dieter, Sandner Christina, Scheucher Stefanie, Sindhuber Alexander, Sommerbichler Julia, Steiner Laura, Sturm Katharina, Wechselauer Eva, Wizany Lisa-Maria, Broucek Andrina, Wöss Bettina, Zierer Veronika, Doppler Carina, Dullinger Kathrin, Dunst Alexander, Eder Astrid, Emrich Stefanie, Freinschlag Martin. An der Projektgruppe der **HBLA für künstlerische Gestaltung**, Garnisonstraße / Linz haben folgende SchülerInnen teilgenommen: Aigner Stephanie, Gratzer Magdalena, Hiotu Annina, Hold Ulrike, Hörschläger Susanne, Hutter Simone, Immervoll Leonhard, Kaltenberger Tamara, Kisilak Melanie, Lehner Elisabeth, Mayr Juliana, Baumgartner Stella, Morawetz Elisabeth, Pröll Dieter, Sandner Christina, Scheucher Stefanie, Sindhuber Alexander, Sommerbichler Julia, Steiner Laura, Sturm Katharina, Wechselauer Eva, Wizany Lisa-Maria, Broucek Andrina, Wöss Bettina, Zierer Veronika, Doppler Carina, Dullinger Kathrin, Dunst Alexander, Eder Astrid, Emrich Stefanie, Freinschlag Martin.

An acoustic reading aid for visually impaired
Die akustische Lesehilfe für Sehbehinderte

Franz Wengler / Christof Haidinger

Since it is almost impossible for the visually impaired to use a conventional electronic device with a display, we wanted to find a way to help them do so. Inspired by this thought, we contacted the Upper Austrian Association for the Blind. To assure that our project would fit the needs of the visually impaired, we discussed the problems involved. Due to the wide range of display types, we wanted to find a solution that would give our project universal application.

Since many devices have a display, many of the visually impaired are impeded in their independence both professionally and privately. Through our project they would be given the opportunity to gain footing in the working world. Moreover, they would be in the position to improve their personal independence.

The project can be realized with standard components. These components do not need to be state-of-the-art, a 200 MHz processor is completely adequate and so it is not a question of price.

The project strives to enable the visually impaired to read a display solely with the assistance of a computer. The contents on the display are to be read out over loudspeakers.

Da es für Sehbehinderte so gut wie unmöglich ist, ein herkömmliches elektronisches Gerät mit einem Display zu bedienen, war es uns ein Anliegen, eine Möglichkeit zu finden, ihnen dies zu ermöglichen. Dadurch inspiriert, setzten wir uns mit dem Oberösterreichischen Blindenverband in Verbindung. Um unser Projekt den Bedürfnissen von Sehbehinderten anpassen zu können, wurde die Problematik der Sehbehinderten besprochen. Wegen der Artenvielfalt von Displaytypen wurde nach einer Lösung gesucht, um unser Projekt universell einsetzen zu können.

Da viele Geräte ein Display besitzen, wird es Sehbehinderten erschwert, in der Arbeitswelt, aber auch im Privatbereich, selbstständig zu agieren. Durch unser Projekt würden sie die Möglichkeit erhalten, in der Arbeitswelt Fuß zu fassen. Außerdem wären sie auch im Privatbereich in der Lage, ihre Selbstständigkeit zu vergrößern.

Das Projekt kann mit handelsüblichen Komponenten realisiert werden. Diese Komponenten müssen sich nicht auf dem neuesten Stand der Technik befinden: Ein 200 Mhz-Prozessor würde vollständig ausreichen. Und deshalb sind sie auch keine Preisfrage. Das Ziel des Projektes ist es, Sehbehinderten zu ermöglichen, nur mit der Hilfe eines Computers ein Display zu ablesen zu können. Der Inhalt des Displays soll mittels Lautsprecher ausgegeben werden.

Franz Wengler, born 1983, and **Christof Haidinger**, born 1983, are currently attending technical secondary school at the HTL for Electrical Engineering, Energy Technology and Industrial Electronics in Braunau, Upper Austria. **Franz Wengler**, geb. 1983, und **Christof Haidinger**, geb. 1983, besuchen die HTL für Elektrotechnik, Energietechnik und industrielle Elektronik in Braunau (OÖ).

Klangbilder
Class 7a at the BORG 3 in Vienna / 7a des BORG 3 Wien

The computer has made it possible to generate sounds and images by using just one device. Crucial are the programs we employ to do so. In this project we first generated the sounds. They consist of small units which can be looped and combined with each other. Their small data size is important for their presentation online. The animated graphics were generated individually to fit each sound. These images were calculated based on vectors, which also helped keep the files small. Just the same, the works which ultimately unite image and sound in one interface offer the viewers/users of the page many possibilities for playing the films. The individual sound images can be switched on and off by clicking on a number of buttons, and so permit a large variety of combinations.

Mit dem Computer ist das Erzeugen von Tönen und Bildern mit einem Gerät möglich geworden. Entscheidend sind die Programme, mit denen wir arbeiten. Bei diesem Projekt haben wir die Sounds zuerst erstellt. Sie bestehen aus kleinen Einheiten, die geloopt werden können und sich miteinander kombinieren lassen. Ihre geringe Datengröße ist wichtig für die Präsentation im Netz. Die animierten Grafiken wurden passend zu den einzelnen Tönen generiert. Die Berechnung dieser Bilder aufgrund von Vektoren trägt ebenfalls dazu bei, die Dateien klein zu halten. Dennoch bieten die Arbeiten, die letztlich Bild und Ton in einer Oberfläche zusammenbringen, für BetrachterInnen / BenutzerInnen der Seite viele Möglichkeiten, die Filme zu spielen. Die einzelnen Klang-Bilder lassen sich durch mehrere Schaltflächen ein- und ausschalten und erlauben so viele Variationen ihrer Kombination.

A project by class 7a at the **BORG 3** in Vienna, a college preparatory school. Pupils: Tanja Zeitsek, Nikolaus Hellerich, Benedict Woiter, Stefan Wackernel, Oskar Prochazka, Selcuk Tuncel, Toni Eder, Daniel Hojlo, Maximilian Rupp, Martin Jarasek. Supervision—sounds: Alexander Wallner; project leader and assistance in generating the visuals: Barbara Zeilinger. Ein Projekt der 7a des **BORG 3** Wien. SchülerInnen: Tanja Zeitsek, Nikolaus Hellerich, Benedict Woiter, Stefan Wackernel, Oskar Prochazka, Selcuk Tuncel, Toni Eder, Daniel Hojlo, Maximilian Rupp, Martin Jarasek. Betreuung: Sounds: Alexander Wallner, Projektleitung / Hilfe bei der Bildgenerierung: Barbara Zeilinger.

Das Studio und die Greenbox

Tobias Schererbauer / Matthäus König / Sebastian Schreiner

Our *Greenbox* served as a universal backdrop for film takes and dance interludes. It enabled us to make our visuals more dynamic.

The basic idea: to film sequences which we could later recolor and alter easily on the computer; to create footage which could be used for visualizing music.

The solution: We bought green fabric at a building store and constructed our *Greenbox* in the studio, installed lighting to illuminate the green surface and began positioning the cameras. We asked friends to dance in front of the cameras. Their movements played an important role in the final material. We spent several days shooting very diverse takes. Afterwards the video material was transferred to a PC and reworked. We made the small clips which we needed for the video mix. We hunted for a location to show our work and have so far tried to combine electronic music with live visuals at two festivals.

Unsere *Greenbox* dient als universelle Grundlage für Filmaufnahmen und Tanzeinlagen. Durch sie war es uns möglich, mehr Bewegung in unsere Visuals zu bringen. Die Grundidee: Filmaufnahmen zu machen, die man bei der späteren Bearbeitung am PC leicht verfärben und verändern konnte. Filmmaterial zu schaffen, um Musik zu visualisieren.

Die Lösung: Wir besorgten uns grünen Stoff beim Baumarkt und bastelten uns unsere *Greenbox* im Studio, leuchteten die grüne Fläche aus und begannen Kameras zu positionieren. Wir baten Freunde, vor der Kamera zu tanzen. Diese Bewegungen spielen im Endmaterial eine wichtige Rolle. Wir verbrachten einige Tage damit, die verschiedensten Aufnahmen zu tätigen. Danach wurde das Videomaterial auf dem PC eingespielt und nachbearbeitet. Es wurden kleinere Clips erstellt, die wir zum Videomixen benötigen. Wir suchten uns eine Location und versuchten, auf bisher zwei Festivals elektronische Musik mit Live-Visuals zu verbinden.

Tobias Schererbauer, born 1984, is attending college preparatory school at the BG Schärding, and majoring in computer science and art education; he will graduate in 2003. **Sebastian Schreiner**, born 1984, is attending commercial secondary school in Schärding. **Matthäus König** (born Aug. 26, 1985) has already graduated from college preparatory school. Their interests include art, literature, music and digital video editing.

Tobias Schererbauer, geb 1984, besucht das Bundesgymnasium Schärding (Schwerpunkte Informatik und Bildnerische Erziehung), Matura 2003. **Sebastian Schreiner**, geb. 1984 in Schärding (OÖ), besucht die Handelsschule Schärding. **Matthäus König**, geb. 1985, hat seine Matura schon absolviert. Ihre Interessen sind Kunst, Literatur, Musik und digitaler Videoschnitt.

JURY

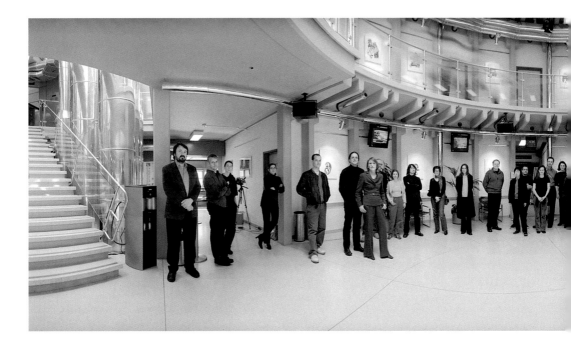

net vision / net excellence
Ed Burton, Joshua Davis, Casey Reas, Steve Rogers, Yukiko Shikata

interactive art
Scott S. Fisher, Tomoe Moriyama, Joseph Paradiso, Christiane Paul, Stahl Stenslie

computer animation / visual effects
Loren Carpenter, Olivier Cauwet, Hiroshi Chida, Bob Sabiston, Rita Street

digital musics
AGF aka Antye Greie, Naut Humon, Alain Mongeau, Marcus Schmickler, David Toop

cybergeneration–u19 freestyle computing
Sirikit Amann, Tina Auer, Horst Hörtner, Manfred Nürnberger, Martin Pieper

prix ars electronica team
Dr. Hannes Leopoldseder, Dr. Helmut Obermayr, Dr. Christine Schöpf,
Gerfried Stocker, Gabriele Strutzenberger, Judith Raab, Christina Aichinger

Net Vision / Net Excellence

Ed Burton (UK) grew up playing with computer programming, with his first software title being published at the age of 17. Following a degree in Architecture at the University of Liverpool, Ed undertook the MA in Digital Arts at the Middlesex University Centre for Electronic Arts. His MA work on computer models of young children's drawing behaviour was subsequently developed into an ongoing PhD research project into artificial intelligence, dynamic systems and developmental psychology. After three years of research and teaching at the Centre for Electronic Arts, Ed joined Soda in 1998 and was the original author of the Java toy sodaconstructor.

Joshua Davis (USA) is a New York artist and technologist producing both public and private work on and off the Web. His site *http://www.praystation.com* was the winner of the 2001 Prix Ars Electronica Golden Nica in the category "Net Excellence". He is currently an instructor at the School of Visual Arts in New York City and lectures globally on his work, inspirations and motivations.

Casey Reas (USA) recently obtained his MS degree in Media Arts and Sciences at the MIT Media Laboratory. His research at the MIT Media Lab's Aesthetics and Computation Group concentrated on interface design, information design, and computational kinetic sculpture. The common thread in his work is the study of dynamic reactive systems that receive and process input as a means of generating and altering visual compositions. Before joining MIT, he worked as Design Director at leading web design companies in New York. He studied design at the University of Cincinnati in the USA.

Steve Rogers (GB) started his career in 1983 designing spectacles for Norville Optical Company. From there, he went on to work for Gillette on the Braun brand in the research labs. In 1986 he left England to work for Philips Electronics in Holland as a product designer. Continuing his career with Philips, he moved to

Vienna in 1980 and to California in 1995. He spent a total of 15 years with Philips Design as Design Director. Before joining the BBC Rogers was VP, Physical Design at Razorfish digital consultancy in San Francisco. Here he had global responsibility for design of physical and service related products. In his first position at BBCi in August 2001 as

Head of Design and Navigation, Rogers was responsible for the design and navigation team defining users' experience of BBCi on the web, interactive TV and emerging platforms. In September 2002 he has been appointed as Head of Production for BBCi. Rogers has a degree from Coventry University in Transportation Design.

Yukiko Shikata (J) is an independent curator & critic based in Tokyo, working as associate curator of Mori Art Museum (MAM), guest curator of Shiseido CyGnet and specially-assigned professor at Tokyo Zokei University. Her works include projects at Canon ARTLAB(co-curator till 2001), Mischa Kuball *Power of Codes—Space for Speech* (Tokyo National Museum, 1999), *PROTOCOLLISION* (online, co-curated, 2000), *Kingdom of Piracy* (online, co-curated, 2001–) and *OPEN MIND* CD(MAM, 2002). She is curatorial committee member of eyebeam (NY) and international advisory board member of Transmediale (Berlin).

Computer Animation / Visual Effects

Loren Carpenter (USA), inventor of the CINEMATRIX Interactive Entertainment Systems® audience participation technology, holds multiple patents and has received numerous awards for inventing breakthrough computer imaging technologies such as RenderMan® to make three-dimensional animated movies like *Toy Story*, *A Bug's Life*, *Toy Story 2* and *Monsters, Inc.* possible. While attending the University of Washington for his studies in Mathematics and Computer Science, he was employed by The Boeing Company. Later he was part of the Lucasfilm Computer Division. Loren is currently Senior Scientist at PIXAR Animation Studios, creators of blockbuster animated feature films released by Disney.

Olivier Cauwet (F) is digital animation supervisor at BUF compagnie. After having studied at Supinfocom (F), where he co-directed the short movie *Ombre portee* (prix SACD imagina 98), he made his way through different companies in post-production in France as well as a participant in a news-illus-

tration project at Agence France Presse. Since April 1998 he has been at BUF compagnie as an animator and animation supervisor on advertising projects, video clips and feature films like *Fight Club*, *The Cell*, *Human Nature* and most recently *Panic Room*.

Hiroshi Chida (J), born in 1968, graduated from the Musashino Art University, Department of Visual Communication Design. He spent two years with an advertising agency working as a graphic designer before joining Polygon Pictures in 1995. After spending time as a CG artist and art designer, he made his directional debut in a highly acclaimed TV commercial for a major Japanese cosmetic company, Shiseido, directing one of its award-winning Rocky & Hopper Hard Mousse commercial series. He has also co-directed the award winning TV animation short series, *Mr. Digital Tokoro*, in which he conceptualized, wrote, and directed 245 three-minute episodes with his partner, Masayoshi Imayoshi. He has since directed the new *Polygon Family* series, which was his wild and bold sequel to the highly acclaimed 1998 short subject *Polygon Family*, which brings 3D animation to a whole new spectrum, integrating 2D graphics and Japanimation techniques in a 3D environment.

Bob Sabiston (USA) is a computer animator living in Austin, TX. He runs Flat Black Films, an animation company dedicated to producing independent short films. He was the animation director of Richard Linklater's 2001 feature film *Waking Life*, which used his propritary rotoscoping technology for animating on top of video footage. Bob is also the director of many short films including *Yard*, *Snack and Drink* and *RoadHead*. Most recently he and his team of animators have completed a short film segment for the Lars van Trier/Jorgen Leth film *The Five Obstructions*. In addition to doing a lot of the drawing, Bob writes all of the software used in Flat Black Film's projects.

Rita Street (USA) has been an editor for *Film & Video Magazine* and a Founder and President of the non-profit organization Women In Animation, Inc. She is also the author of the book *Computer Animation: A Whole New World*. She got her start in publishing at *Animation Magazine* and was later promoted to Publisher. She has been to SIGGRAPH several times and has published books worldwide. Besides her journalism job and her writing she has another big passion: rock climbing.

AGF aka Antye Greie (D) is musician, producer, vocalist author, artist and currently living in Berlin. AGF became internationally known by recording herself reading lines of code and then deconstructing them into a sluice of broken syllables and bursts of breath. AGF takes what has been done before with DSP laptop electronics and turns it on its head – into electronic roar, subsonic beats, vocal processing, multilingual lyric sampling. Selected works: AGF / *head slash bauch* (orthlorng musork 2000, *http://www.musork.com/o_08.html*); laub / *filesharing* (kitty-yo 2001, *http://www.laub-filesharing.de/*); cooperation with Vladislav Delay / *naima* (staubgold 2001); sound installation berlin.klang (SONAR 2000, acoustic code of Berlin). Artist in residence at Podewil 2001 (Berlin contemporary centre); *Quelle Berlin*, a multimedia event based on source code of Berlin; sound installation *audio.lab* (Centre Pompidou 2003).

Naut Humon (USA) is the director of operations for the RECOMBINANT MEDIA LABS in San Francisco. This network of A/V based actions houses the Surround Traffic Control cinesonic system for performance exhibitions and international residencies. He is also producer and curator for the Asphodel label along with his own projects for speaker–screen installations.

Alain Mongeau (CDN) has been founder and artistic director of MUTEC and has directed the section of new media at the Festival international du nouveau Cinéma et des nouveaux Médias de Montréal (FCMM). Additionally he has curated the 6th International Symposium of Electronic Arts ISEA 95 in Montreal. He holds a PhD in communication from the Université de Québec in Montreal and has produced dozens of new media art projects that have been shown at festivals internationally. He has been granted fellowships from the Conseil des Arts du Canada (1997, 1992, 1990), the Ministère des Affaires Culturelles du Québec (1990) and the Fondation UQAM (1988). He travels a lot to watch the evolution of different streams of new media, digital culture and electronic music.

Marcus Schmickler (D) is part of the electronic collective A-Musik, the home-base of acts like MOUSE ON MARS. On his new album, Jan St. Werner (Mouse on Mars, Microstoria) and Jaki Liebezeit (CAN) are involved with additional instruments (gongs, keyboards, drums). *Render Bandits* includes a large range of sound sources and a massive battery of drums. Marcus Schmickler himself and Jaki Liebezeit are responsible for the complexity of rhythms on the album. *Pluramon* is definitely in the tradition of the main German Krautrock band CAN, but neither is the sound of *Pluramon* a copy of the 70's sound nor is the project part of the alternative post rock movement. The use of manipulated instruments like gongs, guitars and special keyboards is inspired by electroacoustic and electronic sources and becomes very percussive on the album. The amplification of sounds creates an immersive environment of acoustic space. The music emits massive soundwaves, sound which is always travelling, never arriving. Sound opens endless horizons and spaces which can be filled with analogies, myths and images.

David Toop (UK) is a musician, writer and sound curator. He has published three books, currently translated into six languages: *Rap Attack*, *Ocean of Sound*, and *Exotica* (selected as a winner of the 21st annual American Books Awards for 2000). His first album, *New and Rediscovered Musical Instruments*, was released on Brian Eno's Obscure label in 1975; since 1995 he has released six solo albums and curated five acclaimed CD compilations for Virgin Records. In 1998 he composed the soundtrack for *Acqua Matrix*, the Lisbon Expo, has recorded shamanistic ceremonies in Amazonas, appeared on Top Of The Pops with the Flying Lizards, worked with musicians including Brian Eno, John Zorn (among others). As a critic and columnist he has written for many publications. He has curated Sonic Boom. In 2001–02 he was sound curator for Radical Fashion. Other recent projects include the composition of a soundtrack for Mondophrenetic and *Needle In the Groove*. Currently he is a Visiting Research Fellow at the Sound Department of the London Institute. *http://www.davidtoop.com*

Scott S. Fisher (USA) is a media artist and interaction designer whose work focuses primarily on interactive environments and technologies of presence. Well known for his pioneering work in the field of Virtual Reality at NASA, Fisher's media industry experience includes Atari, Paramount, and his own companies Telepresence Research and Telepresence Media. A graduate of MIT's Architecture Machine Group (now Media Lab), he has taught at MIT, UCLA, UCSD, and is a Project Professor at Keio University in Japan. His work has been recognized internationally through numerous invited presentations, professional publications and in the popular media. In addition, he has been an Artist in Residence at MIT's Center for Advanced Visual Studies and his stereoscopic imagery and artwork has been exhibited in the US, Japan and Europe.

Tomoe Moriyama (J) studied art history and received an MA degree at the University of Tsukuba. She participated in the Museum Preparation Office of Tokyo Metropolitan Government as a curator, during the doctoral course. Since 1989, she has organized over 30 exhibitions on media art and pre-cinema history including "Re-Imagination", "3D—beyond the stereography" and "UK98: electronically yours" (with J. Reichardt) as a curator of Tokyo Metropolitan Museum of Photography. She is an invited researcher of the University of Tokyo, as well as a lecturer in media art at Waseda University in Tokyo, also its postgraduate course and several other colleges of art. She is a jury member of Digital Contents Grand-Prix of the Ministry of International Trade & Industry, and a member of the council of the Virtual Reality Society, Japan.

Joseph Paradiso (USA) directs the MIT Media Lab's Responsive Environments Group, which explores the development and application of new sensor technologies for human-computer interfaces and intelligent spaces that create new forms of interactive experience and expression. Over the course of his career, his work has encompassed high-energy physics detectors, spacecraft control systems, electronic sensors and electronic music instruments. He has a Ph.D. in physics from MIT and is the winner of a 2000 "Discover Magazine Award" for Technical Innovation for his Expressive Footwear System. Background information and links to his projects can be found at *http://www.media.mit.edu/~joep*.

Christiane Paul (USA) is the Adjunct Curator of New Media Arts at the Whitney Museum of American Art and the director of Intelligent Agent, a service organization and information resource dedicated to digital art. She has written extensively on new media arts and has recently been working on a book about context and meaning in digital art with Victoria Vesna and Margot Lovejoy (to be published by MIT Press) and a book on *Digital Art* for the World of Art Series of Thames & Hudson, UK (to be published in 2003). She teaches in the MFA computer graphics department at the School of Visual Arts in New York and has lectured internationally on art and technology. Her first show at the Whitney, *Data Dynamics* (March–June 2001) dealt with the mapping of data and information flow on the Internet and in the museum space. She also curated the net art selection for the exhibition *Evo1* (Gallery L, Moscow, October 2001), for Fotofest (Houston, Texas, March/April 2002) and the 2002 Whitney Biennial (March-May, 2002). She is responsible for Artport, the Whitney's online portal to Internet art.

Stahl Stenslie (N) is a professor of experimental Media Art at the Media Academy of Cologne, Germany. He works with cognition and perception manipulative projects, spezializing in multi-sensorial interfaces. He's known as one of the Fathers of Cybersex after he built the world's first full-body, tele-tactile

communication systems in 1993 (cyberSM). His mating of man and machine has continued with the semantic god-machine (*erotogod*), currently with the world's highest multi-sensory resolution. Stahl has been exhibiting and lecturing at major international events (ISEA, DEAF, Ars Electronica, SIGGRAPH). He represented Norway at the 5th biennial in Istanbul, Turkey, co-organized 6cyberconf (Oslo '97), won the Grand Prize of the Norwegian Council for Cultural Affairs and moderated the Ars Electronica 2000 Symposium (Next Sex).

U19

Sirikit Amann (A) studied political science, theater arts and economics in Austria, Germany and USA. Since 1987 she has worked for the ÖKS (Austrian Cultural Services) where she is responsible for the concept development and implementation of multimedia projects in schools.

Tina Auer (A) has worked since 1994 as a freelance artist. From 1994 to 1996 she was a member of the collective Contained; since 1996 she has been active as co-founder of the cultural association Time's Up. In 2002 she finished her studies in experimental and visual design in Linz. Her fields of interest range from the functions and behaviours of people in

general situations taken from everyday life and artificially established, to the universal and specific use and abuse of visual media of all kinds – as well as everything in between.

Horst Hörtner (A) studied telematics at the Technical University in Graz and worked both as a developer of real-time control systems and for art projects. He was the co-founder of the group X-space and has also worked for the Seville EXPO, documenta IX, austromir, etc. Since 1995 he has been the technical director of the Ars Electronica Center in Linz.

Manfred Nürnberger (A) is partner of Hiebeler/Nürnberger GmbH, a consultant for interactive cross media formats. He is a pioneer in development and implementation of interactive media projects (amongst others Chello, Primacom, Alacatel). As a founder and CEO of ActiveAgent AG he helped develop

the company to be the second largest advertisement-trader in Europe with branches in Austria, Germany, Switzerland and Hungary. Additionally the Master of Business Administration is author of numerous publications and – together with Christian Eigner – author of *matching net*, a standard work on the new-media-economy.

Martin Pieper (A) is at present chief editor and radio announcer at FM4. For this man from Tulln, it was only a small step from passionate radio listener to radio-maker. In the first letter he ever sent to the Austrian Broadcasting Corporation (ORF), he pretentiously formulated his desire for more good music. With the 24-hour station FM4 more than just this dream has come true. Via radio Ö3's "Zick Zack" and "Musicbox", Martin Pieper joined the team founding FM4 in 1995. During this time he also aged years.

Antoni Abad
Santa Eulalia 21
8012 Barcelona
E
abad@zexe.net

Tcheupel Acte3
9 Rue Marcel Renault
75017 Paris
F
tch@acte3.com

Fabian Aerts
1107 Ch. de Wavre
1160 Bruxelles
B
info@ambivalence.be

Wilfried Agricola de Cologne
Mauritiussteinweg 64
50676 Köln
D
info@agricola-de-cologne.de

ah cama-sotz
Melaan 4
2800 Mechelen
B
bats.cats@skynet.be

Bertold Albrecht
Adalbert-Stifter-Str. 26
79102 Freiburg
D
bertold@bertold.de

Franz Alken
Hardenbergstr. 21
4275 Leipzig
D
franz@hgb-leipzig.de

Eyvind Almquist
Lofotengatan 21
16433 Kista
S
eyvind@virtualexp.net

Thilo Alt
Schnellhaus 46
51503 Rösrath
D
info@die-virtuelle-galerie.de

Antonio Alvarado
C/Navas del Rey, 13
28011 Madrid
E
a.alvarado@grupobbva.net

Diego Alvarez
Calle 41 no 69 a 55 int 4 apto 702
12345 Bogotá
CO
lepixma@hotmail.com

Toshitaka Amaoka
71-1-606 Urata Kaizuka
579-0061 Osaka
J
ta296@amaoka.com

Mark Amerika
PO Box 241
Boulder, CO 80306-0241
USA
amerika@netspace.org

Bernhard Anderl
Schönborng. 13
1080 Wien
A
wordart@neverland.at

Michele Andreoni
Via dei Riari 60
165 Roma
I
info@globalgroove.it

Johannes Auer
Arndtstr. 35
70197 Stuttgart
D
auer@kunsttot.de

Armelle Aulestia
32 Rue Bezout
75014 Paris
F
armelle@aulestia.net

K. Michael Babcock
PO BOX 1811
East Lansing, MI 48826
USA
tiln@aesova.org

Je Banach
264 Valleyview Rd
Thomaston, CT 6787
USA
jala2893@yahoo.com

Joey Bargsten
115 Lawrence Hall/5232
University of Oregon
Eugene, OR 97403-5232
USA
bargsten@darkwing.uoregon.edu

Brandon Barr
11, Shamrock ave, Shamrock lawn, Douglas
Cork
IRL
garrett@asquare.org

Koldo Barroso
Arroyo de la Media Legua, 33
28030 Madrid
E
intuitive@intuitivemusic.com

Nora Barry
PO Box 343
Narberth, PA 19072
USA
norabarry@druidmedia.com

Giselle Beiguelman
Rua Bandeira Paulista 97, cj 81
Sao Paolo - 01311-903
BR
giselle@desvirtual.com

John Bell
5713 Chadbourne Hall, Rm 426
Orono, MA 04469-5713
USA
kelley.caskey@umit.maine.edu

Thomas Berdel
Schießstätte 6
6800 Feldkirch
A
ttl@cyberdude.com

Tara Bethune-Leamen
3363 West 15th Ave
Vancouver, BC V6R 2Y9
CDN
info@tarabethuneleamen.com

Johannes Blank
Amalienstr. 99
80799 München
D
artornot@artornot.org

Natalie Bookchin
1926 Whitmore Ave
Los Angeles, CA 90039
USA
line@calarts.edu

Florian Brandt
Am Wandrahm 23
28195 Bremen
D
mail@brandtmark.de

Mez Breeze
44 Henry St Carlton
Sydney NSW 2218
AUS
netwurker@hotkey.net.au

Sabine Breitsameter
Hans-Bredow-Str.
76522 Baden-Baden
D
sbreitsameter@snafu.de

Jonah Brucker-Cohen
Sugar House Lane, Bellevue
Dublin 8
IRL
jonah@coin-operated.com

Karla Brunet
Av. Presidente Vargas, 1855/1503
97015 Santa Maria - RS
BR
karla@karlabrunet.com

Eva Brunner-Szabo
Währinger Gürtel 51/9
1180 Wien
A
e.b.szabo@t0.or.at

Christophe Bruno
11 Rue Monticelli
75014 Paris
F
chris@unbehagen.com

Sascha Buettner
Westendstr. 7
65195 Wiesbaden
D
sab@kein.org

Brooke Burgess
#302-230 West 4th St
North Vancouver, BC V7M 1H6
CDN
brooke@brokensaints.com

Joel Cahen
211 Dalston Lane
London E8 1HL
UK
newtoy_productions@yahoo.co.uk

Luigia Cardarelli
Via Gramsci 3
1017 Tuscania (VT)
I
lucardar@tin.it

Shulea Cheang
52 Andrews Rd
London E84RL
UK
shulea@earthlink.net

Alexander Chen
13 Charter St, Apt 3 Front
Boston, MA 2113
USA
alex@carbonatedjazz.com

Seb Chevrel
6005 N. Mississipi
Portland, OR 97217
USA
seb@seb.cc

Alison Chung-Yan
805-2881 Richmond Rd.
Ottawa, ON K2B8J5
CDN
achungyan@sprint.ca

Nicolas Clauss
11, Allée de la Corniche
78 410 Aubergenville
F
niclauss@flyingpuppet.com

Curt Cloninger
28 Etta Drive
Canton, NC 28716
USA
registrar@deepyoung.org

Sebastien (a.k.a. Pep) Clouet
1523 Route des Quenières
6140 Tourrettes sur Loup
F
pep@nineaem.com

Peter Colbert
Assmayerg. 31/48
1120 Wien
A
pjedlicka@aon.at

Susan Collins
129 Camden Mews
NW1 9AH London
UK
susan@inhabited.net

Jean-François Colonna
91128 Palaiseau Cedex
F
colonna@cmap.polytechnique.fr

computerteam: -iou
Wolffstr. 3
22525 Hamburg
D
gpichler@surfeu.de

Fabrizio Coniglio
Via Vercelli 24
10036 Settimo (TO)
I
webzoo@coniglioviola.com

Marcello Conta
C/Batel 4 Bajo "C"
28042 Madrid
E
ching@mashica.com

Tania Copechi
c/Ferlandina 23 (2-1)
8001 Barcelona
E
TANIA@0100101110101101.ORG

David Crawford
c/o Mossberg, Garverigatan 3
416 64 Göteborg
S
crawford56@hotmail.com

leon Cullinane
6 Peary Place
London E2 0QN
UK
leon@c6.org

Ursula Damm
Franz-Jürgens-Str. 12
40474 Düsseldorf
D
ursula@khm.de

Luca D'Angelo
Via Sauro 1
42100 Reggio Emilia
I
nothing@k-hello.org

David Dansone
54 East 8th St #6A
New York, NY 10003
USA
davids@dnyc.net

Juliet Davis
5334 Third Avenue North
St. Petersburg, FL 33710
USA
info@julietdavis.com

Michael Dawidowicz
207 Casa Bianca, 1-2-7
Shioyaki, Ichikawa Shi
272-0114 Chiba Ken
J
michael@urbancollective.com

Joseph DeLappe
Department of Art/224
89509 Reno, NV
USA
delappe@unr.nevada.edu

Carlos J. Gomez de Llarena
17 W 54th St. Apt. 8-D
New York, NY 10019
USA
carlos@med44.com

Peter DePietro
PO Box 286270
New York, NY 10128
USA
pvdnyc@hotmail.com

Sergey de Rocambole
Lunacharskogo av., 38 - 276
194356 Saint Petersburg
RUS
rocambol@lynx.ru

Sara Diamond
502 2nd St
Canmore, AL T1W 2K5
CDN
sara@codezebra.net

Dimiter Dimitrov
78, Samokov Blvd., Bl. 305,
Ap. 61
1113 Sofia
BLG
megaart@otel.net

Mason Dixon
1452 N Bosworth
Chicago, IL 60622
USA
mason@designafternext.com

Gisela Domschke
65 Highbury New Park
London N52ET
UK
glenloch@clara.net

Karen Ann Donnachie
Viale Coni Zugna, 4
Milano
I
karen@thisisamagazine.com

DoubleNegatives
3-42-8-405 Jinu-mae Shibuya
150-0001 Tokyo
J
mail@doubleNegatives.jp

Alex Dragulescu
1259 Windsor Rd
Cardiff, CA 92007
USA
alex@loudink.com

Jay Dykes
Greencroft Str
Salibury SP 11JF
UK
j@mytinygarden.com

Christoph Ebener
Mendelssohnstr.13
22761 Hamburg
D
christoph@raumschiff-inter
active.de

Jorn Ebner
37A Cecilia Rd
London E8 2ER
UK
jorn.ebner@britishlibrary.net

Gino Esposto
Langstr. 197
8005 Zürich
CH
carl@micromusic.net

exonemo
3-15-15-301 Kichijoji
180-3 Musashino-City
J
mail@exonemo.com

Meredith Finkelstein
85 4th Ave
New York. NY 10003
USA
mnfinkel@hotmail.com

Andrea Flamini
5577 Crestwood Dr
Kansas City, MO 64110
USA
andrea@flamini.com

Shane Fleming
1237 Howe St
Vancouver, BC V6Z1R3
CDN
sfleming@switchinteractive.
com

Laura Floyd
169 Emerald Green Dr
Lexington, GA 30648
USA
jiffylux@yahoo.com

Maria Luiza Fragoso
Campus Universitário
70910-900 Brasilia
BR
malufragoso@hotmail.com

Alvar C.H. Freude
Ludwig-Blum-Str. 37
70327 Stuttgart
D
prixars-einreichung-
2003@alvar.a-blast.org

Darko Fritz
Jacob van lennepstraat 349
1053 JL Amsterdam
NL
fritz.d@chello.nl

Markus Fürderer
Alemannenstr. 57
78183 Hüfingen
D
markus.fuerderer@plan-phase.
de

Doris Fürst
Hildebrandtstr. 14
40215 Düsseldorf
D
info@bionic-systems.com

Tinsley Galyean
147 Sherman St
Cambridge, MA 2478
USA
tinsley@nearlife.com

Jens Gantzel
August-Bebel-Str. 105
33602 Bielefeld
D
kontakt@jottwege.de

Carmen Garrido
Av. Marquès de Comillas, 6-8
8038 Barcelona
E
vfarras.fundacio@lacaixa.es

Caroling Geary
34 Herons Watch Way,
#1203
Santa Rosa Beach, FL 32459
USA
caroling@wholeo.net

Andreas Gessl
Haus 23
4712 Michaelnbach
A
gess@checkbit.com

Beatrice Gibson
Flat gw, Ramalayam Building,
Peddar Road
400026 Mumbai
IND
bea@nungu.com

Ryan Gibson
1452 N Bosworth
Chicago, IL 60622
USA
mason@designafternext.com

Petra Goebel
40, Buxton Rd
London N19 3XX
UK
petra@pg-01.co.uk

Simon Goldin
9 Manningtree St
London E1 1LG
UK
simon@monetaryinquiry
association.org

Ron Goldin
721 Broadway, 4th Floor
New York, NY 10003-6807
USA
tobiasblue@gmx.net

Michael Göller
Taunusstr. 17
55118 Mainz
D
michael.goeller@t-online.de

Martin Gomez
Loyola Heights
1108 Quezon City
RP
pgomez@student.ateneo.edu

Reinhard Gradl
Wittekweg 11/9
8020 Graz
A
r1i@gmx.at

Gunther Groenewege
60, Rue la Condamine
75017 Paris
F
gunther@groenewege.com

Joris Gruber
Waltherstr. 6
4020 Linz
A
joris@joris.at

Genco Gulan
Hakim Tahsin Sokak 35/2
Emirgan
80850 Istanbul
TR
gencogulan@yahoo.com

Jemma Gura
1419 West 27th St, #8
Minneapolis, MN 55408
USA
lentil@prate.com

Brigitte Hadlich
Sonnige Lehne 3
95466 Weidenberg
D
hadlich@hadlich-art-de

Stefan Hager
Arcisstr. 39
80799 München
D
stefan.hager@transordinator.de

Daniel Hahn
Rue du Beulet 8
1203 Genève
CH
hahn@kleinteilproduktion.de

Jia Haiqing
601, Building 10, Mudanyuan-
beili 20, Huayuanbeilu,
Haidian District
100083 Beijing
PRC
apple@8gg.com

Andreas Haller
Rossello 195 4.2.
8036 Barcelona
E
kyu@xterkyu.net

Tal Halpern
159 Second Avenue, Apt 4
New York, NY 10003
USA
biography@mindspring.com

Jan Hanibal
Mecikova 4
106 00 Praha 10
CZ
jan@hanibalart.cz

Lars Hard
PO Box 2004
22002 Lund
S
lars@cogamp.com

Mongrel Harwood
176 Glendale Gardens
Leigh-On-Sea, SS9 2BA Essex
UK
harwood@mongrelx.org

Masato Hatanaka
Dorotheenstr. 57
22301 Hamburg
D
htnkmst@yahoo.co.jp

Nathan Hemenway
1333 1/2 Masselin
Los Angeles, CA 90019
USA
nhemenway@teeter.org

Lynn Hershman
1201 California St
San Francisco, CA 94109
USA
lynn2@well.com

Martin Hesselmeier
Kirchenstr. 2a
68159 Mannheim
D
martin@plusfournine.de

August Highland
PO Box 99423
San Diego, CA 92169
USA
litob@san.rr.com

Tad Hirsch
10 Williams Street, #24
Roxbury, MA 02119
USA
tad@media.mit.edu

Chi Hoang
Jahnstr. 16
50676 Köln
D
info@chihoang.de

Bernie Hobbs
GPO Box 9994
Melbourne, VIC 3001
AUS
macdonald.carolyn@abc.net.au

Christian Hochstatter
Wallbergstr. 16
82008 Unterhaching
D
taumel@marune.de

Oliver Holle
Hasnerstr. 123
1160 Wien
A
csc@sysis.at, dkk@sysis.at

Andy Hook
GPO Box 9994
Melbourne, VIC 3001
AUS
macdonald.carolyn@abc.net.au

Madelon Hooykaas
Grote Bickerstraat 44C
1013 KS Amsterdam
NL
elsa@euronet.nl

Peter Horvath
198 Spadina Ave Studio 301
Toronto, ON M5T 2C2
CDN
arselectronica@6168.org

Kenneth Tin-Kin Hung
1626 22nd Ave
San Francisco, CA 94122
USA
kenneth@tinkin.com

Minty Hunter
GPO Box 9994
Melbourne, VIC 3001
AUS
macdonald.carolyn@abc.net.a
u

Thorsten Iberl
Böhmerwaldstr. 57
85737 Ismaning
D
info@toca-me.com

Shaun Inman
47 Alandale Parkway
Norwood, MA 2062
USA
design@shauninman.com

INSERTSILENCE
630 Manhattan Ave #3R
Brooklyn, NY 11222-3100
USA
contact@insertsilence.com

Kanae Ito
237 Sullivan St #2A
New York, NY 10012
USA
kanae@kanae.org

Mónica Jacobo
General Paz 1514
5000 Cordoba
RA
monijacobo@hotmail.com

Tyler Jacobsen
51 3rd St
Troy, AL 12180
USA
tyler@conglomco.org

Agathe Jacquillat
Flat33 27 Hereford Rd
London W24TQ
UK
contact@flat33.com

Ravi Jain
228 Chestnut Avenue
Jamaica Plain, MA 2130
USA
ravi@three-abreast.com

Roya Jakoby
75 Bleecker St #4A
New York, NY 10012
USA
roya@girlfish.net

Max Jap
Währinger Gürtel 47/4
1180 Wien
A
miro@japic.name

Cyril Jimpunk
76 Rue du Faubourg du
Temple
75011 Paris
F
error401@jimpunk.com

Dave Jones
88 Main St
Natimuk, VIC 3409
AUS
dave@transience.com.au

Nathan Jurevicins
GPO Box 9994
Melbourne, VIC 3001
AUS
macdonald.carolyn@abc.net.au

Yael Kanarek
76 E 7th St #31
New York, NY 10003
USA
yael@treasurecrumbs.com

Aarre Kärkkäinen
Aallonhuippu 5 b 33
2320 Espoo
SF
aarre@karkka.pp.fi

Wolfgang Karl
Altes Dorf 23
24855 Jübek
D
wk@wkarl.de

Gunnar Karlsson
Ægisgata 7
101 Reykjavik
IS
hilmar@caoz.is

Bjoern Karnebogen
Am Rinkenpfuhl 46
50676 Köln
D
bjoernk@khm.de

Oliver Kauselmann
Zähringer Allee 9
75177 Pforzheim
D
01@onesandzeros.de

Tom Kemp
53 Mill St
Oxford OX2 0AL
UK
tom@twicepublishing.com

Robert Kendall
1800 White Oak Dr
Menlo Park, CA 94025
USA
kendall@wordcircuits.com

Andruid Kerne
3112 Tamu
College Station, TX 77843
USA
andruid@csdl.tamu.edu

Zsolt Keserue
Nap utra 2.1.4
2400 Dunqujvoros
H
keseRue@freemail.hu

KeyWorx Team
Nieuwmarkt 4
1012 CR Amsterdam
NL
sher@waag.org

Heiko F. Kiendl-Müller
Bürgerstr. 8
22081 Hamburg
D
pdc@pxpress.de

Haruka Kikuchi
201-1-5-3,Nishi,Kunutachi-shi
186-0005 Tokyo
J
nekobasu@bmail.plala.or.jp

Suzung Kim
San 56-1 Sin-lim Dong
151-742 Kwan-Ak-Ku
RC
suzung@imagedrome.com

Takakiyo Kitagawa
3-2-18-205 Sekime, Joto-ku
536-0008 Osaka
J
takakiyo@yo.rim.or.jp

Thorsten Kloepfer
Zähringer Allee 9
75177 Pforzheim
D
10@onesandzeros.de

Randy Knott
111 Lawton Blvd #412
Toronto, ON M4V1Z9
CDN
randy@iamstatic.com

Erika Kobayashi
3-38-6 Hagiwara-kata
167-54 Shoan
J
erika@homesickless.org

Daniil Kocharov
Lunacharskogo av., 38 - 276
194356 Saint Petersburg
RUS
daniil_kocharov@yahoo.com

Kenji Kojima
41 West 89th St
New York, NY 10024
USA
webart@kenjikojima.com

Ilya Komarov
Drovyannoy per., 4 - 1
190121 Saint Petersburg
RUS
mur@lynx.ru

Christoph Korn
Oberlindau 112
60322 Frankfurt
D
korn@pol-music.de

Shirin Kouladjie
#411 - 509 Dunsmuir St
Vancouver, BC V6B1Y4
CDN
k@photomontage.com

Ksenija Kovacevic
Cara Lazara 6
24000 Subotica
YU
ksenijasu@hotmail.com

Annja Krautgasser
Friedmanng. 20/9
1160 Wien
A
nja@vidok.org

Mirko Kubein
Steubenstr. 44
99423 Weimar
D
mirko@kubein.de

Gil Kuno
2-2-2 Higashiyama #904,
Meguroku 153-43
Tokyo
J
gil@unsound.com

Chris LaBonte
296 Linsmore Crescent
Toronto, ON M4J 4I9
CDN
petrielounge@rogers.com

sulake labs
eteläranta 14
130 Helsinki
SF
belly@sulake.com

Francis Lam
C2712 Kornhill, Quarry Bay
Hong Kong
PRC
francis@db-db.com

LAN
Birmensdorferstr. 260
8055 Zürich
CH
aruest@trash.net

Teresa Lang
385 ave Mont Royal West,
apt. 305
Montreal, QC H2V2S4
CDN
tiger@smokingmoose.com

Last Fm
86b Greenfield Rd
E1 1EJ London
UK
martin@last.fm

Torsten Lauschmann
Top right Flat, 268 Kenmure
Str
Glasgow G 412QY
UK
hello@lauschmann.com

LeCielEstBleu
52 Blvd Beaumarchais
75011 Paris
F
kristine@lecielestbleu.com

Gicheol Lee
45 River Drive South #1207
Jersey City, NJ 7310
USA
cameo@studiotimo.com

Simone Legno
Anagnina 331 c1
40 Roma
I
simone@tokidoki.it

Tom Leonhardt
13A Saint Mathias Place
Toronto, ON M6J 2N4
CDN
tomtom@ping.ca

Rita Leppiniemi
Suonionk 8 C 90
530 Helsinki
SF
rita@muu.fi

Manuela Leu
Zieblandstr. 5
80799 München
D
aec@heiligenblut.de

Peter Luining
Kattenburgergracht 17 K
1018KN Amsterdam
NL
email@ctrlaltdel.org

Nathan Martin
40 State St Floor 2
Troy, AL 12180
USA
nathan@hactivist.com

Roman Minaev
Soerensen
24143 Kiel
D
minaev@muthesius.de

Davis O. Nejo
Rainerg. 35/2/9
1050 Wien
A
ccc@t0.or.at

Golan Levin
78 South Elliott Place
Brooklyn, NY 11217
USA
golan@flong.com

Garrett Lynch
11, Shamrock ave, Shamrock
lawn, Douglas
Cork
IRL
garrett@asquare.org

Matej Krtince
3241 Podplat
SLO
flasher@pikslar.com

Ricardo Miranda Zuñiga
133 Middleton St. 5th Fl.
Brooklyn, NY 11206
USA
ricardo@volume71.com

William Ngan
Flat 27E, Hong Park Mansion,
Park Vale, Quarry Bay
Hong Kong
PRC
contact@metaphorical.net

Lia
Schelleing. 26/2/30
1040 Wien
A
lia@re-move.org

H. D. Mabuse
Amizade, 94 / 503 A
52011260 Recife
BR
mabuse@manguebit.org.br

Fumio Matsumoto
2-11-27-302 Yakumo Meguro-
ku
152-0023 Tokyo
J
matsumoto@plannet-arch.com

Enrico Mitrovich
Via P. Ignago 14
36033 Isola Vicentina (VI)
I
emitrov2@goldnet.it

Yoshimasa Niwa
Endoh 5322
252-0816 Fujisawa Shi, Kana-
gawa Ken
J
niw@imgl.sfc.keio.ac.jp

Haidee Lima
Amizade, 94 apt 503 Bl-A
Graças
52011260 Recife - PE
BR
hccl@cesar.org.br

Machfeld
Johann-Strauß-G. 29/5-6
1040 Wien
A
mastro@machfeld.net

Bernd Mattiebe
Vogelsangstr. 101/1
70197 Stuttgart
D
bernd@mattiebe.de

MKG-Team
Kurfürstenstr. 47
53115 Bonn
D
andrea.helbach@t-online.de

Ragnar Helgi Olafsson
Asendi 8
108 Reykjavik
IS
ragnar@webwaste.net

Holger Lippmann
Singerstr. 1
10179 Berlin
D
lippmann@lumicon.de

Alastair Macinnes
38 Garton St
Carlton North, 3054
AUS
almaci@hotmail.com

max x-maxx hoffs
Friedenstr.16
40219 Düsseldorf
D
x-maxx@web.de

Andrea Modenese
Via dell'Altopiano 3
31033 Castelfranco Veneto
(TV)
I
andreamod@ovo3.com

Zsolt Olejnik
Dombay u. 7.
7720 Pécsvárad
H
nicron@underground.hu

Victor Liu
647 East 11th St #22
New York, NY 10009
USA
victor@n-gon.com

Leandro Madrazo
Quatre Camins, 2
8022 Barcelona
E
madrazo@salleurl.edu

Nuno Maya
Quinta Da Boa Esperanca,
Lote 14
2710 Sintra
P
nuno.maya@iF.com

Motor (a.k.a. Angelo
Comino)
Lungo Dora Voghera 152
10153 Torino
I
motor@addictions.it

Oniris
13 Rue Versigny
75018 Paris
F
peire@libertysurf.fr

Marita Liulia
Rauhankatu 7 E 38
170 Helsinki
SF
liulia@medeia.com

Michael Takeo Magruder
31A Jobs Lane
Coventry CV4 9DZ
UK
m@takeo.org

Wendy McLean
GPO Box 9994
Melbourne, VIC 3001
AUS
macdonald.carolyn@abc.net.au

Mouchette
Van Speykstraat 91B
1057 GR Amsterdam
NL
mouchette@mouchette.org

Alessandro Orlandi
Via Montepertico 105
19125 La Spezia
I
info@aleart.net

Thierry Loa
26 Olive Avenue, Suite 507
Toronto, ON M2N 7G7
CDN
tloa2003@yahoo.com

Sergio Maltagliati
Via Mammianese 81
51017 Pescia (PT)
I
maltaser@tiscali.it

Antonio Mendoza
4021 Holly Knoll Dr.
Los Angeles, CA 90027
USA
gotcipro@yahoo.com

Julien Moulin
34 Rue Vasselot
35000 Rennes
F
moulinjulien@wanadoo.fr

Karen O'Rourke
10 Rue Véronèse
75013 Paris
F
korourke@wanadoo.fr

Freya Lombardo
10 Selwyn Str
Elsternwick, VIC 3185
AUS
fl_y@bigpond.com

mami.0
18 Rue des Quatre Fils
75003 Paris
F
mami.0@free.fr

Marcello Mercado
Neusser str. 22
50670 Köln
D
m_2@gmx.de

Gisela Müller
Ferdinand-Miller-Platz 10
80335 München
D
admin@worldwatchers.de

Juan Carlos Orozco
Velásquez
Peter-Welter-Platz 2
50676 Köln
D
juan@khm.de

Heide Lorek
Altes Dorf 23
24855 Jübek
D
info@pixnhits.com

Calin Man
Enescu 1
2900 Arad
RO
revoltaire@go.ro

Yucef Merhi
300 Mercer St # 17L
New York, NY 10003
USA
www@cibernetic.com

Benjamin Mündörfer
Im Weißen Tal 8
64331 Weiterstadt
D
muendoerfer@web.de

Andrea Otero
Rennelbergstr. 2
38114 Braunschweig
D
aotero@arsneo.de

Jessica Loseby
Miracle' Church Lane, Birdham
Chichester PO20 7AT
UK
jess@rssgallery.com

Andreas Margreiter
Mariahilferstr.51/2/17
1060 Wien
A
am@wunderwerk.at

Myriel Milicevic
Kollwitzstr.89
10435 Berlin
D
lamblights@fetafarm.com

I8U n/a
01220 Atwater
Montreal, Quebec H3K3J3
CDN
muse@i8u.com

Christopher Otto
243 Henry St #14
New York, NY 10002
USA
thisisfresh@yahoo.com

Alessandro Ludovico
Via Capriati 16
70125 Bari
I
a.ludovico@neural.it

Aliyah Marr
119 Hamilton Ave
Fairview, NJ 7022
USA
amarr@radi8.org

Radovan Milinkovic
NA Hroude 43
100 00 Praha 43
CZ
autopsia2001@hotmail.com

Taiyo Nagano
24 Ravensdon St
London SE11 4AR
UK
taiyo@jellyhunters.com

Randall Packer
2332 Huidekoper Pl NW
Washington, DC 20007
USA
rpacker@zakros.com

Eun-Ha Paek
44 Henry St, Flr 4
Brooklyn, NY 11201
USA
eun-ha@milkyelephant.com

Rick Palmer
18 Charlotte Rd
London EC2A 3PB
UK
liz@blocmedia.com

Christian Paraschiv
113 Rue Nationale
75013 Paris
F
paras.c@infonie.fr

Niki Passath
Kübeckg. 15/2/36
1030 Wien
A
niki@ff33.cc

Xavier Pehuet
32 Rue de l'Assomption
75016 Paris
F
hollowgram@noos.fr

Margaret Penney
49 Clinton Ave
Dobbs Ferry, NY 10522
USA
margaret@dream7.com

Ben Pinckney
2204 East Devonshire Ave
Phoenix, AZ 85016
USA
ben@songsofacorporation.com

Émilie Pitoiset
5-7 Rue Hippolyte Pinson
94340 Joinville le Pont
F
unlink@free.fr

Playing Field
Keizersgracht 264
1016 EV Amsterdam
NL
claud@montevideo.nl

Angelo Plessas
2194 8th Ave
New York, NY 10026
USA
ap@angeloplessas.com

Tim Plumb
37 Russell St
Cardiff CF243BG
UK
Tim@pixelpimp.net

Rossano Polidoro
Via Pasquale Pace 3
65013 Citta S. Angelo
I
info@TU-M.com

Mia Pontano
Via Ca' Baseggio, 31
36056 Tezze sul Brenta
I
info@pontano.it

Nina Pope
257 Well St
London E9 6RG
UK
nina@swansong.tv

Waldemar Pranckiewicz
Krzywoustego 11f/2
73-110 Stargard
PL
czas@free.art.pl

Processing.net
Via Montenavale 1
10015 Ivrea
I
c.reas@interaction-ivrea.it

Mami P-Y.
18 Rue des Quatre Fils
75003 Paris
F
linked222@free.fr

Joseph Rabie
129, Rue Gaston Doumergue
31170 Tournefeuille
F
joe@overmydeadbody.org

Marcelo Radulovich
444 Norfolk Dr.
Cardiff, CA 92007
USA
m@marceloradulovich.com

Marcin Ramocki
138 Bayard St
Brooklyn, NY 11222
USA
mramocki@earthlink.net

Sal Randolph
50 Prince St #2J
New York, NY 10012
USA
sal@highlala.com

Charles Rapeneau
Route de Celhaya, 14 rés.
Olaya
64250 Cambo-les-Bains
F
holeg@free.fr

Sonya Rapoport
6 Hillcrest Court
Berkeley, CA 94705
USA
sonyarap@lmi.net

Nadine Rennert
Horstweg 24
14059 Berlin
D
nadine.rennert@freenet.de

Robert Resac
Webg. 12/5
1060 Wien
A
robert.resac@chello.at

Simone Ricci
Via Milazzo 2
15100 Alessandria
I
simricci@tiscali.it

Don Ritter
204 15th St
Brooklyn, NY 11215
USA
ritter@aesthetic-machinery.com

Hughes Rochette
18 Rue Marthe Aureau
77400 Lagny sur Marne
F
hughes.rochette@strathom.com

Timothée Rolin
1 Rue Charles Garnier
93400 Saint-Ouen
F
webmaster@synesthesie.com

Fred Romano
Paseo Isabel II, 10, 1° 2a
8003 Barcelona
E
fromano@teleline.es

Lisa Rosenmeier
Grøndalsvej 24
2000 Frederiksberg
DK
rosenmeier@artofheart.dk

Rebecca Ross
715-719 Broadway, 12th
Floor
New York, NY 10003
USA
rebecca@cat.nyu.edu

Tim Otto Roth
Bahnhofstr. 1
77728 Oppenau
D
tor@imachination.net

Warren Sack
510 Hagar Court
Santa Cruz, CA 95064
USA
translation_map@yahoo.com

Vendula Safarova
Ryparova 35
700 30 Ostrava 3
CZ
vendulka1@email.cz

Isabel Saij
Körnerstr. 11
50823 Köln
D
info@isabelsaij.de

Joshua Schachter
124 West 60th St
New York, NY 10023
USA
joshua-aec@burri.to

Matthias Schelling
Schützenstr. 16c
6850 Dornbirn
A
matthias.schelling@students.f
h-vorarlberg.ac.at

Nina Schneider
Kolovec 8
1235 Radomlje
SLO
ales@edda.si

Kai Schneider
Alaunstr. 53
01099 Dresden
D
info@photocase.de

Inga Schnekenburger
Villinger Str. 14
78166 Donaueschingen
D
inga@schnekenburger.de

Tamar Schori
9 Hadaga St.
68177 Tel-Aviv Jaffa
IL
tmr_s@netvision.net.il

Hansgeorg Schwarz
Bunte Str.12
76131 Karlsruhe
D
hansgeorg@phormation.de

Manfred Seifert
Stadtring 142
64720 Michelstadt
D
mansei@t-online.de

Michael Sellam
43 Rue Léon Frot
75011 Paris
F
michael@incident.net

Iman Shaggag
6158 Lebanon Ave 1st Floor
Philadelphia, PA 19151
USA
shaggag@sudanartists.org

Mark Shepard
74 Varick St
New York, NY 10013
USA
victor@dotsperinch.com

Tomoo Shimomura
27-5, Inokashira 3 chome,
Mitaka-shi
181-0001 Tokyo
J
tomoo@tomoo.net

Masayuki Shirai
Tokyo Metropolice
201-13 Komae-shi
J
bamse@s2.ocv.ne.jp

Rick Silva
2805 Sundown Ln 110
Boulder, CO 80303
USA
rick@lightmovingintime.com

Shahjahan Siraj
House-58, Rd-15A (New),
Dhanmondi R/A
8802 Dhaka -1209
Bangladesh
siraj@drik.net

Johannes Skala
Am Hausberg 48
3945 Hoheneich
A
hillhouse@gmx.at

Frank Stäblein
Schlossbergstr. 19
82386 Oberhausen
D
webmaster@earthquake-
productions.de

Stanza
92 Lilford Rd
London SE5 9HR
UK
stanza@sublime.net

Birte Steffan
Ossastr. 46
12045 Berlin
D
tina@ttwo.de

David Steiner
Bremer Str. 71
10551 Berlin
D
steiner@udk-berlin.de

Sven Steinmeyer
Gotzingerstr. 52-54
81371 München
D
aec@schoenere.de

Igor Stepancic
M. Jevrosime 35
11000 Beograd
YU
igor@blueprintit.com

Taco Stolk / Arthur Elsenaar
Kadijksplein 10
1018AC Amsterdam
NL
tawstolk@wlfr.nl

Leslie Streit
33 Jennings Ct
San Francisco, CA 94124
USA
leslie@new-performance.org

Gerd Struwe
Schönsteinstr. 12a
50825 Köln
D
struwe@biogenart.de

syndikaton
Alvenslebenstr. 2
66117 Saarbrücken
D
henrikekreck@hotmail.com

József Tallér
Szív u. 35. 3. 22.
1063 Budapest
H
ogg@interware.hu

Peter Tappler
Köstlerg. 10/10
1060 Wien
A
happypolitics@stahlglatt.net

test bed
Straßburger Str. 24
10405 Berlin
D
conrads@zedat.fu-berlin.de

Pall Thayer
Sorlaskjol 32
107 Reykjavik
IS
pall@fa.is

Ernst Thoma
Flurweg 1
8260 Stein am Rhein
CH
ernstthoma@sounddesign.ch

Geoffrey Thomas
1455 W. Rascher #2W
Chicago, IL 60640
USA
storybeat@storybeat.tv

Clement Thomas
165 Bd de la Villette
75010 Paris
F
ctgr@free.fr

Lisa Tilder
109 Brown Hall, 190 W 17th
Ave
Columbus, OH 43210
USA
tilder.1@osu.edu

Andrej Tisma
Modene 1
21000 Novi Sad
YU
aart@eunet.yu

Brad Todd
6557 Clark
Montreal, Quebec H2S 3E8
CDN
bt@mobilegaze.com

Jürgen Trautwein
1135 Bush St #14
San Francisco, CA 94109
USA
jtwine@jtwine.com

Richard Trigaux
19 Av. Lacouture
81500 Lavaur
F
trigaux.richard@wanadoo.fr

Gert Tschögl
Domplatz 21
7000 Eisenstadt
A
gert.tschoegl@forschungs
gesellschaft.at

Takeshi Tsuboi
3-15-3-102 Kozu Chuo-ku
542-0072 Osaka
J
ken-ken-@xf6.so-net.ne.jp

tsunamii.net
7, Nim Rd
807541 Singapore
SGP
tsunamii@dangermuseum.com

Florin Tudor
Vitejiei, Nr 2, Bl 1, Ap 57,
Sector 2
732743 Bucharest
RO
monafloe@hotmail.com

Ubermorgen
Hollandstr. 7/19
1020 Wien
A
hans@ubermorgen.com

Hiroko Uchiyama
1900 Asamizodai
228-8538 Sagamihara
J
uchi@joshibi.ac.jp

Atsuko Uda
1-1-7 Fujie-Chou
J
makura@iamas.ac.jp

Theodore Ushev
4590 Queen Mary #410
Montreal, QC H3W 1W6
CDN
theodore@ushev.com

Carla van Beers
Pietheinstraat 119
2518 CG Den Haag
NL
cvb@africancolours.com

Rosanne van Klaveren
Viktorsberg 23
4822 TE Breda
NL
rosanne@braintec.info

Mona Vatamanu
Vitejiei, nr 2, bl 1, ap 57
732743 Bucharest
RO
monafloe@hotmail.com

John Vega
PMB 187 2525 Arapahoe Ave
E4
Boulder, CO 80302
USA
jvega@dancingimage.com

Andrey Velikanov
Krutitskaya Naberezhnaya
1115088 Moscow
RUS
andrey@velikanov.ru

Mateja Verlic
Ljubljanska 4
2000 Maribor
SLO
mkc.maribor@guest.arnes.si

Judith Villamayor
Bv. Oroño 857
2000 Rosario
RA
villamayor@uolsinectis.com.ar

Lilly-Ann Vittorio
Simmeringer Hauptstr. 68-
74/4/13
1110 Wien
A
Lilly_Ann1@hotmail.com

Tadej Vobovnik
Slovenceva 76
1113 Ljubljana
SLO
ideachannel@volja.net

Nikolai Vogel
Humboldtstr. 14
81543 München
D
nv@blackink.de

Violeta Vojvodic
Bulevar Kralja Petra Prvog 69
21000 Novi Sad
YU
office@urtica.org

Robert Wacha
Gartenstadtstr. 18
4040 Puchenau
A
robert_wacha@hotmail.com

Tamas Waliczky
Beregszasz ut 70
1118 Budapest
H
tamas@waliczky.com

Heinz Widmer
Wasserwerkg. 7
3011 Bern
CH
heiwid@bermuda.ch

Michael Wild von Hohenborn
Bennauerstr. 53
53115 Bonn
D
info@schaltkreisacht.de

Niko Wilkesmann
Heimstr. 2
10965 Berlin
D
nikowilkesmann@web.de

Dominic Williams
39 Coverdale Rd
Lancaster LA1 5PY
UK
mail@domwilliams.co.uk

Virgil Wong
PO Box 54, Cooper Station
New York, NY 10276
USA
virgil@paperveins.org

Kirk Woolford
Rozenstraat 144 III
1016 NZ Amsterdam
NL
phred@bluehaptic.nl

Guido Woska
Carl-Schurz-Str. 44
13597 Berlin
D
woska@corporatehouse.de

Nanette Wylde
33 Dexter Ave
Redwood City, CA 94063
USA
nan@preneo.com

Shinya Yamamoto
3-1-21#305, Moriminami-
machi, Higashinada-ku
658-11 Kobe-shi
J
info@sinplex.com

Minha Yang
Seoul Nat'l Univ 49-101,
Sillim-dong, Kwanak-gu
151742 Seoul
RK
elesign@yahoo.co.kr

Carlo Zanni
Via Strigelli 9
20135 Milano
I
cz@zanni.org

Jody Zellen
843 Bay St #11
Santa Monica, CA 90405
USA
jodyzel@aol.com

Doublecell Zookeeper
393 Ashland Ave
Staten Island, NY 10309
USA
zookeeper@singlecell.org

Wieland Zumpe
Beethovenstr. 8
4107 Leipzig
D
gustav@rz.uni-leipzig.de

IMG SRC
Shioirikouji 1F 5-2 Shinsen-
cho Shibuya-ku
150-45 Tokyo
J
miki@imgsrc.co.jp

Picture Projects
176 Grand St, Third Floor
New York, NY 10013
USA
acorn@picture-projects.com

r a d i o q u a l i a
43 Finn House, Bevenden St
London N1 6BL
UK
radioqualia@va.com.au

Lokiss
220 Rue du Fbg St Antoine
75012 Paris
F
lokiss@lokiss.com

DNA Studio
405 S. Beverly Drive 4th Floor
Beverly Hills, CA 90212
USA
dana@dnastudio.com

INTERACTIVE ART

/////////fur////
Trimbornstr. 7
51105 Köln
D
zoo@fursr.com

Adriano Abbado
Via Crema 18
20135 Milano
I
adriano@abbado.com

Manuel Abendroth
18 Rue P.V. Jacobs
1080 Bruxelles
B
lab-au@lab-au.com

AIR BRAKE
4-8 Kitanocho Simabashi
640-8416 Wakayama City
J
air-brake@jtw.zaq.ne.jp

Sandor Ajzenstat
105 - 46 Noble Str.
M6K 2C9 Toronto, ON
CDN
sandor@interlog.com

Ricardo Ali
Calle 159b N° 20a-15 apt 202
Bogotá
CO
rialsa9@hotmail.com

Ingemar Almeros
Acusticum 4
941 28 Pitea
S
katarina.delsing@tii.se

Max Almy
2959 Seabreeze Drive
Malibu, CA 90265
USA
magika@earthlink.net

Toshitaka Amaoka
71-1-606 Urata Kaizuka
579-0061 Osaka
J
ta296@amaoka.com

Jussi Ängeslevä
The Truman Brewery, 91 Brick
Lane
London E1 6QL
UK
ross@rcstudios.com

Marcel.li Antúnez Roca
La cera 27
8001 Barcelona
E
li@marceliantunez.com

Applied Interactives
4248 N. Lamon Ave., #3B
Chicago, IL 60641
USA
ai@appliedinteractives.com

Jörg Auzinger
Pressg. 29
1040 Wien
A
auzinger@ frieze.net

Anita Bacic
PO BOX 1270
St Kilda Str, VIC 3182
AUS
anita@popsiclemedia.com

Hernando Barragan
CRA 67 No 50-81
Bogota
CO
hbarragan@utensil.net

Stefan Baumberger
Pfeifferstr. 3
99423 Weimar
D
baumberg@habeko.net

Brogle Beat
Eglistr. 8
8004 Zürich
CH
bbrogle@access.ch

Laura Bellof
Dalbergstien 7
170 Oslo
N
rat@telecoma.net

J.D. Beltran
531 Utah Str.
San Francisco, CA 94110
USA
jdbeltrn@pacbell.net

Jon Berge
153 Oak Str.
Columbus, OH 43205
USA
partnersms@aol.com

Erich Berger
Dalbergstien 7
170 Oslo
N
rat@telecoma.net

Luca Bertini
Corso Vercelli 27
20144 Milano
I
kakkha@libero.it

Ennio Bertrand
Via Soldati 12
20154 Milano
I
extraplayer@iol.it

bertrand g
34 Quai des Bateliers
67000 Strasbourg
F
bertrandg89@hotmail.com

bino and cool
Birgersjobergsv. 3
112 54 Stockholm
S
binocool@virtualrules.net

BIOS Team
Peter-Welter-Platz 2
50676 Köln
D
jg@khm.de

Boris Breuer
Virginiastr. 17
66482 Zweibrücken
D
borisbreuer@gmx.de

Shawn Brixey
35 Thomson Hall
Seattle, WA 98195
USA
shawnx@u.washington.edu

Sheldon Brown
9500 Gilman Drive
La Jolla, CA 92093
USA
sgbrown@ucsd.edu

Jihoon Byun
Sindaebang 1-dong woosung
APT. 13-dong 403-ho.
156-786 Dong-Jak Gu
ROK
sea037@hanmail.net

Mariela Cadiz
Rue Royer Collard 4
75005 Paris
F
mariela@film.calarts.edu

Remo Campopiano
133 Hammond Str.
Seekonk, MA 2771
USA
remo@remo.net

Birgitta Cappelen
Krutmeijersgatan 10 a
21741 Malmö
S
brigitta.cappelen@k3.mah.se

Slavica Ceperkovic
69 Rue des Arts
59100 Roubaix
F
slavica@digitalexhaust.com

Kalim Chan
18217 Via Calma 1
Rowland Heights, CA 91748
USA
kalimchan@aol.com

Lin Yew Cheang
PO Box 856
Wanganui
NZ
linyew@hyperthesis.com

Chu-Yin Chen
15 Allée du Parc de la Bièvre
94240 L'Hay les Roses
F
chuyinchen@yahoo.com

David Cheung
55 Michael Drive
Toronto, ON M2H 2A4
CDN
aocaamw@yahoo.com

Motoshi Chikamori
Hamadayama1-18-9-202,
Suginami-ku, Tokyo
168 - 65
J
motoc@attglobal.net

Hyemi Cho
5 Saint Marks Place #16
New York, NY 10003
USA
hc371@nyu.edu

Peter Colbert
Assmayerg. 31/48
1120 Wien
A
pjedlicka@aon.at

Rosemary Comella
734 W. Adams Blvd.
Los Angeles, CA 90089
USA
rcomella@annenberg.edu

Claudio Conti
Via Borgo Dora 12
10100 Torino
I
clacide@libero.it

Ross Cooper
The Truman Brewery, 91 Brick
Lane
London E1 6QL
UK
ross@rcstudios.com

Laure Crespel
41, Bld. Paul Dourmer
51100 Reims
F
crespellaure@hotmail.com

Dieter Crombez
Schoonmeersstraat 52
9000 Gent
B
wim.debruyn@hogent.be

Lynda Cronin
25 Oakfern Crescent
Stittsville, ON K2S 1E5
CDN
lmcronin@rogers.com

Cycloid
242-58 Kogasaka, Machida-
shi
194-0014 Tokyo
J
ryu1@m2.ocv.ne.jp

Gina Czarnecki
32 Queen Str.
Newport on Tay, DD68BD
Dundee
UK
gczarnec@dux.dundee.ac.uk

Raffaello D'Andrea
101 Rhodes Hall
Ithaca, NY 14853
USA
rd28@cornell.edu

Raymond DeBolt
3140 Shasta Ave.
Columbus, OH 43231
USA
debolt1@msn.com

Magali Desbazeille
70 Rue d'Aubervilliers
75019 Paris
F
magali@desbazeille.nom.fr

D-Fuse
13-14 Great Sutton Str.
London EC1V 0BX
UK
mike@dfuse.com

Diego Diaz
c/ Pintor Salvador Abril n° 44
pta 9
46005 Valencia
E
diediaga@laboluz.org

Federico Diaz
Marie Cibulkove 30
14000 Prague 4
CZ
info@e-area.cz

Tina Dietz
Albrechtstr. 8
12165 Berlin
D
zentralflughafen@gmx.de

Ivor Diosi
Drienova 15
82101 Bratislava
SK
ivory@post.sk

Götz Dipper
Lorenzstr. 19
76135 Karlsruhe
D
dolfi@zkm.de

Gearoid Dolan a.k.a. screaMachine
216 East 12th Str., #4B
New York, NY 10003
USA
g-man@screamachine.com

Hartmut Dorschner
Schönfelder Str. 1
1099 Dresden
D
margit@freejazz.de

Scott Draves
116 Liberty St
San Francisco, CA 94110
USA
spot_prixars@draves.org

Erwin Driessens
Eikenweg 9 d/e
1092 BW Amsterdam
NL
notnot@xs4all.nl

Jean-Marc Duchenne
Grises
26740 Savasse
F
Bertrand.Merlier@univ-lepn2.fr

ecoma artcore
Lemsahlerlandstr. 165
22397 Hamburg
D
dekomaniac@hotmail.com

Peter Johann Ehrl
Grasingerweg 1
93343 Altessing
D
p.ehrl@t-online

ESG - extended stage group
Dieffenbachstr. 37
10967 Berlin
D
krueger@buero-staubach.de

Tirtza Even
530 Riverside Dr. #5J
New York,NY 10027
USA
teven12345@aol.com

Interactive Media Team
Exhibitions Dept.
Central Park West @ 79th St.
New York, NY 10024
USA
jcollins@amnh.org

Paul Farrington
71 Lincoln St.
Brighton BN29UG
UK
studio@studiotonne.com

Frank Fietzek
Zionskirchstr. 9
10119 Berlin
D
frank.fietzek@t-online.de

Jessica Findley
170 Tillary Str. #202
Brooklyn, NY 11201
USA
sonic_ribbon@hotmail.com

Orm Finnendahl
Seelingstraße 47/49
14059 Berlin
D
finnendahl@folkwang-hoch-
schule.de

Joachim Fleischer
Hugo-Eckener-Str. 9
70184 Stuttgart
D
j.-fleischer@t-online.de

Eric Forman
156 Perry St.
New York, NY 10014
USA
eric@ericforman.com

Nathalie Fougeras
5 Rue de Terre Neuve
75020 Paris
F
nathalie-artec@netcourrier.com

Noriyuki Fujimura
Room 111 CFA CMU, 5000
Forbes Ave
Pittsburgh, PA 15213-3890
USA
noriyuki@andrew.cmu.edu

Christopher Galbraith
3 Hedge Court, Apt. 3
Snyder, NY 14226
USA
crg3@buffalo.edu

Jeremy Gardiner
Creative Technology Centre,
Grove House, 1 the Grove
London W5 5DX
UK
mail@jeremygardiner.co.uk

Michelle Gay
19 Northcote Ave.
Toronto, ON M6J 3K2
CDN
michelle@steamworks.net

Dmitry Gelfand
3-95 Ryoke-cho
503-0014 Ogaki
J
ciborium@hotmail.com

Petra Gemeinboeck
Siebenbrunneng. 39/72
1050 Wien
A
beta@evl.uic.edu

JoAnn Gillerman
950 61st Str.
Oakland, CA 94608
USA
viper@metron.com

Mark Goulthorpe
65 Rue du Faubourg St Denis
75010 Paris
F
decoi@easynet.fr

Sascha Graf
Vonmattstr. 22
6003 Luzern
CH
saschagraf@gmx.net

Lars Grau
Raabestr. 1
10405 Berlin
D
larsen@typefighter.com

Simon Greenwold
E15-301, 20 Ames St.
Cambridge, MA 2139
USA
simong@media.mit.edu

Kathrin Grunwald
Reuchlinstr. 31
70176 Stuttgart
D
modularlab@mac.com

Mark Guglielmetti
Unit 916, 422 Collins St
3000
Melbourne
AUS
mark@iii.rmit.edu.au

Genco Gulan
Hakim Tahsin Sokak 35/2
Emirgan
80850 Istanbul
TR
gencogulan@yahoo.com

Hanna Haaslahti
Koskelantie 21
610 Helsinki
SF
hanna@fantomatico.org

Peter Hagdahl
Dalagatan 27
11324 Stockholm
S
peter.hagdahl@kkh.se

Daniel Hahn
Rue du Beulet 8
1203 Genève
CH
hahn@kleinteilproduktion.de

Noaki Hamanaka
Tansumachi 41, Osaki Bldg.
1620833 Tokyo
J
h-arch@interlink.or.jp

Mark Hansen
111 Bowery, 3rd Floor
New York, NY 10002
USA
cocteau@stat.ucla.edu

Heiko Hansen
47 Rue de la Vilette
75019 Paris
F
heiko@hehe.org

John Harford
728 South Ave. West
Westfield, NJ 7090
USA
thefragment@thefragment.com

Norihisa Hashimoto
NHK Digital Stadium Office,
2-2-1 Jinnan Shibuya-ku
150-8001 Tokyo
J
digista@telecomstaff.co.jp

Sibylle Hauert
Holderstr. 4
4057 Basel
CH
shauert@dplanet.ch

Nathan Hemenway
1333 1/2 Masselin
Los Angeles, CA 90019
USA
nhemenway@teeter.org

Herman
Im Rudert 15
35043 Marburg
D
atelier@kuenstler-herman.de

Lynn Hershman
1201 California St.
San Francisco, CA 94109
USA
lynn2@well.com

Peter Higgins
14 Barley Mow Passage
London W4 4PH
UK
info@landdesignstudio.co.uk

Daniel F. Hirth
Marktplatz 3
71229 Leonberg
D
dhrth@publc.org

Tatsumi Hiyama
1-10-34-402 Jingumae,
Shibuya-ku
150-0001 Tokyo
J
tatsumi@cd5.so-net.ne.jp

Georg Hobmeier
Schönfelderstr. 1
01099 Dresden
D
riviera@gmx.li

Risa Horowitz
21-300 River Ave.
Winnipeg, MB R3L 0B9
CDN
risa_horowitz@yahoo.ca

G. H. Hovagimyan
11 Harrison St.
New York, NY 10013
USA
ghh@thing.net

Eunjung Hwang
303 10th #1RB
New York, NY 10009
USA
hwangeunj@hotmail.com

Takeshi Inomata
4-5-18 Higashiyama
4860811 Kasugai, Aichi
J
ino-00@iamas.ac.jp

Haruo Ishii
30-1 Ishibata Narumi-cho
Midori-ku
458-0801 Nagoya-shi
J
MXC00275@nifty.ne.jp

Margarete Jahrmann
Vorgartenstr. 199/1/13
1020 Wien
A
team@climax.at

Ravi Jain
228 Chestnut Ave.
Jamaica Plain, MA 2130
USA
ravi@three-abreast.com

Tristan Jehan
Sugar House Lane, Bellevue
8 Dublin
IRL
tristan@media.mit.edu

Crispin Jones
14 Kennington Park Place
London SE11 4AS
UK
crispin_away@hotmail.com

Jovi Juan
784 Palmer Road Apt 1A
Bronxville, NY 10708
USA
jovi_juan@yahoo.com

Akio Kamisato
1-1-50 Mano, Paru 8 House
#306
520-0232 Otsu City, Saga
Prefecture
J
digista@telecomstaff.co.jp

Istvan Kantor
58 Wade Ave., Unit 12
Toronto, ON M6H 1P6
CDN
amen@interlog.com

Michelle Kasprzak
563 Church St. Suite C
Toronto, ON M4Y 2E4
CDN
kasprzak@badpacket.org

Henry Kaufman
16 Fort Washington Place
Cambridge, MA 2139
USA
henryars@tumbao.net

Kohske Kawase
2-22-14 Sakuradai, Nerima-ku
176-0002 Tokyo
J
www@kawasekohske.info

André Keller
Callinstr. 14
30167 Hannover
D
andre@ponton-lab.de

Hee-Seon Kim
Heidemannstr. 116
50825 Köln
D
sun@khm.de

Marsha Kinder
734 W. Adams Blvd
Los Angeles, CA 90089
USA
rcomella@annenberg.edu

Georg Klein
Arndtstr. 1
10965 Berlin
D
coma@georgklein

Andrew Kleindolph
2840 11th Ave.
Oakland, CA 94610
USA
femur@extrasleepy.com

John Klima
130 Broadway
Brooklyn, NY 11211
USA
klima@echonyc.com

Jeff Knowlton
25057 Chestnut
Newhall, CA 91321
USA
knowlton@34n118w.net

Sachiko Kodama
1-5-1, Chofugaoka
182-8585 Chofu City, Tokyo
J
kodama@hc.uec.ac.jp

Shirin Kouladjie
#411 - 509 Dunsmuir St.
Vancouver, BC V6B1Y4
CDN
k@photomontage.com

Gunther Kreis
Max-Beer-Str. 6
10115 Berlin
D
g@jeansteam.de

Manfred Kroboth
Mexikoring 15
22297 Hamburg
D
kroko@foni.net

Lali Krotoszynski
R. Francisco Perroti, 761
5531 Sao Paulo
BR
lalik@ajato.com.br

Olga Kumeger
Bolshaja Filevskaja 45-1-16
121433 Moscow
RUS
kumeger@yahoo.com

Gil Kuno
2-2-2 Higashiyama #904,
Meguroku
153-43 Tokyo
J
gil@unsound.com

Martin Kusch
4164 Parthenais, Appt. 2
H2K 3T9 Montréal, QC
CDN
mkusch@kpluriel.org

Kumiko Kushiyama
518-25 Nikaidou, Kamakura,
Kanagawa
248 Kamakura
J
kushi@ea.mbn.or.jp

Katarina Kvarnsjö
Ystadsgatan 47A
21444 Malmö
S
katarina.kv@passagen.se

David Labiano
Victoria 2
8003 Barcelona
E
rotok@ctv.es

Christin Lahr
Ackerstr. 18
10115 Berlin
D
lahr@nonresident.de

Minna Långström
Lönnrotinkatu 17 B 2
120 Helsinki
SF
minna@virtaanimated.com

Frank Lantz
605 C Madison St.
Hoboken, NJ 7030
USA
franklantz@yahoo.com

Bei-Kyoung Lee
Birkenstr. 70
40233 Düsseldorf
D
mail@selfmotion.com

George Legrady
Department of Art Studio
Santa Barbara, CA 93106
USA
legrady@arts.ucsb.edu

J.U. Lensing
Winkelsfelderstr. 21
40477 Düsseldorf
D
theater-der-klaenge@t-
online.de

Sophea Lerner
CM&T, Sib.A. PL 86
251 Helsinki
SF
sophea@phonebox.org

Michael Lew
Sugar House Lane
8 Dublin
IRL
lew@media.mit.edu

Limiteazero
Via Vespri Siciliani, 12
20146 Milano
I
info@limiteazero.com

Ya Lu Lin
19416 Cranfield Lane
Tinley Park, IL 60477
USA
yalu@evl.uic.edu

Marc Lin
13357 Holly Oak Cir
Cerritos, CA 90703
USA
marc@macaque.net

David Link
Lütticher Str. 34
50674 Köln
D
david@khm.de

Dimitris Lioupis
256 Pireos St.
18233 Rendi, Athens
GR
lioupis@cti.gr

Robert Lisek
Bulwar Ikara
54 130 Wroclaw
PL
lisek@lisek.art.pl

Lynn Lukkas
3316 Hennepin Av South
Minneapolis, MN 55408
USA
lukka005@umn.edu

Rikard Lundstedt
Spånehusv. 63c
21439 Malmö
S
rikard.lundstedt@tii.se

Michael Lutz
Postfach 440143
80750 München
D
michaellutz@lycos.de

Machfeld
Johann-Strauß-G. 29/5-6
1040 Wien
A
mastro@machfeld.net

Katia Maciel
Praca Santos Dumont no. 30
Ap. 204
22470-060 Gavea
BR
kmaciel@acd.ufrj.br

Mayu Makinouchi
Shimomatsubara 655
350-1153 Kawagoe
J
makichan@hh.iij4u.or.jp

Sven Mann
Werderstr. 23
59672 Köln
D
sven@khm.de

Justin Manor
E15-302 20 Ames St.
Cambridge, MA 2139
USA
manor@media.mit.edu

Marité Márquez Yong
Popocatepetl # 132 int 8
3300 Mexico, D.F.
MEX
tenebria@hotmail.com

Martin
22, Rue St. Claude
75003 Paris
F
mlenclos@viguier.com

Jean-Marc Matos
28 Rue de la Cocagne
31280 Dremil-Lafage
F
kdmatos@worldnet.fr

Seiichiro Matsumura
D704, 2-79, Aomi, Koto-ku
135-64 Tokyo
J
sei@cfdl.t.u-tokyo.ac.jp

Takahiro Matsuo
1-6-8-#504, Takagi, Minami-ku
815-0004 Fukuoka
J
matsuo@rms.kyushu-id.ac.jp

Benoît Maubrey
Bahnhofstr. 47
14806 Baitz
D
maubrey@snafu.de

Yiannis Melanitis
Velvendou 30
11364 Athen
GR
melanitis@hotmail.com

Esther Mera
1212 El Paso
Los Angeles, CA 90065
USA
mera@shoko.calarts.edu

Agnes Meyer-Brandis
Brabanter Str. 25
50672 Köln
D
agnes@khm.de

Cristiana Moldi Ravenna
S. Croce 2180
30135 Venezia
I
psta@mracpublishing.com

Mark Molnar
Nemetvölgyi ut 57-59, mfsz/1
1123 Budapest
H
momark@freemail.hu

Ben Morieson
4/98 Dover St.
Richmond, VIC 3121
AUS
carben67@ains.net.au

Atsushi Morimoto
518-25 Nikaidou, Kamakura,
Kanagawa 248-0002
Kamakura
J
kushi@ea.mbn.or.jp

Przemyslaw Moskal
1115 FDR Drive Apt. 10A
New York, NY 10009
USA
moskal@laksom.com

Iain Mott
21/79-81 Franklin St.
Melbourne, VIC 3000
AUS
mott@reverberant.com

Florian Mueller
Stephanienweg 20
79224 Umkirch
D
floyd@floydmueller.com

Geert Mul
Exercitiestraat 20B
3034 Rotterdam, RB
NL
geert@v2.nl

Robert Mulder
788 Cedarwood Drive
Kingston, ON K7P 1M7
CDN
robmulder@sympatico.ca

mvd°°°°
Belpairestraat 30
2600 Berchem
B
bolwerk@freegates.be

Iori Nakai
3-9-30 Matsubara, Naka-ku
460-0017 Nagoya
J
digista@telecomstaff.co.jp

Shunsuke Nakamura
#302, Kokusaikaikan, Ijiri 2-36-40, Minami-ku
811-1302 Fukuoka
J
shunsuke@rms.kyushu-id.ac.jp

Marit Neeb
Alte Schönhauserstr. 39/ 40
10119 Berlin
D
marit@maritneeb.de

Henry Newton-Dunn
Takanawa Muse Bldg, 3-14-13
Higashigotanda, Shinagawa-ku
141-0022 Tokyo
J
henry@csl.sony.co.jp

Primoz Novak
Cepovanska Ulica 4
1000 Ljubljana
SLO
primoznovak@hotmail.com

Carlos Nunes
Passeio das Âncoras, Lt. 4.18,
Bl. 1, R/Ch C * Expo 98
1990 Lisboa
P
info@a-perve.rcts.pt

Nika Oblak
Cepovanska Ulica 4
1000 Ljubljana
SLO
nikaoblak@hotmail.com

Martin Ocko
Tugomerjeva 12
1000 Ljubljana
SLO
ocko@scientist.com

Ethem Özgüven
Communication Faculty
Kustepe Kampusu
Kustepe-Sisli Istanbul
TR
eozguven@bilgi.edu.tr

Dave Pape
642 Elmwood
Buffalo, NY 14222
USA
jranstey@buffalo.edu

Carroll Parrott Blue
734 West Adams
Los Angeles, CA 90089
USA
khkang@usc.edu

Tony Patrickson
Farravaun, Glann
Oughterard, Co. Galway
IRL
topa@iolfree.ie

James Patten
20 Ames St.
Cambridge, MA 2141
USA
jpatten@media.mit.edu

Magdalena Pederin
Vodovodna 4
10000 Zagreb
HR
magdalena@art-me.org

Robin Petterd
19 Cato Avenue
7000 West Hobart
AUS
robin@otheredge.com.au

Michael Pinsky
47 Earlsferry Way
London N1 0DZ
UK
michael@michaelpinsky.com

Josephine Pletts
90 Surr St.
London N7 9EN
UK
ph@p-h.org.uk

Thomas Ploentzke
Jablonskistr. 24
10405 Berlin
D
ploenne@ploenne.de

Alan Price
1000 Hilltop Circle
Baltimore, MD 21043
USA
price@umbc.edu

Carole Purnell
Quinta da Boa Espera NCA,
Lote 14
2710 Sintra
P
nuno.maya@iF.com

Oswald Putzer
Gr. Schiffg. 11/7
1020 Wien
A
oswald.putzer@surfeu.at

Jean-Michel Quesne
68 Rue des Archives
75003 Paris
F
skertzo@skertzo.com

Melinda Rackham
PO Box 1744
2012
Strawberry Hills
AUS
melinda@subtle.net

Hayes Raffle
77 Massachusetts Ave. NE18-5F
Cambridge, MA 2139
USA
hayes@media.mit.edu

Andrés Ramírez Gaviria
Baumg. 29-31 66/7
1030 Wien
A
info@andresramirezgaviria.com

Mette Ramsgard Thomsen
Mithras House, Lewes Rd.
Brighton BN2 4AT
UK
m.ramsgard-thomsen@brighton.ac.uk

Michael Reith
Dunckerstr. 90 a
10437 Berlin
D
michael@kunstingenieure.de

Catherine Richards
41 Delaware Ave.
Ottawa, ON K2P OZ2
CDN
richards@vottawa.ca

Martin Rieser
Sion Hill
Bath BA5 1AF
UK
m.rieser@bathspa.ac.uk

Silvia Rigon
658 1/2 Midvale Ave.
Los Angeles, CA 90024
USA
silvia@silviarigon.com

Hervé Robbe
30 Rue des Briquetiers
76600 Le Havre
F
robbe@club-internet.fr

robotlab
Lorenzstr. 19
76135 Karlsruhe
D
gommel@robotlab.de

Axel Roch
New Cross
London SE14 6NW
UK
a.roch@gold.ac.uk

Simo Rouhiainen
Runebergink. 6b, C46
100 Helsinki
SF
simo@uiah.fi

Niklas Roy
Strelitzer Str. 23
10115 Berlin
D
nikl@s-roy.de

Alex Sanjurjo Rubio
Travessera de Dalt, 56
8024 Barcelona
E
alex.sanjurjo@iua.upf.es

Joyce Rudinsky
Hanes Art Center, CB# 3405
Chapel Hill, NC 27599
USA
jrudinsk@email.unc.edu

Christopher Ruetsch
4 Ave. du Parc
31706 Blagnac Cedex
F
studio-sam@libertysurf.fr

Semi Ryu
4523-4 Forest Hill Ave
Richmond, VA 23225
USA
sryu2@vcu.edu

Jo Siamon Salich
Prießnikstr. 48
01099 Dresden
D
salich@gmx.de

Eva Sanagustin
Avda. Roma 52, 3-4
8015 Barcelona
E
evasf@hotmail.com

Manthos Santorineos
Mavromichali 168
114 72 Athens
GR
dafne@fournos-culture.gr

Tomoki Saso
Endou 5322
252-0816 Fujisawa-shi, Kanagawa-ken
J
needle@imgl.sfc.keio.ac.jp

Junichi Sato
#303 Fuji View Mansion, 1-3-9 Fujimidai, Kunitachi-shi
186-0003 Tokyo
J
sato-j@k3.dion.ne.jp

Tomo Savic-Gecan
Waterpoortweg 427
1051 PZ Amsterdam
NL
tomo@xs4all.nl

Stefan Schemat
Winckler Str. 5
20459 Hamburg
D
stefan@schemat.de

Simon Schießl
77 Massachusetts Ave. NE18-5F
Cambridge, MA 2139
USA
simon_s@media.mit.edu

Anne-Marie Schliener
Akademie Schloss Solitude,
Solitude 3
70197 Stuttgart
D
opensorcery@opensorcery.net

Antoine Schmitt
68, Rue Ramus
75020 Paris
F
as@gratin.org

Jo Schramm
Pücklerstr. 33
10997 Berlin
D
mail@joschramm.de

Michael Schwab
161A Herne Hill
London SE24 9LR
UK
michael.sc@gmx.net

Bill Seaman
Am Kölner Brett 6
50825 Köln
D
distr@235media.com

Gebhard Sengmüller
Margaretenstr. 106/17
1050 Wien
A
gebseng@vinylvideo.com

Paul Sermon
13 Longford Ave., Greater
Manchester
Manchester M32 8QB
UK
p.sermon@salford.ac.uk

Marie Sester
47 Ann Str., #3F
New York, NY 10038
USA
marie@sester.net

Xin Wei Sha
196 Warren Str., NE
Atlanta, GF 30317
USA
xinwei@mindspring.com

Gregory Shakar
721 Broadway 4th Floor
New York City, NY 10003
USA
greg@moodvector.com

Charles Atlas Sheppard
#12-23 Str. East
Saskatoon, SK S4T 0H5
CDN
charles@pavedarts.ca

Shirley Shor
690 Pennsylvania AV. #210
San Francisco, CA 94107
USA
shirleys@friskit.com

Andreas Siefert
Herrenstr. 54
76133 Karlsruhe
D
andy@traumpirat.de

Zachary Booth Simpson
3209 Hemphill Park
Austin, TX 78705
USA
oink54321@yahoo.com

Smartstudio
Karlavägen 108
10450 Stockholm
S
arijana@tii.se

Scott Snibbe
1777 Yosemite Ave, Suite
315
San Francisco, CA 94124
USA
scott@snibbe.com

Franc Solina
Trzaska c 25
1000 Ljubljana
SLO
franc@fri.uni-lj.si

Christa Sommerer
3-95 Ryoke-cho, Ogaki-shi
503-0014 Gifu
J
christa@iamas.ac.jp

Achim Benjamin Spaeth
Rosenbergstr. 113
70193 Stuttgart
D
abs@gedankengebaeude.de

squidsoup
2nd Floor, 59 Rivington Str.
London EC2A 3QQ
UK
ant@squidsoup.org

Norbert Streitz
Dolivostr. 15
64293 Darmstadt
D
streitz@ipsi.fhg.de

Koh Sueda
1-16-11-402 Koishikawa,
Bunkyo-ward
1120002 Tokyo
J
apochang@toki.waseda.jp

W. Mark Sutherland
3A Roblin Avenue
Toronto, ON M4C 3P7
CDN
wms@interlog.com

Keiko Takahashi
1-25-4 Hyakunin-cho, Shin-
juku-ku
169-8522 Tokyo
J
keiko@jec.ac.jp

Hiroko Tanahashi
Sorauer Str. 4
10997 Berlin
D
hiroko@posttheater.com

Joseph Tasnadi
Damjanich 52, 2/2
1071 Budapest
H
oximoris@axelero.hu

Florian Thalhofer
Choriner Str. 28d
10435 Berlin
D
ars@thalhofer.com

Christoph Theiler
Grundsteing. 44/1/5
1160 Wien
A
theiler@t0.or.at

Kurt Laurenz Theinert
Steinstr. 3
70173 Stuttgart
D
projektpartner.theinert@t-
online.de

Blast Theory
Unit 43a Regent Studios 8
Andrews Road
London E8 4QN
UK
matt@blasttheory.co.uk

theWanzke
Frieseng. 10
60487 Frankfurt
D
reinhard.wanzke@dasbyro.de

Tif Bitmap
Dzirnavu 4-7
1010 Riga
LV
bitmap@neonet.lv

Jan Torpus
Hammerstr. 102
4057 Basel
CH
jan.torpus@balcab.ch

Naoko Tosa
N52-390, Massachusetts Ave.
Cambridge, MA 2139
USA
naoko@mit.edu

Nobumichi Tosa
Landic Akasaka Bldg.2-3-4
Akasaka, Minatoku
107-52 Tokyo
J
goda-@za2.so-net.ne.jp

Georg Tremmel
Kensington Gore
London SW7 2EU
UK
georg.tremmel@rca.ac.uk

Selina Trepp
1652 W Division St
Chicago, IL 60622
USA
selinatrepp@earthlink.net

Zoya Trofimiuk
10/151 Fitzroy St.
St. Kilda, VIC 3182
AUS
troff.ac@bigpond.com

uma AG
Donau-City-Straße 1/6. Stock
1220 Wien
A
office@uma.at

Asa Unander-Scharin
Värtavägen 21
115 53 Stockholm
S
asa.unander-scharin@telia.com

Olaf Val
Brehmstr. 5
50735 Köln
D
coVal@gmx.de

Michiel van Bakel
Hooidrift 122 A
3023KV Rotterdam
NL
vbakel@xs4all.nl

Edwin van der Heide
Bergstraat 57 A
3035 TC Rotterdam
NL
heide@knoware.nl

Jan van Loh
Schliemannstr. 22
10437 Berlin
D
polizon@web.de

Paul Vanouse
175 North Str., apt. 315
Buffalo, NY 14201
USA
vanouse@buffalo.edu

Eric Verhnes
21 Rue de la Mare
75020 Paris
F
qdnd1@noos.fr

Paul Verschure
Winterthurerstr. 190
8057 Zürich
CH
pfmjv@ini.phys.ethz.ch

Fernanda Viegas
20 Ames St, room E15-450
Cambridge, MA 2138
USA
fviegas@media.mit.edu

Bill Vorn
641 Rang des Quatorze
St. Marc sur Richelieu,
Quebec J0L 2E0
CDN
bill@billvorn.com

Ludmila Voropai
Follerstr. 85
50676 Köln
D
voropai@khm.de

Kazumi Wada
Karlstr. 25
76133 Karlsruhe
D
mazcan@ba2.so-net.ne.jp

Steffen P. Walz
Dennerstr. 56
70372 Stuttgart
D
spw@playbe.com

Yao Wang
NE18-5F, 77 Mass. Ave.
Cambridge, MA 2139
USA
yao@media.mit.edu

Chiaki Watanabe
1186 Broadway
New York, NY 10001
USA
chiaki@nicknack.org

Arent Jan Weevers
Oude Grensweg 107
7552GE Hengelo (Ov)
NL
a.j.weevers@het net.nl

Herwig Weiser
Rosenhügel 3
50259 Pulheim-Brauweier
D
hw@zgodlocator.org

Ralf Wendt
Wittekindstr. 10
6114 Halle / S.
D
GURICHTE@aol.com

Peter Williams
3805 Freeman Terrace
Mississauga, ON L5M6Y5
CDN
pwilli1@umbc.edu

Michael Wilson
721 Broadway 4th Floor
New York, NY 10003-6807
USA
mike.wilson@nyu.edu

Fabian Winkler
3723 Mentone Ave Apt. #9
Los Angeles, CA 90034
USA
fwinkler@hfg-karlsruhe.de

Maciej Wisniewski
170 W. 23rd Str.
New York, NY 10011-2425
USA
maciejw@netomat.net

Emmanuel Witzthum
Bucholzer Str. 8
10437 Berlin
D
witzthum6@yahoo.com

Rob Wolpert
3812 Mack Road #L
Fairfield, CA 45014
USA
robertjosephwolpert3@yahoo.
com

Mike Wong
City University of Hong Kong
Kowloon
PRC
smmike@cityu.edu.hk

Sala Wong
3805 Freeman Terrace
Mississauga, ON L5M6Y5
CDN
cwong4@umbc.edu

Alexa Wright
70 Great Portland Str.
London W1W 7NQ
UK
alexa@dircon.co.uk

Keigo Yamamoto
24-10, Oomura-Cho
919-03 Fukui-City
J
keigo@nn.iij4u.or.jp

Andrew Young
Pasteurstr. 29
10407 Berlin
D
ay@udk-berlin.de

Hyun-Jung Yu
11-1 Daehyun, Seodaemoon
120-750 Seoul
ROK
hyunjung@ewha.ac.kr

Grégoire Zabé
24 Rue du Nideck
67000 Strasbourg
F
gregoire.zabe@nobox-lab.com

Andrea Zapp
13 Longford Ave.
Manchester M32 8QB
UK
zap@snafu.de

Julia Zdarsky
Magdalenenstr. 1/10
1060 Wien
A
star@starsky.at

Felicia Zeller
Wissmannstr. 43
12049 Berlin
D
ulti_edia@rocketmail.com

Fei Zhou
Schöppenstedter Str.28
38100 Braunschweig
D
zhoufei@gmx.net

Christian Ziegler
Lorenzstr. 19
76135 Karlsruhe
D
chris@movingimages.de

Michael Zoellner
Eichelgarten 8
91257 Pegnitz
D
zoellner@formwerks.de

Ruthe Zuntz
Dunckerstr. 90 a
10437 Berlin
D
michael@kunstingenieure.de

COMPUTER ANIMATION / VISUAL EFFECTS

Andrea Ackerman
109 West 26TH St., 10th
Floor
New York, NY 10001
USA
mullaneyandackerman@earth
link.net

Elodie Adias
10 Ave. Henri Matisse
59300 Aulnoy lez Valencien-
nes
F
supinfocom@valenciennes.net

alecks
Philosophenweg 57
34121 Kassel
D
info@corri-d-or.net

Christoph Ammann
420 Homer St.
Vancouver, BC V6B 2V5
CDN
sabrina@vfs.com

Andreas Angelidakis
2194 8th Ave. #4S
New York, NY 10026
USA
a@angelidakis.com

Gints Apsits
Kr. Barona 9-21
1011 Riga
LV
apsits@apollo.lv

Eric Armstrong
9050 W. Washington Blvd.
Culver City, CA 90232
USA
maryr@imageworks.com

Vanessa Arsen
65 Heward Ave. Bldg. A,
S201
Toronto, ON M4M 2T5
CDN
christat@calibredigital.com

Artemiy Artemiev
Ul. Krilatskaya 31-1-321
121614 Moskau
RUS
info@electroshock.ru

Michael Aschauer
Stumperg. 59/5
1060 Wien
A
m@ash.to

Hugues Audet
420 Homer St.
Vancouver, BC V6B 2V5
CDN
sabrina@vfs.com

Javier Badillo
2878 bsmt 1, 41st Ave. E
Vancouver, BC V5R 2X3
CDN
javier@naturemail.net

Jordi Bares
40-41 Great Marlborough St.
London W1F 7JQ
GB
natacha@mill.co.uk

Stefano Barozzi
Via Procaccini 25
20154 Milano
I
marco.farina@greenmovie.co
m

Thierry Bassement
10 Ave. Henri Matisse
59300 Aulnoy lez Valenciennes
F
supinfocom@valenciennes.net

Scott Becker
7234 W. North Ave. 1102
Elmwood Park, IL 60707
USA
artscb@interaccess.com

Albert Georg Beckmann
Am Taubertsberg 6
55099 Mainz
D
agbeckmann@web.de

Anthonny Bellagamba
10 Ave. Henri Matisse
59300 Aulnoy lez Valencien-
nes
F
supinfocom@valenciennes.net

Anat Ben-David
Tudor Grove
London E9-7QL
UK
ben_david_anat@hotmail.com

Ayala Ben Nachum
80 Levi Eshkol St.
69361 Tel Aviv
IL
aya_kaya@hotmail.com

Felix-Gabriel Bernard
335 de Maisonneuve East
Blvd, Suite 300
Montreal, Quebec H2X 1K2
CDN
isabella@nadcentre.com

Stefano Bertelli
Via Oroboni 3
45026 Cendinara, RO
I
s.bert@liberto.it

Marco Bertoldo
135 Mississippi St., 3rd Floor
San Francisco, CA 94107
USA
cchavez@mondomedia.com

Alfred Bleuler
Sandfelsenstr. 3
8703 Erlenbach
CH
a.bleuler@tiscali.ch

Jürgen Blümlein
Siemensstr. 96
70469 Stuttgart
D
mail@juergenbluemlein.de

Simon Bogojevic Narath
Bosanska 28
10000 Zagreb
HR
lskorin@open.hr

Chris Bond
300-70 Arthur St.
Winnipeg, MB R3B1G7
CDN
hmccallum@franticfilms.com

Claudia Bonollo
Plaza Cascorro 3 - 3 IZQ
28005 Madrid
E
claudiabonollo@meta-
morphic.com

Annabelle Boudineau
Chemin du Temple
13200 Arles
F
supinfocom@arles.cci.fr

Simon Bourgeois
Chemin du Temple
13200 Arles
F
supinfocom@arles.cci.fr

Simon Bridoux
Chemin du Temple
13200 Arles
F
supinfocom@arles.cci.fr

Hubert Bruno
1 Rue Gutenberg
92800 Puteaux
F
nobruhubert@hotmail.com

Michael Buchwald
19 Heisesgade
2100 Copenhagen
DK
michbuch@centrum.dk

BUF
3 Rue Roquepine
75008 Paris
F
celinef@buf.com

Phyllis Bulkin Lehrer
471 Broadway
New York, NY 10013
USA
astraphl@concentric.net

Joseph Burrascano
209 East 23rd St.
New York, NY 10010
USA
mbarrett@sva.edu

**Andres Castañeda Espinosa
de los Monteros**
Brezo no. 62 col. Nueva Santa
Maria
2800 Mexico, D. F.
MEX
tacubas@yahoo.com

Julien Castillan
Chemin du Temple
13200 Arles
F
supinfocom@arles.cci.fr

Framestore CFC
19-23 Wells St.
London W1T 3PQ
GB
press@framestore-cfc.com

Chris Chapman
1223 Wilshire Blvd. 695
Santa Monica, CA 90403
USA
cmchapman@cmgrafik.com

Bastien Charrier
10 Ave. Henri Matisse
59300 Aulnoy lez Valenciennes
F
supinfocom@valenciennes.net

Sylvie Chartrand
763 Boul. St-Joseph Est App.
4
Montréal , QC H2J 1K3
CDN
sylvart@hotmail.com

Sam Chen
725 Redondo Ct. #31
San Diego, CA 92109
USA
sambochen@yahoo.com

Bill Chen
Balaclava & Epping Roads
North Ryde, NSW 2113
AUS
meganp@aftrs.edu.au

Alex Cheparev
209 East 23rd St.
New York, NY 10010
USA
mbarrett@sva.edu

Nicolas Chevallier
10 Ave. Henri Matisse
59300 Aulnoy lez Valenciennes
F
supinfocom@valenciennes.net

Doug Chiang
91 Rue Lauriston
75116 Paris
F
Nadia.d@sparx.com

Yeon Choi
Fletcher Hall 310
Lafayette, LA 70504
USA
yeon@louisiana.edu

Chun-hsiao Chou
6349 NE Radford Dr. #3615
Seattle, WA 98115
USA
chunhsiao@sinamail.com

Tommy Cinquegrano
2700 N. Tamiami Trail
Sarasota, FL 34243
USA
strovas@ringling.edu

James Clar
635 E 6th, Apt #3w
New York, NY 10009
USA
jvc203@nyu.edu

Nico Clark
40 Mendip Rd
Bristol BS3 4NY
UK
nclark@bmth.ac.uk

Joe Clasen
922 Rio Lindo
San Clemente, CA 92672
USA
surferjoe@lightwavelab.com

Axel Clévenot
4 Rue du port
92110 Clichy
F
mrager@exmachina.fr

Alex Colls
Aribau 228 Princ 1 Esc Izq
8006 Barcelona
E
alex@zoorender.com

Fabrizio Coniglio
Via Vercelli 24
10036 Settimo (TO)
I
webzoo@coniglioviola.com

Yann Couderc
10 Ave. Henri Matisse
59300 Aulnoy lez Valenciennes
F
supinfocom@valenciennes.net

James Cui
272 N. Los Robles Ave. #5
Pasadena, CA 91101
USA
cui_james@hotmail.com

Mike Daly
Balaclava & Epping Roads
North Ryde, NSW 2113
AUS
meganp@aftrs.edu.au

Diana Danelli
Via Magenta, 34
26900 Lodi
I
diadanelli@tiscali.it

Jerôme Decock
10 Ave. Henri Matisse
59300 Aulnoy lez Valenciennes
F
supinfocom@valenciennes.net

Betsy de Fries
499 Alabama Space 112
San Francisco, CA 94110
USA
jerry@littlefluffyclouds.com

Raimondo Della Calce
Via Paolo Antonini 2/1
16129 Genova
I
ray@art5.it

Peter de Lorenzo
PO Box 138
Robertson, NSW 2577
AUS
pdls@ozemail.com.au

Nicolas Deveaux
10 Ave. Henri Matisse
59300 Aulnoy lez Valenciennes
F
supinfocom@valenciennes.net

Anouk de Wercq
van Campenhoutstraat 35
1000 Brüssel
B
portapak@pi.be

Benjamin Deyries
10 Ave. Henri Matisse
59300 Aulnoy lez Valencien-
nes
F
supinfocom@valenciennes.net

Pierre Dietz
Thüringer Str. 26
65428 Rüsselsheim
D
info@contrabasta.de

Benni Diez
Mathildenstr. 20
71638 Ludwigsburg
D
katrin.arndt@filmakademie.de

Pete Docter
1200 Park Ave.
Emeryville, CA 94608
USA
jsalter@pixar.com

Hajo Drott
Platanenstr. 3
82024 Taufkirchen
D
hajo-drott@onlinehome.de

James Duesing
School of Art, Room 300 CFA
Pittsburgh, PA 15213
USA
jduesing@andrew.cmu.edu

Ryan Duncan, Scott Kikuta
2700 N. Tamaimi Trail
Sarasota, FL 34234
USA
strovas@ringling.edu

John Dykstra
9050 W. Washington Blvd.
Culver City, CA 90232
USA
maryr@imageworks.com

Nicholas Economos
P.O. Box 28
Alfred Station, NY 14803
USA
economos@infoblvd.net

Anita Egle
30, Damjanich
7624 Pécs
H
egle.anita@freemail.hu

Michael Enzbrunner
Koetnerholzweg 37
30451 Hannover
D
enzi_@web.de

Ernie Erdwaty Bte Sernan
180 Ang Mo Kio Ave. 8
569830 Singapore
SGP
ranna_seah@nyp.edu.sg

Kevin Ernst
#919-550 Jarvis St.
Toronto, ON M4Y 2H9
CDN
kevinernst@hotmail.com

Interactive Media Team
Central Park West @ 79th St.
New York, NY 10024
USA
jcollins@amnh.org

Birgit Faber
Donau-City-Straße 1/OG 3
1220 Wien
A
gervautz@imagination.at

Mathilde Fabry
10 Ave. Henri Matisse
59300 Aulnoy lez Valenciennes
F
supinfocom@valenciennes.net

Frank Falcone
317 Adelaide St. West, Suite
903
Toronto M5V1P9
CDN
anne@gurustudio.com

Meike Fehre
Behringstr. 34
22763 Hamburg
D
info@puppetmotel.com

Mike Fettery
420 Homer St.
Vancouver, BC V6B 2V5
CDN
sabrina@vfs.com

Andrew Fielden
420 Homer St.
Vancouver, BC V6B 2V5
CDN
sabrina@vfs.com

Filmtecknarna
440 Lafayette 6th Fl.
New York, NY 10003
USA
brett@curiouspictures.com

John Fischer
75 Warren St.
New York, NY 10007
USA
jfischer@artmus.com

Thorsten Fleisch
Seestr. 107
13353 Berlin
D
snuff@fleischfilm.com

Pál Fodor
30, Damjanich
7624 Pecs
H
fopa@art.pte.hu

Mark Fordham
65 Heward Ave., Bldg. A,
S201
Toronto, ON M4M 2T5
CDN
christat@calibredigital.com

Jeff Fowler
2700 N. Tamiami Trail
Sarasota, FL 34234
USA
strovas@ringling.edu

Antonia Fredman
Balaclava & Epping Roads
North Ryde, NSW 2113
AUS
meganp@aftrs.edu.au

Saul Freed
35A Duncan Terrace
London N1 8AL
UK
ks@subres.com

Luc Froehlicher
13-15 RUSe Gaston Latouche
92210 Saint Cloud
F
marie@alamaison.fr

Luca Gaddini
Via di Tiglio, 1275
55100 Lucca
I
info@lucagaddini.it

Dani Gal
Willemerstr. 31
60594 Frankfurt
D
dani22gal@yahoo.com

Celia Galan Julve
Manso 44 - 2 - 2
8015 Barcelona
E
celiagalan@hotmail.com

Robert Gerlach
Seestr. 17
88214 Ravensburg
D
r-gerlach@online.de

HC Gilje
Naunynstr. 88
10997 Berlin
D
hc@nervousvision.com

Rupert Glasson
Balaclava & Epping Roads
North Ryde, NSW 2113
AUS
meganp@aftrs.edu.au

Karoe Goldt
Neubaug. 45/13
1071 Wien
A
dietmar@sixpackfilm.com

Michel Gondry
3 Rue Roquepine
75008 Paris
F
celinef@buf.com

Neil Goodridge
10/201 Franklin St.
Melbourne, VIC 3000
AUS
neil@boingproductions.com

Matthias Götzelmann
Strassburgerstr. 82
22049 Hamburg
D
blumenstueck@hotmail.com

Mark Gravas
5 Ridge St.
Sydney, NSW 2060
AUS
phil@kapowpictures.com

Michaela Grill
Neubaug. 45/13
1070 Wien
A
dietmar@sixpackfilm.com

Balázs Gróf
Damjanich
7624 Pecs
H
fopa@art.pte.hu

Gunter Christian Grossholz
Mathildenstr. 20
71638 Ludwigsburg
D
guntergrossholz@gmx.de

Stephanie Grotto
Chemin du Temple
13200 Arles
F
supinfocom@arles.cci.fr

1.0.3 Group
Cortagy
74520 Savigny
F
cqfd103@hotmail.com

Marek Hamera
ul. Bystrzycka 71/16
54-215 Wroclaw
PL
gemel@amuz.wroc.pl

Christina Hanson
PO Box 734
Cupertino, CA 95015-0734
USA
smudge@backbreaker.com

Happy Ship
PO Box 1720
9701 BS Groningen
N
martin@happyship.com

Peter Hauenschild
Eisenbahng. 12/1
4020 Linz
A
hauenschild@fischerfilm.com

Roman Havertz
Bundesstr. 139
52159 Roetgen
D
sign@noninweb.de

David Haxton
2036 Sharon Road
Winter Park, FL 32789
USA
haxtond@aol.com

Matthew Henderson
420 Homer St.
Vancouver, BC V6B 2V5
CDN
sabrina@vfs.com

Dirk Hennig
Ostendorferstr. 10
27726 Worpswede
D
dirk.hennig@cupere.de

Marc Hermann
Am Weiher 22
20255 Hamburg
D
info@marc-hermann.de

Zdeno Hlinka
Jegeho 21
82108 Bratislava
SK
zden@satori.sk

Oliver Hockenhull
#701-1701 Powell St.
Vancouver, BC V5I5C9
CDN
flyswatterproductions@shaw.ca

Leigh Hodgkinson
Basement Flat, 13 Jenner Rd.
London N16 75B, Stoke
Newington
GB
hoonpatrol@hotmail.com

Franz Hoffman
Cesar Roux 29
1005 Lausanne
CH
lapanosse1@hotmail.com

Harald Holba
Rubensg. 1/7
1040 Wien
A
harald@holba.at

Daniel Holzwarth
Lindenstr. 25
72074 Tübingen
D
d.holzwarth@gmx.de

Seiji Hori
19-2,Yagihashi
305-0842 Tsukuba, Ibaraki
J
chroma@mx1.ttcn.ne.jp

Dave Houghton
40-41 Great Marlborough St.
London W1F 7JQ
GB
natacha@mill.co.uk

Ludovic Houplain
25 Rue du Faubourg Poisson-
nière
75009 Paris
F
hcinq@wanadoo.fr

Rumiko Hoya
1-23-5 Shiba-nishi
333-0855 Kawaguchi City,
Saitama Prefecture
J
digista@telecomstaff.co.jp

Lisa Hutton
204 Mt. Baker Court
Ellensburg, WA 98926
USA
originalone@charter.net

Eunjung Hwang
303 10th #1RB
New York, NY 10009
USA
hwangeunj@hotmail.com

Bakuhatsuto Ikeda
saito 2nd Bldg, 17 Sanei-cho,
Shinjuku-ku
Tokyo
J
taira@trilogy-fs.co.jp

Ivan Iliev
Alxingerg. 5/43
1100 Wien
A
ivan.iliev@chello.at

Masa Inakage
5322 Endoh
252-0816 Fujisawa
J
inakage@sfc.keio.ac.jp

Yuichi Ito
#207, 6-11, Udagawacho
150-0042 Shibugaku, Tokyo
J
itoon@mu2.so-net.ne.jp

Mayu Ito
Coop Midori #201, 3-4-12
Ogawa-nishi
187-0035 Kodaira-shi, Tokyo
J
digista@telecomstaff.co.jp

Guillaume Ivernel
91 Rue Lauriston
75116 Paris
F
nadia.d@sparx.com

Rodorigo Iwasaki
420 Homer St.
Vancouver, BC V6B 2V5
CDN
sabrina@vfs.com

Todd Jahnke
65 Heward Ave., Bldg. A,
S201
Toronto, ON M4M 2T5
CDN
christat@calibredigital.com

**Muhanmad Ayman
Jamaluddin**
Jalan Multimedia
63100 Cyberjaya
MAL
ayman@mmu.edu.my

Jaroslaw Janas
Solskiego 48
45-564 Opole
PL
sztuka@uni.opole.pl

Schawn Jasmann
Unit 2, 145 Hopewell Ave.
Ottawa, ON K1S2Z2
CDN
s@schawn.com

Ruby Jérôme
74, Rue Vendôme
69006 Lyon
F
jeromeruby@hotmail.com

Bernd Jestran
Greifswalderstr. 29
10405 Berlin
D
anne@kitty-yo.de

Jones Joey
202 S Lake Ave. #300
Pasadena, CA 91101
USA
joey@shadedbox.com

Voldemars Johansons
11. Novembra krastmala 35
(207. telpa)
1050 Riga
LV
voldemars@parks.lv

Katica Jordán
30, Damjanich
7624 Pecs
H
fopa@art.pte.hu

Hi Jun
3-17-21 Kichijoji minami-cho
Musashino-shi
180-0003 Tokyo
J
mondo@hi-jun.com

Jun Jie
180 Ang Mo Kio Ave 8
569830 Singapore
SGP
ranna_seah@nyp.edu.sg

Boaz Kaizman
Im Dau 20
50678 Köln
D
kaizman@t-online.de

Sebastian Kaltmeyer
Im Mediapark 1
50670 Köln
D
kaltmeyer@netcologne.de

G. F. Kammerer-Luka
10 Rue Marceau
90000 Belfort
F
KAMMERER-LUKA@wana-
doo.fr

Ivan Kaplow
2700 N. Tamiami Trail
Sarasota, FL 34234
USA
strovas@ringling.edu

Gunnar Karlsson
Ægisgata 7
101 Reykjavik
IS
hilmar@caoz.is

Dusan Kastelic
Miklosiceva 38
1000 Ljubljana
SLO
festivals@film-sklad.si

Yoichiro Kawaguchi
7-3-1 Hongo, Bunkyo-ku
113-8654 Tokyo
J
yoichiro@iii.u-tokyo.ac.jp

Kohske Kawase
2-22-14 Sakuradai,nerima-ku
176 0002 Tokyo
J
www.kawasekohske.info

Rudolf Kellner
Wichtelg. 15/13
1160 Wien
A
r.kellner@mail.com

Elmar Keweloh
Rembertiring 41
28203 Bremen
D
elm@soulcage-department.de

Ivika Kivi
PK 389
10503 Tallinn
EST
ivika@artun.es

Corey Kleim
420 Homer St.
Vancouver, BC V6B 2V5
CDN
sabrina@vfs.com

Martin Koch
304 Bedford Ave. 3rd Floor
Brooklyn, NY 11211
USA
martin@sukkoch.com

Csaba Kocsis
30, Damjanich
7624 Pecs
H
fopa@art.pte.hu

Akino Kondoh
2-21-2-702 Onitaka
272-0015 Ichikawa City,
Chiba Prefecture
J
digista@telecomstaff.co.jp

Ralf Kopp
Landgraf-Georg-Str. 68
64283 Darmstadt
D
ralf.kopp@bucher-kopp.net

Barbara Kowa
Giesebrechtstr. 12
10629 Berlin
D
barbarakowa@operamail.com

Andreas Krein
Weideng. 52
50668 Köln
D
feedback@andreaskrein.net

Werner Kubelka
Rua C 396 Aldei Itaipu
24355-260 Niteroi, Rio de
Janeiro
BR
wkub@uol.com.br

Anna Kubik
Mathildenstr. 20
71638 Ludwigsburg
D
qbik@go2.pl

Eric Kunzendorf
1280 Peachtree St. NE
Atlanta, GA 30309
USA
ekunzendorf@yahoo.com

Kayoko Kuwayama
1-1090 Hayashi-cho
503-0015 Oogaki-shi
J
digista@telecomstaff.co.jp

Fabrice Lagayette
Chemin du Temple
13200 Arles
F
supinfocom@arles.cci.fr

Wilhelm Landt
Mecklenburgerstr. 10
28203 Bremen
D
willi@soulcage-department.de

Juan Carlos Larrea
2700 N. Tamiami Trial
Sarasota, FL 34234
USA
strovas@ringling.edu

Lane Last
621 Exchange St.
Union City, CA 38261
USA
lanelast@utm.edu

Joon Y. Lee
209 East 23rd St.
New York, NY 10010
USA
mbarrett@sva.edu

Scott Lemmer
420 Homer St.
Vancouver, BC V6B 2V5
CDN
sabrina@vfs.com

Francois Xavier Lepeintre
10 Ave. Henri Matisse
59300 Aulnoy lez Valenciennes
F
supinfocom@valenciennes.net

Shiu Li
420 Homer St.
Vancouver, BC V6B 2V5
CDN
sabrina@vfs.com

Lia
Schelleing. 26/2/30
1040 Wien
A
lia@re-move.org

Liisa Lounila
Tallberginkatu 1 E 76
180 Helsinki
SF
av-arkki@av-arkki.fi

Andy Luginbühl
Ferdinand-Hodler-Str. 16
8049 Zürich
CH
ndl@eyemachine.com

Dieter Lunt
Tucholskystr. 42
10117 Berlin
D
cd-lunt@vordembild.de

Wayne Lytle
317 Nye Rd.
Cortland, NY 10345
USA
feedback@animusic.com

Rigoletti M
Müggelstr. 16a
10247 Berlin
D
rigoletti.m@berlin.de

Yann Mabille
40-41 Great Marlborough St.
London W1F 7JQ
GB
natacha@mill.co.uk

Muriel Magenta
P.O. Box 1854, Lenox Hill
Station
New York, NY 10021
USA
michele@3dgiant.com

Michael Takeo Magruder
31A Jobs Lane
Coventry CV4 9DZ
UK
m@takeo.org

Matthias Maier
Finkenstr. 15
70199 Stuttgart
D
maier_m@gmx.de

Akiko Mandara
Pastoral #102, 5-18-6 Shaku-
jiidai, Nerima-ku
177-0045 Tokyo
J
digista@telecomstaff.co.jp

Gerhard Mantz
Helmstr. 11
10827 Berlin
D
mantz@gerhard-mantz.de

Marek Marana
243 East 34th St.
New York, NY 10016
USA
marekmarana@yahoo.com

Sven Martin
Mathildenstr. 20
71638 Ludwigsburg
D
katrin.arndt@filmakademie.de

Pedro Luis Masa Parra
Paco Mutlló 31 B, 1 4
8208 Sabadell
E
m.animacio.audiovisual@uab.es

Riichiro Mashima
1-1-1 Omori Honcho, Omori
Heights #308
143-0011 Tokyo
J
digista@telecomstaff.co.jp

Anna Matysik
Mathildenstr. 20
71638 Ludwigsburg
D
katrin.arndt@filmakademie.de

Matt Mawford
Unit 18, 41 Old Birley St.
Manchester M15 5RF
UK
matt@highdensity.co.uk

Nuno Maya
Quinta Da Boa Esperanca,
Lote 14
2710 Sintra
P
nuno.maya@iF.com

Dean McCallam
Watford Rd.
London HA1 3TP
UK
w9911421@wmin.ac.uk

Matthew McCosker
Cnr Balaclava and Epping Rds
Sydney, NSW 2122
AUS
mat@usingeneral.net

William McCrate
420 Homer St.
Vancouver, BC V6B 2V5
CDN
sabrina@vfs.com

Zack McGill
549 State Rd
Windsor Hts, IA 26075
USA
zmcgill@bgnet.bgsu.edu

Jure Medvedsek
Dunajska 192
1000 Ljubljana
SLO
zlatokosi@yahoo.com

Siri Melchior
33-34 Rathbone Place
London W1T 1JN
UK
joanna@passion-pictures.com

Arina Melkozernova
1522 E.Southern Ave, #2005
Tempe, AZ 85282
USA
amelk98@yahoo.com

Marcello Mercado
Neusser Str. 22 c/o Peters
50670 Köln
D
m_2@gmx.de

André Metello
R. Antonio Parreiras 80
24210320 Niteroi - RJ
BR
andre.metello@uol.com.br

Michael Meyer
Upper Borg 155
28357 Bremen
D
mike@soulcage-department.de

Tayuta Mikage
2-3-6 Nagaisaku Kisarazu-shi
Chiba-ken
J
digista@telecomstaff.co.jp

Dennis Miller
47 MacArthur Rd.
Wellesley, MA 2482
USA
dhmiller@attbi.com

Tamás Mojzer
30, Damjanich
7624 Pecs
H
tombois@freemail.hu

Jordi Moragues
Peter-Welter-Platz 2
50676 Köln
D
jordi@khm.de

Mamoru Morimoto
Setagaya Kinuta
Tokyo
J
mamosystem@ybb.ne.jp

Kazuma Morino
Daikanyama Pacific *605 10-
14 Sarugaku-cho Shibuya-ku
150-0033 Tokyo
J
kazuma@stripe.co.jp

Ann Morrison
51 Glassop St., Balmain
Sydney, NSW 2041
AUS
am@anmore.com.au

Nathalie Morviller
10 Ave. Henri Matisse
59300 Aulnoy lez Valenciennes
F
supinfocom@valenciennes.net

Ricardo Moyano Elías
Ronda Sant Antoni 27, 1° B
8010 Barcelona
E
m.animacio.audiovisual@uab.es

Remi Munier
Chemin du Temple
13200 Arles
F
supinfocomqarles.cci.fr

Yoichi Nagashima
10-12-301, Sumiyoshi-5
430-0906 Hamamatsu, Shizu-
oka
J
nagasm@computer.org

Imre Nagy
420 Homer St.
Vancouver, BC V6B 2V5
CDN
sabrina@vfs.com

Yuval Nathan
Tzaytlin
64956 Tel Aviv
IL
yuval_nathan@hotmail.com

Anneliese Neuhold
Göstingerstr. 31
8020 Graz
A
Anneliese.Neuhold@fh-joan-
neum.at

Carlos Nogueira
Rua Tito 54
5051000 São Paulo
Brazil
carlos.enogueira@sp.senac.br

Timo Novotny
Pater Schwartzg. 11A
1150 Wien
A
newneighbor@usa.com

Atte Juhani Numinen
420 Homer St.
Vancouver, BC V6B 2V5
CDN
sabrina@vfs.com

Steve Oakes
440 Lafayette 6th Fl.
New York, NY 1003
USA
brett@curiouspictures.com

Brian Sum
420 Homer St.
Vancouver, BC V6B 2V5
CDN
sabrina@vfs.com

Attila Szabó
30, Damjanich
7624 Pecs
H
szatsan@freemail.hu

t. o. L
1-14-7 Tsukishima, Chuo-ku
104-0052 Tokyo
J
info@kinetique.co.jp

Philippe Tailliez
Rue du Fb du Temple
75000 Paris
F
philippe.tailliez@tiscali.be

Joe Takayama
293-6 Fukumaru, Wakamiya-
cho, Kurate-gun
8220101 Fukuoka
J
joe@designer.so-net.ne.jp

Ying Tan
220 Coachman Drive
Eugene, OR 97403
USA
tanying@darkwing.uoregon.edu

Usagi Tanaka
1-9-26-907 Edagawa
Koutou-ku Tokyo
J
KY9T-TNK@j.asahi-net.or.jp

Evan Tapper
1 Park Place, Apt 4
Fredonia, NY 14063
USA
tapper@fredonia.edu

Ushio Tazawa
Coop Kumakura #201, 3-30-
20 Minami-oizumi, Nerima-ku
178-0064 Tokyo
J
digista@telecomstaff.co.jp

telefish
Ullmannstr. 13/21
1150 Wien
A
olga.dafeldecker@chello.at

Barnaby Templer
Basement Flat, 13 Jenner
Road
London N16 75B, Stoke
Newington
GB
hoonpatrol@hotmail.com

Sok Hooi Teng
Jalan Multimedia
63100 Cyberjaya
MAL
juhanita@mmu.edu.my

Yong Jin Teo
Jalan Multimedia
63100 Cyberjaya
MAL
juhanita@mmu.edu.my

Simon Tessier
5524-C St. Patrick, Entree C,
Loft 480
Montreal, Quebec H4E 1A8
CDN
simon@damnfx.com

Andreas Teuchert
Görlitzer Str. 50
10997 Berlin
D
ateuchert@web.de

Russell Tickner
40-41 Great Marlborough St.
London W1F 7JQ
GB
natacha@mill.co.uk

Jan Tomanek
Na Rybnicku 12
120 00 Prag 2
CZ
tomanek@aaa-studio.cz

Satoshi Tomioka
Syatore Joji Town #105, 3-5-4
Kichijojiminami-cho
180-0003 Musashino-shi,
Tokyo
J
tomioka@tt.rim.or.jp

Bruce Tovsky
425 14th St., Apt c8
Brooklyn, NY 11215
USA
bruce@skeletonhome.com

Anna Tow
Balaclava & Epping Roads
North Ryde, NSW 2113
AUS
meganp@aftrs.edu.au

Meni Tsirbas
7408 Lexington St.
West Hollywood, CA 90046
USA
dane@menithings.com

Pink Twins
Tallberginkatu 1 E 76
180 Helsinki
SF
av-arkki@av-arkki.fi

Maxim Tyminko
Hammer Dorfstr. 15
40221 Düsseldorf
D
maxim@khm.de

Anton Tyroller
Anatomiestr. 22
85049 Ingolstadt
D
anton@tyroller.net

Mari Umemura
15 Victoria Chambers, Mark
St.
London EC2A 4EL
UK
ume@btinternet.com

Anna Ursyn
University of Northern Colo-
rado, Dept. of Visual Arts
Greeley, CO 80639
USA
ursyn@unco.edu

Theodore Ushev
4590 Queen Mary #410
Montreal, Quebec H3W 1W6
CDN
theodore@ushev.com

Oerd van Cuijlenborg
6 Rue Jean Bertin
26000 Valence
F
folimage@wanadoo.fr

Jerry van de Beek
499 Alabama Space 112
San Francisco, CA 94110
USA
betsy@littlefluffyclouds.com

Juha Van Ingen
Tallberginkatu 1 E 76
180 Helsinki
SF
av-arkki@av-arkki.fi

Sandra Vasquez dela Horra
Platanenstr. 8
40233 Düsseldorf
D
svdlh@khm.de

Mona Vatamanu
Vitejiei, nr 2, bl 1, ap 57
732743 Bucharest
RO
monafloe@hotmail.com

Giuliano Vece
Donaustr. 129
12043 Berlin
D
vece@khm.de

Vesa Vehviläinen
Hattelmalantie 5-7 c 71
710 Helsinki
SF
info@pinktwins.com

Mathieu Veillette
335, de Maisonneuve East
Blvd, Suite 300
Montreal, Quebec H2X 1K1
CDN
isabella@nadcentre.com

Urban Velkavrh
Jakceva 39
1000 Ljubljana
SLO
urban@slo.net

Erwin Gomez Vinales
Jorge VI 753, Las Condes
Santiago, RM
RCH
rokunga@spondylus.cl

Dominic Vincent
335, de Maisonneuve East
Blvd, Suite 300
Montreal, Quebec H2X1K1
CDN
dominicvincent@sympatico.ca

Nicolas Vitte
10 Ave. Henri Matisse
59300 Aulnoy lez Valenciennes
F
supinfocom@valenciennes.net

François Vogel
13, Rue de Mont-Louis
75011 Paris
F
info@entropiefilms.com

Ludovic Walsh
23 Rue du Château des
Rentiers
75013 Paris
F
ludowalsh007@yahoo.com

Louis Wang
70 Rungan 5th St.
320 Jungli City, Taoyuan
RC
louis@ingo.com

Tim Weimann
Frisonistr. 2
71636 Ludwigsburg
D
tim@das-dritte-d.de

Georg Weiss
Elisabethstr. 23
80796 München
D
george.weiss@t-online.de

Christian Wieser
Carl-Spitzweg-Str. 50
90768 Fürth
D
mail@chris-wieser.com

Nina Wild
PF 2464 Engelstr. 64
8026 Zürich
CH
ninawild@yahoo.com

Joan Wildman
218 Knutson Dr.
Madison, WI 53704
USA
jwildman@facstaff.wisc.edu

Damon Wolfe
420 Homer St.
Vancouver, BC V6B 2V5
CDN
sabrina@vfs.com

Mike Wong
City University of Hong Kong
Kowloon
PRC
smmike@cityu.edu.hk

Wotomoro
4635 de Brebeuf
Montreal, Quebec H2J 3L2
CDN
sylvain.moreau@videotron.ca

Koji Yamamura
4-8-10 Kasuya, Setagaya-ku
157-0063 Tokyo
J
yam@jade.dti.ne.jp

Vonda Yarberry
1743 South Kimbrough
Springfield, IL 65807
USA
vondayarberry@smsu.edu

Mark Yoo
420 Homer St.
Vancouver, BC V6B 2V5
CDN
sabrina@vfs.com

Kanako Yoshida
1-17-3 Takadanobaba, Shin-
juku-ku
169-0075 Tokyo
J
digista@telecomstaff.co.jp

Hirosuke Yoshimori
Aoki Bldg #203, 1-11-4
Tomioka, Koto-ku
135-0047 Tokyo
J
digista@telecomstaff.co.jp

Yasuhiro Yoshiura
3-42-16 Wakahisa, Minami-ku
815-0042 Fukuoka-shi
J
digista@telecomstaff.co.jp

Albert Yu
435 46 St.
Brooklyn, NY 11220
USA
yukaho@yahoo.com

Steve Zabel
420 Homer St.
Vancouver, BC V6B 2V5
CDN
sabrina@vfs.com

Stefan Zauner
Hauptstr. 117
4232 Hagenberg
A
mtd@fh-hagenberg.at

Harry Zhuang
180 Ang Mo Kio Ave. 8
569830 Singapore
SGP
ranna_seah@nyp.gov.sg

René Zumbühl
Langstr. 64
8004 Zürich
CH
sacco@swix.ch

DIGITAL MUSICS

[skoltz_ kolgen]
473 Blvd. St. Joseph Est
Montréal, Québec H2J1J8
CDN
2@dioxyde.net

[The User]
Staalkade 6
1011JN Amsterdam
N
Geert-Jan@staalplaat.com

33.3
1325 SE Marion St.
Portland, OR 97202
USA
ken@aesthetics-usa.com

365soundproject
Kamer 105, 34 Matenweg
7522 LK Enschede
NL
soundproject365@hotmail.co
m

About this Product
539 E. Villa #22
Pasadena, CA 91101
USA
phthalo@phthalo.com

Menno Aden
Saarbrücker Str. 30
10405 Berlin
D
menno@uni-bremen.de

Mathew Adkins
9/11 Old Rd
Holmbridge HD9 2NU, West
Yorkshire
UK
m.adkins@hud.ac.uk

Gunter Adler
Max-Brauer-Allee 75
22765 Hamburg
D
jyrgen@gmx.de

Aelters
109, Rue Jeanne d'Arc
59000 Lille
F
aelters@ski-pp.com

Akuvido
Bizetstr. 102
13088 Berlin
D
akuvido@web.de

Marco Albert
Via Garigliano, 8
20100 Milano
I
maikko@otolab.net

Liana Alexandra
Rosia Montana
Nr.4,Bl.05,Sc.4,Ap.165
77584 Bucharest
RO
lianaalexandra@pcnet.ro

Oscar Rodrigo Alonso Inclán
Angel Urraza #622 Col. Del
Valle
3100 México, D.F.
MEX
polivia@radioeducacion.edu.mx

Oren Ambarchi
31/8 Macleay St.
Potts Point NSW 2011
AUS
jerkerproductions@yahoo.com

Ralph Ammer
Liselotte-Herrmann-Str. 12
10407 Berlin
D
ralph@ammerart.de

Amoxi-Wolff
Denisstr. 4
90429 Nürnberg
D
postmeister@amoxi-wolff.de

Anat and chicks on speed
Tudor Grove
London E9-7QL
UK
ben_david_anat@hotmail.com

Brendon Anderegg
583 Driggs Ave
Brooklyn, NY 11211
USA
anderegg@staartje.com

Elizabeth Anderson
Ave de Mont Carlo, II
1190 Bruxelles
B
e.anderson@skynet.be

Andreja Andric
Jevrema Grujica 6
11000 Belgrade
YU
aandreja@galeb.etf.bg.ac.yu

Anne
Wisbyer str. 1
10439 Berlin
D
anne@brandshof.de

Antenna Farm
539 E. villa #22
Pasadena, CA 91101
USA
phthalo@phthalo.com

VJ Anyone
3rd Floor, 72 Great Eastern St
London EC2A 3JL
UK
the_one@anyone.org.uk

Takamasa Aoki
Chiyozaki Nishi-ku
550-23 Osaka-shi
J
neutrino@juno.ocn.ne.jp

Jon Appleton
3023 Jericho Str
White River Jct., VT 5001
USA
jon.appleton@dartmouth.edu

Patrick Ascione
Hameau aux Roux
14140 Lisores
F
patrickascione@wanadoo.fr

Oliver Augst
Kaiserstr. 40
60329 Frankfurt
D
augst@textxtnd.de

Wolfgang Bachschneider
Unertlstr. 11
80803 München
D

Mark Bain
Pesthuislaan 39
1054 RH Amsterdam
NL
simulux@planet.nl

Kovács Balázs (Xrc)
Murányi
8000 Székesfehérvár
H
xrc@stud.btk.pte.hu

Christian Banasik
Zietenstr. 11
40476 Düsseldorf
D
c.banasik@t-online.de

Jesse Barrett
3/21 Tourello Ave, East
Hawthorn
Melbourne, VIC 3123
AUS
dr.j@oxygen.ie

Natasha Barrett
Blasbortvn. 10
873 Oslo
NL
natashab@notam02.no

Mason Bates
936 Bayview Ave. #B
Oakland, CA 94610
USA
list@masonbates.com

Andrea Belfi
Via Valpolicella 64
37025 Parona (VE)
I
andrea@chocolateguns.com

Bob Bellerue
9202 Langdon Ave
North Hills, CA 91343
USA
bellerue@calarts.edu

Milosz Bembinow
Grojecka 104/1
02-367 Warsaw
PL
miloszb@wa.home.pl

Douglas Benford
63 Windmill Rd
London TW8 0QQ
UK
douglas@benfo.demon.co.uk

Benge
158 Forest Rd.
Loughton IG10 1EG
UK
benspost@hotmail.com

Justin Bennett
van der Duijnstraat 61 A
2515NG Den Haag
NL
justin@this.is

William Bennett
PO Box 914
Edinburgh EH17
UK
susanlawly@freeuk.com

Sébastien Béranger
17, Rue de la Véga
75012 Paris
F
sberanger@club-internet.fr

Rodney Berry
2-2-2 Hikaridai, Keihanna
Science City
619-0288 Kyoto
J
rodney@atr.co.jp

Andreas Bertilsson
Möllevångstorget 12
214 24 Malmö
S
maximilian@komplott.com

Paolo Besagno
Via Cà Cecchi 35/5
16010 Sant'Olcese (GE)
I
canterini@tin.it

Chuck Bettis
186 Franklin Ave (1st Floor)
New York, NY 11205-2704
USA
chubbfire2002@yahoo.com

Marc Beugnies
Chemin de Campuno
31380 Villariès
F
marc.beugnies@free.fr

Fsco Biasiol
Viale G. Garibaldi, 101
34077 Ronchi dei Legionari
I
Fsco.biasiol@tiscali.it

BiP_HOp
BP 64
13192 Marseille, Cedex 20
F
ip@bip-hop.com

B j m
Via Marinai Alliata 15 b
90146 Palermo
I
bbjmm@tin.it

Antun Toni Blazinovic
Gorenci 32
10000 Zagreb
HR
obad1@yahoo.com

Markus Bless
Ledererg. 9
4861 Schörfling
A
markus.bless@ufg.ac.at

Daniel Blinkhorn
65 Pine Str Chippendale
Sydney, NSW 2008
AUS
bookofsand@hotmail.com

BMB con.
Obrechtstraat 240
25 Den Haag
NL
bmbcon@this.is

Odyssey Bogussevich
Federativny prospect 5-1-7
111399 Moskau
RUS
odyssey@mccinet.ru

Félix Boisvert
8324 de Gaspé
Montréal, QC H2P2K1
CDN
feul@internet.uqam.ca

Sinan Bokesoy
16, Rue de l'Union
94140 Alfortville
F
bokesoy.sinan@wanadoo.fr

Dan Boord
Fine Arts Department
Boulder, CO 80309
USA
luis.valdovino@colorado.edu

Andre Bosman
4 Ice House Lane
Norwich NR1 2BQ
UK
andre.bosman@ntlworld.com

William Bottin
Via Siracusa 24
35142 Padova
I
william@bottin.it

Christian Bouchard
5425 Rue Bordeaux #325
Montreal, QC H2H 2P9
CDN
christian_b@sympatico.ca

Dino Bramanti
Via Valdicastello 173
55040 Pietrasanta
I
dino.bramanti@libero.it

Marek Brandt
Erich-Weinert-Str. 12
4105 Leipzig
D
brandt@privatelektro.de

Frank Bretschneider
Dunckerstr.89
10437 Berlin
D
fb@frankbretschneider.de

Aldo Brizzi
Rua Afonso Celso 109 - 401
40140-080 Salvador Bahia
BR
solar@cpunet.com.br

Jean-Francois Brohée
Rue de la Seconde Reine, 44
1180 Bruxelles
B
djinbrohee@hotmail.com

Karsten Brustad
Hawwestadbakken 6
1718 Greaker
NL
karsten.brustad@sensewave.
com

P. Miles Bryson
641 N. Vineyard
Mesa, AZ 85201
USA
drsquid1@cox.net

George Budd
1463 S. Sherbourne Dr.
Los Angeles, CA 90035
USA
earshot20@aol.com

Erik Bünger
Hammarby Alle 30C/201
12079 Stockholm
S
erikbunger@hotmail.com

Adam Butler
Lindenstr. 32
50674 Köln
D
adam@isness.org

Thomas Cahill-Jones
Music Dept., Edgbasion Park
Rds
Birmingham B15 2TT
UK
tom_casual_jones@hotmail.com

Mira Calix
PO Box 25378
London NW5 1GL
UK

Christian Calon
3678 Henri-Julien
Montréal, QC H2X 3H5
CDN
klong@sympatico.ca

Lidia Camacho
Ángel Urraza 622
3100 México D.F.
MEX
polivia@radioeducacion.edu.mx

Mannlicher Carcano
711 Machray Ave
Winnipeg, MB R2W 1B4
CDN
rfgodot@shaw.ca

Mauro Cardi
Via Luigi Tosti 45
179 Roma
I
m.cardi@edisonstudio.it

Jeff Carey
Usselincxstraat 3
2593VG Den Haag
NL
jcarey@radiantslab.com

Massimo Carlentini
Via del Mare, 132
96013 Carlentini (SR)
I
m.carlentini@tiscali.it

Kim Cascone
748 Edgemar Ave
Pacifica, CA 94044
USA
kim@anechoicmedia.com

Werner Cee
Krofdorfer Str 41 b
35398 Gießen
D
Cee.obrecht@t-online.de

Victor Cerullo
Via Caneve, 77
30173 Mestre (VE)
I
moog@libero.it

Leo Cesari
2 Rue Marianne
1180 Bruxelles
B
leocesari@libero.it

Cédric Ceulemans
Montagne aux Ombres
1150 Bruxelles
B
cedric7979@yahoo.com

Richard Chartier
601 N. Eutaw St #410
Baltimore, MD 21201
USA
chartier@3particles.com

Loren Chasse
933 Dolores
San Francisco, CA 94110
USA
earafoot@hotmail.com

Chin-Chin Chen
11568 Brookland Dr.
Allendale, MI 49401
USA
chenc@gvsu.edu

Antonino Chiaramonte
Via Angelo Bellani, 21
153 Roma
I
a.chiaramonte@inwind.it

Mista Chio
2368 Rue Chapleau
Montreal, QC H2K 3H3
CDN
iroro@sympatico.ca

Ty Chiu
15F-2, 245, sec.1, Fu-Shing
South Rd.
106 Taipei
RC
djty@ms68.hinet.net

Martin Christel
Gryphiusstr. 24
10245 Berlin
D
mchristel@t-online.de

Thanos Chrysakis
6 Lushington Rd
London NW10 5UU
UK
carillon@zoom.co.uk

Se-Lien Chuang
Schaftalbergweg 33
8044 Graz
A
cse-lien@sime.com

Nikita Chudjakov
Sint-Jansvest 14D
9000 Ghent
B
neuronick@yahoo.com

Alison Chung-Yan
805-2881 Richmond Rd.
Ottawa, ON K2B8J5
CDN
achungyan@sprint.ca

Miha Ciglar
Celjska 9
2000 Maribor
SLO
miha.ciglar1@guest.arnes.si

Kit Clayton
539 E. Villa #22
Pasadena, CA 91101
USA
phthalo@phthalo.com

Philip Clemo
49A Vanbrugh Park
London SE3 7JQ
UK
clemo@philipclemo.com

Jay Cloidt
539 E. Villa #22
Pasadena, CA 91101
USA
phthalo@phthalo.com

Paul Clouvel
6 Rue du Charrier
18000 Bourges
F
paulclouvel@laposte.net

Ernesto Coba
Cra 7a #45 - 48 Apto. 1604
Bogota D.C.
CO
ketismo@hotmail.com

Gianluca Codeghini
Via Pizzi 29
20141 Milano
I
kok@kok.it

Peter Colbert
Assmayerg. 31/48
1120 Wien
A
pjedlicka@aon.at

Jonathan Coleclough
8 Western Rd
Reading RG1 6PD
UK
Jonathan@Coleclough.net

super_ collider
The metway, 55 Canning st
Brighton BN2 0EF
UK
emma@no-future.com

Nick Collins
10 Beechlawns torrington
Park north Finchley
London N12 9PP
UK
nick@sicklincoln.org

Mark Cooley
701 S. Pickwick
Springfield, MO 65802
USA
mgc868f@smsu.edu

Fernando Corona (aka Murcof)
Suite 216, Bon Marche Building, 241 Ferndale Rd
London SW9 8BJ
UK
info@murcof.com

Marco Cortesi
V. Varesi 36
6600 Locarno
CH
mcortesi@freesurf.ch

Ollivier Coupille
21 Rue du Roule
75001 Paris
F
Ollivier.Coupille@wanadoo.fr

Phil Curtis
226 S. New Hampshire Ave #3
Los Angeles, CA 90004
USA
pcurt@hotmail.com

D84
539 E. Villa #22
Pasadena, CA 91101
USA
phthalo@phthalo.com

Daedelus
539 E. Villa #22
Pasadena, CA 91101
USA
phthalo@phthalo.com

Palle Dahlstedt
Sven Hultins Gata 6
412 96 Göteborg
S
palle@design.chalmers.se

Giovanni Damiani
Via G.Damiani Almeyda 5
90141 Palermo
I
gdami@libero.it

Das Fleisch feat. Sirene
Gartenstadtstr. 18
4040 Puchenau
A
robert_wacha@hotmail.com

Martin Daske
Neue Scheune 23
14548 Ferch
D
tribordstudio@web.de

Alex Davies
2/144 Cleveland St, Chippendale
Sydney, NSW 2008
AUS
alex@neurospike.net

Alberto de Campo
Bergstr. 59/33
8020 Graz
A
adc@khm.de

Ijnveïq de Ernestine
23 Placette des Plaquetminiers
6560 Valbonne
F
kinousmith@aol.com

Franco Degrassi
Via G. Cozzon 2
70125 Bari
I
fdegrassi@libero.it

Christopher DeLaurenti
PO Box 45655
Seattle, WA 98145
USA
chris@delaurenti.net

Elwyn Dennis
Bunjil's Cave Rd
Stawell West, Victoria 3380
AUS
elwyn.dennis@bigpond.com

Christian Dergarabedian
Sancho Marraco 4,4
8004
Barcelona
E
dialsinfin@hotmail.com

Joe Diebes
400 West 13th Str
New York, NY 10014
USA
jdiebes@mindspring.com

Dinky aka Alejandra Iglesias
PO Box 20368
New York, NY 10002
USA
todd@carparkrecords.com

Rocco Di Pietro
1428 King Ave. #26
Columbus, OH 43212
USA
rdipietr@cscc.edu

Agostino Di Scipio
Via Salaria Antica Est. 33/A
67100 L'Aquila
I
discipio@tin.it

DJ / rupture
c/ Call, 17, 2-1
8002 Barcelona
E
nettlephonic@yahoo.com

DJ CPK
539 E. Villa #22
Pasadena, CA 91101
USA
phthalo@phthalo.com

DNTEL
539 E. villa #22
Pasadena, CA 91101
USA
phthalo@phthalo.com

Roberto Doati
Via Giorgione 66
35020 Albignasego
I
r.doati@flashnet.it

Andrew Dobson (Digitonal)
36 Carmel Court, Kingsdrive,
Wembley Park
London HA9 9JE
UK
andy@digitonal.com

Jim Dodd
1 Seaview St, Waverley
Sydney, NSW 2024
AUS
bloq@couchblip.com

Mr Dorgon
138 1st Ave #2
New York, NY 10009
USA
mrdorgon@yahoo.com

Roland Dorman
36 Carmel Court, Kingsdrive,
Wembley Park
London HA9 9JE
UK
themultiplex@hotmail.com;
cdorman@hotmail.com

Hartmut Dorschmer
Schönfelderstr. 1
1099 Dresden
D
margit@freejazz.de

Double Adaptor
8 Lisburn St
Dublin 7
IRL
roytronix@yahoo.com

Kevin Drumm
1523 North Wicker Park Ave
#2
Chicago, IL 60622
USA
lefondst@ripco.com

The Dry Heeves
38-161 Greenfields Drive
Fredericton, NB E3B 5L9
CDN
heeves@nb.sympatico.ca

Bertrand Dubedout
39, Rue de Rabastens
31500 Toulouse
F
bdubedout@online.fr

Andrew Duke
1096 Queen St #123
Halifax, NS B3H2R9
CDN
andrewduke@CDN.com

John Duncan
Fraz. Scrutto 48
33040 San Leonardo (UD)
I
info@johnduncan.org

Sasha Dundovic
B. Stipcic 41
51000 Rijeka
HR
dundovic@att.net

Stephan Dunkelman
Ave Clemenceau 92
1070 Brüssel
B
dunkelman@wanadoo.be

Tomas Dvorak
Ripska 19
13000 Praha 3
CZ
floex@floex.cz

Jens-Uwe Dyffort
Eylauer Str. 3
10965 Berlin
D
info@dyffort-driesch.de

Marcin Dymiter
41 Grottgera 40A/7
80-319 Gdansk
P
fpomd@univ.gda.pl

E. T. Sound
Seitenstetteng. 5/17
1010 Wien
A
info@2gas.net

Eavesdropper and Waterman
Marcqstraat 6
1000 Bruxelles
B
yves@knobsounds.com

Rudolf Eb.er
2-10-17 Fukae Minami,
Higashi-Nari-ku
537-0002 Osaka-City
J
r............error@docomo.ne.jp

Jorn Ebner
37A Cecilia Rd
London E8 2ER
UK
jorn.ebner@britishlibrary.net

Gerhard Eckel
Beethovenstr. 8
53115 Bonn
D
mail@grenzenlosefreiheit.de

Derek Ecklund
12265 NW Big Fir Circle
Portland, Oregon 97229
USA
mesmer@pacifier.com

Michael Edwards
138/8 Calton Rd
Edinburgh EH8 8DP
UK
m@michael-edwards.org

Martin e Greil
Hatlerstr. 51
6850 Dornbirn
A
martin@aspara.org

eight frozen modules
8fm@eight-frozen-modules.com

Electronicat
1 Pass. Du Ruisseau du
Menilmontant
75020 Paris
F
fredbigo@gmx.net

Leif Elggren
Tobaksspinnargatan 4
117 36 Stockholm
S
leif.elggren@mbox300.swip
net.se

Carsten Endraß
Eichenstr. 6d
83083 Riedering
D
markant-records@t-online.de

Hey Erler
Weserstr. 37
12045 Berlin
D
heyrec@gmx.de

errorsmith
Schwedter Str. 28
10119 Berlin
D
me@errorsmith.de

Essetesse
1150 Sunvue Place #2
Los Angeles, CA 90012
USA
essetesse@yahoo.com

Alan Fabian
Willigisstr. 4
50969 Köln
D
alan.fabian@web.de

Marion Fabian
Dominicusstr. 50
10827 Berlin
D

Fan Club Orchestra
Residence Baudoux, 137 Ave.
de Brabanconne
1030 Brusells
B
scratchpetland@sonig.com

Michael V. Farley
827 Feura Bush Rd
Delmar, NY 12054
USA
mvfarley@aol.com

Paul Farrington
71 Lincoln St, Brighton
Brighton BN29UG
UK
studio@studiotonne.com

Faust Faust
Ertinger Str. 45
88525 Dürmentingen
D
info@klangbad.de

Simon Fell
24 Chauntry Rd
Haverhill CB98BE
UK
shf@brucesfingers.co.uk

José Miguel Fernandez
43, Quai Pierre Scize
69009 Lyon
F
jmf@cnsm-lyon.fr

Miguel Angel Fernández-Naranjo
Angel Urraza #622 Col. Del
Valle
3100 México, D.F.
MEX
anaranjo@radioeducacion.edu
.mx

Antonio Ferreira
Av. Gaspar Corte Real, n18
4E
2750 Cascais
P
nop35624@mail.telepac.pt

Fetish 69
Fichtenstr. 12
1097 Dresden
D
bert.offermann@doxa.de

Roberto Filoseta
1 Admirals Close, Colney
Heath
Herts AL4 0QD
UK
R.L.Filoseta@herts.ac.uk

Orm Finnendahl
Seelingstr. 47/49
14059 Berlin
D
finnendahl@folkwang-
hochschule.de

Rajmil Fischman
Music Department
Keele - Staffordshire ST55BG
UK
r.a.fischman@mus.keele.ac.uk

Hans Fjellestad
740 13th St, Studio 323
San Diego, CA 92101
USA
hans@zucasa.com

Robert Flatow
70 east 10th street
New York,NY 10003
USA
mlumbo@earthlink.net

Peter Fleschhut
Kirchplatz 5
87509 Immenstadt
D

Carlo Forlivesi
1-22-3 Toshima Kitaku
114-0003 Tokyo
J
carlo_forlivesi@hotmail.com

Jason Forrest / Donna
Summer
29 North Henry St. Apt #1
Brooklyn, NY 11222
USA

Massimo Fragalà
Via Acicastello 25
95020 Ficarazzi (CT)
I
massimofragala@tiscali.it

J. Frede
PO Box 292045
Los Angeles, CA 90029
USA
jfrede@ritualdocument.com

Heribert Friedl
Langackerg. 37
1190 Wien
A
heribert.friedl@aon.at

Burnt Friedman
Bernhard-Nocht-Str. 87
20359 Hamburg
D
oke@nonplace.de

Frozen Modules
539 E. Villa #22
91101 Pasadena, CA
USA
phthalo@phthalo.com

Fuckhead
Piringerhofstr. 11
4020 Linz
A
sinus@sil.at

Akemi Fujita
84 Pusewardens Close
London W13 9PW
UK
akemi@luc.vg

Thomas Gäbhard
Dingbuch 3
83139 Söchtenau
D
tgaebhard@t-online.de

Jerry Galle
Kruiningenstraat 193
2900 Schoten
B
jerry.galle@wanadoo.be

Jens Gantzel
August-Bebel-Str. 105
33602 Bielefeld
D
kontakt@jottwege.de

Paolo Geminiani
Via Alfredo Oriani, 6
48025 Riolo Terme (Ra)
I
pgeminiani@libero.it

Genesis
PO Box 345
11173 Stockholm
S
info@kooks.org

Thomas Gerwin
Calvinstr. 13
10557 Berlin
D
inter.art.project@t-online.de

Stelios Giannoulakis
College Rd
LL57 2DG Bangor, Wales
UK
stgiann@yahoo.com

Klaus Giesriegl
Fasserg. 2
6060 Hall in Tirol
A
dvthaur@chello.at

Gisburg
182 Franklinstr. #E17
Brooklyn, NY 11222
USA
gisburg@burg.net

Ron Goldin
721 Broadway, 4th Floor
New York, NY 10003-6807
USA
tobiasblue@gmx.net

Andreas Golinski
Süding 20
44787 Bochum
D
kapravelos@gmx.de

Annie Gosfield
301 East 12th St #3D
New York, NY 10003
USA
AGosfield@aol.com

David Grubbs
423 First St #3
Brooklyn, NY 11215
USA
bluesea@dragcity.com

Elisabeth Grübl
Bürgerspitalg. 18/3/11
1060 Wien
A
e_gruebl@inode.at

Grundik + Slava
230 Riverside Dr
New York, NY 10025
USA
grundik@earthlink.net

Claudia Hägeli
8 bis, Rue Marguerite
75017 Paris
F
hageli8@yahoo.fr

Takehiro Hagiwara
684-14, Soya
257-0031 Hadano
J
hagi@tkhr.net

Sven Hahne
Wiesbadenerstr.1
51065 Köln
D
hahne@khm.de

Jia Haiqing
601, Building 10, Mudan-
yuanbeili 20, Huayuanbeilu,
Haidian District
100083 Beijing
PRC
apple@8gg.com

John Harford
728 South Ave West
Westfield, NJ 7090
USA
thefragment@thefragment.com

Jean Louis Hargous
Quartier Harismendia
64122 Urrugne
F
jeanlouis.hargous@wanadoo.fr

Masato Hatanaka
Dorotheenstr. 57
22301 Hamburg
D
htnkmst@yahoo.co.jp

Healamonster &Tarsier
282 Prospect Park West
Brooklyn, NY 11215
USA
onesecond@17ftjellyfish.com

Tom Heasley
9663 Santa Monica Bl. #125
Beverly Hills, CA 90210
USA
tom@tomheasley.com

Maximilian Hecker
Greifswalder Str. 29
10405 Berlin
D
anne@kitty-yo.de

Tim Hecker
#3 - 179 Cobourg St.
Ottawa, ON K1N-8H4
CDN
hecker_t@yahoo.ca

Florian Hecker
Ruckerg. 10/21+22
1120 Wien
A
info@mego.at

Jens Hedman
Sondermalarstrand 61
11825 Stockholm
S
jens.hedman@mail.com

Katharina Hein
Oderberger Str. 20
10435 Berlin
D
ufonics@gmx.net

Erdem Helvacioglu
Yildizposta Cad. 11/23
Gayrettepe
80280 Istanbul
TR
erdemhel@turk.net

Nathan Hemenway
1333 1/2 Masselin
Los Angeles, CA 90019
USA
nhemenway@teeter.org

Stephan Hempel
Grunewaldstr. 2-5
10823 Berlin
D
stephanhempel@tiremail.de

Günter Henkelmann
Sonnenstr. 36
85405 Nandlstadt
D
Henkelmann.CHEMOLAB@t-
online.de

Javier Hernando
Plaza Ibiza 19/3/2a
8031 Barcelona
E
javhernando@mac.com

S. Arden Hill
396 Home St
Winnipeg, MB R3G 1X4
CDN
duul_drv@shaw.ca

Kim Hiorthoy
PO Box 2069 Grunerlokka
505 Oslo
NL
joakim@smalltownsuper-
sound.com

Geert-Jan Hobijn
Staalkade 6
1011NK Amsterdam
NL
geert-jan@staalplaat.com

Karl Hochguertel
Callejon nr. 5
78550 Real de Catorce
MEX
cvantomorrow@hotmail.com

Hannes Hoelzl
Arnstädter Weg 6
51103 Köln
D
hannes@earweego.net

Felix Höfler
Körner Str. 48
50823 Köln
D

Jan Jacob Hofmann
Florastr.11
60487 Frankfurt
D
janjacob@web.de

Paul Hogan
549 Riverside Dr.Apt. 6A
New York, NY 10027
USA
paul@hoganmusic.com

Klaus Hollinetz
Steinhumergutstr. 1
4050 Traun
A
klaus.hollinetz@servus.at

Hood
1325 SE Marion St.
Portland, OR 97202
USA
ken@aesthetics-usa.com

Kanta Horio
Shiobaru 4-22-11 Seiwa
Heights 2-205
815
32
J
horio@adin4.com

Martin Howse
Unit 22, 38-40 Upper Clapton
Rd
London E5 8BQ
UK
m@1010.co.uk

John Hudak
26 Parkway Dr
Dobbs Ferry, NY 10522
USA
jhudak@pobox.com

Nik Hummer
Gumpendorferstr.47/21
1060 Wien
A
thilges@thilges.at

I8U
01220 Atwater
Montreal, QU H3K3J3
CDN
muse@i8u.com

Kozo Inada
5-3-5-902 Kusaka-cho Higashiosaka-shi
579-8001 Osaka
J
snd@jp.org

Hans Joachim Irmler
Ertinger Str. 45
88525 Dürmentingen
D
faust-klangbad@t-online.de

Yukiko Ito
#303 Fuji View Mansion, 1-3-9 Fujimidai, Kunitacih-shi
186-3 Tokyo
J
cokiyu@mac.com

Colditz James Chapman
1 Burnbank Terrace,
Glasgow G20 6UT
UK
colditz@psychiatricrecords.com

Juri Jansen
Mittelstr. 51
57555 Mudersbach
D
FABIA@t-online.de

Els Jegen
Weissensteinstr. 18
3008 Bern
CH
info@els-jegen.ch

Jan Jelinek
Dunckerstr. 7
10437 Berlin
D
info@scape-music.de

Hilmar Jensson
Gardsendi 11
108 Reykjavik
IS
Hilmar@hilmarjensson.com

Bernd Jestran
Greifswalder Str. 29
10405 Berlin
D
anne@kitty-yo.de

Alexander Jöchtl
Wildberg 2, Schloss Wildberg
4202 Kirchschlag
A
ismirschlecht@servus.at

Takayuki Joe
5-37-19-102 Sakurajosui
Setagaya-ku, Tokyo
156-45
Tokyo
J
tet@cubicmusic.com

Voldemars Johansons
11. Novembra krastmala 35
(207. telpa)
1050 Riga
LV
voldemars@parks.lv

Charles Jowett
118 Walcott St
Stow, MA 1775
USA
the10planet@yahoo.com

Gary Joynes
9236 - 81 St
Edmonton, CA T6C 2W3
CDN
gjoynes@telusplanet.net

Elsa Justel
36, Rue Emile Dequen
94300 Vincennes
F
justelsa@wanadoo.fr

Frédéric Kahn
36, Grande Rue de Vaise
69009 Lyon
F
f.kahn@free.fr

Mark Kammerbauer
Reichenberger Str. 26
84130 Dingolfing
D
nexialist@nexialist.com

Ejnar Kanding
Struenseegade 15 A, 5. th
2200 Copenhagen N
DK
kanding@contemporanea.dk

Jaroslaw Kapuscinski
245 Notre-Dame-de-Fatima
Laval, QU H7G3Y6
CDN
kapuscinski@attbi.com

Konstantinos Karathanasis
11 Hedge Ct #4
Snyder, NY 14226
USA
kk28@acsu.buffalo.edu

Ines Kargel
Beethovenstr. 19
4020 Linz
A
ines@kargel-neuhaus.net

Jussi Karsikas
Valajankatu 3 B 22
40600 JKL
SF
juskars@jyu.fi

Paras Kaul
Mason Hall, 4400 University Drive, MS 2F7
Fairfax, VA 22030
USA
pkaul@gmu.edu

Koji Kawai
3-14-18 Minamiogikubo Suginamiku
167-0052 Tokyo
J
metamu@interlink.or.jp

Hideko Kawamoto
1121 Hasty Rd #21
Laurinburg, NC 28352
USA
hk0008@mac.com

Kohske Kawase
2-22-14 Sakuradai,nerima-ku
176-0002 Tokyo
J
www@kawasekohske.info

Martin Kilger
Venloer Str. 4
50672 Köln
D
B.zurNedden@soundscape-africa.de

Yunchul Kim
Berrenrather Str.409
50937 Köln
D
tre@khm.de

Gregers Kirkegaard
C/O Gross Skodsgorgvej 236
2850 Naerum
DK
isw@email.dk

Mark Kirschenmann
4772 Washtenaw Ave. A1
Ann Arbor, MI 48108
USA
sonikmann@earthlink.net

Kenneth Kirschner
510 West 218th St #5B
New York, NY 10034
USA
music@kennethkirschner.com

Klammer / Grundler
Winkelg. 2-4
8010 Graz
A

Roger Kleier
301 East 12th St
New York, NY 10003
USA
rkleier@aol.com

Sven-Ingo Koch
Kampwiese 20
58239 Schwerte
D
skoch@stanford.edu

Thomas Koener
Lange Str. 54
44137 Dortmund
D
thomas@koener.de

Felix Kubin
Harkortstr. 123
22765 Hamburg
D
gagarin@iworld.de

Panayiotis Kokoras
Halifax College, Ainsty Court,
Block A, Flat 1, Garrowby
Way
Heslington YO10 5NE, York
UK
panayiotiskokoras@hotmail.com

Matej Kolar
Komenskeho 30
586 01 Jihlava
CZ
groban@seznam.cz

Kenji Komoto
win-Minamigyotoku102 Ainokawa Ichikawa-shi
272-0143 Chiba
J
kenji@komo.to

Pavel Kopecky
Strizkovska 80
18000 Prague
CZ
p.kopecky@atlas.cz

Konrad Korabiewski
Rynek Debnicki 1/2
30319 Cracow
PL
korabiewski@hotmail.com

Dmitry Kormann
73 Sarehole Rd, Hall Green
Birmingham B28 8DY
UK
kormann@btinternet.com

Andreas Korte
Ringesweide 3
40223 Düsseldorf
D
mail@akorte.com

Kpt.michi.gan
1325 SE Marion St.
Portland, OR 97202
USA
ken@aesthetics-usa.com

Drew Krause
507 W. 111th St. #34
New York, NY 10025
USA
drkrause@mindspring.com

Anja Kreysing
Am Steintor 24
48167 Münster
D
kreysing@muenster.de

Kriegsgewinnlacombo
Otto-Worningerg. 5/2
1130 Wien
A
fmhabla@magnet.at

Thom Kubli
Johann-Mayer-Str.4
51105 Köln
D
kubli@netcologne.de

B.Ganesh Kumar
New #200 [old # 100] Lake
View Rd
600 033 West Mambalam,
Chennai
India
ganeshaestheticmusic@yahoo.com

Gil Kuno
2-2-2 Higashiyama #904,
Meguroku
153-43 Tokyo
J
gil@unsound.com

Thomas Kusitzky
Urbanstr. 176
10961 Berlin
D
thomas@controller-band.de

Ryoko Kuwajima
The Antique Shop, Cliff Rd,
Wellingore,
Lincolnshire LN5 0HY
UK
info@melangerecords.com

Lucas Kuzma
6500 Yucca St. #500
Los Angeles, CA 90028
USA
prix@philtre.com

Brandon LaBelle
1200 South Highland Ave.
Los Angeles, CA 90019
USA
blabelle@earthlink.net

Eric La Casa
PO Box 55579
Atlanta, GA 30308
USA
fenton@stonehenge.wrek.org

L'altra
1325 SE Marion St.
Portland, OR 97202
USA
ken@aesthetics-usa.com

Diane Landry
650, de LaSalle Studio 102
Quebec City, QU GIK 2V3
CDN
dilandry@clic.net

Pierre Lange
3, Rue de la place
89510 Etigny
F
plange@leriredelajoconde.com

Language Removal Services
1440 Allison Ave
Los Angeles, CA 90026
USA
60@languageremoval.com

Marco Antonio Larsen
PO Box 292299
Los Angeles, CA 90029
USA
volt_age@appleisp.net

Brian Yee Huan Lau
rm J Lap Hing Bldg 275-285
Hennessy Rd Wanchai
WCH E1 Hong Kong
PRC
brainy@netvigator.com

Torsten Lauschmann
Top right Flat, 268 Kenmure
St.
Glasgow G 41 2QY
UK
hello@lauschmann.com

Iury Lech
Nou 15
17111 Vulpellac-Girona
E
iurylech@jazzfree.com

Seungyon-Seny Lee
411-12 HongEun 3-Dong
Sedaemun-ku
120 103, Seoul
RK
senylee@ccrma.stanford.edu

Les 7 Mondes
8, Fingal St, Greenwich
London 10 0JJ
UK
sevenworlds@les7mondes.com

John Levack Drever
Flat 1, 17 Queens Crescent
Exeter EX46AY, Devon
UK
johndrever@moose.co.uk

George Lewis
Markgraf-Albrecht-Str. 14
10711 Berlin
D
fmp.distribution@t-online.de

Stefan Lex
Stengelstr. 8
80805 München
D
stefanlex@gmx.de

Lia
Schelleing. 26/2/30
1040 Wien
A
lia@re-move.org

Libythth
539 E. Villa #22
Pasadena, CA 91101
USA
phthalo@phthalo.com

Jörg Lindenmaier
Maastrichter Str. 11
50672 Köln
D
lindenmaier@khm.de

Lithops
Kleiner Griechenmarkt 28-30
50676 Köln
D
mail@sonig.com

Bernhard Loibner
Yppeng. 5/14
1160 Wien
A
bernhard@allquiet.org

Erika Carmen López Pérez
Angel Urraza #622 Col. Del
Valle
3100 México, D.F.
MEX
erikalp@radioeducacion.edu.mx

Ioscil
PO Box 259319
Chicago, IL 60625-9319
USA
krankypromo@interaccess.com

Low Res
Jagerstraat 20
8200 Brugge
B
blueramen@plugresearch.com

Jarek Lublin
Czernika 1B
92 538 Lodz
PL
nilbul@poczta.onet.pl

Lucky Kitchen
13 Torrent de le Vidalet, 5
8001 Barcelona
E
aaland@luckykitchen.com

Andy Luginbühl
Ferdinand Hodler-Str. 16
8049 Zürich
CH
ndl@eyemachine.com

Sergio Luque
Grotemarkt 19 b
3011PC Rotterdam
NL
sergioluque@mac.com

Peter Machajdik
Hagarova 13
83151 Bratislava
SK
peter@machajdik.de

Yoshio Machida
1-27-4-201, Kokuryocho,
Chofu
1820022 Tokyo
J
info@yoshiomachida.com

Marcus Maeder
Schöneggstr. 5
8004 Zürich
CH
marcus_maeder@domizil.ch

Massimo Magrini (aka Bad
Sector)
Via Fonda, 11
55065 Pieve di Compito (LU)
I
m.magrini@bad-sector.com

Ashis Mahapatra
55 South 1st St 3R
Brooklyn, NY 11211
USA
ashis85@hotmail.com

Matthias Mainz
Berliner Str. 37
51063 Köln
D
matthiasmainz@hotmail.com

Patrice Manillier
79 Rue de la Jarry
94300 Vincennes
F
pmanillier@noos.fr

Chris Mann
8 Harrison Street #5
New York, NY 10013
USA
chrisman@rcn.com

Mapstation feat. Ras
Donovan
Spichernstr. 17
40476 Düsseldorf
D
mapstation@gmx.de

Glenn Marshall
3414 Hollywood Dr
Austin BT1 2GQ
USA
glenn@butterfly.ie or

Edgardo Martinez
F.M. Esquiù 3026
3000 Santa Fe
RA
edmar@fhuc.unl.edu.ar

Elio Martusciello
Via Montiano, 8b
127 Roma
I
emartus@tin.it

Massaccesi
539 E. Villa #22
Pasadena, CA 91101
USA
phthalo@phthalo.com

José Mataloni
Silvanstr. 9
50678 Köln
D
mataloni@spiralstern.com

Rob Mazurek
2624 W. Agatite
Chicago, IL 60625
USA
robmazurek@earthlink.net

Danny Mc Carthy
2, Chestnut Dr
Midleton Co Cork
IRL
soundworksunlimited@IRL.com

Nathan Medema
1725 Riverside Dr
Ottawa, ON K1G 0E6
CDN
nymh@freenet.carleton.ca

Bud Melvin
2236 N. Sawyer
Chicago, IL 60641
USA
budmelvin@hotmail.com

Joao Mendes
Pca Padre Souza, 9
20930-070 Rio de Janeiro
BR
jmend@gbl.com.br

Olivier Ménini
3 Rue des Tanneurs
69009 Lyon
F
hom@cnsm-lyon.fr

Radboud Mens
Staalkade
1011JN Amsterdam
N
radboudmens@xs4all.nl

Marcello Mercado
Neusser Str. 22, c/o Peters
50670 Köln
D
m_2@gmx.de

Miro Merlak
539 E.Villa #22
Pasadena, CA 91101
USA
phthalo@phthalo.com

Robert Merlak
539 E. Villa #22
Pasadena, CA 91101
USA
phthalo@phthalo.com

Nathan Michel
88 College Rd West
Princeton 8544
USA
nmichel@princeton.edu

Christof Migone
6641 ave. du Parc
Montreal, QC H2V 4J1
CDN
cm@christofmigone.com

Mikomikona
Chorinerstr. 85
10119 Berlin
D
mikona@zuviel.tv

Roger Mills
34 Claremont Rd, Bishopston
Bristol BS7 8DH
UK
roger@skunkmonkey.co.uk

Mimi + Boyd
539 E. Villa #22
Pasadena, CA 91101
USA
phthalo@phthalo.com

Minamo
1006-332 Nishiterakata-Machi
Hachioji
192-0153 Tokyo
J
mail@cubicmusic.com

Stefan Mitterer
Refsnesalleen 3
1518 Moss
NL
sextags@pakistanmail.com

Chikashi Miyama
2-37-12 Matsubara, Setagaya-
ku
156-0043 Tokyo
J
miyama@zf6.so-net.ne.jp

Werner Möbius
Taborstr. 51/51
1020 Wien
A
wernermoebius@hotmail.com

Mocky
Reichenbergerstr. 143
10999 Berlin
D
mockyrecordings@hotmail.com

David Monacchi
Via B. da Montefeltro n.74
61029 Urbino
I
davidmon@tiscalinet.it

Gordon Monahan
R. R. 4
Markdale, ON
CDN
funnyfarmcity@compuserve.
com

Ed Moon
Dominikanerg. 1a/2/8
1060 Wien
A
edmund.kramer@chello.at

Luigi Morleo
Via Rodi 15
70121 Bari
I
luigi.morleo@tin.it

mou, lips!
Vico III San Bernardo, 13
65013 Citta Sant'Angelo
I
box@mou-lips.com

MaYa MoUsE
Asnom 56/2/17
1000 Skopje
Macedonia
zmay@mol.com.mk

Mouse on Mars
Kleiner Griechenmarkt 28-30
50676 Köln
D
mail@sonig.com

Federico Muelas
324 west 47 th st. #5B
New York, NY 10036
USA
contact@federicomuelas.com

Jon Mueller
PO Box 070352
Milwaukee, WI 53207
USA
crouton@croutonmusic.com

Günter Müller
Steinechtweg 16
4452 Itingen
CH
g.mueller@datacomm.ch

Benjamin Mündörfer
Im Weißen Tal 8
64331 Weiterstadt
D
muendoerfer@web.de

Christopher Musgrave
1814 Illinois St.
San Francisco, CA 94124
USA
chris@musgrave.org

Yoichi Nagashima
10-12-301, Sumiyoshi-5
430-0906 Hamamatsu, Shizu-
oka
J
nagasm@computer.org

Shigenobu Nakamura
9-1 Shiobaru 4-chome,
Minami-ku
815-8540 Fukuoka-shi
J
sn@kyushu-id.ac.jp

Toshimaru Nakamura
4-21-16 Hamadayama, Sugi-
nami tou
168-0065 Tokyo
J
setrest@attglobal.net

Steven Naylor
PO Box 1602 Stn Central
Halifax, Nova Scotia B3J 2Y3
CDN
steven.naylor@sonicart.ca

Yuko Nexus 6
#101, 564 Hirata
522-0041 Hikone, Shiga
J
nexus6@ca2.so-net.ne.jp

Phill Niblock
PO Box 147
Preston, VIC 3072
AUS
pniblock@compuserve.com

Serban Nichifor
Str.Principatele Unite Nr.2,Vila
I, Ap.7
70512 Bucharest
RO
serbannichifor@pcnet.ro

Kai Niggemann
Johanniterstr. 17
48145 Münster
D
canine@resonator.de

NIOBE
Elsass-Str. 40 HH
50677 Köln
D
yvcorn@aol.com

Ogurusu Norihide
PO Box 20368
New York, NY 10009
USA
todd@carparkrecords.com

Ralf Nuhn
89A Rectory Rd
London N16 7PP
UK
leislon@ntlworld.com

Sandy Nys
PO Box 106
3200 Aarschot
B
info.trioart@pandora.be

O.S.T.
539 E. Villa #22
Pasadena, CA 91101
USA
phthalo@phthalo.com

OCTEX
Smartinska 152/hala 6
1000 Ljubljana
SLO
teh@nika.si

Rui Ogawa
Yanagihara 1-1-14 Adachi-ku
120-22 Tokyo
J
rui-o@za2.so-net.ne.jp

Igor Olejar
6 Robinglade Dr
Etobicoke M9B 2R1
CDN
bleep@bleeptunes.com

Zsolt Olejnik
Dombay u. 7.
7720 Pécsvárad
H
nicron@underground.hu

Wolfgang Orschakowski
Rehhoffstr. 16
20459 Hamburg
D
wolfgang.orschakowski@imail.
de

Ed Osborn
Linienstr. 156
10115 Berlin
D
edo@roving.net

Matthew Ostrowski
173a N. 3rd. St.
Brooklyn, NY 11211
USA
m@ostrowski.info

Carlos Osuna
Calle 45A # 19-25
Bogotá
CO
ascoartes@yahoo.com

Jörg Oswald
Schinkestr 8-9
12047 Berlin
D
jooswald@gmx.de

Tony Oxley
Markgraf-Albrecht-Str. 14
10711 Berlin
D
fmp.distribution@t-online.de

Ozone Player
Sörnäisten Rantatie 27 A
500 Helsinki
SF
otso@ozoneplayer.com

Sun-Young Pahg
Lisztstr. 31
99423 Weimar
D
sun-young.park@hfm.uni-
weimar.de

Andrea Parkins
48 1/2 East 7th St #2
New York, NY 10003
USA
amparkins@earthlink.net

Zeena Parkins
151 First Ave. #22
New York, NY 10003
USA
zenpark@aol.com

Rosy Parlane
5 Barrington Rd, Grey Lynn
1002 Auckland
NZ
rparlane@hotmail.com

Claudio Parodi
Via Trieste 46/23
16043 Chiavari (GE)
I
cla.parodi@libero.it

Catalina Peralta
Calle 30 A Nr. 3 A - 03, (101)
Bogotà
CO
cperalta@uniandes.edu.co

Georgios Pesios
112
6000 Stara Zagora
BG
georgios@videorent.bg

Angelo Petronella
Via Trognano 7
27010 Bascape (PV)
I
angelopetronella@hotmail.co
m

Edwin Pfanzagl
Paulanerg. 9/15
1040 Wien
A
e.pfanzagl@salzburgfestival.at

Phthalocyanine
539 E. Villa #22
Pasadena, CA 91101
USA
phthalo@phthalo.com

Jean Piche
4524 Patricia
Québec, QC H3W1W6
CDN
jean@piche.com

Jan Pienkowski
6225 Place Northcrest
App.B1
Montreal, QC H3S 2T5
CDN
info@onorecords.com

Pan Pierrakos
47, Kitheronos St
15234 Athens
GR
panpierr@yahoo.com

Irena Pivka
Metelkova 6
1000 Ljubljana
SLO
natasa.zavolovsek@guest.arne
s.si

Hans Platzgumer
Seewiesen 10
6911 Lochau
A
hans@platzgumer.net

Plumbing for beginners
445 Rue St. Pierre, Suite 400
Montreal, QC H2Y 2M8
CDN
tsm@sat.qc.ca

Thomas Poelz
Rauscherstr. 7/10
1200 Wien
A
auditem@chello.at

Helga Pogatschar
Hugo-Hofmannstr. 15b
82064 Strasslach
D
titus@hoerkino.de

Mark Polishook
1404 Thayer Ave
Ellensburg, WA 98926
USA
polishoo@cwu.edu

Andrea Polli
695 Park Ave.
New York, NY 10021
USA
apolli@hunter.cuny.edu

Polwechsel / Fennesz
Ullmannstr. 13/21
1150 Wien
A
werner.dafeldecker@chello.at

Franz Pomassl
PO Box 14
3541 Gföhl
A
laton@t0.or.at

Thomas Porett
673 Aubrey Ave.
Ardmore, PA 19003
USA
tporett@uarts.edu

Porousher
Görbe Dülö 17
7624 Pécs
H
porousher@underground.hu

portable[k]ommunity
3853 Yata-Cho Yamatokooriy-
ama-City
639-1058 Nara
J
taeji@jp.org

Jason Potratz
539 E. Villa #22
Pasadena, CA 91101
USA
phthalo@phthalo.com

Michael Prime
30 Petten Grove
Orpington BR5 4PU, Kent
UK
mikep@myco.demon.co.uk

Gert-Jan Prins
Quellijnstraat 119
1073 XH Amsterdam
NL
gjprins@xs4all.nl

Rostislav Prochovnik
Zednická 953/8
708 00 Ostrava-Poruba
CZ
sangel@sezwam.cz

Pulseprogramming
1325 SE Marion St.
Portland, OR 97202
USA
ken@aesthetics-usa.com

Suli Puschban
Albrechtstr. 8
12165 Berlin
D
zentralflughafen@gmx.de

Luis Angel Romero Quicios
C/ Monsenor Oscar Romero
69 3B
28047 Madrid
E
luis_angel@eresmas.com

R:Benasssi
V. Nuvolone 47
26100 Cremona
I
r1k1@libero.it

Radian
Gymnasiumstr. 6/8
1180 Wien
A
norman@radian.at

Radiomental
16 Rue Martel
75010 Paris
F
jyleloup@wanadoo.fr

Marcelo Radulovich
444 Norfolk Dr.
Cardiff, CA 92007
USA
m@marceloradulovich.com

Takayuki Rai
5-5-1 Kashiwa-cho, Tachi-
kawa-shi
190-8520 Tokyo
J
rai@kcm-sd.ac.jp

Paul Rains
Weavering Str
Maidstone ME14 5JH, Kent
UK
Paul6507@aol.com

Dimitris Rallis
Messologiou 3-Kalamaria
55133 Thessaloniki
GR
dimrallis@hotmail.com

Anna Ramos
Verge de Montserrat 149. 2-1.
8041 Barcelona
E
perkele@ilimit.es

Random Logic
Smartinska 152/hala 6
1000 Ljubljana
SLO
teh@nika.si;
ivan.novak@nika.si

Charles Rapeneau
Route de Celhaya, 14 rés.
Olaya
64250 Cambo-les-Bains
F
holeg@free.fr

Maja Ratkje
Helgesens gt. 16
553 Oslo
N
majar@notam02.no

Kirsten Reese
Kurfürstenstr. 9
10785 Berlin
D
kirsten.reese@gmx.net

Hans Reichel
Markgraf-Albrecht-Str. 14
10711 Berlin
D
fmp.distribution@t-online.de

Andreas Reisner
Weissensteinstr. 18
3008 Bern
CH
info@els-jegen.ch

Jorge Reyes Valencia
Ángel Urraza #622
3100 México D.F.
MEX
polivia@radioeducacion.edu.mx

Claudia Robles
Kölnerstr. 200 D
51149 Köln
D
claudearobles@hotmail.com

Pedro Rocha
R. Vieira de Almeida, 5 10- A
1600-644 Lisboa
P
pedrocha@netcabo.pt

Manuel Rocha Iturbide
Heliotropo 156
4330 Barrio del Niño Jesus,
México DF.
MEX
manroit@laneta.apc.org

Steve Roden
PO Box 50261
Pasadena, CA 91115
USA
sroden@inbetweennoise.com

**Perla Olivia Rodríguez
Reséndiz**
Angel Urraza #622 Col. Del Valle
3100 México, D.F.
MEX
polivia@radioeducacion.edu.mx

Raphael Roginski
Bukowa 39a
05-807 Podkowa Lesna
PL
raphael_roginski@yahoo.com

Volker Rommel
Akademiestr. 2
80799 München
D
fortschritt90@yahoo.com

Lucia Ronchetti
Vlale Gorizia, 24/A
198 Roma
I
luciaronchetti@hotmail.com

Vallard Rook
539 E. Villa#22
Pasadena, CA 91101
USA
phthalo@phthalo.com

Raoul Roucka
Feilitzschstr. 14
80802 München
D
raoul@nonex.net

Keith Rowe
Agrippinaufer 6
50678 Köln
D
markus@staubgold.com

Manfred Ruecker
Am Vogelsfeldchen 3
51373 Leverkusen
D
ketonge@web.de

Michael Ruesenberg
Wiethasestr. 66
50933 Köln
D
realambient@michael-ruesen
berg.de

Christophe Ruetsch
15 Rue Pradal
31400 Toulouse
F
c.ruetsch@wanadoo.fr

Joachim Rüsenberg
Fürstenwall 74
40219 Düsseldorf
D

Miu Ryuta
141 Lundpoint Carpenters Rd
London E15 2JP
UK
miumiu@ntlworld.com

safety scissors vs kit clayton
PO Box 20368
New York, NY 10009
USA

Philip Samartzis
62 Clauscen St.
North Fitzroy, VIC 3068
AUS
p.samartzis@rmit.edu.au

Thomas Sandberg
H.C. Lumbyes Gade 21
2100 Copenhagen
DK
thomas@thomassandberg.dk

Massimiliano Sapienza
Staalkade 6
1011JN Amsterdam
NL
xxxmassimoorg@supereva.it

Scanner
40 Sunlight Square
London E2 6LD
UK
scanner@scannerdot.com

Stefano Scarani
Via Bergognone 45
20144 Milano
I
stefano@tangatamanu.com

Janek Schaefer
34 Crewdson Rd
London SW9 0LJ
UK
janek@audiOh.com

Philip Scheffner
Oppelnerstr. 38
10997 Berlin
D
info@pong-berlin.de

Elisabeth Schimana
Erasinweg 23
2410 Hainburg
A
elise@aon.at

Christof Schläger
Baukwerkerij 1
1021 NS Amsterdam
N
christof.schlaeger@t-online.de

Gunther Schmidl
Ferdinand-Markl-Str. 39/2/16
4040 Linz
A
gschmidl@gmx.at

**Joachim Schnaitter aka
de:con**
Hamerlingstr. 1
4020 Linz
A
joachim.schnaitter@liwest.at

Frank Schültge Blumm
Müggelstr. 26
10247 Berlin
D
fs-blumm@gmx.de

Federico Schumacher Ratti
40 bis, Route de Gençay
86000 Poitiers
F
cesos2@yahoo.fr

Bernd Schurer
Schöneggstr. 5
8004 Zürich
CH
bernd_schurer@domizil.ch

Martin Schüttler
Vorholzstr. 16
76137 Karlsruhe
D
martinschuettler@gmx.de

Stefano Scodanibbio
Fabiani n. 4
62010 Pollenza
I
stefano@stefanoscodanibbio.
com

Scratch Pet Land
Residence Badoux, 137, Ave
de Brabanconne
1030 Bruxelles
B
scratchpetland@sonig.com

Segma
110 Wildwood Drive
Howie Center, NS B1L 1G6
CDN
c_murphy15@hotmail.com

Michael Sellam
43 Rue Léon Frot
75011 Paris
F
michael@incident.net

Sette 7
Philosophenweg 57
34121 Kassel
D
sette7@gmx.de

Mike Shannon
2060 Derbyshire Rd
Maitland, FL 32751
USA
joystreetstudios@hotmail.com

Vergil Sharkya´
63 Renshaw St
Liverpool L1 2SJ
UK
vergilreality@ukonline.co.uk

David Shea
9 Argyle St
Melbourne, VIC 3065
AUS
kristi@dshea.net

Keiichiro Shibuya
14-4-101 Shinsencho
Shibuya
150-0045 Tokyo
J
maria@atak.jp

Alexei Shulgin
Staalkade 6
1011JN Amsterdam
NL
alexei@easylife.org

Rodrigo Sigal
Progreso 15, C-2, Sta Cata-
rina Coyoacan
4110 MEX DF
MEX
rodrigo@rodrigosigal.com

Elzbieta Sikora
Lehle 26
89075 Ulm
D
elzbieta_sikora@hotmail.com

Nuno Silva
Rua Eng. Quartin Graça 33,
1 Esq.
1750-099 Lisboa
P
nuno_espinho@hotmail.com

Julean Simon
Fuerbringerstr.25
10961 Berlin
D
simon@uea-io.de

Eva Sjuve
Järavallsgatan 31A
216 11 Malmö
S
eva@moomonkey.com

Ran Slavin
8 Yehuda Halevy St
65135 Tel Aviv
IL
slavin@netvision.net.il

Snail
Kalvarienbergg. 17/4
1170 Wien
A
hannes@raffaseder.com

Anabella Solano Torres
Angel Urraza #622
3100 México, D.F.
MEX
polivia@radioeducacion.edu.mx

Juan Maria Solare
Adam-Stegerwald-Str. 15
51063 Köln
D
solare@surfeu.de

Solarium
Sonnenheim 7
6344 Meierskappel
CH
solarium@spezialmaterial.ch

Phillip Sollmann
Neue-Welt-Gasse 18/7
1130 Wien
A
philly@gmx.at

Pan Sonic
PO Box 194
531 Helsinki
SF
tiina.erkintalo@avantofestival.com

Jan-Peter E.R. Sonntag
Herthastr. 13
13189 Berlin
D
sonntag2000@hotmail.com

Soulo
9 Blue Bell ct
Newtown, PA 18940
USA
nflanigan@hotmail.com

Stalaktiten och Mirjam
539 E. Villa #22
Pasadena, CA 91101
USA
phthalo@phthalo.com

Arthur Stammet
29, Rue Léon Metz
4238 Esch-sur-Alzette
LUX
arthur.stammet@education.lu

Stars of the Lid
PO Box 259319
Chicago, IL 60625-9319
USA
krankypromo@interaccess.com

Rod Stasick
10455 Sinclair Ave.
Dallas, TX 75218-2225
USA
rod@stasick.org

Steinbrüchel
Rüdenplatz 4
8001 Zürich
CH
steinbruchel@synchron.ch

Christof Steinmann
Hildastr. 6
8004 Zürich
CH
steinmann@spezialmaterial.ch

Sven Steinmeyer
Gotzingerstr. 52-54
81371 München
D
aec@schoenere.de

Markus Strick
Boxgraben 74-76
52064 Aachen
D
mail@markusstrick.de

Joseph Suchy
Körnwerstr. 53
50823 Köln
D
josuch@gmx.de

Supersoul
11051 SW 162 Terrace
Miami, FL 33157
USA
info@metatronix.com

Kotoka Suzuki
Kastanienallee 88
10435 Berlin
D
kotoka_suzuki@yahoo.com

Ben Swire
1281 Waller St
San Francisco, CA 94117
USA
btswire@yahoo.com

Hans Sydow
Frederikshaldvej 19
8300 Odder
DK
sydow@resonance.dk

Janos Szabo
Kleinraabs 2
3593 Neupölla
A
office@artforusers.com

Peter Szely
Geblerg. 57/15-16
1170 Wien
A
peszely@yahoo.com

Frederick Szymanski
110 St. Mark's Place, No.21
New York, NY 10009
USA
fredsz@earthlink.net

Masakatsu Takagi
201, 6-31 Yokotahonmachi,
Toyama pref.
933-849 Takaoka City
J
sari@p3.org

Girl Talk
1596 E. 115th St.
Cleveland, OH 44106
USA
thegirltalk@hotmail.com

Jeff Talman
338 Berry St, 4NE
New York, NY 11211
USA
jefftalman@mindspring.com

Michal Talma-Sutt
Sprengelstr.38
13353 Berlin
PL
mtalmasutt@gmx.de

Hans Tammen
62 Dupont St.
Brooklyn, NY 11222
USA
h.tammen@web.de

tamtam
Erich-Weinert-Str. 21
10439 Berlin
D
lowres@snafu.de

Milos Tanasijevic
Gavrila Principa 7
21205 Sremski Karlovci
YU
delacroix@sezampro.yu

Simon Taylor
13 Darmody St
Weetangera, ACT 2614
AUS
smtaylor@ozonline.com.au

Sean Taylor
Lismullane, Ballysimon
Limerick
IRL
seantaylor@eircom.net

telefish
Ullmannstr. 13/21
1150 Wien
A
olga.dafeldecker@chello.at

Temponauta
Smartinska 152/hala 6
1000 Ljubljana
SLO
teh@nika.si

Terminal 11
539 E. Villa #22
Pasadena, CA 91101
USA
phthalo@phthalo.com

test bed
Straßburger Str. 24
10405 Berlin
D
conrads@zedat.fu-berlin.de

The bug vs the rootsman
feat. dadda freddy
Oakland, CA
USA
info@tigerbeat6.com

the Forsaken Odes Conglo-
merate
1107 ch. de Wavre
1160 Bruxelles
B
info@ambivalence.be

Christoph Theiler
Grundsteing. 44/1/5
1160 Wien
A
theiler@t0.or.at

The Syncopated Elevators
Legacy
1107 ch. de Wavre
1160 Bruxelles
B
info@ambivalence.be

The Teamtendo
58 Bd de Strasbourg
75008 Paris
F
teamtendo@go.com

Thighpaulsandra
Gelliwion Farm
Pontypridd CF37 1QB
UK
thighp@aol.com

Benjamin Thigpen
1, Place Igor Stravinsky
75004 Paris
F
thigpen@ircam.fr

Ernst Thoma
Flurweg 1
8260 Stein am Rhein
CH
ernstthoma@sounddesign.ch

Static Tics
Sleephellingstraat 14A
3071 VN Rotterdam
NL
sound@wormweb.nl

Joe Toion
Domagkstr. 33, Haus 16
80807 München
D
jo@inflagranti-barrel.org

Nao Tokui
4-7-3 MSA401, Toyotamakita,
Nerima-ku
1760012 Tokyo
J
tokui@miv.t.u-Tokyo.ac.jp

Gavin Toomey
37 Marshall St
London W1F 7EZ
UK
gavintoomey@Gtinternet.com

Adam Trawczynski
Adwentowicza 15/5
92-532 Lodz
PL
Grassu@bmp.net.pl

Pierre Alexandre Tremblay
c.p. 934 succ. Snowdon
Montréal, QC H3X 3Y1
CDN
ora@cam.org

Georg Tremmel
Kensington Gore
SW7 2EU London
UK
georg.tremmel@rca.ac.uk

Ulrich Troyer
Schellhammerg. 16/9
1160 Wien
A
uli@mego.at

Kassian Troyer
Schellhammerg. 16/9
1160 Wien
A
katsu.shiro@libero.it

Toshiya Tsunoda
3-34-12 Nakazato Minami-ku
2320063 Yokohama
J
tsunoda@h4.dion.ne.jp

Noriko Tujiko
27-29 Rue de la Cour des
Noues
75020 Paris
F
noriko@slidelab.com

Twine
2183 Professor St #3
Cleveland, OH 44113
USA
greg@twinesound.com

Sébastien Tworowski
1457 Chemin des Combes
6600 Antibes
F
rosa@dial-up.com

Maxim Tyminko
Hammer Dorfstr. 15
40221 Düsseldorf
D
maxim@khm.de

ultra milkmaids
18, Rue Appert
44100 Nantes
F
yann.jaffiol@wanadoo.fr

UMEK
Smartinska 152/hala 6
1000 Ljubljana
SLO
teh@nika.si

Uské Orchestra
1107 ch. de Wavre
1160 Bruxelles
B
info@ambivalence.be

Horacio Vaggione
30, Rue Saint Louis en L'Ile
75004 Paris
F
hvaggione@compuserve.com

Annette Vande Gorne
Place de Ransbeck
1380 Ohain
B
a.vandegorne@musiques-
recherches.org

Edwin van der Heide
Staalkade 6
1011NK Amsterdam
N
heide@knoware.nl

Vesa Vehviläinen
Hattelmalantie 5-7 c 71
710 Helsinki
SF
info@pinktwins.com

Vid
539 E. Villa #22
Pasadena, CA 91101
USA
phthalo@phthalo.com

Alejandro Viñao
27 Coolhurst Rd
London N8 8ET
UK
alejandro@vinao.com

Robert Vincs
234 St Kilda Rd
Melbourne, VIC 3004
AUS
r.vincs@vca.unimelb.edu.au

Virtual Voodoo
Smartinska 152 / hala 6
1000 Ljubljana
SLO
teh@nika.si

Tadej Vobovnik
Slovenceva 76
1113 Ljubljana
SLO
ideachannel@volja.net

Cristian Vogel
Calle Fusina, 5, 2b
8003 Barcelona
E
cristian@no-future.com

Boris Wagner
G. Krkleva 8
10090 Zagreb
HR
renata.wagner@zg.tel.hr

Agnieszka Waligórska
Kajavankatu 4 B 46
4230 Kerava
SF
agaps@nettilinja.fi

Joshua Walker
211 Waterman apt 5
Providence, RI 2906
USA
mary_cry@newyork.com

Mark Wastell
323 Archway Rd
London N6 5AA
UK
sound323@aol.com

Chiaki Watanabe
1186 Broadway
10001 New York, NY
USA
chiaki@nicknack.org

Reynold Weidenaar
155 West 68th St., Apt. 22-D
New York, NY 10023
USA
weidenaarr@wpunj.edu

Herwig Weiser
Rosenhügel 3
50259 Pulheim-Brauweier
D
hw@zgodlocator.org

Marcus Weiser
Löwestr. 8
10245 Berlin
D
weiser@rechenzentrum.org

Anne Wellmer
Middletown, CT 6459
USA
awellmer@wesleyan.edu

Gerald Wenzel
539. E. Villa #22
Pasadena, CA 91101
USA
phthalo@phthalo.com

Lennart Westman
Magnus Ladulåsgatan 7
118 65 Stockholm
S
westman@chello.se

Keith Whitman
PO Box 381964
Cambridge, MA 02238-1964
USA
hrvatski@reckankomplex.com

Wide Eyed
41 Sheppard House, St.
Peters Ave.
London E2 7AB
UK
adlib_x@hotmail.com

Udo Wießmann
Kurze Str. 21
44137 Dortmund
D
handsproductions@gmx.net

WIGGA
88 Pearson Rd
Ipswich IP3 8NW
UK

Jürgen Winderl
Knorrstr. 66
80807 München
D
wind05@ez11.de

Windsor For the Derby
1325 SE Marion St.
Portland, OR 97202
USA
ken@aesthetics-usa.com

Wobbly
539 E. Villa #22
Pasadena, CA 91101
USA
phthalo@phthalo.com

Harry Wolff
Seehofstr. 10A
60594 Frankfurt
D
harry_wolff@web.de

Ryszard Wolny
Zielonogórska 39a/2
66-016 Czerwiensk
PL
ryszard_wolny@op.pl

R.D. Wraggett
57 San Jose Ave.
Victoria, BC V8V 2C1
CDN
mantralab@entirety.ca

Leif Inge Xi
Thurmannsgate 10c h0101
461 Oslo
NL
ex.field@sensewave.com

Ami Yoshida
7-12-1, Avnir Mitaka 201,
Shimorenjyaku, Mitaka
1810013 Tokyo
J
ami@nothing.no-ip.org

John Young
The Gateway
Leicester LE1 9BH
UK
jyoung@dmu.ac.uk

Fu Yu
601, Building 10, Mudan-
yuanbeili 20, Huayuanbeilu,
Haidian District
100083 Beijing
PRC
apple@8gg.com

Nicholas Willscher
Zammuto
8 High St. Apt. 3e
North Adams, MA 1247
USA
nzammuto@wso.williams.edu

Ivan Zavada
63 Prince-Artur West
Montreal, QC H2X 1S5
CDN
zavada@sympatico.ca

Fei Zhou
Schöppenstedter Str.28
38100 Braunschweig
D
zhoufei@gmx.net

Zort Zort
Entre Rios 40
5000 Cordoba
RA
agustin@boltown.com.ar

cybergeneration – u19 freestyle computing

Stefan Achleitner
Haslau 29
4893 Zell am Moos
stefanachleitner@gmx.at

Christoph Aigner
Ödhofstraße 4
3300 Amstetten
christoph.aigner@gmx.at

Lukas Ainedter
Wasserfallstr. 181
5440 Golling
lukai@gmx.at

Thomas Albert
Hauptstr. 21
5151 Nußdorf
samoth@aon.at

Klara Alikin
Erlerbachweg 2
4303 St. Pantaleon

Adeel Alvi
Bergeng. 6 / 2 / 18
1220 Wien
alvi_Adeel86@hotmail.com

Martin Amplatz
Dr.- Dorrekstr. 35
6130 Schwaz
m_amplatz@hotmail.com

Michael Angerbauer
Schauersberg 40
4600 Thalheim / Wels
aservice@nextra.at

Lisa Arnold
Alte Str. 2
6352 Ellmau

David Außerlechner
Clemens-Holzmeister-Str. 11
6020 Innsbruck
webmaster@x-4-x.com

Simon Ausserlechner
Weidach 55
6414 Mieming

Stefan Barbaric
Hochbuchedt 33
4040 Linz

Florian Bartl
Neubaug. 1
3465 Königsbrunn

Markus Beigelbeck
Hauptstr. 48a
7434 Bernstein

Stefanie Berger
Rosenbergstr. 42 / 3 / 4
1220 Wien
sberger@gmx.at

Theresa Berger
Klederringerstr. 147
1100 Wien

Thomas Berger
Guttenbrunnstr. 16
4061 Pasching
svpasching@gmx.at

Stefan Besler
Stampfle 114
6500 Landeck
troop2500@hotmail.com

Christina Bichler
Föhrenwald 32
6352 Ellmau

Ernst Blecha
z98
5672 Fusch an der Groß-
glocknerstr.
dasernstl@austromail.at

Clemens Bleimschein
Birkenstr. 5
4623 Gunskirchen

Patrick Bozic
Seebach 11
9225 Kühnsdorf
patrick86@gmx.at

Andreas Brandstätter
Gerersdorferstr. 17
3443 Sieghartskirchen
koky@gmx.net

Lisa Brandstätter
Angerg. 263
2753 Dreistetten
lbrandstae@hakwr-
neustadt.ac.at

Alexander Bräuer
Große Neug. 32-34 / 6
1040 Wien
alexander.braeuer@chello.at

Florian Bräuer
Kirchstetterng. 41 / 2 / 30
1160 Wien
florian@go2flo.com

Florian Brezina
Hörmanns 28
3961 Hörmanns
creed17@titus.de

Georg Brunmayr
Pichlerstr. 44
4600 Wels
brg@aon.at

Tanja Buchmair
Linden 26
4352 Klam

Matthias Burtscher
Quadraweg 5
6714 Nüziders
mabu@aon.at

Marco Castrucci
St. Lorenzen 50
8811 Scheifling
marcocastrucci@hotmail.com

Christopher Chiu
Grabnerg. 10 / 7
1060 Wien
chj101@chello.at

Markus Christ
Mondseeberg 96
5310 Mondsee
markus.christ@aon.at

Ismail Demirbas
Schillerstr. 22a
5700 Zell am See
ismail@austromail.at

Patrick Derieg
Kapellenstr. 11.
4040 Linz
pat@eliot.priv.at

Andreas Deschmann
Hauptstr. 86
8650 Kindberg

Michael Donnerer
In der Erlach 9
8160 Weiz
michael.donnerer@bgweiz.at

Dominik Dorn
Badlochstr. 2B
6890 Lustenau
dominik@lyrix.at

Philipp Dörre
Neuwirthsiedlung 16
3830 Waidhofen / Thaya
phiphi@gmx.at

Nina Duda
Hunnenweg 16
7000 Eisenstadt
nina.duda@aon.at

Michaela Duftschmid
Kropfing 7
4901 Ottnang

Yvonne Eberhardt
Weinberg 188
7474 Eisenberg
yvonne@eberhardt.at

Birgit Eder
Steinbach 3
5662 Gries
birgiteder@austromail.at

Gerald Eder
Weisching 23
4343 Mitterkirchen

Robert Eder
Döblinger Hauptstr. 55 / 10
1190 Wien
robert.eder@rundesigns.com

Lukas Eggler
Arlberghaus
6763 Zürs
lukas@eggler.at

Thomas Eiper
Griffen 133
9112 Griffen
thomas_eiper@yahoo.de

Bernhard Estermann
Untersbergstr. 828c
5411 Oberalm
synatic@gmx.at

Alexander Etlinger
Baumschulstr. 23
3441 Baumgarten
et1234@gmx.net

Imre Facchin
Streitmanng. 47
1130 Wien
imre.facchin@gmx.at

Manuel Fallmann
Marktfeldstr. 293
3040 Neulengbach
mindistortion@mail.com

Gerhard Fiegl
Farchat 331
6441 Umhausen
gerhard.fiegl@gmx.at

Christoph Fink
A. Dürer-G. 27
2700 Wiener Neustadt
christoph.fink@gmx.at

Christoph Fink
Waldg. 14
6800 Feldkrich
fink.christoph@cable.vol.at

Stefan Forstner
Pürbacherstr. 15
3945 Hoheneich
s_forstner@gmx.at

Florian Fratte
Waidbachstr. 7
8700 Leoben
florian.fratte@htl-
kapfenberg.ac.at

Peter Fraundorfer
Markt 3
4352 Klam

Gabriel Freinbichler
Bergg. 23
4082 Aschach / Donau
g.freinbichler@a1.net

Benjamin Freundorfer
Morizg. 2 / 2 / 13
1060 Wien
benjamin.f@gmx.at

Patrik Friedel
Grodenau 23
7433 Grodnau

Klemens Friedl
Billichsedt 22
4841 Ungenach
klemensfr@hotmail.com

Albert Frisch
Ort 269
6322 Kirchbichl
albert.frisch@aon.at

Clemens Fritsch
Holzackerg. 10
6900 Bregenz
cf@vol.at

Carmen Froschauer
Hörstorf 22
4343 Mitterkirchen
c.froschauer@gmx.at

Andreas Frühwirth
Linden 9
4352 Klam

Sigrun Astrid Fugger
Harterfeldstr. 15
4060 Leonding
listhese@aon.at

Sarah Fürst
Westbahnhofstr. 9
1070 Wien

Martin Gabriel
Untere Hauptstr. 58
7041 Antau
bgmgabriel@hotmail.com

Thomas Gabriel
Steinacker 53a
6850 Dornbirn
thomas.gabriel@vol.at

Martin Gächter
Tschütsch 42
6833 Klaus
martin.gaechter@aon.at

Christoph Galgoczy
Zellerstr. 19
5671 Bruck
galli13@austromail.at

Georg Ganser
Redtenbachstr. 12
3340 Waidhofen / Ybbs
georg.ganser@netway.at

Thomas Ganser
Anzing 36
4113 St. Martin i. M.
ganser0001@hotmail.com

Patrick Gansterer
Spitalg. 2
7400 Oberwart
paroga@paroga.com

David Geiger
Hauptstr. 38
3021 Pressbaum
d.geiger@gmx.at

Agnes Geissberger
Statzendorf 85
3125 Statzendorf
agnes@geissberger.at

Roman Genitheim
Weideng. 8
2136 Laa an der Thaya
fettiborg@gmx.at

Clemens Geyer
Ohlingsg. 6
1110 Wien

Helene Grabner
Im Landlgrund 15
4203 Altenberg

Matthias Grabner
Tauchendorf 27
9556 Liebenfels
grabnerm@gmx.at

Philipp Grasmug
Strauß. 30a
8160 Weiz
grasi@bhak-weiz.ac.at

Peter Gratl
Nr. 128
9991 Dölsach
gratl_peter@web.de

Alexander Grenus
Wientalstr. 27
3011 Neu Purkersdorf
agrenus@gmx.at

Andreas Grill
Prandtauersiedlung 36
6500 Landeck
andi.grill@tirol.to

Franz Gruber
Franz Engl Str. 11
4780 Schärding
fg@jesus.ch

Georg Gruber
Angerweg 23
6401 Inzing
ggggg@utanet.at

Michael Gruber
Walterstr. 30
3550 Langenlois

Peter Gschirr
St. Nikolaus
6143 Pfons
pete13@gmx.at

David Haas
Leharstr. 26
4020Linz

David Hackl
Landgutstr. 17a
4040 Linz

Florian Hackl
Stockenhuberweg 6
4040 Linz

Thomas Hainscho
Am Schirm 8
9063 Maria Saal
thomas_hainscho@yahoo.de

Gregor Haller
Perkonigstr. 2
9141 Eberndorf
mangart@aon.at

Stephan Hamberger
Gmundnerstr. 36
4800 Attnang
st.hamberger@aon.at

Christian Hann
Höllererstr. 12
5671 Bruck
christian.honn@austromail.at

Michael Hänsle
Lindenstr. 6
84359 Simbach
D
fleffyH@freenet.de

Martina Haselberger
Raiffeisenplatz 3 / 12
4623 Gunskirchen

Stefan Haussteiner
Bahnhofstr. 30
5500 Bischofshofen
haussteiner.wolfgang@sbg.at

Robert Hawke
Schüttweg 40
6800 Feldkirch
r.hawke@web.de

Michael Heiml
Berta-Reiterstr. 13
4850 Timelkam
michael.heiml@i-one.at

Vinzent Hilbrand
Seidengarten 27
6830 Rankweil
judith.hilbrand@utanet.at

Bernd Hirschmann
Feldg. 87
8200 Gleisdorf
berhir@hotmail.com

Nicole Hirtl
Kalch 72
8385 Neuhaus am Klausen-
bach
mausi0511@uboot.com

Thomas Hochhaltinger
Brandströmstr. 26
3300 Amstetten
tom@hochi.info

Helmut Hofbauer
Birkenweg 16
4061 Pasching

Bernhard Hoisl
Matthias-Schönerer-G. 11 /
102
1150 Wien
hoisl@gym1.at

Christoph Holas
Am Aigen 12
8046 Graz
christoph@holas.net

Elias Holzer
Weinfeldg. 16
6060 Hall i. T.
elias@hallerjugend.at

Stefan Holzinger
Mallausiedlung 11
3233 Kilb
holzinger@lycos.at

Lorenz Bruno Hölzl
Mitterweg 23
4563 Micheldorf
mobr@A1plus.at

Hansjörg Holzweber
Burgweg 15
6840 Götzis
hansjoerg.holzweber@cable.
vol.at

Stefan Holzweber
Panholzerweg 34
4030 Linz

Rupert Honer
Adelheid-Poppweg 6
4030 Linz

Rene Hösele
Packerstr. 282
8501 Lieboch
rene.hoesele@aon.at

Katharina Hrubesch
Lerchenfelder Hauptplatz 3
3500 Krems
katharinahrubesch@hotmail.
com

Jörg Huber
Glocknerstr.
5671 Bruck
joerg@zacherlbraeu.at

Peter Huber
Neuhofstr. 18
3631 Ottenschlag

Stefanie Huber
Stuben 116
7434 Stuben

Matthias Hudobnik
Waldebene 16
9125 Kühnsdorf
matthias.hudobnik@utanet.at

Waldemar Hummer
Haus Nr. 120
6142 Mieders
waldemar.hummer@gmx.at

Dominik Jais
Plon 114b
6150 Steinach am Brenner
b3-
webmaster@jais.jet2web.at

Lorens Jankovic
Nauseag. 28 / 17
1160 Wien
lorens@gmx.at

Emanuel Jauk
Ludwig-Benedekg. 19
8054 Graz
ejauk@gmx.at

David Jungwirth
Steg 13
4656 Kirchham
david_j@gmx.at

Martin Käferböck
Anzing
4113 St. Martin
Bean1122412@hotmail.com

Lukas Kaltenberger
Laussa 123
4461 Laussa
jedi123@gmx.at

Lukas Kaltenegger
Flösselg. 9
2391 Kaltenleutgeben
kaltenegger@skalu.de

Ewald Kantner
Gartenthal 516
2145 Hausbrunn
Ebtschi@gmx.net

Thomas Katzinger
Katzing 7
4150 Berg bei Rohrbach
djfiresplash@telering.at

Carina Kaufmann
Hummelberg Süd 11
4341 Arbing

Britta Ketzer
Joh.-Schmidtstr. 28
3512 Mautern
britta.ketzer@jetmail.at

Martina Kienberger
Frühlingstr. 30
3363 Neufurth
martina.kienberger@aon.at

Lukas Kindl
Saurweinweg 19
6020 Innsbruck
lukas85@chello.at

Andreas Kirchhofer
Unterhörnbach 11
3542 Klam

Jakob Kirschner
Am Ipfbach 74
4490 St. Florian

Imre Kis
Scheuneng. 25-31 / 6 / 1
3430 Tulln
aon.912585639@aon.at

Jeannine Klaban
Vestenpoppen 73
3830 Waidhofen / Thaya

Paul Klingelhuber
Gewerbepark 3
4341 Arbing
paul.klingelhuber@gmx.at

Laura Kloiber
Lichteneggerstr. 38
4600 Wels

Christian Knoflach
Symalenstr. 15
3500 Krems
christian@kno.at

Marian Kogler
Vöscherg. 14
1230 Wien
marian.kogler@vienna.at

Markus Kölber
8322 Studenzen 83
8322 Studenzen
poxy6006@gmx.net

Dijana Koller
Beckerstr. 36
4614 Marchtrenk
princess_diana_3_9@yahoo.de

Walter Korschelt
Rauchleitenstr. 43
8010 Graz
walter.korschelt@gmx.at

Andrea Kozakova
Bergstr. 9
5020 Salzburg
andrea.kozakova@fh-sbg.ac.at

Zrinko Kozlica
Alois-Stockinger-Str. 16
5020 Salzburg
kgbspeznasputin@hotmail.com

Mario Krammel
Bockfliesserweg 19 / 4 / 24
2230 Gänserndorf
m.krammel@kabsi.at

Andreas Krennmair
Werfelweg 5a
4030 Linz
ak@synflood.at

Thomas Kropsch
Veitsbergweg 7d
8700 Leoben
IronTom16@gmx.at

Alexia Kulturer
Salchendorf 9
9064 Pischeldorf
Alexia.K@gmx.net

Andreas Kuntner
Gschwendt 2b / 14
3400 Klosterneuburg
andi.kuntner@telecom.at

Markus Kupfer
Zehensdorf
8092 Mettersdorf
mkupfer@gmx.at

Karin Lachmann
Liebermannweg 38
4060 Leonding

Jakob Lackinger
Farbstr. 7
4190 Bad Leonfelden
jakob.lackinger@utanet.at

Benjamin Lang
Michael-Hainisch-Strasse 15
4040 Linz
benji999@web.de

Ingo Lang
Droutstr. 8
4020 Linz

Christina Langreiter
Hermann-Müllerweg 9
5671 Bruck
pink070@gmx.at

Thomas Langstadlinger
Rust 92
3451 Michelhausen
thomas.langstadlinger@
telering.at

Rolf Lechner
Hiersdorf 6
4552 Wartberg
rolf@rule.at

Philipp Lehner
Traunaustr. 6
4600 Wels
muddasheep@gmx.at

Gernot Leitgab
Vorstadt 115
8832 Oberwölz
gernot.leitgab@aon.at

Philipp-Lukas Leitner
Mengerstr. 17
4040 Linz
leitinus@hotmail.com

Sebastian Leitner
Fasang. 43
1030 Wien
seb.mail@chello.at

Christian Lischnig
Kreuzg. 1
8111 Judendorf-Straßengel
christian.lischnig@gb-
joanneum.at

Michael Luckeneder
Urtlstr.13
4201 Gramastetten
michael@michael.site38.net

Christoph Lupprich
Ramplach 115 / C / 1
2620 Wartmannstetten
christoph.lupprich@wolfnight.
org

Daniel Mandl
Spargelfeldstr. 113
1220 Wien
dannyo@austriansoccer
board.com

Doris Martinz
An der Walk 20
9020 Klagenfurt
dmartinz@aon.at

Rene Maurer
Tumpen 240
6433 Oetz
rene_von_maurer@web.de

Daniel Mayer
Gerasdorferstr. 55 / 97 / 2
1210 Wien
daniel.maye1@gmx.at

Gudrun Mayer
Unterhöf 50
4073 Wilhering

Stefan Mayer
Dr.-Th.-Mayerstr. 8
5145 Neukirchen
stafe13@msn.com

Christian Mayerhofer
Leharstr. 26
4020 Linz

Stefan Mayerhofer
J.-Blaschke-Str. 24
3300 Amstetten
smayerhofe@hakamstetten.ac.
at

Ralph Mayr
Rudolf-Radinger-Str. 1
3270 Scheibbs
ralph.mayr@gmx.at

Thomas Mayr
Gramberg 2
4673 Gaspoltshofen
mayrt@web.de

Martin Mayrhofer
Bindelandl 8
4490 St. Florian

Maximilian Meduna
Bucheng. 133 / 9
1100 Wien
max.meduna@gmx.net

Erich Meixl
Eigenhofen 21
6170 Zirl
emeixl@yahoo.de

David Meron
Hammerschmidtg. 18 / 22 / 1
1190 Wien
david_meron@hotmail.com

Sebastian Moik
Steinbreite 8
5112 Lamprechtshausen
u19@subdesign.at

Georg Molzer
Ungerfeldg. 24
2540 Bad Vöslau
georg.molzer@gmx.at

Alexander Müller
Spöttlstr. 9 / 1
4600 Wels
mueller.alex@aon.at

Andreas Munk
Blauensteinerstr.
3130 Herzogenburg
andi@andishome.net

Lucas Neumann
Dorfrichterg. 5
2384 Breitenfurt
lucas.neumann@gmx.at

Lukas Neumüller
Marktstr. 19
4312 Ried / Riedmark
004aneu4uk@eurogym.asn-
linz.ac.at

Anna Obermeier
Krugg. 4
2512 Oeynhausen
anna.ober@aon.at

Vincent Oberwalder
Außerkristen 3
6094 Axams
what-the hell@gmx.at

Christian Olear
Maieraustr. 113
4792 Münzkirchen
webmaster@webbersmag.com

Maja Opaterni
Himberger Str. 81-83 / 20 /
12
2320 Schwechat

Amel Osmanoski
Schulstr. 5
4222 Langenstein

Alexander Palmanshofer
Niederkalmberg 11
4352 Klam

Georg Partoloth
Dachsweg 16
9241 Wernberg
g.partoloth@aon.at

Markus Peißl
Kaltenbachweg 18
8570 Voitsberg
mp15260@i-one.at

Christoph Pernsteiner
Lacken 99
4112 Rottenegg
chriz@aon.at

Rajna Petrova Tichova
Karl-Adlitzerstr. 32 / 4 / 5
2514 Möllersdorf

Anna Pichler
Wibug. 1
4070 Eferding

Raphael Pirker
Gsörerweg 28
6580 St. Anton a / A
raphael@nr1webresource.com

Martina Pirklbauer
Lanzenberg 58
4320 Perg

Reinhard Poglitsch
Minihof-Liebau 87 / 1
8384 Minihof-Liebau
poglitsch@everyday.com

Stefanie Prast
Lengberg 1
9782 Nikolsdorf
lengberg@ans.netway.at

Stefan Prattes
Dietmannsdorf 47
8543 St Martin i / S

Philipp Presle
Gschwendt 2b / 1
3400 Klosterneuburg
philipp@mail.austria.eu.net

Matthias Pressler
Jakob-Alt-Str. 6
2380 Perchtoldsdorf
matthias@pressler.co.at

Doris Prlic
Wienerstr. 14 / 3
4020 Linz
pangea@subnet.at

David Purviance
Gutenbergstr. 3
4030 Linz
l.purviance@aon.at

Philipp Radner
Lammerdingstr.8
4600 Wels
philipp.radner@liwest.at

Veronika Ratzinger
Pilgram 22
4323 Münzbach
i.ratzinger@eduhi.at

Andreas Reh
Haidbachstr. 45
4061 Pasching
rehlien@gmx.at

Martin Willibald Reichel
Dr. Höllrigl-Str. 5
2130 Mistelbach
mreichel@hlfkrems.at

Christina Reisner
Schörgendorf 12
4222 St. Georgen / Gusen
christinareisner@yahoo.de

Daniel Reiter
Haidfeld 9a
4230 Pregarten
reiter_9a@utanet.at

Kevin Reitinger
Zirkuswiese 2
4490 St. Florian
kevinkevin@gmx.at

Andreas Richter
Hugbertstr. 3
5020 Salzburg
andreasrichter@asn.at

Christian Riedler
Irrsdorf 235
5204 Straßwalchen
christianriedler@gmx.at

Magdalena Riedler
Grabenstr. 9
4563 Micheldorf

Christopher Rodl
Alpenlandstr. 27
3910 Zwettl

Lukas Roedl
Reithofferplatz 1 / 2 / 4
2632 Wimpassing
lukas@roedl.at

Jenny Röllig
Kinderdorf
7033 Pöttsching
j.roellig1as@surfeu.at

Armin Ronacher
Khünburg, 86
9620 Hermagor
armin.ronacher@gmx.at

Ines Ruess
Fischerg. 97
5020 Salzburg
inesruess@hotmail.com

Bertram Rützler
Albrechtsbergerstr. 25
3382 Loosdorf
boert89@gmx.net

Josef Ryba
Bienerstr. 15
6020 Innsbruck
porg_volders@tsn.at

Julia Carina Sakoparnig
Untergaisberg 4
4352 Klam

Manuela Salcher
Aicheck 8
5241 Ma. Schmolln

Benedikt Schalk
Ing.-Karl-Strycek-Str. 17
2326 Lanzendorf
bschalk@gmx.net

Martin Schasching
Maximilianstr. 15
4800 Attnang-Puchheim
MartinSch@gmx.at

Daniel Schaub
Korng. 5
4552 Wartberg
daniel.schaub@gmx.at

Tobias Schererbauer
Südtirolerstr. 07
4780 Schärding
tobias@serverart.org

Alexander Schiendorfer
Tannenweg 21
4810 Gmunden
alex_schiendorfer@hotmail.com

Fabian Schlager
Waldstr. 9
5161 Elixhausen
hamsterrulez@hotmail.com

Florian Schmidt
Maniglweg 6a
4050 Traun
f.schmidt@traun-stadt.at

Alexander Schnaller
Salurnerstr. 4
6112 Wattens
nettreff.marketing@gmx.at

Wolfdieter Schnee
Ringstr. 28
6830 Rankweil
wolfdieter.schnee@cable.vol.at

Raphael Schöberle
Recheisstr. 12
6060 Hall in Tirol
raphael.sch@aon.at

Peter Schöffl
Panholzerweg 16
4030 Linz

Phillipp Schöftner
Jägerstätterstr. 45
4040 Linz

Moritz Schönauer
Mitterweg 56 a
6020 Innsbruck
moritz@mophll-world.net

Michael Schütz
Wachtbergstr. 36
3500 Krems
mischuetz@a1.net

Thomas Schwab
Knoppen 19
8984 Kainisch
fam.schwab@direkt.at

Helene Schwaighofer
Gosau 690
4824 Gosau

Michael Schwanzer
Gartenstr. 16
3442 Langenschönbichl
michi@wavez.at

Christoph Schwinghammer
Bachweg 8
4502 St. Marien
hyperactivman@gmx.at

Rdolf Seher
Niklas-Gfeller-Zeile 8
3550 Langenlois

Georg Sochurek
Hölderlinstr. 4
3100 St. Pölten
joatschi@hotmail.com

Martin Spazierer
Wienerflurg. 68
1230 Wien
flashh@aon.at

Martin Stadler
Edt 11
4782 St. Florian / Inn
mstadler@gmx.at

Christopher Stampfer
Kulm 10
9102 Mittertrixen
christopher.stampfer@gmx.at

Matthias Steinböck
Riederg. 60a
6900 Bregenz
grillen@abendstille.at

Harald Steinlechner
Unterberg 17
6111 Volders
h.stony@lycos.at

Michael Steyrer
Kreuzberg 48
5500 Bischofshofen
mickname@gmx.net

Jörg Stieg
Hugo-Wolf-Gasse 8b
8010 Graz
oerg@gmx.at

Simon Stix
Davidschlag 57
4202 Kirchschlag

Gabriel Stock
Sandg. 23a / 17
8010 Graz
stocki-inf@gmx.at

Elke Stocker
Erlach 23
9112 Griffen
elke_s@sms.at

Lorenz Stöckl
Sonnleiten 2
3231 St. Margarethen
tux3231@hotmail.com

Katharina Stranimaier
Dietmannsdorf 11
8543 St. Martin i. S.
kathi_geigimaus@yahoo.de

Stefan Strassmair
Fischböckau 129
4655 Vorchdorf
strassi@edumail.at

Sabine Straßmeir
Weinmeisterstr. 13
4563 Micheldorf

Sebastian Streibel
Mauternerstr.133
3511 Furth
office@saeba-art.net

Dominik Peter Stuck
Moos 36
9150 Bleiburg
stucke83@yahoo.de

Hannes Sumnitsch
Wallersberg 23
9112 Griffen
sumpe@aon.at

Christian Sutter
Strehlg. 5 / 3
1190 Wien
webmaster@sutternet.info

Michael Szegedi
Fürstenstr. 7
4052 Ansfelden

Theresa Tauschmann
Obgrün 26
8264 Hainersdorf

Stefan Toller
Gumppstr.10
6020 Innsbruck
stefan.toller@chello.at

Franz Tretter
Hohe Linde Str. 13
4594 Waldneukirchen
energy@infidelity.at

Martin Tripolt
Tandelmarktg. 12 / 12
1020 Wien
martin.tripolt@gmx.at

Nina Uransek
Schilterndorf 57
9150 Bleiburg
nina_uransek@hotmail.com

Alex Urban
Schönbrunnerstr. 133 / 16
1050 Wien
alex.urban@chello.at

Mathias Vacek
Loherhofweg 11
6900 Bregenz
vacek_mathias@cable.vol.at

Manuel Vorderwinkler
Dürnberg 37
4460 Losenstein
manuelvorderwinkler@gmx.at

Patrick-Christoph Vratny
Niederschöcklstr. 16 c
8045 Weinitzen

Sonja Rosa Vrisk
12.-Novemberstr. 8
9020 Klagenfurt
OE84MQ@OEVSV.at

Thomas Waldegger
Nesselgarten 420
6500 Landeck
TW15@gmx.at

Lisa und Arno Wallerstein
Hauptplatz 29
4020 Linz

Markus Waltl
Dellach 54
9872 Millstatt
dvprogramms@gmx.at

Nikolaus Weber
Rastenberg 12
3532 Rastenberg
nikolaus.weber@wwnet.at

Matthias Wedel
Eichenweg
6322 Langkampfen

Gerald Weidinger
Im Auholz 19 / 2
2340 Mödling
kami-kaze@everymail.net

Philipp Weiker
Mariasteflitschg. 6 / 2
8430 Leitring
philipp.weiker@bgbrgleibnitz

Theresa Weitlaner
Lindeng. 4b
8501 Lieboch
baerenklasse@vs-lieboch.at

Thomas Weitz
Siccardsburgg. 4 / 1 / 13
1100 Wien
t.weitz@chello.at

Franz Wengler
Ludwig-Voglstr. 35
5230 Mattighofen
projekt_HW@yahoo.de

Daniel Wess
Siedlungsstr. 1A
3021 Pressbaum

Vallerie Wick
Bolzanistr. 2
3013 Tullnerbach
drs.wick@aon.at

Maximilian Widmaier
Lanserhofstr. 77
5020 Salzburg
mwidmaier@yahoo.de

Petra Wieser
Sillian 25
9920 Sillian
pezi.wieser@gmx.at

Eva Wimmer
Brunneng. 6
2603 Matzendorf
iev@gmx.at

Patrick Wolf
Kalch 10
8385 Neuhaus am Klausen-
bach
wolfpatrick12@hotmail.com

Christian Wressnegger
Ziererfeldstr. 15
4030 Linz / Pichling
wR@madebywR.org

Thomas Würthinger
Dulmading 18
4972 Utzenaich
thomas.wuerthinger@gmx.at

Philipp Zach
Neukirchen 81
5145 Neukirchen
zachpn@hotmail.com

Thore Zahradniczek
Rudolf-Janko-Str. 10
2380 Perchtoldsdorf
thore.zahradniczek@kabsi.at

Christian Zeiler
Bahnhofviertel 8
8850 Murau
christian.zeiler@htl-kapfen-
berg.ac.at

Tanja Zeitsek
Ollersdorferstr. 20
2261 Angern / March

Oliver Zettinig
Uferstr. 26
6020 Innsbruck
ozettinig@aon.at

Peter Zongerl
Grieshof 163
6571 Strengen
peter@dataoberland.com

Patrick Zwickl
Gröhrmühlg. 36e
2700 Wr. Neustadt

Akdemisches Gymnasium Linz
Spittelwiese 14
4020 Linz

Aufbauwerk der Jugend
Lengberg 1
9782 Nikolsdorf

BG Amstetten
Anzengruberstr. 6
3300 Amstetten

BG Blumenstr.
Blumenstr. 4
6900 Bregenz

BG Tamsweg
Lasabergweg 500
5580 Tamsweg

BG und BRG Seebacher
Seebacherg. 11
8010 Graz

BG XIX
Gymnasiumstr. 6 / 15
1190 Wien

**BG/BRG Dr.-Schauerstr. /
Wels**
Dr.-Schauerstr. 9
4600 Wels

BG / BRG Gmünd
Gymnasiumstr. 5
3950 Gmünd

Bg / Brg Leibnitz
Wagnerstr. 6
8430 Leibnitz

**BG / BRG Waidhofen /
Thaya**
Gymnasiumstr. 1
3830 Waidhofen / Thaya

BG-Babenbergerring
Babenbergerring 10
2700 Wr. Neustadt

BHAK Lustenau
Neudorfstr. 22
6890 Lustenau

BHAK Neumarkt
Moserkellerg. 15
5202 Neumarkt

**BHAK / BHAS Wiener
Neustadt**
Ungarg. 29
2700 Wiener Neustadt

BHAS-Mattersburg
Michael-Koch-Str. 44
7210 Mattersburg

Borg 3 Wien
Landstr. Hauptstr. 70
1030 Wien

BORG Carneri
Carnerig. 30-32
8010 Graz

BORG Krems
Heinemannstr.
3500 Krems

BORG Murau
Grössingstr. 7
8850 Murau

BORG Ried
Dr.-Thomas-Sen-Str. 5
4910 Ried i. I.

BORG Volder
Volderwaldstr. 3
6141 Volders

BR / BRG Völkermarkt
Pestalozzistr. 1
9100 Völkermarkt

BRG Petersgasse
Petersg. 110
8010 Graz

BRG Schloss Traunsee
Pensionatstr. 74
4810 Gmunden

BRG / BORG Landeck
Römerstr. 14
6500 Landeck

Bundesrealgymnasium
Franklinstr. 26
1210 Wien

Dr- A.-Schärf-Schule
Schmidg. 8
2320 Schwechat

Dr.-Albert-Jäger-HS2
Weidach 8
6130 Schwaz

Europagymnasium
Baumgartenberg 1
4342 Baumgartenberg

FH Joanneum Graz
Alte Poststr. 149
8020 Graz

FH Salzburg
Schillerstr. 30
5020 Salzburg

**Gymnasium der Diözese
Eisenstadt**
Wolfgarten
7000 Eisenstadt

**Gymnasium Diefenbach-
gasse**
Diefenbachg. 19
1150 Wien

Gymnasium Riedenburg
Albergstr. 88
6900 Bregenz

Gymnasium Schlierbach
Schlierbach 1
4553 Schlierbach

HAK Amstetten
Stefan-Fadinger-Str. 36
3300 Amstetten

HAK Gänserndorf
Hans-Kudlich-Gasse 30
2230 Gänserndorf

HBLA für Kunst
Garnisonstr. 25
4020 Linz

HBLA Lienz
Weideng. 1
9900 Lienz

HGBLA Ebensee
Pestalozziplatz 4
4810 Ebensee

HS Arnfels
Arnfels 190
8454 Arnfels

HS Bad Waltersdorf
Bad Waltersdorf 185
8271 Bad Waltersdorf

HS Bernstein
Schulg. 11
7434 Bernstein

**HS der Pädagogischen
Akademie**
Hubertusstr. 1
9022 Klagenfurt

HS Losenstein
Eisenstr. 41
4460 Losenstein

**HS Neuhaus am Klausen-
bach**
Hauptstr. 2
8385 Neuhaus / Klb.

HS Steinerkirchen
Landstr. 20
4652 Steinerkirchen

HS Untermarkt
Untermarkt 32
6600 Reutte

HS Walserfeld
Schulstr. 10
5071 Wals

HS1 Tulln
Konradg. 2
3430 Tulln

HS-Bruck
Raiffeisenstr. 18
5671 Bruck

HTBLA Braunau
Osterbergerstr. 55
5280 Braunau

HTBLA Kapfenberg
Viktor-Kaplanstr. 1
8600 Kapfenberg

HTBL Hallein
Davisstr. 1
5400 Hallein

HTBLVA Spengergasse
Spengerg. 20
1050 Wien

HTL Dornbirn
Höchsterstr. 73
6851 Dornbirn

HTL Vöcklabruck
Bahnhofstr. 42
4840 Vöcklabruck

HTL Wien 22
Donaustadtstr. 45
1220 Wien

**HTL1 Innsbruck–Wirt-
schaftsingenieurwesen /
Betriebsinformatik**
Anichstr. 26-28
6020 Innsbruck

Informatikhauptschule
Leipziger Platz
1200 Wien

Jugendzentrum Wienerberg
Neilreichg. 115
1100 Wien

Kindergarten Spatzennest
Maria Hilferstr. 62
1070 Wien

Kunstuniversität Linz
Untere Donaulände
4020 Linz

LiTec–HTL2 Linz
Paul-Hahn-Str. 2 - 4
4020 Linz

LMS St. Georgen
Linzerstr. 12
4222 St. Georgen / Gusen

MHS Gosau
Gosau 510
4824 Gosau

Musisches Gymnaisum
Haunspergstr. 77
5020 Salzburg

Piaristen-Volksschule
Wiedner Hauptstr. 82
1040 Wien

**RIEGER-Hauptschule Hart-
berg**
Edelseeg. 18
8230 Hartberg

Roseggerhauptschule
Roseggerg. 4
8720 Knittelfeld

Sacré Coeur Pressbaum
Glostererg. 12
3021 Pressbaum

Sir Karl Popper-Schule
Schellingg. 13
1010 Wien

SZU
Ungarg. 69
1030 Wien

Theresianum Wien
Favoritenstr. 15
1040 Wien

VS 1 Vöcklabruck
Schererstr. 8
4840 Vöcklabruck

VS 2 Linz
Dornacherstr. 33
4040 Linz

VS Bichlbach
Kirchhof 58
6621 Bichlbach

VS Ellmau
Kirchplatz 13
6352 Ellmau

VS Hainersdorf
Hainersdorf 26
8264 Hainersdorf

VS Klam
Klam 52
4352 Klam

VS Klettenhofergasse
Klettenhoferg. 3
1180 Wien

VS Langenstein
Schulstr. 6
4222 Langenstein

VS Lieboch
Hitzendorferstr. 2
8501 Lieboch

VS Mötz
Winkl 10
6423 Mötz

VS Oberlaa
Oberlaaer Platz 1
1100 Wien

VS Paudorf
Kremserstr. 63
3511 Paudorf

VS Pöllau
Grazerstr. 195
8225 Pöllau

VS Zederhaus
5584 Zederhaus

CyberArts, International Compendium Prix Ars Electronica – Net Vision / Net Excellence, Interactive Art,
Computer Animation / Visual Effects, Digital Musics, cybergeneration – u19 freestyle computing
Edition 2003

Prix Ars Electronica 2003
International Competition for CyberArts
Organizer: Österreichischer Rundfunk (ORF), Landesstudio Oberösterreich
Idea: Dr. Hannes Leopoldseder
Conception: Dr. Christine Schöpf
Financing / Copyright: Dkfm. Heinz Augner
Liaison Office: Prix Ars Electronica, ORF, Europaplatz 3, A-4021 Linz
Tel. +43/732/6900-24267
Fax +43/732/6900-24270
E-Mail: info@prixars.orf.at
http://prixars.orf.at

Herausgegeben von / Edited by
Hannes Leopoldseder, Christine Schöpf

Redaktion / Editing
Christian Schrenk, Ingrid Fischer-Schreiber

Lektorat / Copy Editing
Ian Bovill, Ingrid Fischer-Schreiber

Übersetzung / Translation
Aus dem Englischen: Helmut Einfalt
Aus dem Deutschen: Catherine Kerkhoff-Saxon

Grafische Gestaltung, Produktion / Graphic Design, Production
Norbert Artner

Cover
„Flow" by Han Hoogerbrugge / Gil K (Wiggle); „re:move" by Lia;
„Atama Yama" by Koji Yamamura; „bzzzpeek" by Agathe Jacquillat / Tomi Vollauschek.

Druck / Printed by
Gutenberg-Werbering Gesellschaft m.b.h., Linz

Fotocredits / Photo Credits
153: Disney / Pixar. All rights reserved.
183: illue; 185: Norbert Artner; 187: Kristin Svorte
188: james hunt tsai; 226 - 232: Norbert Artner

Published by
Hatje Cantz Verlag
Senefelderstraße 12
73760 Ostfildern-Ruit
Deutschland / Germany
Tel. +49/7 11/4 40 50
Fax +49/7 11/4 40 52 20
Internet: www.hatjecantz.de

Distribution in the US
D.A.P., Distributed Art Publishers, Inc.
155 Avenue of the Americas, Second Floor
New York, N.Y. 10013-1507
USA
Tel. +1/2 12/6 27 19 99
Fax +1/2 12/6 27 94 84

ISBN 3-7757-1355-7

Printed in Austria